TRUDY'S HOUSE

LGNO
Read + enjoy my book!

Loren

TRUDY'S HOUSE

L.H. Mitchell

Copyright © 2008 by L.H. Mitchell.

Library of Congress Control Number:		2008901182
ISBN:	Hardcover	978-1-4257-9959-5
	Softcover	978-1-4257-9953-3

All rights reserved. No part of this book may be reproduced or transmitted in any form or by any means, electronic or mechanical, including photocopying, recording, or by any information storage and retrieval system, without permission in writing from the copyright owner.

This book was printed in the United States of America.

To order additional copies of this book, contact:
Xlibris Corporation
1-888-795-4274
www.Xlibris.com
Orders@Xlibris.com
42615

CHAPTER ONE

Trudy Anderson shifted her weight awkwardly on the bed pillow that she was using to make her hard vanity bench more comfortable. The vanity bench was thinly upholstered but she had discovered that sitting on it for long hours when she was trying to write made half her body go to sleep and distracted her so much that she couldn't concentrate on her short stories.

Trudy stared at the sentence that she had managed to squeeze out several hours earlier and couldn't think of any way to continue the story. As she was coming to the conclusion that she had typed herself into another corner, she jumped at the sound of another loud metallic clang from her husband's auto repair garage on the other side of the common wall that separated her living quarters from the garage.

"Hell-damn!" she muttered under her breath, and tried to think of a clever way that she could salvage her short story but nothing came to mind.

Trudy could hear the muffled voices of men talking and more banging on metal. She glanced at her watch. Time was passing and in a few short hours her son, Neil would come home from school, ending Trudy's free-time session at the typewriter for another day.

Concerned that her free time for writing was running short and feeling frustrated that another day was passing without progress on her short story, Trudy tried to ignore the auto repairs going on next door. As she did at least a dozen times each day, Trudy stared at the paper in her little portable typewriter, pinched a piece of chewing gum in her front teeth, pulled a long string of gum out with her finger tips and coiled it back on her tongue and chewed it again.

Trudy shifted her weight again and looked up at her image in her vanity mirror then looked quickly away. She didn't want to be distracted by anything, especially concerns about her hair or her makeup. She couldn't afford to waste any time. Trudy looked down again at her typewriter, picked up her ink eraser

and balanced it on top of an open bottle of dry skin cream, then flicked it off on the top of her vanity realizing that she was just playing again—wasting time! She hadn't written more than a line of type all day!

The windows in her little bedroom were head high and were decorated with yellow print curtains that were pulled to the side to let the daylight in. There were shades to pull down at night of course, but in a little town like Delake it hardly mattered. She hated life in the little coastal town that went to bed when the sun went down.

Trudy freely admitted to anyone that it was all right that Delake was so quiet. The problem was that there was nothing for her in Delake. She had arrived in Delake two years earlier with her husband and son because it was near the end of the depression years—1938—and they were going broke in Portland. Trudy's husband was a first-rate factory trained mechanic but almost no one could afford to take their car to a mechanic's garage for repairs. If a car needed work most people did the work themselves and installed used parts, or they hired a neighbor who did the work in a backyard, or in someone's home garage.

One day while they still lived in Portland, Trudy's husband announced that he had found a garage and service station on the coast that he had leased. They could make a living there and they were moving as soon as they could. While Delake was barely 100 miles from Portland, it might as well have been 1000 miles in 1938 because of twisting highways that led through every little town on the way—and usually behind an old creeping, smoke-belching log truck. Most people couldn't afford two cars so trips were usually made by bus and that could take three or four hours.

Trudy and her family moved into the living quarters that were a part of the huge, white, barn-like board and batten garage. Facing the front of the building, a pair of large doors were hung at the entrance to the garage and an overhang to the left gave shelter to two old, glass-topped gas pumps with pump handles on their sides. Beyond the gas pumps was the living quarters that were built inside the old building and were about fifteen feet wide and seventy feet long. Everything about the large old garage suggested that it might have been new in the late 1920s.

Trudy and her husband had a bedroom to themselves. There was a kitchen, a bathroom and a smaller bedroom and a front room, and Neil's bed was the davenport in the front room. When Trudy moved into the old building, she offered the small bedroom to Neil but it didn't have a window and Neil preferred the front room because it had a large front window with a view of the gas pumps and beyond them, Highway 101 that ran north and south past the front of the old building. Neil had the added advantage of a table lamp to read by, and the family radio to listen to on Sunday mornings when his father was trying to sleep in.

In moving to Delake they found enough financial security to make a living and plan for a future. The chief drawback was that they had left friends and

relatives behind in Portland, and had lost a life style that Trudy missed, even though she knew at the time that in her present circumstances that lifestyle could not be maintained.

"Well, land sakes!" Trudy's older sister, Jean said on one of Trudy's visits to Portland. "Why don't you try to meet people in Delake? There must be someone there who you could talk with!"

"They're all fishermen and loggers," Trudy said. "There's no art in any of them."

"Art?" Jean said, puzzled. "You mean you want to take up with artists? My Lord! Haven't you learned anything? They can't support you. You have to support them!"

"Jean, I don't mean that kind of artist." Trudy said. "I'm talking about people who understand the arts. Refined people who travel and can appreciate art in others."

"Well," Jean said, brushing imaginary crumbs off the table with a calloused hand. "I suppose I must be one because I don't know what you're talking about. Sounds to me like you've been hanging around with a bunch of idealistic students!"

Trudy dropped the argument because she thought she was too close to telling Jean too much about her private life.

Although he would never admit it or talk about it, one of the big reasons Trudy's husband wanted to move to the coast was to move Trudy away from a social group of artists and writers in the Portland area that she had been attending meetings with. Her husband knew that Trudy was always interested in the arts, even though she had never been trained in the arts and seemed to have little artistic talent, but she had loved to talk about the arts and enjoyed their company.

In fact, the reason Trudy was spending her free time in 1940 trying to write short stories was that one of her friends in Portland had advised her that if she ever wanted to make a change in her life the easiest way to get some money was to write short stories for pulp fiction magazines. And after two years in Delake, and away from her friends and family, Trudy was eager to do something more with her life. She regretted that she had never trained for anything in school—not that schools in her time had ever offered much of a selection of work training for women! She also regretted that she had never tried to find a job where she could get some training, instead of just waiting for someone to come along and marry her! What a fool she had been, she thought.

"Hell-damn!" she said again, and hit her clenched fist on her knee.

Checking her wristwatch again Trudy saw that it was almost time for Neil to come home from school. She would have to start dinner soon, so she yanked the paper out of her typewriter and carefully smoothed out the carbon for future use. She placed the yellow copy paper in one stack and the white sheet on another,

and placed the cover back on the typewriter and pushed it aside. She would think about the story and work on it again when she had a chance.

Later, after dinner as Trudy was cleaning the kitchen and putting things away, her husband walked into the front room and turned on the radio to relax and listen to the news and hear some of his favorite radio programs. Trudy thought about the artists and writers guild that she had socialized with in Portland. Not only had she met new and interesting friends, but she had gained exposure to creative and cultural stimuli that she thought had been missing in her life. After all, she had grown up in Winnipeg, in Canada in a family with three sisters and a mother who worked all day as a scrubwoman. Her father was a traveling salesman who was gone so much of the time that her family had come to think of him as a visitor when he did show up.

Sometime after Trudy started her teen years, her two older sisters moved to Vancouver, Canada, then with almost no U.S. immigration laws in place, the younger of the two migrated to Portland. Trudy, her mother and her youngest sister followed and soon all the sisters had settled in Oregon. Trudy had never been exposed to any kind of professional cultural event as a young girl, and no one in the family knew anything about the arts.

It was after they had moved to the coast and away from her Portland friends with only her husband and son to talk with, that Trudy had decided that she and her husband had very few common interests. In 1940, family life and duty to the family was the universally accepted way to live and Trudy's awakening to the fact that she really did not love her husband of a dozen years was troubling, to say the least. She had no idea why this was so and lacked the insight to deal with her feelings, so she gravitated back to her old friends and relatives. Of even greater concern to her was a deep-seated, nagging feeling that her son, who was now eleven years old, was also a factor that she didn't think she wanted in her life! For Trudy that was a secret thought that she wouldn't discuss with anyone.

On several occasions Trudy had paused in her story writing, looked up from the typewriter and studied herself in the vanity mirror. She had been told that she was a good-looking woman, and she thought that she still looked good. She had shoulder length brown hair that she kept neat and manageable with only a comb and a curling iron. She thought that she looked a little younger than her thirty-five years, and she tried to stay trim in spite of having a full figure. She had always been able to attract men and was confidant that she still could. She recalled one of the artists at the guild in Portland who called her, "Five foot two: eyes of green," after the line in the popular song. "Here she comes!" he would say. Trudy smiled at the memory of the attention she had received. How exciting the guild was, Trudy often mused. Such exciting, interesting people!

To compensate for feeling like she was caught in a vacuum, Trudy was able to catch a ride to Portland for the day, now and then, with someone that she

and her husband knew. Less frequently, her husband would close the shop for a day and ride into to Portland to conduct business and visit the relatives. On rare occasions, Trudy was able to stay over a few days longer and have a good visit with her sisters and her mother before coming home on the bus. One of their favorite stops was to visit a few hours with Faith and Melville Mathews who had been their neighbors and close friends when they lived in Portland. Trudy's son, Neil had developed a friendship with the Mathews' son, Donny. In fact, Trudy and her husband may not have remained friends with the Mathews because of very different income and education levels, had it not been for the close friendship of Donny and Neil. Melville Mathews was a dentist and he and Faith had moved to a small suburban farm just before Trudy and her family moved to Delake. Faith and Trudy were good friends, mostly because neither of them gave much thought to money and the differences in their social status.

Trudy continued to spend hours in front of her little portable typewriter almost every day, pulling at her chewing gum, looking out her bedroom windows at the passing clouds and blue sky, and sometimes daydreaming about better times ahead. No one could ever recall seeing a finished manuscript, or large manila envelopes coming and going in the mail. There was no indication that Trudy had ever finished a short story, but she persisted in trying to write because that friend had convinced her that writing for the pulps was something she could do. It appeared that Trudy expected to earn money as a short story writer using some sort of psychic phenomenon, or possibly a kind of osmosis where the proximity of the typewriter and a blank page would cause the muses to smile on her and help her write short stories that sold. Closer to the truth, she probably didn't know enough about the mechanics of the craft to build a story and finish it. It was all Trudy had and she would keep at it until something else turned up.

In the meantime, by 1941 Trudy was still trying to write short stories and her husband worked hard building his auto repair business. Very little had changed as far as Trudy was concerned, except that their relationship had deteriorated to the point that they found it difficult to retain a social respect for each other. They were concerned that their son, Neil would notice their hostility, but Neil was occupied with his friends, school, and selling magazines door to door. Each week he would sell *Liberty, Colliers, Saturday Evening Post,* and *Ladies Home Journal* magazines along a route that he had built up himself, and each week his father would help him make up the amount that he had overspent on movies and buying model airplanes so he could pay for his magazines.

Neil wasn't shy about making money. When he had finished his homework, he set pins at the bowling alley next door, and collected cascara bark for a buyer in town. If nothing else was going on, Neil and his friends went fishing in the local creeks that emptied into the big lake located just inland from the tiny town.

Neil barely noticed that his parents were having trouble getting along, because he was preoccupied learning to fend for himself!

One Sunday morning Neil awoke early and turned on the radio to hear what was happening in the world. He heard anxious-sounding voices talking about a place called Pearl Harbor with the news that the Japanese had bombed the area and that there was a great deal of damage. He wondered if he was listening to a radio play, and stayed tuned in to the station. After a few minutes a serious-sounding, shaking voice interrupted and said, "Ladies and gentlemen. We are interrupting our regularly scheduled program to bring you this bulletin. We have received word that Japanese airplanes have attacked Pearl Harbor this morning. We are informed that the damage to the Naval facilities there is extensive. We repeat, . . ."

Neil knew this was not a radio play and shouted for his father to wake up. In a few minutes, his father opened the bedroom door, ready to scold Neil for waking him up early. "They say the Japanese bombed Pearl Harbor. Where is that, Daddy?"

As his father got dressed, Neil remembered that whenever they were driving in Portland and happened to see a Japanese ship loading scrap iron, his father would complain bitterly, saying, "Someday we'll be sorry we sold them all that scrap. Those Japs are going to send it all back to us in bombs and ammunition!"

After Neil got dressed and had breakfast, he ran out to see if he could find one of his friends. All the while, his father stayed by the radio and listened for more details of the raid. Later that day, Neil saw his father making phone calls to friends and make tentative plans about something.

"I'm afraid that the Japs will keep on sailing to our coast and either bomb or invade us," Neil heard his father say. "How do we know they don't have an invasion fleet with them?"

Trudy told Neil that his father was telephoning all his friends who were war veterans. They all met later that day to talk about things they could do if the Japanese fleet was sighted off the coast. The men looked at maps and tried to decide where an invading fleet could get a good foothold on the land, and talked about targets that might be worthwhile. There was talk about forming a guerilla army and gathering supplies and ammunition. Finally, there were anxious discussions about what to do with the women and children.

For the next few days the veterans did a lot of planning and located supplies that they could confiscate, and even discussed remote locations high in the coastal mountains where they could meet and form armed camps. Then, after a week or so when no invading Japanese ships were sighted, the veterans relaxed and settled into a civilian wartime existence, but with one eye on the ocean!

Privately, Trudy wondered just where Pearl Harbor was and why it seemed so important to everyone. She didn't understand why her husband and the other veterans were taking things so seriously until she later discovered that other

veterans, other men, and self-proclaimed patriots up and down coast had been making similar plans all week in anticipation of a Japanese invasion on the west coast. When that didn't materialize everyone followed President Roosevelt's war declaration in all its ramifications from blackouts to rationing, including civil defense and the military draft. Trudy guessed that she probably didn't keep up on the news enough, but she couldn't bring herself to make listening to the radio all day a part of her life now.

Trudy and her husband talked at length about their futures together while Neil continued in school. Neil seemed to not notice what was going on at home. Trudy had been wondering how he would take her separation from her husband and saw that he still had the same friends and that he was just as active as ever. The only difference was that things seemed to take on a military slant with Neil, but that could just be because he was getting older and was hearing so much about the war.

Neil's father saw an almost instantaneous difference in his business. People were driving less and they were holding back on having their cars repaired. Everyone seemed to be concerned about the future of the country. The newspapers were filled with news about planned rationing, blackouts and civil defense, making almost everyone aware of the war and the sacrifices that were expected of them. So, Neil's father wasn't surprised to see newspaper articles encouraging people to save. Articles appeared about items that were needed for the war effort, and scrap drives for strategic materials. His father began to see that he might not be able to make a living in the garage business with the war going on. Gas rationing would mean that he would sell less gas. Young men would be in the Army and they wouldn't be driving cars and trucks in Delake. He saw that he would have to cope with rationing problems and a lot more bureaucracy, and began to think about other things he could do to make a living.

A few weeks later, Neil's father took him for a long ride around the lake that the town was named for, and explained the situation to him. After a lot of talking and explaining he asked Neil that if it came down to it, who would he want to live with, his mother or him? Neil had always felt closer to his father and told him so. His father explained that he would have to board Neil with one of Neil's uncles until everything was settled, and he seemed to understand.

By the early spring of 1942 Trudy and her husband had decided to go their separate ways. They mutually agreed to send in applications for war work. Employers with federal government contracts were begging people to go to work for the war effort. Trudy applied for any kind of work, but her husband specifically asked for some kind of work that required his kind of experience. They spent the next few months closing the Delake garage and settling their affairs. By summer, a government contractor hired Trudy as a painter trainee, and she arranged to start at an air base near Spokane, Washington, when her husband moved Neil to his brother's ranch at the end of summer.

Her husband received word that he would work as a civilian automotive advisor in a civil service position with the Army when nearby Camp Adair in Oregon began training a new army division of troops. That assignment was perfect for him because Camp Adair was near Corvallis, and close to Portland. But more important, he could still visit Neil and get to his tools and supplies that were both left on his brother's ranch in northeast Oregon.

"If the dad-gum Japs ever decide to invade us," he told everyone, "it'll take 'em a long time to find northeastern Oregon! Neil will be safe up there."

During the weeks before they had to start their jobs, Trudy and her husband lived apart and each took care of their own affairs. Trudy spent her time in Portland to visiting her mother and her sisters, while her husband closed his garage in Delake and permanently parked an old Chevrolet farm truck that he had used to haul Neil and all their belongings to his brother's ranch in eastern Oregon. He had wanted to use it to camp in when he went hunting, but like a lot of other people preparing for war, that dream was put aside.

Trudy had always enjoyed the company of her youngest sister, Ellen—possibly because the two were so much alike. They often played together as young girls and usually had the same friends, whereas the other two sisters were older and treated Trudy and Ellen as if they were children. Consequently, Trudy and Ellen spent several days together while Trudy was waiting for her civil service assignment.

"So," Ellen said, sizing up her older sister. "You're cutting yourself free from raising a kid and being a married woman," she said. "Maybe life at the coast was dull, but I think you should have tried to meet a few people while you were there. You don't know. You might have been able to meet some nice people. I hear some interesting people live there."

"You don't understand," Trudy said. "Once I was living there and was alone with my husband I realized that we had grown apart. I wanted to have some culture and art in my life, and all I ever heard was car talk and fishing and hunting. And all my friends and relatives are here in Portland. I tried to write for the pulps but that didn't work. I was nearing my wits end when the Japs bombed Hawaii! I don't know what I could have done if they hadn't done that! Then there was Neil who was getting to be like his father in everything!"

"Well, I guess you had some problems," Ellen sympathized. "Don't you want your own son, though?"

"Well, I don't know," Trudy said. "I imagine I need a little time to think about things, but he's more interested in his father right now, and I need some time on my own."

"I know," Ellen said. "You want to date some men and play around a little"

"Well, maybe. My life in Delake was dull, and my husband is all business. He didn't even want to take me out anywhere!" Trudy complained. "We haven't eaten out since we moved to Delake!"

"I haven't been out since before my husband was transferred to New Jersey a year ago," Ellen said. ""But I have my baby."

Trudy paused, trying to imagine what it would be like to be tied down with a baby again. When she had Neil and raised him as a baby she was in love and wanted the experience of raising a child. But now, having gone through the experience of bringing up a child, she wanted to get out and experience life and enjoy a life of socializing.

Trudy had a chance to visit with her older sister Jean, too. Jean was really a half sister who often acted like Trudy and Ellen's mother because when they were young, Jean was usually around to look after them while their mother was out working. At times Jean would hear them out on some problem, then offer advice like a mother would. Trudy and Ellen didn't like it but over the years they had all grown accustomed to that relationship—and being nagged at by two people!

By 1941, Jean's house had become a center of activity for Trudy, Ellen, and their mother who was too old to work and had come to live with Jean, who often said, "Boy! It's a good thing I had the foresight to buy a big house!"

Early in the fall of 1942, Trudy was summoned to Seattle to begin her training for her job in painting insignia on airplanes. Neil's father had to report to his job at Camp Adair on September 15, leaving Neil on his own at age 12, to be cared for by his father's brother and his wife and their two sons. Neil's father had explained that he intended to bring his son home with him at the end of the school year. So, like it or not, Neil started the seventh grade in a tiny country school just after Labor Day. When his father said good bye, Neil had no way of knowing that would be the last time he would see of his father, and Neil's only connection to his former life was his father's tools and family goods that were locked in an outbuilding on his uncle's ranch. He would learn a new way of life where transportation was by horseback—or skis if the snow was deep enough. News came by a grapevine of idle people listening in on a hand-crank telephone network, and serious illness was governed by prayers and hope.

Trudy was transferred to an air base near Spokane, Washington, in mid September and found a fairly active social life. She and her husband had agreed that there was no need to rush into a divorce, because they couldn't afford it. Her husband needed a year to pay off his existing debts and re-establish himself. He thought it was likely that his job would always be at Camp Adair and that he would simply be assigned to whatever Army unit was in training there at the time. He was too old to be sent overseas with the Army. Therefore, his long-range plan was to establish himself in the Corvallis area and send for Neil when he could afford a house.

A few months later, in February 1943, Trudy received a telegram from her husband's unit telling her that her husband had died. The news took Trudy completely by surprise and so stunned her that she sat motionless not knowing

what to do. Friends helped her make decisions and she finally realized that she would have to return to Portland at once to make funeral arrangements.

As Trudy traveled back to Portland on the train she had time to reflect on the position she found herself in. She realized that the life she had longed for and had been living in Spokane was over. Any thoughts she had of living carefree days with little or no responsibility were gone. While she was no longer living on the Oregon Coast, and now in her late 30s, her old life had been tossed back into her lap. Gradually, Trudy realized that prepared or not, she had to accept her responsibilities!

Jean allowed Trudy to take her spare bedroom while she tried to figure out what to do. The day after she arrived in Portland it seemed to Trudy that an almost continuous stream of friends and relatives came by, or telephoned with their sympathies. But, Trudy felt that all the sympathy was misplaced because she had wanted to leave her husband for several years. What she wanted to know was what to do next!

One of the in-laws, her husband's older sister telephoned in the middle of the morning and began the conversation with a polite, somber voice. "Hello? Trudy?"

"Yes, this is Trudy."

"This is your sister-in-law, Amy. How are you holding up?"

"Well, for heavens sake!" Trudy exclaimed. "I haven't talked with you for several years. Oh, I'm holding up fine, I guess. We had separated, you know, so it's not like we've been close all this time."

"Yes," Amy replied thoughtfully. "I understand. But, you two were close at one time and I can imagine that you have some cherished memories of better times."

"Oh! Yes, of course!" Trudy replied. "We had fun when we were first married, but I was such a kid then."

"Yes." Amy replied again.

"You know," Trudy asked hesitantly, "the telegram just said that he had died but it didn't say how or when, or where he was when he died. Goodness! What a surprise! I didn't even know he had been ill!"

"Yes, well I suppose that his civil service office sent the telegram." Amy replied. "Well, let's see, he died last weekend and he really hadn't been sick. But you know, he always had complained about his sinus trouble and that seemed to be getting worse. Anyway, I know he was coming to Portland on the weekends to have dinner with friends, and as I understand it, the night he died he wasn't feeling well after he ate and sat in an easy chair to relax. They said that he developed quite a headache and took some aspirin, then fell asleep in the chair. He was still asleep when they went to bed. Then, they said they looked in on him a few hours later and he had died."

"Goodness!" Trudy exclaimed. "What happened to him? Did they say?"

"Yes. They said that he had had a massive stroke and passed away in his sleep."

"How terrible!" Trudy exclaimed. "Who were the people he was visiting?"

"Oh, I don't know about that," Amy replied. "Someone he met who lives out on the east side, I suppose."

After they had talked a little more and had exchanged pleasantry Amy told Trudy about the funeral plans that had been made, and suggested that Trudy could probably alter things a little if she want to, but Trudy declined. Trudy mulled the conversation over and over for hours after they had hung up. Finally, Trudy came to the conclusion that there was a lot that had gone unsaid. For instance, she couldn't help wondering who he had been visiting when he died. She didn't think that she and her husband knew anyone who lived out on the east side of the city. Then, with so much to think about before her husband's funeral, Trudy forgot about the circumstances of his death and began to think about her real problems.

Neil had arrived by train from eastern Oregon for his father's funeral and spent most of his time during the day or two before the funeral walking around his Aunt Jean's neighborhood, visiting with a girl who had been a childhood friend. She was his own age and lived in the house next door to Jean. Sometimes Neil just sat in the background watching the comings and goings of all the people who stopped by. While he wasn't really sure about the day by day, hour by hour order of events over the next few days, he knew generally what was happening. His mother and some of his relatives wondered if he wanted to attend his father's funeral, but he insisted that he did not because he wanted to preserve the memories of his father when he was alive.

While he sat alone at his Aunt Jean's house on the day of the funeral, Neil spent a good deal of time pondering his own future because plans involving his father had become meaningless. He wasn't sure what life with his mother would be like because he wasn't sure how she could support herself and him, too. While he didn't know how much money a person needed to live on, he did know that they needed a lot of money. For that matter, he wasn't even sure that he would be living with his mother. After all, nothing had been said to him since he arrived.

Neil began to retreat into self-imposed corner. Like a cornered animal, he didn't know what to expect although he thought that he would probably be living with his mother again. After all, she was his mother and he thought that she was probably legally responsible for him. He talked a little about his situation with the girl next door, but she didn't really understand the problem. Eventually Neil just sat in the back ground and watched and listened.

Trudy woke up tired on the day of the funeral. The whole affair was becoming too demanding and too morose for her personality and real feelings to deal with. Inwardly, she considered her husband's death a stroke of good luck that freed her from a lot of complications later on. The bad thing for her was the dawning recognition that her stab at freedom had ended and that she would have

responsibilities to deal with for years to come. By the time of the funeral, Trudy was just beginning to understand what was ahead of her and she had not settled a thing in her mind. In fact, problems that she had tried to avoid living in Delake were pouring back on her like an avalanche and she was just becoming aware of the fact that she was going to have to take a whole new direction in her life.

After the funeral she felt physically and emotionally exhausted. She allowed several of her husband's brothers to lead away from the graveside and back to the large black limousine that had brought her to the cemetery. Someone opened the door and Trudy sat down on the large, comfortable seat and sighed deeply. Before she drifted off to sleep she looked down at the folded flag on her lap, damp with a collection of water droplets from a light rain that had begun. She ran her fingers across the white stars on the blue cloth field of the flag, thinking that her husband had been a good, honest man but too full of business, then fell asleep.

It seemed to Trudy that she had just closed her eyes for a moment but when she opened them, her sister Jean was standing in the open door of the car shaking her arm. Trudy blinked at her and looked around. The car was parked in front of the funeral home and the uniformed chauffer was watching her with one arm resting on top of the front seat. A handful of family members wearing dark, somber clothing and were standing around the car, peering in and waiting for her to wake up. Trudy looked at her wristwatch and saw the she had been asleep for almost an hour!

"Come on, Trudy!" Jean said with an impatient voice and tugging on Trudy's sleeve. "Wake up! Everyone is waiting for you. We want to go down to a lunch counter somewhere for coffee and something to eat!"

Still groggy, but feeling rested, Trudy allowed herself to be coaxed out of the big, comfortable limousine. She was surrounded by relatives as she walked to another car and she was vaguely aware of muttered condolences and half-expressed questions from people who she barely knew. She felt defensive and answered in whispered words that made her feel like she was talking to herself. It would have been so much easier if she had known what to say!

She was loaded into a full car and driven to a near-by restaurant where the help was waiting for them to arrive. They were shown to a side room where they could talk privately. Trudy ate a sandwich and a salad with some coffee and soon was beginning to feel better. She had the waitress fill her coffee cup again and finally relaxed. She looked around at the people in the group. Most were her husband's relatives and were people she had tried to avoid throughout her marriage because she felt like she had so little in common with them. They were people who cherished close families. All were descended from farmers and teachers and all were full of obligations and duty to each other and members of their extended family. All were qualities that Trudy knew were supposed to be good and noble, but that she personally found to be prying and restricting.

"What about your son, Trudy?" one of the in-laws began. "I thought we'd see him at the funeral."

"Well, I had a talk with him this morning about that. I told him that it was his father's funeral and that he might regret not coming," Trudy explained.

"He told me that he wanted to remember his father the way he was and not associate his memory of him with a funeral," Trudy said. "I didn't think I should make him come because he seems to know his own mind."

"Well, of course," someone said, "I can understand that. I'd probably be the same way."

"But when he's older, don't you think that he'll always wish that he had gone to the funeral?" a woman's voice said.

Not waiting for an answer, another voice asked, "Have you had a chance to make any plans for your future yet, Trudy?"

"No, not yet," Trudy answered. "This has all happened so suddenly that I haven't hardly had a chance to catch my breath!"

"Trudy," a different, more educated voice said. "You're at a crossroads in your life. You've got to think about what you'd like to do with the rest of your life—not how. Think about where you'd like to be—not in terms of specific places, but in terms of surroundings. Think about weather; big and little cities; mountains and seashore. Now, where do you see yourself?"

Trudy stopped talking and turned around to see who was addressing her, and listened intently. Peering at a seated figure back lighted by a window, she saw that it was Leonard, her brother-in-law who was a newspaperman from Idaho, and one of the two brother-in-laws that she had any respect for at all and she valued his advice.

"Trudy, you want happiness and contentment in your life and you can find it if you deal with your present problems as quickly as you can, take stock of your situation, and define your goals. If you put it off, each new day will be just like the day before and you will not be content."

Trudy sat still for a few moments then said, "Well, as you know, I was born and raised in Winnipeg, Canada, and they have such terrible winters there. When I was a young girl I decided that when I could, I would live someplace that's warm and sunny. Someplace where there are no cold winters."

The rest of the people—all veterans of many cold winters—sat quietly and listened politely.

"All right," Leonard said in a slow, steady voice. "Do you know where that place is? Because, if you don't, you'll have to find it. And, you'll have to move pretty fast before your money runs out! It sounds cruel, but I'll bet it's a fact!"

Trudy's face blanched a bit. She looked toward Leonard, not really certain how to deal with his bluntness. He was right, of course. She had no idea how much money she could put together to make such a move. She already knew that

there was no insurance money that she knew of, and she had no idea how much money she could raise if she could sell all his tools and personal things.

"Well," Trudy replied. "I think that is the best advice I've had. You're right, of course. I don't know where that place is, but I'll find it."

"It won't be easy for you," Leonard said. "With a war on nothing is easy. Ease and convenience are the first things to disappear in wartime. I hope you're able to find whatever it takes to make a good life for yourself."

Trudy looked at Leonard and thanked him. She wasn't sure how to take him because his advice seemed almost out of place and out of character for the gathering at the restaurant. She thought the others felt the same way because nothing more was said about Leonard's advice, aside from the widely held family opinion that whenever he left the room it amounted to a brain-drain! The conversation dwindled back to small talk and visiting, because most of the relatives had not seen each other for a long time.

Later that evening Trudy talked a while with Jean and her mother, then went to her room to get ready for bed. Instead, she sat down to mull things over and think about Leonard's advice. Trudy was becoming acutely aware of her practical shortcomings. She wasn't skilled in anything. All she had ever done was domestic work—keeping house—and she was honest enough with herself to admit privately that she was a terrible housekeeper. And, she was learning to use a spray gun to paint aircraft but she could only do some of the work with a lot of supervision. She knew, judging by the pay she was getting, that she couldn't earn enough working as a painter to support herself and her son. Still wearing a slip and a blouse, and feeling despondent, Trudy lie down across the bed and fell into a deep sleep until morning.

The next day, feeling no wiser than the day before, and after long talks with her mother and her sisters, Trudy took the first steps in long-range planning to find a way to make a living. She tried to discuss rough ideas with Neil, laying out her plans with him but, soon saw that he was too young to understand and she knew that she wasn't really getting through to him because she didn't know all the details herself! Finally, she sent him back to his uncle's ranch to finish the school year, telling him that there would be changes ahead for both of them.

With Neil taken care of for the time being, Trudy accepted offers of help from her in-laws to sell all of her husband's tools, personal things, and supplies that he had stored on his brother's ranch. Trudy also sold most of her furniture and her husband's car, keeping the farm truck and enough household items to furnish another house. Money from all the sales trickled in and Trudy was careful to put all she could into a bank account, even if it increased by only a few dollars at a time. She had made up her mind that since she had no idea what she would do, she would be better off having as much as possible in cash so she could act

quickly if she had to. By the end of spring with most of the money she expected in the bank, she only had a little over two thousand dollars!

Jean went to work every morning by 7:30, and came home at about five. Ellen worked sporadically, depending on where and when she was needed as a clerk for the county, so Trudy occupied her spare time looking through newspapers and magazines for training in some line of work, and helping her mother when she was at home. Trudy was beginning to feel anxiety about her future. She knew that she and Neil could not stay at her sister's because although Jean would not refuse them, Trudy knew that none of them had the temperament to live that close together.

To make matters worse, Trudy had become disenchanted with her friends at the art guild because they didn't really understand that with her husband's death, she suddenly had the responsibility of the raising of her own son thrust back on her. She lacked the means and ability to earn enough to support herself and her son, and they actually suggested that she was taking it all too seriously! Worse yet, they thought that Leonard's advice was impossible because she could chase all over the world looking for the perfect life!

One morning Trudy sat at the breakfast table with Jean, talking about her plans. "Oh, I don't think I'd be very comfortable trying to make new start in a place with just one or two thousand dollars behind me these days," Jean said with the wisdom that comes from years of struggling with money. "You'll need a lot more than that! You'll need every cent you can raise, and that probably won't be enough," Jean continued ominously. "I've had to work all my life for everything I have, and believe you me, I know!"

Trudy looked over the jobs in the paper again, wondering if she couldn't handle some of the better paying ones. She even went downtown and put in applications to see if she could get the jobs. She was turned down because she lacked the experience, and on one occasion she lacked training in math. Trudy went back to her room at Jean's house to fight sleepless nights with frightening nightmares. Trudy often felt like crying in the night when she would wake up from the nightmares, but she thought that was a weakness that didn't confront the problem. She learned that if she thought about something more positive she could go back to a restful sleep. Trudy had the good fortune to be born with a fierce determination and strong will, but she still had to discover those qualities.

Trudy knew that she could quickly get used to single life again, and probably would not miss her husband because their marriage had been so bad in recent years. However, her brief experience of learning how to paint insignia for the government had shown her what it took for her to make a living. While training, she barely earned enough money to buy the things that she considered essentials, and Trudy did have meager needs. The thought of being able to earn enough for herself and Neil to live on was beginning to give her moments of near-panic

feelings whenever the subject came up, or when she sat down with someone to try to make plans because she knew what kind of earnings she could expect in the future. Her employers had made that very clear when she started the training to become a painter in case anyone wanted to drop out. That was an option that Trudy had never considered because she was certain that she couldn't qualify to do anything else.

In the meantime, Trudy continued to receive checks in the mail for tools and equipment that her husband had owned and one of his brothers or friends had sold to someone. She banked the money and watched her account grow, tiny step by tiny step. She sent notes to everyone who helped her to thank them for their trouble. Because of her own personal make up it didn't occur to Trudy that her in-laws were simply good people responding to a family need.

Chapter Two

Late in May, Trudy received a phone call from Faith Mathews whom she had not heard from for almost a year—before Trudy and her husband had gone their separate ways. The call caught Trudy by surprise because she had been so consumed by her own pressing problems that she had not given anyone else a thought. Faith had been her neighbor and a good friend when she lived in Portland.

"Hello!" Faith said cheerfully. "I thought I'd call and see how things are going. I saw you at the funeral but you looked so busy and so tired that I didn't want to bother you."

"Well, for goodness sake!" Trudy exclaimed, suddenly wondering why she had not called Faith sometime during the weeks since the funeral. "Imagine hearing from you! I guess I've been so busy working on all my husband's papers that I just didn't . . ."

"Well, I imagine you have been busy!" Faith said, interrupting Trudy's excuses. "You know, I never did hear what he died of. It happened so suddenly!"

"It was a stroke," Trudy replied. "The death certificate said it was a massive stroke. From what I've heard, he had gone to somebody's house for dinner and didn't feel well after he ate, so he sat down in an easy chair to relax. They said he fell asleep there and they left him alone but looked in on him several hours later and he had died!"

"Well, mercy sakes," Faith exclaimed over the phone. "And, he was only what, forty—what?"

"Forty-seven," Trudy said.

"I'd sure like to hear what you're planning now that your whole life has been turned upside down," Faith said. "Well, shoot. We just have a lot to catch up on. What are you doing now?"

"Right now?" Trudy asked. "Well, I'm selling off all my husband's tools and all the other things I don't think I want any more. My husband had taken it all up

to eastern Oregon and stored everything at his brother's ranch, you know. I'm not sure what he had taken up there, but I think it was tools, tires, drums of gasoline, and lot of his personal things. His brothers are selling it all for me."

"That's nice of them," Faith said. She paused as if deciding how to open the subject, then said, "So, are you making any plans for your future yet?"

"Well," Trudy started, clearing her voice, "I really don't have any definite plans yet, but I've been thinking about a lot of things. I've been talking with a lot of people to get ideas, too. I guess what it all comes down to is, how am I going to make a living and live in a place where I'd like to live?"

"And?" Faith asked, only half expecting an answer because Trudy always did have her head in the clouds. She knew Trudy as well as anyone did and she really didn't think that Trudy had any answers yet. But, of course, curiosity was one of the reasons she called.

"And," Trudy started, "and I really don't have any idea what I'm going to do, Faith."

Faith sensed that she was getting close to one of Trudy's raw nerves, and backed off. "What about Neil?" she asked. "Where are you keeping him while you sort everything out?"

"He was staying with his uncle on a ranch in eastern Oregon," Trudy said. "We had him come down for the funeral, then sent him back there to finish the school year because I really didn't know what else to do with him."

Faith knew exactly what Trudy was talking about because she already knew that Trudy had almost no motherly instincts. She'd heard stories about Trudy from her own son over the years, and had seen how Trudy had treated the neighborhood children when she and Trudy had lived next door to each other. She wasn't surprised that Neil was living on a ranch in eastern Oregon! Yet, there were qualities about Trudy that she liked, and guessed that Trudy's apparent callousness came in part from her childhood experiences.

"Well, I'll bet he likes that!" Faith said cynically, thinking that Neil must feel like he had been cast adrift with his father dead and an unloving mother.

"I suppose so," Trudy admitted. "But he gets along with his aunt and uncle and he has a cousin there—a boy—who is his own age. Besides, I really don't have any way of keeping him here. I can hardly take care of myself right now!"

Sensing another raw nerve, Faith changed the subject a little. "You know, Trudy, I think we need to talk because, my gosh, what are you going to do? Do you have a little free time tomorrow? I could drive down and pick you up and we could have lunch out here."

Trudy agreed at once, because she had always trusted Faith's common sense and conversation that was supported by a good, sharp mind. In fact, Trudy was one of a number of people who respected Faith for her judgment and keen intellect.

Faith would be just as quick to say that being smart didn't make her any richer, but provided her with a ready supply of friends looking for advice!

Faith arrived at Jean's house before ten the next morning and Trudy was waiting for her. As they got into Faith's car, Faith grinned and said, "I expect you'll have to learn to drive now. It's almost impossible to get around anymore without a car."

"Yes," Trudy said looking out at the wide river as they crossed one of the city's many bridges. "I'm finding out that there are so many things I have to do these days. It would be such a convenience to have a car."

Faith glanced over at Trudy as they drove out of the business area and up into the western hills that bordered the city. A few minutes later, they were driving up Terwilliger Boulevard toward the Veteran's Hospital, and then Faith turned off and drove down on Condor Street where they had both lived back in the middle thirties.

"I thought you'd like to see our old street once more," Faith said.

"Well, how nice," Trudy said looking around from the car. "It's still the same view overlooking the city, isn't it?"

"Do you want to get out and look?" Faith asked. "It might be a while before you have a another chance to see the street."

"No thanks, Faith." Trudy responded. "It all brings back too many memories. I feel like I could walk up into that house and he'd be sitting there listening to *Amos and Andy*, or *Fibber McGee and Molly*. He's still there."

Faith studied Trudy for a minute then, seeing Trudy wasn't comfortable being in their old neighborhood, she drove on out to her farm which was just beyond the metropolitan build-up. It was a good place to relax and talk and Faith wanted to sound Trudy out what would be a get-away trip for Faith, but an exploration for Trudy.

Faith parked the car on the driveway next to her old, but welcoming farmhouse. "Come on in, Trudy. I'll make us some coffee and a lunch," Faith said as she walked on in ahead of Trudy. "Find a good place to sit so we can talk a little."

Trudy sat at the kitchen table in a surprisingly comfortable kitchen chair and relaxed, watching Faith pull a few things out of the refrigerator for their lunch. Trudy took a graham muffin from a plate on the table, spread some butter and blackberry jam on it and ate a few bites. "Oh, Faith, these muffins are wonderful, and that smells like real coffee!"

"It is," Faith answered. "When I saw that they were going to ration things, I did a little hoarding. When you have a farm you can do a little dealing with stores."

"My goodness," Trudy said. "Weren't you wise to do that! How long have you lived out here now? You and your family moved away about a year before we did, didn't you?"

"Yes, about three or four years," Faith replied. "But, tell me about your plans."

As Trudy sipped coffee and nibbled at another graham muffin she told Faith about the things Leonard had told her, and how she thought his suggestions helped by giving her direction. She told her about her plans for taking care of Neil, and how she was raising money by selling off her husband's tools and their excess furniture, and how she had dreamed of living in a warmer climate because she loved sunshine and never wanted to see ice and snow again.

Faith thought for a minute and brushed at the crumbs on the table with the side of her hand. "Well," she said at last. "I suspected that you would be looking for a move—and Lord knows, you sure need some help finding a way to make a living. I need to take a vacation. I need to get away from this farm for a while, and I have a nephew who will weed for me. Right now, things are starting to grow so I don't have to be here. Maybe we can do each other some good because I could drive the car and we can split expenses, but we'll be needing gas and I think you can get all the ration stamps we need because of your circumstances."

Trudy immediately brightened up and looked at Faith. "You mean we could drive somewhere? That sounds wonderful!" Trudy said enthusiastically. "But what are you telling me about the gas?"

"Well," Faith replied. "They are rationing gas now. They tell you how much gas you can have each week, and give you rationing stamps. You can't buy gas unless you have stamps, and you get just so much gas for each stamp. But, I think you can get extra stamps because you want to relocate. Anyhow, we'll go down to the rationing office and find out."

"My goodness!" Trudy exclaimed. "What a lot of rigmarole to buy gas!"

"Yes, but it's for the war effort," Faith said "The old farmers around here say it's to keep us from wasting rubber tires."

"What about Neil and Donny?" Trudy asked. "Won't they have to come with us?"

"Sure, but they can have the back seat to themselves and they'll be all right."

"So, to make sure I understand," Trudy said. "We're going to take a trip in your car and we'll split the expenses. Where are we going, and how will that help me?"

"You said you want to go to California, didn't you?"

"Well, yes but I just wasn't sure exactly what you meant," Trudy responded. "I'm going to have to do something this summer because I won't have money for anything else."

"Well, Trudy, that's what I'm saying," Faith answered. "You want to find out about California as a place to live and work, and you can't find out anything from here. You have to go down there and see it and talk with people. You'll have to go and learn everything you can while I drive, and you'll have to figure out what you're going to do to earn a living, too."

Trudy's House

"Well, how far will we go into California, and how long will we have?"

"Trudy," Faith began getting exasperated with Trudy's reticence to grasp what Faith considered an opportunity delivered with a silver spoon. "I'm trying to offer you what I see as a one-time chance to go look and see what you can do with it. I'm free to leave as soon as Neil gets back from eastern Oregon, and we can go as far as L.A. and spent maybe two or three weeks looking. You'll have to decide whether you like it or not, and try to find some kind of a job. I'll get a vacation and get to see California, too, and I hope I'll get some satisfaction in seeing you get a life you like. If you don't go down there I think you'll just have to take some lousy job in town and make what you can of it."

Trudy listened to Faith without moving and felt ashamed of herself for not really understanding what Faith was trying to do. "Well you're right, or course," Trudy finally said. "But it seems to me that we should know something about the places we're going to see, and I really need to think about what I can and can't do."

"Yes, of course" Faith said. "We need to take stock and find out what you're equipped to do."

Faith and Trudy spent several hours until mid afternoon going over all of Trudy's interests, experiences, and schooling trying to discover if Trudy had any special talent or ability to do anything and Faith finally tossed down her pencil and paper saying, "Trudy, I don't know. You'll just have to keep your eyes open for something you think you can do. Between now and when we're ready to go this trip we'll have to read everything we can about California. We should ve several places for you to look at for places to live and work. We also have to to the OPA office to get a gas allowance."

Trudy glanced at Faith and said, "The OP . . . what?"

"The OPA—The Office of Price Administration that the government opened a couple of months ago. They control all the rationing."

"Trudy," Faith started in a serious tone. "You have to understand about this trip that while I need a vacation, I'm doing this for you, too. I think you are going to need a lot of luck to find any kind of work that will pay you a decent income, and I doubt if you can find anything while you're working for someone else, unless you work two jobs. Maybe you can do that for a while because you're strong, but gee whiz, you don't have any training or experience at all! And then, if you try to work two jobs at once your health will go. You'll be an old woman by the time you're 45!"

Trudy didn't say a word, but just sat and looked at Faith with teary eyes.

Faith watched her for a moment, then said, "I'm sorry, Trudy. Maybe I shouldn't be so blunt. It's a tough world out there, and I guess I'm telling you that you'll need to keep thinking about the kind of work that you'll be able to do to make a living. You may only have this chance so it won't be much of a vacation for you."

Trudy and Faith were quiet as they drove back into town. Faith guessed correctly that Trudy was adjusting to the idea that she'd have to knuckle down and would be in touch again after a few days of talking with her sisters and thinking about job hunting. She knew that Trudy had a lot of adjusting to do and probably didn't know what it took to "knuckle down"!

When they arrived at Jean's house, Trudy got out of the car, smiled at Faith and said, "I'll phone in a couple of days. Thank you!" and Faith watched her go up the steps and walk into the house before she started the drive home.

Trudy spent the next few days and nights mulling over her lunch with Faith and all that had been said. She'd been hurt when Faith pointed out to her that she couldn't do anything to make a living and that it was doubtful that she could make a living holding down two jobs! Faith's comments wounded Trudy's pride, but deep down she suspected that it was probably true. Then, that evening she talked briefly with her sister, Jean.

"Land sakes!" Jean cried out from her kitchen. "Why would anyone want to go all the way to California to find work? There's plenty of work right here. You'll just have to learn to live a little cheaper is all. You can start out by living here. Pay me a little rent, and then get out on your own when you can! My lands! They're crying out for help in those war jobs!"

Trudy chided herself in asking Jean about her opinion at all. She should have known that Jean would think it was silly to move anywhere—especially chasing the sunshine in California! During the weeks that followed, Trudy avoided any talk about herself with anyone in her family. She had come to realize that everyone seemed to have their standards for what they considered acceptable living conditions. Trudy had always dreamed of a life in warmth and sunshine, in a house in a nice setting with flowers around and good friends nearby. Her younger sister, Ellen had similar standards, but saw herself married with a good family and a loving husband. With Ellen, warmth and sunshine weren't quite as important. Jean's dream was to be secure in a world with reliable people—any world; anywhere.

During the next few days, Trudy thought more and more about Faith's comment about how their trip to California might be her one chance to go and see it all. After all, it was two or three weeks out of a summer for which she had no plans. If nothing else, it would be a vacation (forgetting for the moment, Faith's advice that it shouldn't be thought of as a vacation) preceding what would certainly become years of hard work supporting herself and Neil. At best, she would have the opportunity of seeing California and maybe finding something she could do there to earn a living in a place where she wanted to live. Could she afford it? Certainly she could if she worked at trying to find a life there.

If she didn't take the trip at all, she would have to start job-hunting right away, and then always regret she hadn't taken the time to go look. She recalled

Trudy's House

her brother-in-law's advice that she would have to act fast before her money ran out.

The next morning Trudy telephoned Faith and asked if she still planned to take the trip. "Of course," Faith said. "It sounds like you've done a lot of thinking."

"Well," Trudy said. "I've discovered that it's no good talking with other people about things that are really up to me."

"That's sure true!" Faith said. "Listen, can you put your hands on the death certificate, and your own identification papers?"

"Yes, I have them right here. Why?"

"Good, I'll come down first thing in the morning and pick you up. We have to go the O.P.A. rationing board and apply for gas stamps," Faith said. "After that, we ought to look at some magazines for articles about California. Maybe we could go to a used bookstore and see if they have books with photographs. We need to get ready, Trudy!"

The next day Faith came over early and picked Trudy up. It was still early when they approached the ration board with their appeal for gasoline. The man they saw looked over Trudy's papers and talked with Faith for a few minutes. Finally, he listened as Trudy asked about gasoline for her husband's old truck that would be used to move her remaining goods to California. The man said that their request was perfectly reasonable and necessary under the circumstances and allowed their request for more gas. To their surprise, he even allowed 150 gallons of gasoline for Trudy's truck!

With their spirits high, Faith drove Trudy to a downtown neighborhood where several used bookstores were located, walked through several and bought three good recent highway travel books on California. Finally, they stopped by the automobile association office downtown and found a few maps of the cities they would drive through. With the war going on and few people traveling, highway maps were very scarce. By mid afternoon, they stopped by a café for coffee and a salad each and looked over their material. Faith wanted the maps and gas coupons and let Trudy have the books to look over so she could learn something about California.

"Well," Faith exclaimed. "I think we're almost ready to go. Now, when do you expect Neil to come home?"

"I just got a letter from him and he said that his last class is on the fourth of June, and he expects to catch the train on the seventh and be in Portland on the eighth. I can get the money whenever I can get to a bank, so we can leave anytime after the ninth. Will that be all right?" Trudy said.

"It should be," Faith said. "Donny's last day is June fourth, too. Now you have to read through those books so you'll know about California before we get there. I think you should try to pick out a few places that you would really want

to see, and then you'd have to see what kind of work there is there, too, because you're going there to work. Remember that, Trudy! You're going to have to find something that pays well enough to support both of you. It won't be easy because they don't give those jobs to women!"

"Why is that?" Trudy asked. "I mean, I've heard that, but I never knew why!"

"Well, I think most employers figure that men have families to support and if you're a woman you're just working for extra money. Then, I guess they think most men have trades and professions to follow and that women will get married sooner or later and not be in the company very long."

"How far down in California do you think we'll go?" Trudy asked.

"Well, I think we should try to drive through the towns we think might be good for you, and not retrace our steps, or anything like that. We'll go down one highway and back on another, and probably go down as far as Los Angeles," Faith explained. "Oh, by the way, it'll be hot down there so bring along clothes that are easy to take care of and aren't too heavy.

"Really? Los Angeles? Just imagine!" Trudy exclaimed

Faith looked at Trudy with the feeling that she may not have heard anything after mentioning "Los Angeles". "Trudy," she said. "You heard what I said about light clothing?"

"Yes!" Trudy replied. "I'm listening. Wear light clothing."

To Trudy, the coming trip to California was like anticipating a coming vacation, not that she had ever experienced having a vacation. But she knew it would be the same. She could imagine escaping a tedious, boring job and looking forward to a carefree week or two somewhere. After all, she had been married for over a dozen years and had come to look on each new year of the marriage as less satisfying than the year before, and she still blamed her husband for her lost years without realizing that she was the one who had changed. Trudy had become an adult during those dozen years and had developed her own personality in accordance with the hundreds of thousands of influences, good and bad, which are given to us all from our ancestors and all the people we meet in life. Simply put, she wasn't the same person that she had been when she first got married.

As she packed for her trip with Faith, Trudy thought about how her life had changed in a few short months. Although it was not living the simple carefree life that she had wanted to have, she was definitely off on a new course that was sure to bring changes for her, even if she had to come back with Faith and get the best job she could find. She was sure that she was not the first woman to have to face a difficult life raising a son on her own with very little help. And there was always a chance that she might remarry at some point in the future and have someone to help her with her burden.

Words like "destiny" and "karma" began to come back to her. She had heard the pseudo—intellectuals discuss ideas at the writers meetings she used to attend, and

remembered that they used those words frequently. She had had to look them up and finally ask about their meanings. Trudy wondered at times if she were working with her own karma when she was thinking about what she might do with her life.

Neil finally arrived in Portland full of tales about his life on his uncle's eastern Oregon ranch. As Trudy rode home on the bus with Neil and listened to him talk, she noticed that he had changed a little. He seemed more like a farm boy. He had filled in a little more physically and carried an outdoor look that made him look capable and independent, and she noticed that his skin lacked a schoolboy's pallor.

When Trudy told him about their plans to travel to California in search of a place to live, Neil grew quiet until Trudy mentioned that they were driving down with Faith and Donny, and he immediately brightened up, seeing it as an adventure with Donny along.

Trudy had not made a checklist of things that needed to be done and had discovered that relying on memory was taxing her. She was forced to run over things in her mind several times a day to get everything done. At the last minute she remembered that she might need a checking account for access to her money, and stopped by her bank to make the arrangements. She also bought new clothes for Neil, and carefully gathered all the papers she might need and placed them in a large envelope and put that in her suitcase, or "grip" as she called it.

Faith phoned on Tuesday, the eighth, and asked if Trudy was ready to go. Trudy's answer in the affirmative didn't satisfy her, and she ran over a few things that she thought Trudy should have with her, just to be sure. After a few minutes, Faith said, "Well, I'll be over early in the morning so we can load up and be on our way. I'll try to be there by about seven. Is that all right?"

"We'll be waiting for you," Trudy responded.

By six-thirty the next morning, Trudy and Neil had dressed and carried their suitcases downstairs by the door. Trudy stood still for a moment going over all the items she knew she had to bring along with her. She closed her eyes and tried to concentrate, wondering if she had forgotten anything. Neil went to the kitchen for some toast and a glass of milk while his mother thought about being ready. Neil watched from the kitchen as his Aunt Jean walked into the room and approached Trudy. "I know you're anxious to go and all that," Jean said in half-whispers. "But I want you to think again about taking a vacation right now. You have a little nest egg in the bank that you can use to get a new start right here. I talked with a man in my church and I think he would hire you. It wouldn't be much pay right away because he'd have to teach you the job, but it would be a start. I'm sure there are lots of jobs around here if you'd only look. Save this money now and you could go to California later."

"Jean," Trudy said impatiently. "I'm not taking a vacation. I'd rather live there. I think I can make a better life for myself down there, and I want to find out about it."

"You are too taking a vacation," Jean whispered. "Why else would anyone go there?

They were interrupted by the sound of a car pulling up to the curb and Trudy looked out the window and waved. Faith had arrived at Jean's house a few minutes passed seven in the morning. It only took about fifteen minutes to load the car and another five minutes to say good-by to Jean and Trudy's mother—both still wondering why Trudy wanted to make a frivolous trip to California when she should be out job-hunting.

Faith advised Donny and Neil that they could have the back seat to themselves for the whole trip if they kept their voices down and didn't fight. If they became troublesome they would be split up, and if that didn't work they'd be sent home. Both boys took the warning as an empty threat, or maybe a mild threat, but with so much at stake they elected to be good. The day was dark and gloomy as they started out and there was enough moisture in the air that Faith had to run the windshield wipers on "slow" for a while.

Two lane highways were the standard in 1943 because the concept of travel by auto had barely gotten started before World War II began. Most main highways were two-lane roads unless you lived in a large sprawling city and then there might be an occasional four-lane road if the local planners were exceptional visionaries. Many medium and large cities like Portland had well-developed transportation systems which most people were accustomed to using, and that coupled with the travel restrictions that were enforced during the war retarded the development of auto travel and the construction of super highways until well after the war.

U.S. Highway 99 was the main north-south auto route on the west coast in 1943. Driving through southern Oregon and northern California meant negotiating over 200 miles of winding two-lane highways through the Siskiyou Mountain Range and parts of the Cascade Mountains foothills. There were many mountain passes to travel through and several mountain passes were over 5000 feet. The scenery was spectacular, and all that was nullified by the reality and stresses of driving the route.

While most freight was shipped by rail during the war years, trucking was becoming popular as a good way to ship freight short distances. In the Pacific Northwest logging trucks hauled huge loads of logs from the forests to the sawmills, driving many miles on public highways. Many of those trucks were second hand, worn out, diesel-guzzling trucks with the doors missing (so the drivers could jump out if the brakes failed or the loads came loose) and they pretty much ruled the highways. Long-distance line trucks were still coming on the scene.

Faith knew the route for the first hour or so because it was the way she always drove to Salem to see her relatives. After that, she had to reach for the maps. She got everyone into navigating by telling them that they had to watch for "99E" highway signs to Eugene. After Eugene they followed "U.S. 99 south"

signs, driving through Roseburg, and Grants Pass. At first Faith used watching for signs as a ploy to keep Neil and Donny occupied and to keep her awake, but after driving to Salem at the wartime speed of 35 mph, she was glad she had thought of the idea. It took them almost two hours to reach Salem that was only about 45 miles from Portland, and they didn't go through Eugene until it was almost noon, but they did make a little better time on the open highways. Fortunately, Faith enjoyed driving and she was good at it. She assured everyone that they would be in California that night.

"California! Just imagine!" Trudy sighed.

In southern Oregon they broke into sunshine but they also started getting caught behind big trucks that gathered a line of traffic that was eight or ten vehicles long before they found a spot on a mountain highway where they could pull over to let everyone pass. Faith's little Ford often couldn't maintain enough speed to keep the engine running cool, and she would have to pull off to let her engine cool while other cars passed them.

"Hell-damn,"Trudy muttered quietly under her breath. Faith was accustomed to Trudy's impatience and even accepted it, grinning as Trudy rolled her window down to look at the scenery, or to get some air. The stops often served a purpose, however, in that it allowed everyone to duck into the roadside bushes to relieve themselves.

As they climbed into the mountains, the air was cooler and they were able to keep moving even though they were often going at truck speeds of five or ten miles per hour. They soon discovered that while they were able to stay on the highway behind the trucks, the trucks often belched so much smoke that they began to feel nauseous and rolling up the windows only made the car stuffy and hot inside. As they climbed up into the Siskiyou Mountains and passed through the small California town of Yreka all four complained of fatigue and headaches from following old trucks for too many miles. The fun and adventure of highway driving to California was beginning to wear thin with everyone.

They were still able to see Mount Shasta as they passed by its western slopes. It was that part of the day just after sunset and before nightfall when the high mountains still had sunlight, but the road they were driving on was dark enough for headlights. Even Trudy was impressed with the beauty of the high mountain. As they entered Dunsmuir, Faith announced that they were dropping in altitude now and that tomorrow they would be driving down the Sacramento Valley. She slowed down in Dunsmuir and pulled into a clean-looking auto court that was displaying its vacancy sign.

A quick dinner of fried chicken, sandwiches and fruit from an ice cooler they had brought along served them nicely and they were all in bed by nine-thirty.

CHAPTER THREE

Faith and Trudy and the kids were more cheerful the next morning. The boys seemed to have forgotten about their complaints from the day before because they were running up and down the lawn in front of the motor court while Trudy and Faith loaded the car.

"Did you sleep all right, Faith?" Trudy asked, as they were getting ready.

"Yeah, I slept pretty well," Faith answered, "but I kept hearing trains and train whistles. They didn't keep me from my rest, though. I feel pretty good!"

Donny and Neil came running over to them saying that they had discovered a canyon behind the auto court with freight trains chugging through it, and better yet, there was a small river beside the tracks and steps that went down to the tracks and the river—could they go down there? Faith and Trudy both responded with firm a "no", adding that they had to have breakfast and then get out on the highway again.

"We saw a restaurant just around the corner," Donny said. "Maybe we can eat right there!"

Trudy and Faith agreed and had breakfast with the kids, then got on the road in less than an hour. Looking around at the surrounding scenery, Trudy said, "I didn't think California would look like this. It's just like Oregon. It's all mountains."

"Well, California has mountains, too, and we're driving down the Sacramento River canyon," Faith said. "But we're going to be out of it in about an hour according to my map, and then we'll be driving in a big valley. The highway should be flat and straight, then."

"My goodness," Trudy exclaimed. "I thought California was all palm trees and bright sunshine."

"I think you're going to have the bright sunshine," Faith said, squinting against the bright morning sun, "but the palm trees come later!

"Say Trudy, when you feel like it, why don't you bring out one of those travel books about California and read parts of it to us so we'll know what to expect at these different places."

"Okay," Trudy replied jovially. "After we get out of these mountains or my head will get woozy from trying to read on a winding road."

The highway was mostly downhill for the next two or three hours of driving. All the while they were dropping in altitude from almost 3000 feet in Dunsmuir to barely 1000 feet at Redding. "I should think the trip will be easier now," Faith said. "This is where the valley starts."

As they drove south and the hours passed, the temperature got warmer and warmer. They soon discovered that someone who recognized an opportunity had anticipated the discomfort of auto travel in the valley heat, and had set up cool, shady orange drink stands at convenient intervals along the highway. The stands were usually small and had a walk-up window for service, but they were always well shaded. Faith and Trudy stopped at almost every one they saw because most of the stands had other drinks including coffee that Trudy was addicted to. They also had sandwiches and hot dogs, and restrooms. Inevitably, all the stops at the orange stands cut into their progress, and they stopped near Stockton for the next night. They were disappointed with their progress because they had stopped at so many orange stands, but then they agreed that the cool drinks had been lifesavers because of the heat!

That night, before they went to sleep, Faith said, "Well Trudy! We need to get our thinking caps on! All this is to locate a place where you would like to live, and I'm forgetting about all that and here I am like a tourist, just driving down the road and taking in the sights!"

"For heaven's sake!" Trudy exclaimed. "Well, I don't think I've seen any place special so far. The scenery has been kind of plain and the towns we've been through have just been farm towns."

"That's about the way I'd see it, too," Faith said. "Well, tomorrow I think the first half of the day will probably be the same so you can read to us then. When we get closer to L.A. I think it will change."

While everyone else was getting ready for bed Trudy started to look through one of the books. After a few minutes, she got Faith's attention and said, "I've been looking at this one. It's a 1941 book on auto travel on the California coast. They have several pages on the Monterey Peninsula and it all sounds very nice. What do you think?"

"Yes," Faith said. "I saw that and I thought it looked nice, too. I've read about that place several times before."

"Well," Trudy said, "can we go there? Here; I'll read some of what it says.

"Monterey Bay is not laid out like a bay in the conventional sense. There is no small entrance that leads to a big, sheltered body of water where boats and ships

can find safe anchorage. Rather, it is a 25-mile long dent in the Central California coastline with Santa Cruz on the north end, and the Monterey Peninsula on the south end. Fort Ord is in the middle, sprawling eastward over the sand dunes and rolling brushy hills.

"The Monterey Peninsula is a five mile by five mile square scenic patch of land that juts into the Pacific Ocean. The small picturesque town of Monterey, rich in Spanish heritage, is on the north side of the peninsula where the peninsula joins the coastline. Pacific Grove is on the northwest corner, with New Monterey and the historic Presidio of Monterey between the two. Carmel-by-the-Sea and Pebble Beach are on the south side of the peninsula. Romantic views and sunny beaches dot the coastline."

"It sure sounds nice, doesn't it?" Faith commented when Trudy had finished reading.

"Have you been there?" Trudy asked.

"No, but like I said, I've heard a lot about it," Faith said.

"I've heard about Carmel-by-the-Sea," Trudy said a little wistfully. "It's one of those places that movie stars go to isn't it?"

"Yes, I think so," Faith replied, then added, "Unless you think that's where you want to live, I think we should go have a look at L.A. first."

"Oh, yes, of course!" Trudy said. "I'm just wondering. That's all."

The next morning Faith and Trudy and the kids were able to get an early start, but had no sooner gotten out on the open highway than they found themselves trailing a long convoy of Army trucks that was moving slowly. The last vehicle in the convoy was a jeep with a big sign mounted on the back of it. It read, "**ARMY CONVOY. DO NOT PASS. SPEED LIMIT 25 MPH**"; then in smaller letters, "STAY BACK 50 FEET".

"Well, doesn't that beat everything!" Faith exclaimed. "Another day of creeping traffic."

"Hell-damn!" Trudy said under her breath. Now feeling more anxious than ever to see Los Angeles. "What's going on?"

"Well, I suppose they're moving troops from one camp to another," Faith said. "I don't expect there's much we can do about it so why don't you read some more from one of your books? It'll help pass the time."

Trudy rummaged though a paper bag of old books and pulled one out. "Well, this is something else about Monterey," she said, and started reading.

"The wealthy Californians discovered the Monterey Peninsula in the late 19th Century and thought it would be a good vacation spot. They made the discovery years before the artists, movie stars, and tourists did."

"My goodness," Trudy exclaimed. "I didn't know that, did you?"

"Yes," Faith said. "I heard about that, and several other places like, Santa Barbara, San Luis Obispo, San Simeon, and places near San Francisco. We'll try to see those, too. Why don't you read some more?"

Trudy's House

"Corporate moguls, 'old money', and those who were rich by other means—most of whom were from San Francisco and Los Angeles—and a few others from around the world found the sunny pine-covered hills, the rocky coastline and the crescent-shaped beaches very much to their liking. By the 1880s, they had formed partnerships and had begun building destination resorts, hotels, golf courses, and grand estates on choice pieces of land with majestic views. The farmers and ranchers who were there before were made wealthy by selling their land and moved away. Eventually, according to many historians the partnerships developed a grand plan for the entire area with future growth and new projects in mind.

"Part of the grand plan, if it was true, was to develop the towns and create land tracts for the not-so-rich, so they could live on the Monterey Peninsula, too. The near-by towns would provide a ready supply of help that would be needed to build and operate the hotels and resorts. Monterey, the city, began to grow and expand beyond its Spanish and Mexican era beginnings.

"Farther out on the peninsula, a church group established the town of Pacific Grove. At first, the area served as a retreat where pious church members communed with nature and God, and held bible meetings in peace and harmony on the grassy meadows by windblown trees in the area. In time, some members bought 30 by 60 foot tent lots that the church offered for sale on the grounds, and pitched tents so that they might live there for many months during each year. Before the end of the 19th Century many of the members built small houses on the tiny lots with the intention of living in the area full time, or retiring there. That brought grocery, clothing and hardware stores and a town was born.

"Carmel-by-the-Sea, which is across the hill to the south from Monterey and Pacific Grove, began a little like Pacific Grove in that there is an old California mission there, and many people lived around the old mission. However, with its scenery and sunshine it became a haven for reclusive artists of all kinds after the start of the 20th Century, and any plans for making Carmel a religious retreat were abandoned."

"My goodness, Faith!" Trudy said. "I have never heard about this place! It sounds so interesting and sunny!"

"Look!" Faith said, gesturing ahead. "They're finally pulling over."

As she spoke, Faith slowed the car and watched the big Army trucks pull off the highway and stop in a cloud of dust in the shade of a long row of eucalyptus trees that appeared to border the highway for miles ahead. One of the soldiers jumped from the trailing jeep and motioned for the traffic to pass. Faith sped up a little, with ten or twelve cars following her and drove past what must have been a hundred Army trucks that were loaded with cheering, waving soldiers.

After passing the convoy, Faith, Trudy and the kids drove the rest of the day through flat farmland that appeared to get drier as they went south. They drove

through one small town after another, with only distant mountains for scenery. Trudy decided to read more from her book because the scenery was so bland. The imagery presented by her tour book was preferable for Faith and Trudy than the bleak landscape of the southern San Joaquin Valley!

"The town of Monterey and its adjacent presidio has been in existence since the Spanish era in California in the late 1700s and aside from some growth and some decay, very little had changed until the beginning of the 20th Century. At about that time a few business people realized that there were parts of Monterey Bay that had the potential to be good commercial fishing ports, with some harbor development. They thought that a commercial fishing industry on the central California coast could help feed the growing population in southern California and would provide jobs for hundreds of people. The commercial fishing industry was born on the central coast and protected harbors were developed in Monterey and near-by Moss Landing, and large fish canneries were built to process the catches.

"When World War I erupted in Europe, people all over the world were suddenly made aware of any military presence that was in their own locale. The only military unit in Monterey was a company of cavalry and a field artillery company and both were stationed at the old presidio. Before the United States entered the war, the government bought a large parcel of land along the bay, just north of Monterey and created Fort Ord that was to be used as a training base for the Army. The Coast Guard followed by building a breakwater and a boat station between Monterey and the fish canneries. Finally, the Navy bought the buildings and grounds of a large resort hotel on the edge of Monterey."

"My goodness!" Trudy exclaimed, putting the book down in her lap. She looked around at the passing scenery for a few minutes. The boys were quietly playing games in the back seat, as they had been for most of the trip. "If you see a place where you could stop I could use the bathroom and get some more coffee."

I think I saw a sign about a roadside café up ahead," Faith said. "We'll stop there for a break because I think we have to climb over some mountains before we get to Los Angeles. It's nice of you to read your travel book because it sure keeps me awake, but how much more history is there, and does the book talk about any other places?"

"Well, let me see. It looks like there's another page about Monterey Bay, and I saw something about Santa Barbara, and a place called, Menda-something," Trudy said as she thumbed through the book. Here it is—Mendocino!"

"Well gee whiz," Faith said. "Mendocino is north of San Francisco, I think. That might be cooler, but I don't know what you could do there. Santa Barbara might be expensive because I think it's just north of L.A. So far, I think your best shot is a place like Monterey."

"I'm not sure I like the sound of all the military people there," Trudy commented. "Everyplace where I've seen a lot of military there has been run down stores and houses. Soldiers and sailors attract such a terrible element." Trudy was thinking about the year or two before she was married that she spent living in Tacoma, Washington, with nearby Fort Lewis.

"Well, I suppose that's true, but you don't go near those neighborhoods. For one thing, most of these soldiers are draftees," Faith said. "They're better people because they have girl friends or wives and they're only in the military for the duration. I would think that they would bring business to an area."

"Explain that to me," Trudy asked, clearing her throat, "I don't follow you."

Faith glanced over at her in the fading afternoon light. "Well, when you have a war and you need troops, you have the men all register for the Selective Service, then you have them report to go in the military in some orderly way—probably when you have room for them to be trained. That's called the draft, and the ones you order to report are draftees. Usually, the understanding is that they are in for the duration of the war."

"For heavens sake!" Trudy exclaimed. "Whether they like it or not! Imagine!"

"You didn't know, Trudy?" Faith asked. "Don't you look at the newspapers?"

"Well, of course I've been hearing about these things, but I never really knew what they were doing!"

"Well, if Donny or Neil were old enough, they'd have to register for the draft, then go whenever they're called!" Faith added.

"Gosh," Trudy said. "They're so young"

"The next time you're around draftees," Faith said, "look in their faces. They're just kids. I hate to see them go, but that's the way with war. I think they call them up when they're eighteen and out of high school. It's the way it has been all down through the ages."

When they were on the road again, Trudy still had enough light to see and read a little more from her travel book.

"Between World War I and World War II military development in the Monterey area was pretty much at a standstill while the fishing industry grew and prospered. Fishermen and the cannery workers lived near the canneries in a newer part of the city on the west side of the Presidio. They called that part of town New Monterey, although it is actually a part of Old Monterey. Life in New Monterey was routine, with the biggest variable being how good the fishing is on any given day. During the fishing season the fishing boats, large and small, sail out of the bay in the early morning hours, fish until the boats are loaded, and sail back toward Monterey to unload their catches in big, floating hoppers just off shore from the canneries. Then, usually in early afternoon, the cannery whistles blow, signaling that it was time for the workers to walk down the hill and

begin canning the catch. By late afternoon the entire north side of the Monterey Peninsula reeks of fish."

"That's all there is about Monterey in this book—just some pictures and a map. Oh, and there's something about the weather and the restaurants on a place called 'Fisherman's Wharf".

"No, that's okay," Faith said, struggling with her driving. It was late afternoon and she was climbing over a winding mountain highway. They had left the valley behind, catching glimpses of it from vistas along the highway. "I think this must be the road they call the 'grapevine', she said.

"Trucks have a terrible time on this highways with brakes going out, and all," she said. "That's mostly going down hill. Going up hill, they break down a lot. Anyhow, you might as well give up reading for today because it's getting too dark, and I've got to pay attention to this road. Los Angeles should be on the other side of this mountain."

"It seems like a pretty wide road," Trudy observed as they were passing a truck that was creeping up the steep grade. It was on a paved shoulder lane that looked like it was there just for trucks and other slow vehicles. "I didn't even smell his smoke—lots better!"

"They've built wide shoulders of the roads so slow-pokes can pull over and let the cars go past," Faith said as she gripped the steering wheel and shifted gears again. "I wish they'd take a lesson and make more highways like this at home."

After nearly an hour of steady uphill driving, Faith, who had been watching the engine temperature gauge on the dashboard, peered ahead and said quickly, "Trudy, there are some signs ahead. Look and tell me what they say!"

"Uh," Trudy mumbled. "Signs?" She had been lost in thought about finally getting to see Los Angeles, after hearing about it for so many years.

"California 99," said one voice from the back seat. "Summit, Tehjahn Pass, 4170 feet", came the other voice.

"Thank you!" Faith called to the kids in the back seat. "But, you pronounce that pass, 'Te-hon'. It's Spanish, and in Spanish you pronounce the 'J' like an 'H".

"Why is it Spanish?" Donny asked, bothered with the idea.

"Because this part of the country once belonged to Spain and then Mexico."

"I believe it's all downhill now," Faith said, sifting into high gear again. "We should be about an hour from downtown Los Angeles."

"Really!" Trudy responded, paying attention to the passing scenery. "Are we that close? There's no sign of anything."

"There will be when we get out of these mountains," Faith said, "The sun is going down now so it will be getting dark when we get down to the bottom of this hill. We'll have to find an auto court as soon as we get into town."

Trudy agreed and that evening they stayed in a quiet little motor court in Burbank. They found a city map at a gas station where they filled the car tank and had the attendant look things over under the hood. They ate dinner, bought a newspaper and went back to their room to plan the next day. Both Trudy and Faith wanted to include the places they had heard about in their plans for sightseeing.

When Faith and Trudy settled in their rooms for the night they made some tentative plans. "I want to see Forest Lawn Cemetery where so many movie stars are buried," Faith began. "Then we'll want to see Wilshire Boulevard, and Sunset Boulevard, and the La Brea Tar Pits, and Hollywood."

"Yes," Trudy said. "And I'd like to see Olivera Street and Grauman's Chinese Theater."

"Well," Faith said with a chuckle. "It looks like we're going to have a couple of busy days. We'd better get some sleep—and, let's not forget why we're here! Keep looking!"

"Don't they have a zoo in this city?" Donny pleaded. "We need to have something to see, too!"

Faith glanced at Trudy, who looked like she was going to ignore Donny's appeal, and then said, "All right, we'll try to find something for you kiddies. You've done pretty well on this trip."

The next morning they were up early and drove downtown and found a small, clean hotel that had its own parking lot. They checked in and moved their belongings to a third floor room. Faith and Trudy agreed that judging from what they had seen so far, Los Angeles didn't interest them very much, even though they knew there was a lot of defense work there. They both had agreed that as long as Trudy was relocating she should try to find a place that she would enjoy living in.

They were narrowing their search to the Monterey Peninsula, Santa Barbara, and several other places that they had heard about. Nevertheless, while they were in Los Angeles they elected to take several days and have a good look around. Trudy was still curious about parts of the city and wanted to see them before she ruled the whole city out. After all, they had discovered that an extra day or two in L.A. wasn't very expensive and there was a lot to see.

To that point, the most unique thing that they had discovered about Los Angeles was the traffic signals that were on all the street corners. They were the usual red-stop, green-go traffic lights, but all the lights had little red and green signs that flipped out from the side of the traffic light with a loud "ding" when the light changed. Donny and Neil had never seen anything like them and collapsed into fits of laughter when they first noticed the lights. By the next day they no longer noticed them and looked for something else to make fun of.

That afternoon, they found their way to Griffith Park so Neil and Donny could see the zoo. Later, they drove to Forest Lawn Cemetery to search out a

few celebrity gravesites. The following day, they drove out to an orange grove so Donny and Neil could see how oranges grew. On the third day, they decided to look at some of the stores near the hotel before they did more sightseeing. All four walked up the street looking at stores and more or less following the hotel man's directions when they came across a little street car called "Angels Flight" that went on a long block up a hill to another street. The hill, called Bunker Hill, ran through the city for what appeared to be a mile or so. Faith and Trudy anticipated the boy's need to ride the little trolley to the top of the hill and back down again, bought tickets without asking the boys first and waited while the boys took their ride to the top and back. That paved the way for Faith and Trudy to visit a department store that they had spotted.

Inside the department store, Faith and Trudy walked down an aisle toward a crowd of women, and as they walked they became interested in sale goods that were on several large tables. When they reached the tables, they noticed that most of the women were turning around and walking quickly out of the store with out talking. Trudy and Faith glanced at each other, realizing that something was wrong and they quickly grabbed the boy's hands. Looking beyond the women, they spotted a short, young, Latin-looking man who was facing them a few tables away. The man seemed to minding his own business as he calmly picked through the merchandise, and he was ignoring everyone near him as they tried to move away from him.

Trudy and Faith, as well as the others who first saw the man, stood motionless and stared at his bizarre appearance. He wore a highly stylized dark, pinstriped suit with broad, padded shoulders, tight to the waist, with a yellow shirt and dark tie. On his head he wore a very broad-brimmed white fedora-type hat that cast such a deep shadow over his face that it was almost impossible to see his expression.

"What on earth . . . ?" Trudy began, but stopped talking when Faith elbowed her arm.

The little man heard her and glanced in her direction, but then went back to picking through the merchandise. He moved slowly around a table, coming in their direction. He looked up at the circle of women and casually eyed them.

Trudy caught sight of his face and drew in a breath. Without a word, she whirled around and dragged Neil through the store, out the door, and didn't stop until she had walked a hundred feet down the sidewalk. She was joined in a few minutes by Faith and Donny. Faith looked at Trudy, saying, "My goodness. What happened to you?"

"I saw a devil in that man!" Trudy exclaimed, leaning heavily against the building and trying to calm herself. "I've never seen anything like that!"

"Well, let's go on. We haven't been to Olivera Street yet!" Faith said. "He was a zoot suiter, Trudy. Surely you've heard about them?"

They began walking north and east toward Olivera Street. "No," Trudy answered, "I guess I haven't."

When they got to the street corner, they had to wait for the traffic light to change and Faith nudged Trudy again. "Look across the street," she said in a low voice.

Trudy followed Faith's gaze and saw another zoot suiter across the street facing them. She noticed that his suit was about the same as the one in the department store, but now she could see the suit below his waist. The coat hung to his knees and she could see some kind of watch chain or key chain hanging from under the coat to the man's ankles. His pant legs fit tightly around his ankles, and he wore dapper white and black shoes.

"Now you kids keep your heads down and don't do anything that would draw his attention, do you understand me?" Faith cautioned. "These men can be very dangerous."

The light changed and they began walking across the street. Trudy noticed that everyone gave the little man lots of room. She watched him out of the corner of her eyes as they walked passed each other because while his clothing looked very fashionable, it was out of place and the total effect was almost comical.

"After he had walked on passed them, Trudy asked, "Are the zoot suiters criminals, then?"

"I really don't know," Faith said. "I've been reading about them in the papers so I guess a lot of them are. I've sure read about crimes they've committed. The thing is they say that a lot of them carry razor blades in their hatbands, and straight razors in their pockets. It seems to me that I read about them first in places like New York, but out here I think it's the Mexican gangs—the ones they c ll 'pachucos' that dress that way. I hear that the servicemen hate them because they flirt with their girls."

"Really?" Trudy exclaimed as they walked. "Ooo, golly Faith. I don't think I like being around them at all!"

Walking together, they made their way along the street toward the large main entrance of the Union Station, and just across the square they spotted the well-marked entrance of Olivera Street. It was a short street that was filled with Mexican shops and restaurants and was usually mentioned in tourism books about Los Angeles. Trudy approached the street entrance with the same reverence as someone entering a cathedral.

"Golly Faith," Trudy said enthusiastically. "Isn't this place wonderful? Look at all the colorful things! Come on!"

Faith and the kids followed Trudy slowly down the street and watched as she started going through the shops that displayed Mexican goods of all kinds. Before she had gone far, Donny and Neil asked if they couldn't go back to the

entrance of the street and wait for them. "All right," Faith said sternly, "But you kiddies stay right there and don't go wandering off!"

Donny and Neil walked back to the street entrance and stood watching the people come and go when they began to hear some kind of commotion across the square from where they stood. As they looked, the noise grew louder. It sounded like shouting and yelling, and Donnie and Neil moved around to see what was happening. Then they saw a man running towards them, then turn and run down the sidewalk toward the Union Station. Another man came running behind him, and both turned and ran up some steps into the second floor of a building A moment later, a half dozen sailors in white uniforms and several men in khaki uniforms came running down the street, shouting at each other. They were followed by several dozen civilians who looked like they just wanted to see what was happening.

The servicemen stopped in the middle of the block and looked around for the two men they had been chasing. Then they ran up the steps into the building and there was more shouting as the two men, wearing what looked like the tattered remains of zoot suits, came running back down the steps and out into the street just as military police in two vans and a Los Angeles police car showed up. More sailors got out of the vans and gathered the two men up and put them in a van. As they did, the servicemen who had been chasing them walked calmly down the steps and disappeared into the gathering crowd.

"Well, would you look at that!" Donny heard his mother say, and turned around to find her and Trudy standing right behind them.

"Did you guys see that?" he asked. "Wow!"

"Yep, we sure did!" Faith answered, and then glanced at Trudy who was still staring at the commotion. "I hope you kiddies have seen enough of Los Angeles because I think we're leaving in the morning!"

"Aw, gee whiz!" Donny complained. "We haven't seen anything yet!"

"What do you think we're doing here? You two are along for the ride—remember?" Faith said. "We're doing this for Trudy, so she can find a place to live—remember?"

"Well, I wanted to see what else there is here!" Donny persisted.

"Alright," Faith said. "We'll look around. Now stop complaining."

"Aw, jeez!"

Faith, Trudy, and the two boys walked back to the car and Faith promised Neil and Donny one last drive around Los Angeles. Faith, who was a little heavier and a little older than Trudy, was feeling tired and hot and welcomed a chance to sit in the car with the windows down and drive leisurely around the city for an hour or so. They stopped at a few small parks and the La Brea Tar Pits before going back to the hotel so the two boys would have something to talk about on the trip home.

Chapter Four

"Golly, Faith," Trudy said as she sat eating a breakfast of a sweet roll and half of a grapefruit. "Those zoot suit people really upset me. Just looking at them scares the life out of me!"

Faith listened as Trudy talked and waited for the waitress to pour them a second cup of coffee before she answered. Faith was a much more composed and orderly person than Trudy was and didn't let the zoot suiters upset her. She saw them as potentially dangerous, but not likely to be a problem for herself, the kids, or Trudy if they left them alone and did not draw attention to themselves for some reason. Faith saw them as fad-oriented, and probably much more of a problem for their own kind. She had already had a stern talk with Neil and Donny and told them to stay away from the zoot suiters and to not make fun of their clothing or anything.

"Well," Faith said continuing her conversation with Trudy. "I think you're doing the right thing. You certainly don't want to live any place where there are things going on that upset you. From what I've read about L.A. the zoot suiters are just one of the problems here. They've had growth problems that started before the war, and now they're bringing in people to work in the shipyards and the aircraft industry—and I suppose other places—and that puts a strain on things. New roads, new utility services, more places to live and that means higher taxes and makes the whole area more expensive. If they can find a reliable source for drinking water here, this city is going to grow. Shoot! Everybody likes the weather!

"Really? Golly, but you've done a lot of reading!" Trudy said, listening. "As I look at all these places and I don't see anyplace that really appeals to me, and I still don't know what I could do to earn some money! That worries me, Faith. I'm afraid that I won't find anything and I'll end up doing drudgery and living in some awful neighborhood somewhere."

45

Faith looked at Trudy for a moment because she didn't know either, but she would try to imagine how Trudy fit in different locations and in different jobs, and although she didn't tell Trudy what she was doing, she didn't see a fit. She didn't see how Trudy could work successfully as a clerk or a waitress, and she couldn't imagine Trudy working in a factory or assembly line atmosphere. So she had ruled out those kinds of jobs. Faith had also tried to imagine Trudy living in Los Angeles, and that seemed very improbable. Trudy loved independence and she enjoyed being near the arts, but Faith couldn't imagine what that translated to in terms of earning a living. She looked at her watch, seeing that Trudy and the kids had finished breakfast. "Well," she said to Trudy, "let's keep working on it. We'll come up with something, I'm sure. Now, I think we'd better get going if you want to see Santa Barbara."

Without complaint, the boys climbed into the back seat of the loaded car, and were anxious to get on the road. Obviously, they had had enough of Los Angeles, too! They began driving the car south on Hill Street and after a short distance, Trudy looked up at a sign that read, "Highway 26" with an arrow pointing left and right.

"If you turn right on this street that will get us to the beach, won't it?" she offered.

"We can sure find out," Faith chuckled, making a right turn. "Olympic Boulevard," she said. "I think that's one that gets us to Santa Monica Beach."

An hour later they were driving north on alternate Highway 101 with ocean, fishing piers and a beach on their left. After driving a short time the houses and buildings of Santa Monica on their right turned into brush-covered steep hillsides that rose up from the edge of the highway. They strained to see the ocean on the left, but only caught glimpses of it between houses that were being built along the edge of the highway.

"Mom!" Donny called from the backseat. "Why do they call this an alternate highway?"

"Because there's a main Highway 101 somewhere else," Faith answered.

After a few minutes silence to digest the answer, Donny called again, "But Mom!"

"Because the city is so big that they need two main highways to carry all the cars and trucks that have to go there," Faith answered without waiting for the question, hoping that would satisfy him.

After they had driven ten miles or so, the buildings that blocked their view began to thin out and they relaxed a little, feeling that they were finally leaving the city behind. After driving a few more miles they came to a creek that flowed down out of the hills, crossed under a short highway bridge, and meandered across the beach to the ocean. Faith pulled the car off the highway on the beach side, and parked. Donny and Neil scrambled to get out, and ran down to the beach.

Trudy's House

"Don't go running off now," Faith called after them. "You kiddies stay in sight because we won't be here long!"

Faith pulled a road map out of the door pocket by her leg and began studying it. She had looked over the route a few days earlier, but it was getting hazy in her memory.

"The highway sign on the bridge says this is Topanga Creek," Trudy said, craning her head around to look at the hills on their right. They had followed hills ever since they left Santa Monica.

With the kids running down on the beach, Faith felt free to be more direct with Trudy. They had reached about the halfway point in their trip and Faith was becoming a little concerned that Trudy had not yet found a plan for herself. Faith had observed that Trudy didn't seem to know how to explore. Faith thought that she would probably have been more aggressive in working on the problem while Trudy seemed to be living day by day like she would if she had stayed home. In fact, Faith was beginning to feel that Trudy was treating the trip like a vacation, rather than a search for a better life. While she really wasn't sure just what Trudy should be doing, Faith thought that if it were her, she would be at least talking with people who were involved in different kinds of work, or reading newspaper ads, or doing something. But Trudy wasn't doing any of that. She was sightseeing!

Faith watched the kids running in the sand for a few minutes trying to think of a way to motivate Trudy. Finally, she turned to Trudy and said, "I think we'll be in Santa Barbara for lunch. Now, I don't really think this is a good place for you because I don't see what you could do to make a living here, but you never know. So, I think what we should do is buy a newspaper and look it over. I'd look for jobs in the classified ads and see how many there are. I'd look for rooms, apartments, and houses for rent, and house for sale."

"You mean that I should look for jobs here?" Trudy asked. "I haven't even seen the place, yet."

"No, that's not what I'm getting at," Faith said. "I have an idea that a place with a lot of business going on will have lots of ads for jobs—and you'll want to see what kind of jobs they're advertising for! If there are a lot of rental places to live, that could mean that there are a lot of people coming and going. If there are just a few houses for sale, then it's a stable community."

"Oh," Trudy said. "Golly, Faith. That kind of thing would never occur to me! Does it work like that?"

"I don't know," Faith chuckled. "It's just an idea. We'll see! I assume that we're going to write off the Los Angeles area, then? I mean, I can't imagine you punching a time clock."

"Oh heavens!" Trudy said. "I'm grateful to you for driving us there because I didn't have any idea what it was like. After what I saw there, I think I'd be better

47

off in a smaller town and I've decided that I like being near the ocean. It's so refreshing after that city!"

"All right," Faith said. "So now we're heading north and we'll be driving through the whole Santa Barbara area which includes several towns, but like I said, I don't think it will be a good place because it's so close to Los Angeles. I mean, I think it is so stable because people with money have been coming here for years for their weekends away. I've heard that a lot of the movie people live here, so it's all established. Do you know what I'm getting at?"

"Yes, I think so," Trudy said. "You're saying that there's no new opportunity here. I imagine the war has put a lot of restrictions on living out here, too. I mean, they have to deal with gas rationing too, don't they?"

"Yes—say, you're right!" Faith answered, mulling Trudy's response over in her mind as they drove down the road. "You know, maybe you've got something there. Let me think about it for a minute."

Trudy looked at Faith with a puzzled expression and waited as Faith worked on the idea. "You know, it was something you said—something about new opportunity and the war. An idea flashed through my mind when you were talking and I'm trying to remember what it was. Shoot!"

Trudy kept quiet and let Faith think. She couldn't imagine what she had said to give Faith a clue about her future, but it seemed prudent to keep quiet. As they drove, there was very little traffic on the roads. The volume of traffic only picked up when they drove through towns and farm communities. The mountains that had been on their right had all but disappeared into the distance. It seemed to Trudy that they were driving across a wide valley with trees and fields of green crops on both sides of the highway.

During the next hour of driving Faith still hadn't indicated that she remembered her passing idea. They drove past the intersection where the real Highway 99 meets the alternate 99, much to Donny's satisfaction, went through several large towns, and got their mountains back again on the right side of the highway. Then Trudy noticed that the highway was becoming more scenic with trees on both sides and flower gardens around the houses.

"It looks like we're coming into Santa Barbara," Faith commented.

"This place is beautiful!" Trudy said, looking around. They got glimpses, then views of the waterfront with boats just beyond the ocean shoreline. When the highway turned to go into the business area it became a broad boulevard with flowers everywhere. Faith pulled up and parked near a restaurant. They stretched and got out of the car.

"My goodness!" Trudy said as she looked up and down the street. "This is the nicest looking town we've come to. Don't you think so, Faith? Look; there are blossoms and greenery everywhere you look!"

"Well," Faith said softly. "Remember what I told you. This is a very wealthy town. I'm sure this is the way they like it! But, I'm hungry. Let's go eat."

Trudy watched Faith pick up a newspaper as they walked into the restaurant, then followed her to a booth with Donny and Neil eyeing the milkshakes. They ordered and Faith spread out the newspaper as they waited for their sandwiches. "Now," She said, "let's see if my ideas work."

Trudy was surprised to see that there were very few jobs listed and there were only weekend rentals and several rooms for rent in the area. In fact, the classified ads section didn't even fill a page of the newspaper! "Faith, you were right!"

"Well, I was right this time, but let's try this out in some other towns before we say I'm a genius!" Faith chuckled, then folded away the newspaper to make room for their orders that had arrived.

After they had eaten lunch and walked out on the sidewalk again, Trudy looked up and down the street and said, "Well, I'd certainly like to live here. It's such a beautiful town!"

Faith glanced at her and said, "If you could earn a living here."

"Well," Trudy said. "Everyone seems to be working. There must be something I can do."

"Trudy!" Faith said quickly. "That's what I've been trying to tell you! Just think about this; you have told me that you don't have any work experience, and that you've never been trained to do anything."

"Yes," Trudy said, "—well, they were training me to paint insignias on airplanes."

"All right, can you do that—on your own, I mean?"

"Well, no. Not yet." Trudy said.

"Well, Trudy! Then you're not trained! Don't you see?"

"Well," Trudy replied. "I thought it might count for something on the right job."

"That's pretty specialized work. A sign painter might find that interesting, but then sign painting at that level wouldn't get you much money," Faith said. "Remember that you have to earn enough to support the two of you. Look, if a man needs someone for a job and he has six applicants, he's going to hire the man who has the work experience who will be able to help him the most." As she spoke Faith realized that Trudy had probably never really tried to get a job.

"Well, I suppose you're right," Trudy answered, giving in to Faith's argument. "That makes a pretty bleak picture for me, doesn't it?"

"What it comes down to," Faith explained, "is that you have to find a situation where there is a job and no one is around to fill it, and that isn't very likely. Maybe another way to put it is that you have to create your own job."

"What?" Trudy said. "I can't do that. I don't have the wherewithal to do such a thing."

"Maybe yes, and maybe no," Faith answered cryptically. "Maybe what you have to do is to start using your noggin now. Maybe you can use some of your money to buy yourself a job. Maybe you can find someone who needs help with something you can learn about, like assembling something, or distributing something."

"But, I've never done anything like that," Trudy protested.

"Trudy," Faith persisted, "listen here. What you've never done before doesn't really matter with this idea. It's what you can do now that counts. If you don't start thinking this way, you know you'll be back up there working in the ship yards like 'Rosie the Riveter'. If we can find a situation of some kind, you'll be able to work more on your terms than someone else's. You said it when we were driving. You have to find a place with new opportunity!"

"You're right," Trudy said. "I'd sure hate to work for someone else—especially in the ship yards!"

"I know," Faith chuckled. "That's why I brought it up! Here's the car. Let's start driving and maybe something will come up." After driving up and down a few streets in Santa Barbara, Trudy and Faith and the kids were on the road again, following Highway 101 north. Faith told herself that they also couldn't afford not to recognize opportunity if it was there.

"According to the map," Faith said, "the next big town is San Luis Obispo. Now, that's one of the towns that I thought you could look at, and it's about three to four hours from here. There are a couple of other towns before that for us to look at, but I don't expect they'd be as good for you. There's another town just after that, but it's more inland because after San Luis Obispo, the highway goes inland for a while."

"What's at San Luis Obispo?" Trudy asked.

"Well, it's bigger, and it has a college, and it's one of the old historic California towns near the ocean," Faith said. "I don't think it has the attraction for the movie people that Santa Barbara has. It's too far from L.A. for that—but, I think I remember that they made a few movies around there. But, if the truth were known they probably made a few movies all around here!"

"You know," Trudy said. "All this kind of talk makes me feel uneasy, like I have to get up and do something."

"I hope I'm not putting too much pressure on you, Trudy," Faith said. "That's not the point. I just want us both to keep our eyes open for ideas and opportunities, and you can't do much in the car. We just need to stay aimed at that idea of finding something you can do on your own, because it's not likely you can make a living at a job with Neil to support. So, let's not get anxious over it. We just want to keep our eyes open."

"Oh, okay," Trudy said. "I guess I understand what you're saying."

Trudy's House

Both Trudy and Faith fell silent and watched the passing scenery. About halfway to San Luis Obispo they came to vast produce fields, and drove along looking at row after row of vegetables.

"You know," Faith said after a long silence when both women just watching the scenery and driving. "You know, I don't think you should feel bad about things, Trudy, because under the circumstances I think you're doing about all you can do.

"When most people make a big change in their lives, they do it cautiously, keeping all kinds of alternatives to follow if something goes haywire. All this was just dumped into your lap on pretty short notice. In fact, I guess you could say that what you were doing before was the change, and your husband's death is . . . well, never mind," Faith said, getting lost in her own stream of logic.

Trudy looked at Faith with a puzzled expression.

"Anyway," Faith continued, "I was going to say that you've been forced into a position that no one would want to be in, and I think you're doing as well as anyone would."

Late that afternoon, they drove through Pismo Beach and had a look at the ocean again as they drove. They discussed stopping there for the night to eat some seafood, but decided in the end to stick to their schedule and push on to San Luis Obispo. Once there, they drove up and down several streets to get a feel for the town and finally stopped at an auto court for the night after both Trudy and Faith decided that they didn't see opportunity there.

The next morning they were on the highway by 8:30 a.m. with the hope of reaching the Monterey Peninsula by noon. In starting early Faith had not realized that there was an added advantage in that the highway led straight onto a grueling, winding climb up a mountain road that surely would have led to car problems if they had tried it later in the heat of the day. Faith decided as they went over the mountain summit and into the Salinas Valley that Providence was still with them. They must be doing things right.

For the next few hours they drove up the valley at the tedious rate of 35mph toward the small town of Salinas. Faith and Trudy said very little, mulling over Trudy's possibilities and half listening to the constant chatter from the two boys in the back seat. Trudy looked at the unremarkable dryness of the distant hills that paralleled the highway on both sides, and hoped that the Monterey Peninsula was not like that! She had pinned her hopes on the Monterey Peninsula and she would be terribly disappointed if it turned out to be another uninspiring place.

The valley seemed to be more vegetable fields with just a few small towns and several very old Spanish missions. The drive was long, dusty and monotonous and when they arrived at Salinas, with its highway junction to the Monterey Peninsula, everyone was ready to return to the coast. Following all the highway signs off Highway 101, they found themselves on another highway that was much more

scenic in that it led through low, brushy greenery and scrub oak trees that quickly gave way to scraggly evergreens and tall pines. The scenic highway led past some beautiful grasslands shaded with oak trees that made an idyllic scene complete with grazing horses. A few miles of low hills marked a natural division between the Salinas Valley and the green coastal area near the Monterey Peninsula.

The volume of traffic picked up quickly as they drove into Monterey and followed signs that directed them toward the waterfront. In the twenty-five mile drive from Salinas and Highway 101, the scenery had changed dramatically from dry, brush and grass-covered hills and the dusty valley floor, to green forested hills and flower-filled yards and neat, small houses.

"What a difference in scenery!" Faith remarked as they drove down the streets of Monterey. "Look at all those tall, picturesque pine trees. All the limbs are at the top!"

"Yes!" Trudy said, looking around at the shops as they drove. "Aren't the trees different! And, look at all the service men in uniform! I wonder what's going on."

"Well," Faith said. "It's the middle of the week in the middle of June. I don't think anything special is going on. I think it just that there are so many military people here."

As she spoke, Faith was maneuvering through Monterey's winding streets until they could see the masts of boats riding at anchor over a row of parked cars and railroad tracks. On their left were the white backs of buildings that had their fronts on the next street to the left. They came to an awkward street intersection and followed the traffic flow to the right, passing an old adobe building that had a sign saying that it was the Custom House and that it was one of the historic buildings in Monterey. They drove across another intersection and found curb parking on the right, just past a bus stop.

"Oh, my goodness," Trudy blurted out. "How picturesque! Just look at that harbor"

"Mom!" Donny called out from the back seat. "We need to get out of here!"

"You kiddies wait until we decided what we're going to do," Faith snapped back. She looked at her watch and said, "It's past lunchtime. Let's get out and find a place to eat."

The four of them sat quietly for a few minutes taking in the view. On their left, they could see several blocks of houses that seemed to extend from the left and come to an end at a grove of deep green evergreen trees and a dry, grassy hillside that was right in front of them and about three blocks away. At the top of the hill and a little to the right, they could see what appeared to be a monument. The street they were parked on led toward the hill, turned to the right and led around the right side of the hill.

The rail track they had seen before ran between them and a beach that was about a hundred feet away to their right and twenty feet below the level of the

Trudy's House

street they were parked on. It was a narrow rocky beach that continued on around the base of the hill in the distance and disappeared. Beyond the hill there seemed to be some buildings that looked like factories. They could see a long breakwater that extended far to the right. Between them and the breakwater dozens of white fishing boats of various sizes were riding at anchor. On their right, as they looked at the fishing boats, was the entrance of a pier, or wharf, that appeared to extend several hundred yards over the water. There could see a number of buildings on the wharf that looked like fish markets and shops.

"I think those buildings that look like factories over there are the fish canneries, and that's where New Monterey and Pacific Grove are—and the end of the peninsula, too. This place on out right must be Monterey's Fisherman's Wharf." Faith said. "Shoot! Let's go get some lunch on the wharf!"

"Mom!" Donny called again. "We need to get out of here!"

"All right!" Faith said, "But don't get out in the street. Get out on Trudy's side and we'll go get some lunch. Now, stay with us and don't go running off!"

Out of the car and on the sidewalk, Trudy looked around at the things she could see from where the car was parked. "Gee, look at all those fishing boats and that colorful wharf. I like this place, Faith!"

Faith laughed at Trudy and said, "Trudy, you'd like anyplace that's sunny and full of color! Actually, I think we ought to have a good look at this town because Fort Ord is just across the bay there, and there are lots of military around here. I'll bet there's lots of new business in town, too. Let's get a paper and talk to a few people over lunch."

They gathered up the kids and walked over to Fisherman's Wharf and went into a little café near the wharf entrance, picking up a newspaper from the counter as they walked in. They were served quickly and flipped through the pages of the newspaper as they ate.

"I'll bet that there's a real housing shortage with all the soldiers training here," Faith commented as she flipped through the newspaper pages.

"Why would that be," Trudy asked. "I don't know much about the military, but I would imagine that they keep the soldiers at the Army camp, don't they?"

"I'm sure they do," Faith answered, "but the soldiers must have family here, too. Don't you think that their wives and girl friends follow them around before they actually go to war? I suppose they're sent right overseas from here, aren't they?"

As they ate lunch, the waitress overheard them and came over to talk for a minute. When the waitress found out that they were traveling and thinking of moving there she took a little more time with them. And when the waitress heard that Trudy was looking for some place to buy, she said that there was a real shortage of rooms and apartments in the area.

"If you got enough money maybe you could start a rooming house," the waitress said, half joking. "I don't know anyone who has an apartment. Just about

everyone has a room and a hot plate. You should see some of the rooms they're renting out! They're awful!"

Faith looked at Trudy with a serious expression for a moment and said pointedly, "Trudy, too bad you don't have rooms to rent."

"Me?" Trudy laughed. "Where would I get enough money to buy a place big enough for rooms? And, I wouldn't know the first thing about it either!"

Faith thought for a minute and looked at her watch. "It's almost two o'clock," she said. "Let's go look around!"

They paid their bill and thanked the waitress, then went back to the car and began driving toward Pacific Grove. They drove around the hill that had been in front of them when they had parked by the wharf, and followed the boulevard up the hill and through another business section of town. As they drove, the fish canneries were down the hill on their right and they noticed that there was a smell of fish that filled the air.

"What a smell," Faith said as she drove, "this is New Monterey, which is part of the town of Monterey. I think it's just a newer section of town."

"It doesn't look that new," Trudy observed. "In fact, it looks like it was built about fifty years ago!"

"Well, you know how names stick," Faith commented. "It was probably promoted as 'New Monterey' back years ago, and everyone still calls it that. What's this coming up?"

They had driven through six or eight blocks of small community businesses and were coming to an intersection where about half the traffic was turning left and going up the hill, while the rest was going straight ahead, past red, barn-like buildings and tall fencing that was on both sides of their boulevard.

"What street are we on?" Faith said. "I don't know if we should turn left or go straight."

"I just looked," Trudy said. "It's Lighthouse Avenue. Why not just go straight ahead for now. We can't get too far off, can we?"

"Sure, why not?" Faith said. "We'll want to see what's here anyhow, won't we?"

Faith drove straight through the intersection, and saw that in one block after the intersection the business area ended and they were in a residential neighborhood. She decided to pull over next to a large vacant lot and get her bearings.

"Those red buildings that we just passed had a sign that said, 'Work Lumber Company," Trudy said, "and right in the middle of the block there was a decorative wooden sign with 'Pacific Grove City Limits' on it."

"Why don't you two kiddies run back to that gas station on the corner," Faith said, giving the kids a chance to get a little exercise. "Tell them that we're from Oregon and we want to know if we're in Pacific Grove now."

Faith watched Donny and Neil trot down the sidewalk toward the gas station. "That will make them feel helpful," she added with a grin. "They must feel all cooped up after riding in the back seat for a week."

While the two boys were getting information, Faith kept watching them but stopped talking for a minute and thought about what she wanted to say. "Trudy, I want you to think about this. I think I may have found something for you. It falls right in with some of the ideas we've been talking about, but you know, if the prices are right you could rent rooms here."

"Oh Lord!" Trudy said. "I don't know how to do that, and I don't have that kind of money!"

"Well, now wait a minute," Faith said. "When you buy property like this you give them as little as possible as a down payment. That way you have some money for improvements, and some money to operate on. You'd have to have something to live on until you got money coming in."

"Oh," Trudy exclaimed. "I couldn't do that! I hate buying on credit!"

"You'd better change that idea," Faith said. "When you are in business, you use credit. When you are on your own and working for wages, maybe not. But I think I see a way for you to get along here, and believe me, you'll need credit! Everyone does just starting out."

Just then Donny and Neil returned from the gas station with a map in their hands and big smiles on their faces. They climbed in the back seat squeezing past Trudy's seat back and Donny handed the map to his mother. "That man was nice," Donny said. "He gave us that street map and said that the guys who named the streets in Monterey and Pacific Grove probably couldn't see their eyes, . . . Um." Donny stumbled

"He said that they probably couldn't see eye to eye on things," Neil finished.

"Yeah," Donny continued, "because this street is Central Avenue now in Pacific Grove and Lighthouse is up a block."

"Well," Faith said. "it's nice to hear Neil. I thought you'd left us. You've been so quiet."

"I figure that you're talking with Donny," Neil responded, showing that he still had a lot of eastern Oregon habits still in him.

"Well," Faith said, "Let's drive around and see what's here."

She started driving down Central Avenue, now and then slowing down to look at houses that were for sale, and maybe even circling the block to get a better look. Three or four houses on Central Avenue were especially large, and Trudy wrote their addresses down and made a note of who the realtor was, on the "For Sale" sign. Some of the signs looked like they had been on the houses for a year or more. They had faded lettering, rusty nails, and weeds growing up along the stakes, making Faith wonder just how active the real estate market was in Pacific Grove!

They spent most of the afternoon zigzagging across Pacific Grove and New Monterey. Faith was wearing herself out shifting gears in the car and turning corners. Finally, they decided that they should be looking for an auto court or hotel to spend the night—or several nights, since both Faith and Trudy had decided that there was lots of opportunity in the area.

They decided to stop and eat dinner in a little restaurant in Pacific Grove and watch the street outside change as the sun was going down. They noticed that there were a lot of men in uniform in the restaurant, eating with their wives or girl friends. After dinner, they looked again for a place to stay, and finding nothing, decided to try to find a quiet place and sleep in the car. They drove back toward Monterey looking for a safe, quiet place where they could park. In an hour or so, they found what seemed to be the end of a rural road, parked the car in a dark place, and made themselves as comfortable as possible and went to sleep.

Chapter Five

A dog began barking at the rising sun and morning bird songs awoke Trudy and Faith from an uncomfortable nights' sleep. They stirred slowly and twisted and stretched in their car seats trying to move their cramped muscles that had become sore from sleeping in awkward positions. Faith glanced at Donny and Neil who were still asleep in the backseat covered by the car blanket they had been sitting on during the trip. They had both kicked their shoes off and were sleeping on the seat in opposite directions, each with his head beneath a car window.

Faith peered around the car in the early morning light to see where they were. She knew that they had driven to the end of a city street because she had seen a barricade across the road in the car's headlights when they parked. Now, in the dim light of morning she could see that they had stopped at the edge of a small lake that was rimmed with eucalyptus trees and low brush. On either side of the street were a few little houses with space around them. They heard roosters crowing nearby and guessed that someone was raising chickens in their yard

"I'm going to duck out for a pee before it gets too light outside," Faith said.

"Me too," Trudy said, eyeing a tall bush near the trees.

"Shh!" Faith said as she slipped silently out the door. "Don't make any noise!"

Faith got back in minutes and waited for Trudy before closing the car door. At last, Trudy came back. They closed the car doors and Faith started the car and backed it down the street to turn around. The noise of starting the car and closing the doors made the dog bark louder and woke Donny and Neil.

"Mom!" Donny cried out. "I've got to go! Let me out!"

"Well," Faith said. "You kiddies get your shoes on and I'll pull over as soon as I can."

Faith pulled the car up by a small wooded area and let the kids go out to relieve themselves, while she talked with Trudy. "You know," she began, "I've

57

got a hunch about that place where we were yesterday. I suspect we might find something for you right there. I was wondering how you felt about it."

"Yes," Trudy answered. "I have a good feeling about this place. I think we should go back there today and see what there is, but let's get something to eat first. I'm starving! Oh, here come the kids. I'll let them in."

Faith followed her senses back into Monterey. The street plan followed the shape of the bay in a large semi circle, causing newcomers in the area to lose their bearings. Faith tried to remember the route they had taken the night before and backtracked to downtown Monterey. She had driven a little less than five miles which was less distance than she remembered.

As they drove down Alvarado Street, which seemed to be the main street in Monterey, Faith spotted a restaurant sandwiched between several bars and pool halls, that appeared to be open. She pulled up to the curb and told the boys that they were to go to the washroom and clean up while she and Trudy got a table. As they walked in together, the boys went on to find the restrooms while Faith and Trudy sat in a booth and waited to be served. Faith looked around for a morning paper but only saw San Francisco papers. The place was busy enough to have several waitresses working.

"Excuse me," Faith called as a waitress strode passed with her hands full of plates of food., "Do you have a morning paper?"

The same waitress came back in a minute or two saying, "No, Ma'am. Not local. They don't put the paper out until early afternoon. Can I help you?"

"Oh, okay," Faith said, as the two boys returned and squeezed into the booth. They ordered, ate their breakfast, and then talked to kill time before the stores opened. "I want to go see a realtor before we drive all over the countryside," Faith said. "I want to know how much property is here, because after we saw those big houses for sale yesterday I think this is the place for you."

"Really?" Trudy said, surprised that Faith had come up with something without discussing it first. "Well, do you think it's wise to see a real estate salesman for this?"

"Of course! Why not?"

"Well," Trudy said, "don't they charge for what they do? I can't afford all that!"

"Of course they charge," Faith said. "But they also know what's going on and where things are. Trudy, I think they can save us days and days of looking, and if they're any good they'll fill us in on the other things, too."

"What other things?" Trudy asked.

"They'll be able to tell us about the business atmosphere here," Faith said "Maybe they can tell us where we can get a room, too. I don't want to sleep in the car again!"

"Oh, Hon," their waitress said in a loud voice. She had been busing the next booth and overheard Faith's remarks. "Did I just hear you right? Did I just hear you say that you had to sleep in your car last night?"

Faith twisted around in the booth, surprised that she had been overheard. "Why yes," she said. "We couldn't find a place to stay last night. Do you know of a place to stay?"

"Sure thing, Hon. There's this lady who comes in here for lunch sometimes and says she's been fixing up an old inn on Houston Street," the waitress explained in a thick drawl. "I remembered the name of the street 'cause that's where I'm from—Houston, Texas! Anyway, I've seen her place because my husband—he's in the Army—and I were looking, too. It's a tiny little old historic place, but it would be good for y'all for a couple of days. It was too little for us. Do you want to know the address?"

"Sure!" Faith said with a grin, "write it on this napkin."

Faith and Trudy quickly paid their bill and gave their waitress a hefty tip for her thoughtfulness, and rushed over to the inn and rented two rooms. The inn was small, as the waitress had told them, and as they discovered when they arrived at the inn, it was over 100 years old and its size reflected its historic origins. They had a community bathroom that was down the hall, but the inn was comfortable and clean and it suited them. Then, as they would learn later that day, it was probably the only place on the Monterey Peninsula that had a vacancy!

It was almost eleven a.m. by the time they had the car unloaded and they were ready to go searching for whatever Trudy needed. "You said that I should look at places that have a lot of activity," Trudy said to Faith as the got back in the car. "As we sat in that coffee shop this morning I noticed that there were a lot of people walking by. Do you think that they were all going to jobs? Well, I guess they would be at that hour of the morning."

"I thought so, too," Faith said. "Of course, most of those people were in the military, but that's still 'jobs' these days!"

"Really?" Trudy responded. "How do you know they were in the military?"

That kind of response from Trudy irritated Faith. It was the kind of question that shouldn't need to be asked. It was the kind of question that a silly, disinterested person would ask, and in Trudy's case Faith thought it was a kind of laziness. She had never known Trudy to take an interest in world affairs. Instead, she would look at impractical, meaningless people and events that hinged on the arts and the occult, and let her husband deal with the mundane details like buying food and paying the rent.

"Well, Trudy," Faith said calmly, because she thought that Trudy had to be led into the practical world gently, "Didn't you notice that all those people were dressed pretty much the same?"

"Yes, I guess I did," Trudy said. "I saw some Army and Navy men in the crowd, but most just wore dark jackets."

"Trudy!" Faith laughed. "They were in the military too! They don't all put insignia on their jackets!"

"Oh," Trudy said. She had started to watch the scenery as Faith made her way through the streets toward Pacific Grove. The two women were quiet as they drove through the streets of Monterey, both looking up and down streets, studying the people and the businesses as they drove passed. When they got to Pacific Grove, Faith drove up and down streets that didn't offer views or any other obvious features that might run the sale price up, but even then many of the largest houses still had extra features like being located on big pieces of land, close to stores, etc.

The first time they stopped at a house for sale, they studied the building and wrote down the house number, but coming from a city that had street names plainly mounted on posts at street corners, they looked up and down the block for a street name when Neil noticed that they were painted on the curbs at the street corners.

"For gosh, sakes," Faith commented. "I've never seen anything like that. No wonder we couldn't find the names of streets last night!"

It was after noon when they discovered that they had followed Lighthouse Avenue all the way out to the end. Faith pulled over to the side of the road and studied the area. There was a cemetery on the right, dark green pine trees and brush ahead and on the right, with a narrow road leading left and right. A hefty wire fence stood in front of them with signs saying something about "U.S. Government Property" hanging on it. Beyond the fence they could see a low lighthouse built on the peaked roof of a small building.

"Shoot!" Faith exclaimed. I guess we aren't going to find out more about the lighthouse by sitting here."

Faith turned right and drove passed the cemetery and a golf green, and right again on a narrow road that looked like it might lead back to the town. They could see houses several blocks away, but for the time being, they were driving along grassy fields and wind-blown cypress and pine trees. The bay was just visible about half a mile to their left.

Donny and Neil craned their necks to look out the back window to catch a last glimpse of the lighthouse. "It wasn't even a good lighthouse!" Donny complained. "Lighthouses are supposed to be tall and they should stand on a rocky point!"

"I'm hungry!" Neil said. "When do we eat?"

Faith drove several long, undeveloped blocks with grassy fields and an occasional tall tree on their left and a golf course on their right until she reached a crossroad. She turned right and drove several blocks until she reached Lighthouse Avenue again, then made a left turn back into town. As they drove up the little hill to Lighthouse Avenue they began to get back into the town again and more houses for sale. Both women were impressed with the tall, bushy-topped pine trees that seemed to grow all around the area.

"I'll tell you what, Trudy," Faith said as they drove slowly into the main part of the town. "I'm sure we can do a lot better by just going to see a real estate agent,

and stop all this driving around! There are so many old houses around here that you need a secretary to jot down all the stuff on the signs as we go buy. I vote for stopping to eat somewhere in town, then dropping in on a realtor."

"Yeah!" the kids in the back seat cried in unison.

"Uh, Faith," Trudy protested. "Are you sure that's best? I just don't have the money to pay a real estate agent all that money. Do you really think they can do that much for us?"

"Why sure, Trudy." Faith said. "I know what people say about real estate agents. You might be able to buy a little house or a piece of land on a handshake like people used to do, but you're looking for something special."

"I am?" Trudy retorted. "I'm not even sure I want a piece of property, yet! You say I can do something like renting rooms out, but I don't know anything about doing that, Faith! I've never owned anything because I've never had enough money to buy anything, and you think I can be a landlady!"

Faith pulled the car over to the curb and cut the engine off, then turned and looked at her friend for a moment. "All right," Faith said. "Look here. What do rooms rent for? Would you say about eight or ten dollars a week? Suppose you had six rooms that you could rent. That could give you sixty dollars a week, or about $250 a month. If you let them have kitchen privileges for about $2.50 a week, or another $60 per month, you'd have over $300 month coming in and pay about $75.00 for your mortgage, and another $25 or $30 for utilities, against whatever you think you could earn working for someone with no experience. Do you see what I mean?"

"Well," Trudy persisted, "you're telling me that I'd have to have credit, and everyone has always told me to stay away from credit!"

"Trudy, like I told you before, you have to have credit if you're going to be in business. You have to find something where you can put something like $1000 down to buy, then figure on spending another five hundred or so on used furniture and paint," Faith explained. "No matter what kind of business you do, you have to deal with credit, and you have to have enough to buy in, and you have to have operating capital. You have to get used to that idea."

"Golly," Trudy said. "This idea is so far from anything I ever thought of. How do I know I'll be able to rent the rooms? It sounds like such a gamble and so much responsibility!"

"All right," Faith said impatiently, "We can say we had a nice ride to see California, go home, and you can get a job in the shipyards."

"Oh, Lord!" Trudy moaned. "I guess that's where I'd get the most pay, too!"

"Well?" Faith questioned. "Have I convinced you? If I haven't, think about this; that $300 month you earn renting rooms is worth more to you than just $300 because you won't have to pay anyone rent. You will already have a place to stay, and you will be building equity. That means that your property will be worth more to you as you live in it and maintain it."

Faith watched Trudy mull things over in her mind. Faith was almost certain that Trudy didn't understand it all, but she was beginning to lean towards buying property. "Let's go talk with some real estate people. That can't hurt, can it?"

"Yes, I guess that'll be okay," Trudy finally said. "As you say, I don't have to deal with them if I don't want to. Have you noticed all the geraniums that grow here?"

Faith drove another half dozen blocks until they were in the center of the Pacific Grove business district, and turned right on Forest Avenue because it seemed to be a well-traveled street. They drove uphill a long block with little stores on both sides of the street. She pulled into a corner gas station and auto repair garage called the City Hall Garage and stopped at the gas pumps. Checking her watch, Faith realized that they could make some extra time by having lunch somewhere and visit a real estate office, so she asked the garage man if he would do a lube and oil change and fill the car's gas tank.

Stepping out of the garage and onto the corner sidewalk, they stood together and looked up and down Forest Avenue, which seemed to be a north-south main street in town. The cross street where Faith was standing was considerably smaller and was named Laurel Avenue. "Well," she observed, "I guess this has all the elements of a small town. Look across the street here. The city hall, police station, and fire station are all in one small two story building."

At that moment, chimes sounding from a clock tower high above them rang out a musical tune, followed by twelve gongs. Trudy and Faith jumped at the sound and looked up at the clock face in the tower.

"Wow!" Neil exclaimed. "Look Mother, it's twelve o'clock!"

"Hell-damn!" Trudy said in a low voice. "Those bells scared the life out of me!"

Faith chuckled at Trudy's language, but privately disapproved of it with the kids around and didn't comment. Trudy didn't use it enough to complain about. "Well, come on," Faith said. "We'd better find a place to get some lunch."

They walked slowly down the sidewalk on Forest Avenue, looking in all the store windows and making mental notes of all the small businesses that they passed. It appeared to them that Pacific Grove was a busy community. The first thing that Trudy and Faith noticed when they started down the street was a used furniture store across from the garage. On the way down the hill they saw a radio repair business, a portrait photographer's shop, a shoe repair business, a small food market, and an attorney's office. Near the corner of Lighthouse they noticed a Rexall Drug store and a Chinese-American café that were almost across the street from each other.

"Now," Faith said as she stood in front of the cafe, "this looks good to me!"

Donny and Neil groaned loudly because they were more interested in hamburgers and milk shakes. Faith and Trudy gave them each several dollars and told them that they would be in the café or the real estate office that was located

next door. They were warned to check back often and to stay within a few blocks of the car. "Be back here at two o'clock no matter what," Faith called after them as they trotted down the street.

Faith and Trudy had a quick lunch in the café, paid the bill, then walked next door to the real estate office they had seen before they ate. The Forest Avenue Real Estate Office was in one of the older buildings on the street. The street door looked to be original because it didn't have the proportions of a newer door. It was noticeably wider and lower than standard doors, and a plate glass window in the top half of the door more or less matched the awkwardly placed windows on either side of the door. Anyone walking by could look directly into the real estate offices.

When Faith and Trudy walked in, the street door felt heavy and they could hear a bell tinkle somewhere alerting whoever was in the office that they had company. Once inside, they saw that they had stepped into the center of one large room. From inside, the glass looking out was wavy and distorted. The printing on the glass windows could be read as shadows on the oiled wooden floor. The décor was roughly Teddy Roosevelt era with dark forest scene wallpaper and shelves of books, and one large hanging wall map of Pacific Grove.

Standing in the middle of the large room they could see a large, old-fashioned wooden desk on each side of the room. One desk looked like a collection point for stray books and letters that were found out of place in the office. The other was obviously the active business desk because a light with a dark green glass shade hung above it and illuminated the desk. A woman who looked like she was in her early forties was talking on the telephone, scribbling notes on a paper tablet, and nursing the ash of a dying cigarette all at once. Faith saw an ashtray and handed to her. The woman took the ashtray, smiled, and dropped her ash in it, then held up her pointing finger indicating that she would only be another minute.

Faith and Trudy each sat in a hardwood waiting room chair that were lined up near the door, and listened the woman respond with grunts and other noises to comments made by whoever was on the phone with her. They could hear a radio somewhere playing very softly, and an announcer saying something about marines landing in the Gilbert Islands. After several minutes, the woman said good-by to who ever she was talking with, and hung up. She stood up and smiled at them and said, "Hi! I'm Madge Flynn. What can I do for you?"

"Well," Trudy said, clearing her throat. "We've been driving around looking at houses and we'd like to find out what the prices are."

"Certainly," Madge said with a smile. "Do you have some addresses?"

Faith decided to jump into the conversation so they could get some information, rather than be led around with sales talk.

"I'm Faith Michaels and this is Trudy Anderson. We're down from Portland. Now, Trudy had just lost her husband and she sees this as a good time to relocate.

One idea she has is to buy a small house and get a job somewhere, but Trudy doesn't have any skills or job background. I've been trying to show her that if she could find the right kind of property in the right area, that she could make a living renting out rooms. But, we need to know about prices."

Madge studied the two women for a moment with the experienced eye of a professional saleswoman. She could usually size up a prospect with a few minutes of chitchat, and she saw at once that Trudy was very hesitant about buying a house. Madge needed more information, and needed to know a lot more about Trudy.

"I see," Madge said. "Well, I have some listings that might work for you, or if you want to give me some addresses I might be able to tell you about them. You know, you're wise to looking now because this war has brought the real estate market down in this area. Now, what price range are you looking for and how big a house do you want?"

"Listen," Faith said. "We don't have a lot of time so I think we'd better put our cards on the table. Trudy doesn't know much about buying property and I've had a little experience with it up in Oregon, but we're certainly not professionals. Trudy is the buyer and she is looking for an opportunity.

"Now," Faith continued, "the situation is that Trudy is having to change her lifestyle after losing her husband. It would be correct to say that she is exploring her options, and I'm her friend and I'm trying to help her. Like I said before, Trudy isn't trained to do anything and she has to do something pretty quick. Now, I've been trying to show her that I think she could make a living renting rooms in a place where there is a strong demand, and I think that is probably the case right here. What do you think? Am I right?"

"Absolutely," Madge replied. "You wouldn't believe what people are renting these days, just so they can be near their men. There's a desperate need for clean rooms. Now, let me ask a couple of questions. Trudy, do you have any dependents?"

Trudy's brain had stopped working when Madge told them about the need for rooms, and she almost missed Madge's question. "Uh," she began after a moment. "Oh! Yes! I have a 12 year-old boy."

"Hmmmm," Madge said, obviously running listings through her mind. "Yes! I think I know a good place for you. Let me make a phone call first to see if it's still available."

"Oh! But, I," Trudy began when she was stopped by Faith nudging her arm.

"Yes?" Madge asked before she reached for the phone.

"It's nothing," Faith said. "Go ahead."

Madge glanced at Trudy for a moment, then made her phone call. Like a good journalist calling her editor, Madge was able to talk on the phone without people standing nearby being able to hear the conversation.

In a few minutes Madge hung up and asked Faith and Trudy, "Do you two have time to look at some property? It's not far."

"Sure!" Faith said. "That's why we're here! We've got two boys out in town somewhere, though. We'll have to round them up first."

"All right, you do that while I bring my car around the front," Madge said. "It' a maroon Buick."

Faith and Trudy went out on the sidewalk and looked up and down the street with no luck. They crossed Forest Avenue and walked into the Rexall Drug store to see if they were at the soda fountain, then Trudy spotted a Greyhound bus depot on the other side of Lighthouse Avenue.

"Faith," she said, "if you want to wait at the real estate office, I'll go down and see if they're looking at funny books."—Trudy's expression for "comic books".

Faith waved and went back while Trudy looked in the bus depot and found the boys looking at comic books. Trudy noticed that the bus station was next door to a movie theater and that the theater was open for an afternoon matinee. She gave the boys enough money to see the movie and buy some popcorn, agreed to meet them in front of the theater when the movie let out and rushed back to meet Faith and Madge to go see the house. In less than ten minutes, Madge pulled her big Buick into the driveway of one of the first houses that Trudy and Faith had looked at when they first drove into Pacific Grove.

"This is it," Madge said. "This is absolutely, positively the best deal I can think of for you, Trudy."

Trudy sat in the rear seat of the car and looked out at the house. Directly in front of them was a two-car garage. A large, overgrown hedge filled in the space between the garage and Fourth Street on the eastern side of the property. The old hedge, which was at least six or seven feet high started again on the other side of the garage and bordered the sidewalk almost all the way to the western corner of the block. A three-foot high fence filled in the property line between the end of the hedge and the corner. Ten or twelve feet inside the property line stood a large old shingled, house that was two stories high with a gabled roof. Everything was painted a dark, dull, faded barn red. Trudy had to get out of the car to see the rest of the property, which looked over grown and neglected from the street.

"What do you think?" Madge said. "Do we want to get out of the car to see what the old place looks like?"

"Yes! Of course!" Faith said. "Come on, Trudy. Let's take a look!"

Trudy got out of the car and followed Madge and Faith as they walked around the property, but did not listen to their commentary. The yard was in terrible shape with tall weeds and grasses growing up through clumps of aloe vera, geraniums, nasturtiums, a dozen or so rose bushes. and various evergreen and boxwood bushes that were desperately in need of trimming. Paths led through

the gardens that were bordered by granite river rocks that varied in size and oval shapes up to a foot across.

"Goodness!" Trudy exclaimed as they made their way toward the front door. "How long has this house been vacant?"

"Oh, I think several years," Madge replied. "I could find out if you really want to know."

"No," Trudy replied. "I was just curious."

Faith and Trudy stood on the front porch with Madge as she searched through her keys. They looked at the houses around the area and noticed that the house they were looking at was easily the largest. As they looked up the hill, the houses seemed to get smaller and older. In fact, they noticed that the largest houses were built in the first block off the bay. Finally, Madge found the key and unlocked the door.

As Trudy entered the empty room, she noted a front window on her left, a course of six smaller windows along the west side of the room with sun streaming into the long room. There was a small fireplace at the end of the room, with a view window of the bay on the left, and a door on the right. Near-by on her right was an old-fashioned wide doorway with a pair of sliding doors that could close off a dining room—the room beyond—from the long living room. Another door turned out to be the entrance to a large kitchen with laundry room, pantry, and a servant's quarters beyond that.

"Take a look at this!" Madge said, opening a kitchen door to an interior stairway. Going to the right was a set of steps leading to the second floor. Going to the left was another door that led back into the long living room, but there was also a set of half a dozen steps that led down into a large artist's studio with a huge, square window that provided a beautiful view of the bay through sixteen individual old wavy glass panes. The studio had another fireplace on a back wall, and another door that led to outside steps on Fifth Street.

Faith and Trudy followed Madge upstairs to the second floor. Near the top, they came to a landing and the steps turned to the left and found a short stairway to the left again that led to the main part of the second floor. Going to the right, they entered the east wing of the second floor. Madge went left first where there were three bedrooms, a bathroom and a storage room. When they went across the hall to the wing of the second floor, there were two more large rooms and another bathroom.

Faith noted that there was a third fireplace in one of the three bedrooms, and that the rooms facing the bay had beautiful views of the bay. "Well, Trudy," she said, "if the price is right I think you've found your house! I've seen half a dozen rooms in here that you could rent out in short order."

"You have?" Trudy said.

"They're asking six thousand, five hundred dollars," Madge said, smiling.

"Oh Lord!" Trudy cried. "So much?"

Trudy's comment surprised Madge, but irritated Faith who said, "Trudy, we need to have a talk."

"I've got to go check on a few things while I'm here," Madge said, quickly leaving the room and walking downstairs. "I'll leave you two alone for a minute to let you talk."

"Trudy!" Faith said in a low voice. "Can't you see this? Can't you see what it is? You couldn't ask for a better situation. All this place needs is cleaning, painting, some used furniture, and locks on the doors and you could have an income in a month after you take possession! Why, I can see six rooms you can rent with very little trouble, and have an income of about $250 a month almost right away, and your own place to stay is included! You sure couldn't earn that much going to work in the shipyards!"

"But, Faith!" Trudy protested. "Think of all that debt! It would take me years to pay that off! I'd be a broken old woman in that time!"

Faith looked at her friend for several minutes, then decided to talk with Madge with Trudy there to listen. In short, she wanted to convince Trudy with reason.

Faith and Trudy spent another quarter hour or so looking through the upstairs before going down to the sunny front living room where they found Madge waiting. "Y'know," Faith said, strolling over to Madge while Trudy gravitated to the sunshine that was flooding the worn hardwood floor under the course of windows in the side of the room. "I'll bet that the reason this place has been on the market so long is that it's much too big for a family and not built well enough for people with money—and probably not in a first-class location, either"

Madge smiled at her and said, "You should have been in real estate. This property is the last remaining big asset in a trust and they would probably make concessions to get rid of it."

"That's what I thought," Faith said. "Trudy has been told to avoid credit at all costs and big numbers really scare her, but this house is exactly what she needs and she doesn't see it. I think she would buy it if you put it to her in terms she could understand. She doesn't have a lot of money, but I think she could handle a reasonable price, if you get my meaning."

Madge looked at Faith for a moment, then said, "When you two are ready we can run back to the office so I can make a few calls and maybe do a little math. You say that you're pretty sure she would buy the property?"

"Well, do you know of any obvious or expensive problems this place has?"

"No," Madge said. "As far as I know, everything works."

"Then I think she will buy it," Faith responded.

A half-hour later they were back in Madge's office and Madge was on the phone.

"You and Neil could redo those floors—y'know, wash them and paint them, put down some rugs and get a few pieces of furniture, and put locks on those

doors, and you could be renting those rooms out in no time. Why, next month you could start renting," Faith told Trudy.

"Neil's only a boy," Trudy said. "He can't do that kind of thing. I'd have to do everything myself. That place sounds like a lifetime of work!"

"Kind of like what you'd be doing if you just went home and didn't buy this place?" Faith asked sarcastically. "Trudy, if you'd been working for someone else all these years, you'd be wishing you could be working for yourself! And by the way, I don't think you should sell Neil short. He's probably capable of a lot more than you give him credit for!"

"Trudy, I'd like to stick my two cents in here," Madge said. "I probably shouldn't say a thing, but I can see something here that you can't see, I think. I believe Faith is right in advising you to become a landlady renting rooms here. Just from a business point of view, that would be something you could do to make a living—and probably a better living than you could make by going to work for someone. How well you do is up to you, but I think you'll do all right just renting the rooms. It seems to me that your attitude toward all this is your main stumbling block."

"Well," Trudy said. Whenever Trudy felt like she had to defend herself, she began with "Well." "As long as I've lived all I've heard is to stay away from credit."

"If you are the bill payer in the family," Madge said, "you either pay rent for a place to stay or you make payments on a mortgage. Almost everyone thinks that it is better to be paying on a mortgage because then you own. Someday the mortgage gets paid off and then you are the owner. When you rent, the rent goes on forever. You know, a mortgage is one kind of credit."

Trudy looked quickly at Madge, then at Faith. "Faith knew at once that Trudy had not thought of credit and a mortgage as being the same thing."

"Trudy, don't worry about the business of renting rooms," Madge said. "I'll be happy to sit down with you and get you straightened out. There are only a few things that you have to know. The rest in just common sense."

"Well," Trudy said, clearing her throat. "I guess you two are right. When I think about it all, it's probably the best thing for me. Why don't you tell me about it then."

"Trudy," Madge said. "I promise you that I am trying to help you. You may have to learn about renting rooms, but I think Faith is correct in talking you into this property. I think it is a good thing for you because it's the only way that I can see for you to earn a decent living, under the circumstances."

"All right," Trudy responded. "I appreciate your help. I don't know what I'd do if I didn't have someone to advise me."

"So Trudy," Madge said. "I just want you to know that I'm not just trying to make a sale, but I sincerely want to help you. Believe me, I think you and this property are a perfect match.

Trudy's House

"Now Trudy, I had another talk with the people who represent this estate and they are anxious to settle it. I think they are interested in working with you on this," Madge said. "I'll need a down payment. Can you put $1500.00 down."

Trudy's face went pale and her expression changed to astonishment.

"You know," Faith interjected. "Trudy and I were talking about that just a while ago and we had worked out a plan based on $1000.00 down, that still would give her some working capitol to start this rooming business with. Fifteen hundred would be crowding her too much."

Madge glanced at Faith and smiled. "I'll have to phone them again. How's your credit, Trudy."

"I don't know," Trudy said. "I never use credit. Well, sometimes I buy things on layaway, but I suppose that isn't the same."

"Have you ever had bad credit?" Madge asked. "Have you ever had credit, and have you ever had a credit rating?"

"No," Trudy responded. "Never. My husband always took care of that sort of thing."

"Excuse me again," Madge said with a smile, "while I consult with the Ivory Tower!"

Madge walked over to her cluttered desk, sat down and dialed a number again while Trudy sat next to Faith in the uncomfortable wooden chairs near the front door. They sat listening to Madge's muffled voice as she talked with someone who seemed to have a lot of authority.

"I think this is good," Faith said softly so that Madge wouldn't hear her. "It sounds like they are tailoring a loan for you. They must be anxious to sell that old place. Do you have about a hundred dollars in cash on you?"

"Yes," Trudy answered. "I have two hundred dollars pinned to my girdle. Why?"

"Well," Faith said. "If whoever she's talking with goes along with this sale—and I think they will—Madge will ask you for a down payment, which I'm guessing will be about $1200. You will have to pay that much to move in, but before that—right now—you can give her about one hundred dollars for what they call 'earnest money'. That would be evidence of your good intentions."

"My good intentions? Really?" Trudy said. "Do they think I'm going to run off after all this?"

"Now Trudy, just hold your horses," Faith said. "That's not it at all. That's just real estate talk for your putting down part of the down payment. Of course, you can put $1200 down now if you want to and skip all this."

"I don't have that much with me," Trudy said.

"Exactly my point," Faith said with a laugh as Madge put the receiver on the phone and stood up and stretched.

"You'd better get that hundred dollars out," Faith whispered to Trudy.

Madge looked out on the street for a few minutes. It was obvious to Trudy and Faith that she was thinking about something so they remained quiet until Madge turned to face them. She picked up some forms and a tablet of scratch paper from her desk and walked over to sit next to Trudy in one of the hard waiting room chairs.

"Trudy," she asked, "do you have some cash with you that you can put down on this house today?"

Trudy cleared her throat before answering. "Well, yes. I guess I do. How much do I need?"

"Here's the situation," Madge said. "I've just talked with the office that is selling this property. They said they will offer it to you for $5,000, as is, if you can give them $1000 down and make payments of $50.00 each month until it is paid for. If you can give me a reasonable amount of earnest money, like a hundred dollars or so, today we will deduct that from the $1000 dollars down and you will have to pay that amount—$900—by the end of escrow, which would be about the end of July. Then you could take possession of the property."

Trudy turned and looked at Faith because she had not followed everything that Madge just said. "Well, I . . ." Trudy began, not knowing what to say.

"What rate?" Faith inquired.

"Umm," Madge said. "I'd have to figure it out. I'm just repeating what they said on the phone, but I'm guessing about 8 percent for eight or ten years. Point is, the low payment would allow her to get a toehold on the property, and she could always double up with no penalty payments. And, about that 'as is', I don't know of any special problems with the house but I would expect that someone would have to go over things when she moves in to see if everything is okay."

Faith looked at Madge for a minute or two, then said to Trudy, "Well, for gosh sakes, Trudy. Sign the papers before someone changes their mind!"

"Then, can I give you a hundred dollars now and send down nine hundred in a week or two?" Trudy asked.

"That will work," Madge replied. "Come on over to my desk and we'll go over everything. Now, Trudy, I want you to come into this office to see me when the escrow period is over. Okay? Are you two driving back in the morning?"

"I think so," Faith answered. "We both have a lot to do."

An hour later Faith and Trudy walked out of Madge's office and walked over to a little café near the theater for some coffee while they discussed everything and waited for the kids to get out of the theater. Trudy closed her eyes and tried to relax as they talked.

"Trudy," Faith said after a long pause. "I hope you know that you really got lucky. Maybe you don't realize it yet but I think that place was waiting for you to come along!"

"Golly," Trudy said, gazing out at the passing street traffic, then closed her eyes again.

CHAPTER SIX

The trip back to Portland from Pacific Grove was by the most direct route that Faith could take because she needed to get home to look after her own life, and Trudy was anxious to tell her friends about her California adventure. The general route was to drive highway 101 northward through what was then the small farm town of San Jose in 1943, across the Carquinez Straits near Vallejo, to meet Highway 99 in the Sacramento Valley, and drive north to Portland. The uneventful trip took two days of hard driving.

They started the trip early in the morning so they could get a full day of driving in before they stopped for the night. Trudy was quiet for the first few hours and Faith wondered if she was having second thoughts on buying the house or just mulling over plans on what she planned to do with the house when she took possession in a month.

At last Trudy turned to look at Faith and said, "You know, I've been thinking about that house and I don't think I know where to start with it. I mean—I know I have to get rooms rented and all that, but I really don't know what to do first. Because as you know, I've never owned a house, and I'm not sure what I'd have to have for the people who will rent from me."

"Well, Trudy, I think you'll have to get some paper and sit down and go over everything in your mind. Write it all down. Then figure out what has to be done first, what's second, and so on," Faith answered. "I think the first thing you ought to do is figure out which rooms you can fix up right away to get money coming in, and which ones you can rent sometime later on, then figure out where your own quarters will be. You probably ought to set up your quarters in a part of the house that you can't rent very easy."

"Yes," Trudy answered. "That sounds like good advice. I've been thinking that the maid's place behind the kitchen would be a good place to live. Neil would

need his own room and he says he thinks he would like that linen room at the top of the steps on the second floor"

"So," Faith said, "you have been thinking about it then. That sounds good to me, but I think you should keep an open mind on it. You might like some other arrangement."

"Sure," Trudy said. "I have been thinking a lot about it, but you know the only time I've ever rented anything in my life was last winter when I was learning to paint insignia on airplanes. I don't have any idea how to go about renting rooms."

"Well, Trudy!" Faith retorted. She paused to collect her thoughts and her growing frustration with Trudy's apparent ignorance in the simplest business functions. Faith concentrated on traffic for a few minutes, then turned her thoughts to Trudy as they drove out on the open highway again.

"All right," Faith continued. "Imagine that you are looking for a room to rent. Put yourself in the shoes of the people you want to rent to. They're temporary, because they are wives, girl friends, mothers, whoever, of the servicemen, and the servicemen are only there long enough to go through some training or something. When that's over, they get sent overseas and your renters will go home. Now, if you were renting a room at your place, what would you want?"

"A bathroom!" Donny called from the backseat, giggling.

"Okay, you kids," Faith said. "We'll stop for lunch at the next café that we see."

"Now, Trudy," Faith said, getting back to the subject. "Think about it. What would you be looking for?"

"Golly, let's see," Trudy began. "I'd want a convenient, dry, warm, room—clean."

"I think it's the law that if you rent rooms or apartments, they have to have heat and bathrooms," Faith advised.

"Really?" Trudy said. "I suppose it would have to be, wouldn't it. Well, I'm not sure. What would you say?"

"Think about it, Trudy," Faith said. "What about sheets and towels? What about things to clean with? Are you going to clean the rooms, or are the renters going to do it? What about a place for them to eat? Are going to cook for them?"

"Oh, heavens!" Trudy cried. "I never thought about all that! I can't do all that!"

"All right now, hold your horses!" Faith said. "A boarding house is one where the meals are provided with the rent. Or, some just call it room and board. That's like you've seen in the movies where everyone sits down around a big table to eat.

"Then there's what some people call a housekeeping room. I think that's where the landlady or a cleaning woman comes in regularly and makes your bed and cleans your room for you. Another thing is offering 'kitchen privileges' to someone. Now, that's where they pay a little more than the rent so they can

come into your kitchen and cook a meal with their own food. They generally get a corner of the 'fridge and a cupboard of their own.

"Another way to rent is to just rent the room with some furniture and be done with it. The bad side of that is that you never see how they're keeping their room."

"Well, what's wrong with that?" Trudy asked, puzzled.

"It's your room in your house," Faith said. "You want to know how they're treating the room. If you don't see inside the room once in a while you don't know if they're stacking garbage in the corner, painting the wall black, or sending coded messages to Berlin. You should know if your renter lives like a normal person."

"Oh, Lord!" Trudy cried. "Can all that be possible?"

"Of course it is," Faith said. "The world is full of all kinds of people. For everything that you can possible imagine; and for all the bizarre behavior you've ever heard of, there is someone, somewhere who believes in it with all their heart and soul. If you don't know that now, you should. That's the real world. What we all have to do is know that it exists, and avoid those people."

"Oh, Faith! That's just terrible! Am I going to have to watch for all that?"

"Well, I believe that if a person isn't aware of these things, they're glossing over all the bad in life, so the ugliness and unpleasantness will be out of their lives. Then when something does happen they're shocked, dismayed, troubled, and generally confused, and I think that there is a person who wasn't paying attention. I don't concentrate on the bad or dwell on it, but I am aware that it is there and I can deal with it when I see it."

Trudy was quiet for a while, and Faith knew Trudy well enough to know that she was digesting and evaluating everything that they had just talked about. When they arrived in Vacaville they stopped for lunch and Trudy had changed the subject.

"My goodness but it's hot here after Pacific Grove!" Trudy said.

"Yes it is, but you're in the Sacramento Valley now!" Faith said as she opened the door of the little café. As they walked in they were met by currents of air from several fans.

"Sorry!" a waitress called from the far end of the counter. "We always have to apologize to people who have never been here before. The fans keep the flies and some of the heat out! Table or counter?"

The four of them ate a light lunch and started out on the highway again in less than an hour. Trudy and Faith were quiet for most of the afternoon, content to watch the passing scenery and listen to the endless banter between Donny and Neil as they passed the hours in the back seat. They got as far as Dunsmuir again before stopping for the night. They even stayed in the same motel that they had stayed in several weeks before when they were headed south.

After they had had dinner and were walking back to their motel, Faith said, "Well, Trudy, you've seen a lot since we were here a couple of weeks ago."

"I'll say!" Trudy said. "I didn't have any idea what to expect in California, and I had no idea what I was going to do with my life."

"When we talked earlier today, you sounded like you might not want to be a landlady," Faith said.

Trudy cleared her throat and said, "I thought about that all afternoon and I guess you're right. I have to do something to bring in money and it appears that being a landlady is what I can do. I'll just have to learn about it—and Madge said that she would help me. I think when I get back down there and start in on that house things will fall into place. After all, I think it'll take a while and I'll have a chance to think about it again down there. I'll have to get as much money as I can together because I know it won't be cheap."

"Yes, that's right," Faith said. "And, don't forget, you'll start having an income as soon as you get rooms rented. Just take time to think things through before you act and you should be all right."

Faith and Trudy and the kids started early the next morning and arrived in Portland at dinner time that evening. Trudy ran up the steps at her sister's house and rang the doorbell. Neil brought their luggage and belongings up to the door while Jean unlocked the door to let them in. Faith and Donnie waved good-bye and drove off to their farm.

"Land sakes!" Jean exclaimed when she opened the door. "Here you are back again! Well, tell me about your trip."

Trudy spent the rest of the evening telling Jean about her trip, talking about the places they had seen and the things they had experienced. Jean listened carefully as Trudy told her all the details and about the decisions they had arrived at. Jean didn't say a thing when Trudy told her about buying her house and her decision to become a landlady. Instead, she said that everyone was tired and she would hear it all again the next morning.

One morning soon after she arrived back in Portland Trudy began thinking about being a landlady and all that revolved around the work, like dealing with tenants and managing the building when she hardly knew anything about houses and how things worked. She drank some coffee and ate some toast but felt an uneasiness rising up within her. She wasn't ill. She just was beginning to feel all sorts of self-doubts about moving away from the comfort and familiarity of friends and relatives to take on a whole new life that, despite encouragement from Madge and Faith, seemed preposterous to her at the moment.

After all, Trudy thought, she had never owned anything. She had never worked at anything, aside from trying to paint insignia on airplanes and she wasn't good at that. She had never even thought about having property, or having any kind of a position of authority! What made her think that she could be a

landlady in her own building just because someone said that they thought she could do it?

Trudy pressed her forehead into her palms with her elbows on the table and stared at her plate. Then, Trudy thought again about supporting herself and the cost of raising Neil. If only she didn't have the responsibility of raising a teenage son! Trudy reached across the table and grabbed the morning paper that Jean had been reading before she rushed off to work, and found the want ads. She looked through the jobs quickly with the same results she had always had. The better paying jobs in war work required experienced people—and then, the money offered didn't come close to the estimates that Faith had given her if she ran her own rooming house.

Trudy spent the next few days talking with people and generally trying to build a more positive attitude about renting rooms, because she knew that if she were going to make the change to California she would have to do it with a positive attitude. Trudy knew instinctively that she had to make the decision once and for all to become a landlady and stay with it. After all, Faith and Madge had worked to give her a good start and she decided that was something that she had to hang on to. Without realizing what was happening, Trudy began to develop a resource that she had not been aware of—a kind of self-determination that had been dormant because of her passive life style. She would subconsciously develop this new aspect in her personality and use it many times in the future, and not always to her benefit.

Trudy and Jean didn't talk about the trip for a few days. Trudy remained busy going over her possessions and important papers since she finally knew what she was going to do with her life. She sold everything that she could not use in her new life to raise as much money as possible, even trading clothing and knick-knacks to get a more seasonal wardrobe for California, and to get some good, serviceable work clothing.

She sent the balance of the down payment as soon as she could, being very careful to follow Madge's directions. As chores were done and goals were accomplished, Trudy began to think more about becoming a landlady. As questions came to her, she wrote them down with the intention of reading them to Faith first, then Madge if Faith didn't know the answer. She did the same with ideas about her house, eventually accumulating a big envelope full of ideas written on scraps of paper and the backs of envelopes.

One night before she went to sleep, Trudy lay in bed thinking about her house and realized for the first time she was actually thinking in terms of being the owner of the property and that she no longer had doubts about becoming a landlady! Her plans had gone from "if" to "when", and she wondered if somehow this was the start of the more mature outlook on life that her husband always said she should have at her age!

A few days later, Jean asked her again about California and the trip. Trudy knew that Jean really wanted to know more about the house she had bought, and so began telling her about Pacific Grove. The conversation soon got around to Trudy becoming a landlady and Jean was skeptical as always. Only now Trudy recognized it as skepticism born of many disappointments in life, and years of financial hardship.

"I don't see how you can make enough money renting those rooms," Jean said, using her hand to brush imaginary crumbs and dust from her dining room table. "You put all your money up like that—go into debt, and where's the money to pay bills? Land sakes! You have to buy furniture and paint and all that. Then you have to have rooms rented by the time the bills come in so you can pay them. I'd worry about getting the rooms rented out in time because if you don't you'll be out on the street! I think you're better off getting a good, reliable job. You do the work and get paid every week or two. Then you know where you are! No sir! I don't think things come to you all that easy!"

"Well, I've bought the house," Trudy said. "For better or for worse, I've done it. I'm still young enough and strong enough to go out and get a job if it doesn't work out. There's a lot of military down there and not nearly enough rental rooms for the people who follow them. The real estate lady said that I'd have no problem renting the rooms out."

"Well maybe you've lucked out," Jean said shaking her head slowly. "I sure hope so for your sake, and for Neil's sake! My Lord, I'll bet he has a time just knowing where his home is. His world has been first one place, and then another, as they say. Not only that, he hasn't known a father for almost a year!"

Jean sat quietly for a few minutes fingering a crocheted place mat then said, "Your supply of renters depends on all those draftees in that camp, I suppose?"

"Yes," Trudy said. "That's right."

"Then, what are you going to do when the war is over?" Jean asked. "Have you thought of that?"

"Well, no," Trudy admitted. "We haven't talked about that exactly, but that place is a resort area and I could probably rent to vacationers. After all, the house is only half a block from the beach."

"Uh-huh," Jean said. "And isn't it seasonal, too?"

"Well, I don't think so," Trudy said. "It's not like the beaches up here. People say that the weather is usually warmer there. Anyway, I hope that I will have the house in shape by then. Maybe I could turn it into flats or something."

Jean shook her head slowly with a worried look on her face, and said, "I sure hope you know what you're doing. You're taking an awful big step."

Trudy had never stood up to Jean because there was almost fourteen years between them. Her older sister had helped raise her and her youngest sister, Ellen, when they were children. In some ways Jean was almost like a mother

to both Trudy and Ellen. Now, Trudy found herself in the position of having to stand her ground and tell Jean that she had made her plans and intended to stick with them.

"I've been wondering what I could do ever since the funeral when I found out that I would have to support myself and Neil, too, and I didn't have any idea what I could do," Trudy said. "Faith and I talked about what I could do to make a living with no training at all, all the way down to California and this was the only thing that we could think of that I could do that would let me earn enough money. I think I really got lucky, or that God was looking out for me, or something, because if I hadn't found that house I'd still be wondering what to do. I'd be on the dole I suppose, because I never learned how to do anything!"

"Yeah," Jean said finally, realizing that she had touched a nerve with Trudy. "I can see that you have worked on this and you have strong feeling about it. Maybe it's right."

Trudy tried to stay busy for the next few weeks, staying out of her older sister's way to avoid another disturbing confrontation. Jean worked in a clothing factory and was gone every day until five-thirty or six in the evening. That's when Trudy and Neil ate and took care of anything that had to be done downstairs. They tried to spend weekends and evenings out with friends, and welcomed evenings when someone came to visit because Trudy knew that Jean would never discuss family matters with company in the room. Trudy welcomed Sundays too, because Jean was an avid Lutheran and would not miss church or church functions.

It was inevitable however, that there were times when Jean and Trudy were in the house together and to Trudy's surprise, no mention was made again about Trudy becoming a landlady in California. After giving the matter a lot of thought, Trudy assumed that this was because Jean had given Trudy credit for a sensible, mature decision and left it at that.

One day in the middle of July, a thick manila envelope arrived in the morning mail for Trudy from the Bank of America in Monterey. Trudy set it down in the middle of Jean's dining room table and phoned Faith.

"I'm coming into town this afternoon," Faith said. "Those papers are all important to you so don't open the package. You don't want to mislay anything."

Faith arrived just after lunch, picked up Trudy and her package and drove to a downtown bank where a friend of Faith's was a title officer. After a few minutes o greeting and introductions, the two women sat down with the title officer and opened the big envelope. They watched as the man sifted through the paper work and set aside a few documents, then sat back smiling at them.

"This all looks pretty standard to me," he said. "This is a pretty standard title kit from the Bank of America. They say you are buying a property in Pacific Grove, California for $5000 dollars, and that they have accepted your down payment of $1000. You agree to pay them a balance of $4000.00, plus interest, at the rate of

six and one half percent, and that your payments will be $50.00 per month until paid. Is that agreeable to you, Mrs. Anderson?"

"Why, yes. I suppose so," Trudy said softly. She was surprised that they had accepted her offer to buy.

"Then, you need to sign these papers that I have set aside, and initial these others and we will send it all back to them by registered mail," the man told her. As she signed, Trudy ignored the small talk between Faith and the bank man who were talking about the trip and what a find the house was for Trudy.

As they got ready to leave, the bank man stood up and said, "Congratulations Mrs. Anderson. As a homeowner, you need to keep all these papers—and any other important papers in a safe place like a safety deposit box at the bank you'll be doing business with. Now, you understand that there will be other papers to sign when you go back down there—let's see—on July 29th. If you can't make it on that date, be sure to let them know and I'm sure they will set a new date."

"I will, and thank you so much," Trudy said, feeling truly appreciative.

When they were outside again, Trudy turned to Faith and said, "Oh, heavens! I wouldn't have known what to do with all that paperwork! He certainly did help. How will I ever thank you for all your help!"

"Well," Faith said with a smile, "shoot! You can rent us a room when we come down there for a vacation sometime. How's that?"

The two women visited for a while in a coffee shop and as they parted again, Faith advised Trudy the she should get in touch with Madge as soon as she got back to California. Madge would be sure to see that everything was done right. The next day Trudy sent Madge a note saying that she would like to come into her office on Monday, the 2nd of August, because that would give her a full work week to get organized and make the trip down to Pacific Grove.

Finally, with enthusiasm building for her move to a new life in the sunshine, Trudy contacted an old friend from her days when she was active with the writer's group in Portland. The man had promised her that he would drive her old truck to California for her. Trudy realized that she had to be careful in hiring a driver because the wrong person could drive the truck out of town and never be seen again. After all, she had loaded the truck with anything that she might find useful in her new home, especially furniture and any family things that she still valued.

When Trudy met the man face to face again she had the feeling that although he had been a trusted friend, he now seemed like a stranger because she had experienced so much since they last met. Nevertheless, Trudy gave him her new address, gas stamps, and money to get down to California, and he promised to drive the truck down in September when the weather was a little cooler. When they parted, Trudy hoped that she could still trust him.

Finally, Trudy packed two old suitcases and a trunk with all of their clothing, and packed several boxes with linens and towels. She spent the last few days

and evenings visiting friends and going through tearful farewells and good wishes making Trudy feel like she was moving far away forever. Even her sister, Jean apologized for being so aloof. "It doesn't hurt to be a little cautious," she sniffed.

With wartime highway speeds in effect, Trudy's bus didn't reach Monterey until Saturday, the 31st. Trudy had the bus station hold her luggage until Monday so she would only have to move everything once. She made her way over to the little inn on Houston Street for a place to stay until she could get in her own house. The lady who Trudy had met a month before remembered her and invited her in her office.

"Well!" the woman said. "Sure I remember you! You're back so soon! Where's the other lady?"

"It's just the two of us now," Trudy said. "I just got off the bus from Portland because I bought a house in Pacific Grove and I'm moving down here."

"Oh? Is that right?" the woman replied. "So you found a place. I remember that you were looking. So, I guess you and the other woman drove home to settle things and now you're back again. Which place did you buy? Here, write it down for me so I'll remember."

Trudy wrote the address down, saying, "It's a big old reddish brown place on Central and Fifth. I'm going to rent rooms there."

"Central and Fifth," The woman said, squinting at the wall and trying to picture the house in her memory. "Is that the gray place?"

"No. Reddish brown—with a big hedge around it."

"Oh! That place!" The woman said smiling. "Sure, I know it. Boy! That's a big place. You've got a lot of work ahead! Look, we should know each other. I'm Rosa Silviera. They call me Rosy."

Trudy introduced herself and Neil with apologies about a phone number and address because she had just arrived back in Monterey. "I'll have to let you know everything after I get established," Trudy promised. "I don't know if I'll get a phone right away, though."

"Oh, you'll have to get a phone right away," Rosy cautioned. "They'll make you, as soon as you start renting to the military. That's one of the things you have to have, because they want to be able to get in touch with the servicemen right away."

"Really?" Trudy exclaimed.

"That's right," Rosy said. "Have you rented rooms before or is this all new to you like it was for me?"

Trudy looked quickly at Rosy and exclaimed again, "Oooo, my goodness! Is this new to you, too?"

"It was," Rosy said. "Renting rooms is new to me but I've always lived here in Monterey. When I heard that there was such a demand for rooms, I decided

that since I'm all alone in the world and never married, it would be a good way for me to make a living. So, I decided to get this place and fix it up a little and go into business."

"Well," Trudy said. "My husband died six months ago and left me with one son and myself to support. Imagine! When I was in school I didn't learn a thing about how to support myself."

"Me neither!" Rosy said. "They just taught us to sew a little, and all that other stuff—algebra and history and stuff. And what did I do with it? I worked in the fish canneries until I got this place!"

Trudy grinned at Rosy's colorful way of expressing herself, and said, "My husband didn't die in the war or anything like that. He died of a stroke and left me with our son to support."

"Oh," Rosy said sympathetically. "That's tough for you."

"So, this is what I'll be doing. Thank heavens I found this big house!" Trudy said, then changing the subject, "You know, Neil and I just got off the bus and we're both pretty tired."

"Sure, sure," Rosy said amiably, "Go rest up. We can talk again tomorrow."

The following day was Sunday, and Trudy took Neil in tow and walked around the historic part of Monterey, which included most of the downtown area. Trudy wanted to know which stores were in town, and she wanted to get a general idea of where things were. She was certain that she would be looking for ways to furnish her house and intended to take advantage of any sales that might come up. There were curtains and drapes to think about to start with, and Trudy had no idea how many windows were in her house!

After talking with Faith and Madge, Trudy learned what she should have known if she had thought about it—that each room she rented would have to have some basic furniture like a double bed with a good set of springs and mattress, a table or two, a lamp and maybe several chairs. She knew that she would have to provide some kitchen facilities, but had no idea just what they were. Trudy decided that she needed to sit down and have a talk with Rosy because she had just gone through what Trudy was thinking about. She also needed to talk with Madge about the same things. Madge was a realtor and she would know what people expected.

After walking around Monterey all day, Trudy and Neil had a dinner in one of the many cafes in Monterey and returned to the inn to talk with Rosy again. Using a little foresight, Neil had found a book and some comic books in one of the stores they went through, and went back to their room to read while Trudy and Rosy visited.

"Oh, come on in!" Rosy said when she spotted Trudy. "I've been expecting you. Have you been out sight-seeing?"

"I'm all worn out," Trudy said. "I've walked all over Monterey today."

Rosy slid a hot cup of coffee across the table toward Trudy and followed that with a little pitcher of milk and some sugar. Trudy accepted the coffee gratefully, and thanking Rosy, slid the milk and sugar back to her. "Just the coffee, thanks," she said. "How wonderful! I love coffee and this smells real."

"It is real," Rosy said with a smile. "I get it from my brother who works out at the fort. He's good to us kids."

"Kids?" Trudy said. "Oh, you mean your family lives here in town near you."

"Sure!" Rosy laughed. "We all live here—two sisters and two brothers. Well, except for one brother who's an oddball and lives 'way up in Carmel Valley. What about you? I guess you don't have any family around here, huh?"

"No, I'm from Portland," Trudy said, "and I still have two sisters up there. When my husband died I saw that as an opportunity to make a move and go live in a warmer climate, like I've always wanted."

"So you wanted to be warmer," Rosy said. "Well, I've never been to Portland but I think it would be too far north for me, too. I'm Sicilian. I've got to have warm sunshine!"

"I'm Swedish," Trudy said, "but I must have been Sicilian in my past life because I love warm weather and sunshine, too!"

Rosy laughed at Trudy and said, "Well, I think you would make a good Sicilian."

"You know," Trudy said, clearing her throat and getting more serious, "I was just a housewife before all this happened and I don't know anything about being a landlady. I would appreciate any ideas and advice that you could pass on to me."

"I'll tell you," Rosy said after thinking a few minutes, "I think everybody who rents is different. Some people think everything is okay as long as people pay their rent on time. I think that this is my building and I want tenants who are considerate of others, so when I get a place ready to rent I fix it up like I would expect to find it if I was renting the room. That way, the people I rent to have about the same standards as I do. And, if they break something I expect them to put it right."

"What about drunks and people having parties who make too much noise?" Trudy asked. "What do you do about them?"

"Right away, I ask them to be quiet," Rosy said, wagging her finger as if she were scolding. "Remember—to my standards! If they don't shut up I call the cops on them!"

"You call the cops?" Trudy asked. "You call the cops if they're noisy, too?"

"Sure I do," Rosy said. "And, if they're military, I call the M.P.s"

"They don't care if you call them for that?"

"They want to know," Rosy said. "They want to know because they want to keep the peace, and the noisy people are affecting your whole place."

"Oh," Trudy replied. Everyone she had ever known avoided contact with the police because they didn't want to draw attention to whatever they were doing. They weren't criminals but they were cautious about official curiosity.

"Gee," Trudy said, finishing her coffee and standing up. "I have so much to learn."

"Maybe," Rosy said with a broad grin, "but I think you'll learn fast."

Trudy went back to her room and went to bed early for a restless night. She and Neil ate a quick breakfast and were on their way before nine a.m. Trudy wanted to follow the bank's instructions to the letter. Carrying her purse and her bulky envelope of papers she walked over to the bank's office on Alvarado Street, but discovered that the bank's title department had a different address. Urging Neil to hurry, Trudy walked quickly up and down the streets until she found the title office and went inside.

"Good morning!" a young woman said.

Trudy walked to the woman's desk and said, "Good morning. I'm Trudy Anderson and I'm supposed to come in today."

"Good morning, Mrs. Anderson," a man at another desk said. "Won't you have seat? This won't take long."

Trudy directed Neil to sit in a chair near the door because she wanted to concentrate on whatever the man at the desk had to tell her.

"Did you have a nice trip down from Portland?" the man asked in an obvious attempt to put Trudy at ease.

"Yes," Trudy said, watching him shuffle through her file folder. "Very nice."

"Hmm," he mumbled. "There's that, and that one too. Yes. Now, here we go."

Trudy watched as he laid out a half dozen pages in front of her. She noticed the little red "x"s on lines here and there. Then, he said, "This all seems to be in order. Now I'd like you to sign your full name in these spaces with the red marks, and follow the signatures with today's date—August 2nd. That's it, then initials where I point."

The man watched carefully, and then moved the papers as Trudy signed. When she had finished, she listened carefully as he gave her instructions on what she had signed, how to make payments, late fees, and so on. Trudy made up her mind that she had to see Madge as soon as she could because she was already forgetting what the man had just said.

When they left the title office Trudy led Neil to a bus stop and caught the bus to Pacific Grove. The man in the title office had given her the keys to her new house and she had put them in her purse. As they rode the bus, Trudy clutched her purse against her side.

Trudy was still clutching her purse to her side when they walked into Madge's office twenty minutes later. "Hello, Madge!" Trudy called as she opened the door to Madge's office. "I'm back."

Madge looked up from her typewriter and waved. "Hi, Trudy! Welcome home!"

Trudy and Neil each sat in a hardwood waiting room chair near the door and took deep breaths. "Well, I've done it. I've just come from the bank and signed all the papers," she said.

Madge smiled broadly, took a final puff on her cigarette before mashing it out in her filled ashtray. She looked over at Trudy and said, "So now you've signed and you own property, and I'll bet you have questions for me."

"Yes," Trudy said. "Do you know, I've just come from signing all those papers and I really don't know what he said."

Madge laughed and beckoned for Trudy to bring all her papers over to the other desk on the other side of the room. "You need to know about these and you want to know how to keep them safe. We can start by making sure they don't get mixed up with my other papers."

Seeing that things would take a while, Neil went outside again to explore the town while Madge talked with his mother. Madge went over everything with Trudy and had Trudy transfer all the utilities in her name while they were still at the office. Madge even had Trudy order telephone service, confirming what Rosy had said—that she had to have a telephone if she was going to rent to military people.

"Now," Madge said. "If you want to go find Neil, I'll drive you two down to your new house!"

It took Trudy fifteen minutes to find Neil, and she spotted him going into the Greyhound Bus depot next to the theater to look through magazines again. Ten minutes later, they were in Madge's car going to their new house.

Madge pulled up at the curb by the front door. Trudy thought the house looked exactly the same as they had left it. It was as if they had just been gone over night.

"Let's look around the outside of the house first," Madge advised. "You want to be sure everything looks okay—you know, no broken windows or broken in doors."

"Really?" Trudy gasped. "Can that happen here?"

Madge glanced at her. "Sure!" That can happen anywhere!"

The large old two-story house was built on the west end of a small city block. Madge, Trudy and Neil walked around the house to their right that took them through an overgrown, dry, weed-laden garden that had colorful native flowers blooming among the weeds. A two-car garage was built on the east end of the block, and the garden extended between the two buildings, down a hill and into the back yard where the garden reached through the middle of the block, from side street to side street—a distance of about 150 feet.

Their little procession followed the garden path around the east end of the house, around the back, and came out on a side street. The house was built right

to the sidewalk on the west side. Madge led Trudy and Neil up the west side of the property, along the side of the house and back to the front of the house again. Along the way, Madge pointed out where garbage cans had been stored, the basement entrance were the furnace was, and a tiny little door that opened on the side street that was so small that almost no one could use it.

"Maybe that was a door that was used for deliveries or something," Neil suggested. "Someone could stand outside and hand things through to someone inside. If the people who lived here had servants they probably wouldn't want strangers coming in the basement."

"Good theory!" Madge said. "Maybe you're right!"

Madge unlocked the front door and stood aside to let Trudy go in first. Trudy walked in slowly, looking first at the long course of windows that took up most of the west wall of the room. She thought that the room looked more long and narrow than she had remembered. A large window overlooking the front of the house was on the left as she walked in, and a disproportionately small fireplace was at the opposite end or the room. Trudy thought that it must have been intended for heating rather than appearance. A mantle of dark wood that surrounded the small fireplace made the entire end of the room look gloomy rather than impressive. There was one more slightly smaller window just to the left of the fireplace that provided a limited view of the bay.

Trudy looked back at the long course of windows and noted that the sun was shining straight into the room through those windows. She would have a couch there, she thought, where she could relax in the afternoon. Just then, Neil interrupted her daydream by pushing past her impatiently to explore the rest of the house.

Madge followed Trudy through the dining room that was attached to the east side of the big living room, and on into the kitchen. It wasn't the kind of kitchen you'd expect to find in a single-family home. It was too big and no thought was given to a layout for intimate family gatherings because the only window looked right out on to the street, next to the porch. Anyone walking by could easily glance across twenty feet of yard to see the lady of the house in curlers having her first cup of coffee in the morning!

One door on the north side of the kitchen led to a basement door going one way, and to a long laundry room with an exit door to a rickety back porch. Another door on the same wall led to a long, thin pantry with a screened in cooler on the north side of the house and at the end of the back porch. Trudy examined both rooms before strolling back into the kitchen where she made a left turn and went through another door that led to what was presumed to be the maid's quarters. That space was just several empty rooms with a separate entrance on the front of the building. It included a fifteen foot square room, a small closet, a basic bathroom, and a large entryway. Trudy thought that the

maid's quarters was more suitable for a man because the bathroom sink and toilet looked like they dated from World War One, and the shower was hand made from galvanized tin. Trudy looked around the rooms carefully, trying to memorize it all.

Marge had been watching Trudy as she looked through the house, then took Trudy by the arm and led her through another door in the kitchen that was near where they first walked into the room. That led to an interior hallway and the stairs to the second floor. Another set of stairs going down six steps led into the large artist's studio room with its big window and fireplace, and a door that led to a side street entrance. The wallpaper in the studio room was really dark green burlap with hunting scenes printed on it. Had it not been for the large artists window, the room would be gloomy. Still, Trudy felt like the room needed lighting. One detail she had overlooked when she first saw the room was a large window shade mounted on the window sill so that it pulled up. A cord was attached to it that ran through a pulley at the top of the window and back down to a hook below the rolled up shade to hold it in position.

"I don't think I've ever seen an arrangement like that," Trudy told Madge.

"Me neither," Madge said, "but it seems to work! Trudy, I've got to get back to the office, but let me suggest that you start with one of the rooms upstairs and concentrate on fixing up just one—and the bathroom, of course. Don't try to take on too much or it might get the best of you. You can get some basic furniture at the used furniture places, or on sales at the stores, and get them to deliver for you. When you're ready to rent a room, come see me and I'll tell you about it. So, paint, clean up, buy some furniture, and fix up the kitchen and bathrooms—five or six things—okay? Got to go!"

Neil saw Madge leave, and thinking that he had a little time to look around the area, he stuck his head in the room and asked if he could go look at the beach.

"All right," Trudy said, "but come back in about an hour because we have to go buy some things."

Trudy went upstairs, found a window and watched Neil run down the hill to the beach that was less than a block away. Trudy stood still and looked around the bare room. The only sound was from the waves breaking on the beach, and traffic passing in front of the house. Trudy ran the events of the last couple of days through her mind and tired to remember the things she still had to do. She had to open a bank account and get a safe deposit box. She had to buy some stationery supplies. She needed cleaning supplies and Neil to carry them home.

Trudy looked around the empty rooms in her house and decided that she really needed everything. Trudy felt a little light headed and sat down on a step. Chairs to start with. She needed more furniture. She needed beds. Trudy felt cold and realized that she was perspiring. Suddenly, her house seemed like a big dark, awesome trap that she had committed herself to and she could see no way

out. A sickening sense of panic began to rise up inside her and she had an urge to run somewhere—but where?

Trudy held her head in her hands and closed her eyes. Feeling weak and shaky, she moved quickly and sat on the top wooden step of the stairway. She sat still wondering if she was going to be sick. Finally, she pulled a rumpled handkerchief out from her pocket and dabbed at the perspiration that had gathered on her face and arms. Trudy sat up straight and looked around from her vantage point at the top of her steps.

The house was completely quiet aside from the noise of an occasional truck or bus driving past in front. She looked at the stairway leading to the floor below. The brown wooden steps were bare. Worn, drab, old-fashioned wallpaper covered the walls on both sides of the stairway. The ceiling over the stairway was covered with pale colored wallpaper with a barely recognizable pattern in it, and two bare bulbs at either end of the upstairs hallway provided the illumination when doors weren't open to allow light in.

Trudy looked around at the rooms that she could see into and all were bare, empty, and uninviting. Thinking about what she had to do and the money she had to spend depressed her. She felt a hopeless feeling well up in her and she allowed a few minutes of crying to let the feeling out—to let it pass. As she sat, she began to wonder if she had made a huge mistake in buying the old house. She thought that it was a lot more than she could deal with when she only had Neil's help. She had no business thinking that she could bring such a big old house to life and use it to make a living! Jean had been right. She could have found a job in Portland for less money, but also with less risk and certainly less stress!

Trudy sat for a while at the top of her steps first thinking that she could beg out of buying the old house, then deciding that was childish! She was giving up before she started! In time, she felt better, and more relaxed, and stood up and took in a few deep breaths. Slowly, she walked through her upstairs rooms and took note of each room's good points and weak points and began to see that Faith had been right. She knew that there were two or three rooms that needed very little work to make them ready to rent. When they were rented, she would have a weekly income!

Trudy decided that she could concentrate on one room at a time, and not to look at her house as one big, overwhelming job. She felt her confidence returning and resolved that somehow she would make the house work for her. She walked along the second floor hallway thumping the wall with her fist and telling herself that she would have these rooms rented! She would do it!

CHAPTER SEVEN

Trudy took a deep breath, summoning her inner strength like a captain taking command of his ship, and began walking from room to room slowly. As she did, she resolved not ever again to allow herself to think of her rooming house as an impossible task. Trudy clenched her teeth in anger with herself for allowing negative feelings and thoughts to creep back in her mind like thieves in the night, when her livelihood depended on all the positive action she could muster.

Trudy told herself that she could sit in the house and stew over things that could be done with her property—and eventually run out of money. Or, she could get to work on her house, a room at a time and rent the rooms, a room at a time. She would get advice from Madge and Rosy, and anyone else who might know, and get the rooms ready, and not worry about "how" or "why" any more!

Trudy studied the two rooms at the top of the stairs. One had a fireplace and a view, and the other was between two rooms and had a small view and not much more. They were about the same size—a little larger than an average bedroom. Both had to share a large bathroom across the hallway. Trudy decided then and there that they were the two rooms she would start with, and the bathroom, too.

Trudy tried to be objective in deciding what had to be done, but really wasn't sure, so she decided that for this one time she would ask Rosy and Madge for their opinions. In the meantime she had to find Neil and get some cleaning supplies.

Trudy stood by the view window of the room she thought she should start with and watched for Neil in the scene below. As she stood there she thought about her life on the Oregon coast and the life she had been living just a year before. How hopeless it all seemed at the time! She shook her head slowly as she recalled the useless hours she had spent sitting at her old typewriter hoping to write a saleable short story, completely unaware of the coming changes that were just around the corner in her life.

87

Trudy was not raised in a religious home and consequently was not inclined to attribute the unforeseen changes that come to us all in life to God, but to the more nebulous concept of "fate" or "destiny", or even just "luck". For Trudy, finding her house was luck, but she could not make any sense of the fact that she was still responsible for Neil, who was just thirteen! He was too young to be a real help for her and she thought of him as an unavoidable expense who would become helpful to her in later years.

Feeling impatient to get on with the day, Trudy finally walked downstairs and checked all the doors to see if they were locked, then walked out the front entrance to the corner just in time to see Neil walking up the hill from the beach. "It's about time you got back, mister. We have to walk up to a store and get some cleaning things so we can get started. You know, I don't have a lot of money so we have to get some rooms ready to rent and soon as we can," she said as they started walking to Pacific Grove.

In 1943, there were no supermarkets in a town like Pacific Grove, and discount stores were unheard of, so shoppers usually went to certain kinds of stores that were likely to carry whatever they wanted. Trudy knew she could find her cleaning supplies at the hardware store or a dime store, but she wanted to look in the big department store she had seen in town, and she needed to talk with Madge.

Trudy and Neil stopped at a little restaurant and had a sandwich first, then she asked Neil to look through the department store and dime store for a wet mop and a bucket and a straw broom and make a note of the prices while she went to talk with Madge. Her intention was to keep Neil occupied for an hour so she could concentrate on several questions with Madge, and at the same time find out if the department store was more or less expensive than the dime store.

After talking with Madge about the rooms, Trudy found Neil walking toward the bus depot again after just leaving the dime store. "Neil!" Trudy called and got his attention. "Where were you going?"

"Oh!" he said. "Well, all the stuff was cheaper in the dime store, but they had more different kinds at Holman's department store."

"Alright," Trudy said, accepting Neil's word because it sounded right. "Come on, we have to go get the things at the dime store. Then we're going home to get started with this."

They went back to the dime store and bought a wet mop and a broom, a dustpan, and a lot of other things to clean the rooms, then walked home. By the time they walked in the front door Neil was exhausted and needed to just sit for a while.

"I'm going upstairs to see what needs to be done," Trudy said, taking some of the cleaning things upstairs with her. "Bring the rest of the cleaning tools when you come upstairs."

Neil sat for a while thinking about the house and seeing the reality of getting rooms ready to rent. He knew that he would be told to do a lot of the work, but he also knew that there was no one else to do it. It was August and he wanted to go to the beach and make some friends, but he also wanted to just enjoy the beach. Unlike the Oregon beaches that were long and flat that he was used to, the Pacific Grove beaches were small and rocky and he was fascinated with them.

After ten or fifteen minutes, Neil heard his mother calling his name from upstairs. He picked up the rest of the cleaning things and brought them upstairs and found his mother in the bedroom with the view.

"Now, I've decided what we're going to do," she started. "I want you to clean all the woodwork in this room and the next room with soap and water. Then you'll have to rinse it off. Do the same thing with the floors and rinse them. Try not to leave any soapy places. Don't get a lot of water around because of the electrical things, and I want you to be careful about getting too much water on the floors, too, because it could leak through and ruin the ceilings in the room below. Do you understand me?"

"Yeah," Neil said. "What are you going to be doing?"

"I'm going to be measuring the windows for curtains and drapes, and I guess shades, too. Then tomorrow, I'm going to leave you here working while I go out and see what I can find in the stores. Now, I want you to stay with it because we have to get some rooms rented as soon as we can before we run out of money."

"Well," Neil said. "I think you need to do some painting too. The floors are all beat up. The hall floor is a different color at one end than it is at the other. The woodwork has nicks and scrapes in it. I think we have to paint these things and let them dry good before anyone moves in."

Trudy walked into the hallway and looked at the floor, then looked at the floor and woodwork in the other room. Neil heard her say, "Hell-damn! Well, you'll still have to wash everything, then I guess we'll have to paint!"

Trudy walked cross the hall to look at the bathroom and noticed the steam radiators for the first time. "Neil!" she called out loudly. When Neil walked in, she asked him if he knew anything about the radiators or what kind of heat system they might have in the house.

"Nope," he said, looking at the radiators. "I've never seen anything like it."

As she looked around her house, Trudy began to develop a nagging feeling that the little bit of money that she had would be used up quickly just getting started. That thought caused her stomach to knot up a little, and she pushed the negative thought aside with the intention of moving on and getting the rooms rented. However, that thought planted a tiny seed of disharmony in her that would eventually grow into a sequoia-sized personality trait that would govern Trudy's plans for the rest of her life.

Trudy and Neil worked on the two rooms and the bathroom all afternoon—Neil scrubbing and cleaning the walls and floor in both rooms and the bathroom until they shined. Trudy measured all the windows and made notes of things that she thought needed to be done, using a tablet of paper that she had bought in the dime store. She made another list of furnishings that she had to buy, and anything else that was needed, including finding out about the heating. That evening, they ate dinner in a little restaurant in Monterey before going back to their room in the little inn.

"You're back!" Rosy cried when she saw Trudy and Neil. "I'll bet you've had some day, huh?"

"I'll say," Trudy said. As she talked, Rosy pushed a cup of coffee toward her and Trudy sat down. "All the things that we did this morning seem like yesterday morning!"

Rosy's eyes brightened a little and she laughed. "I know just how you feel," she said. "I was just like that with this place. Boy, what a job, huh!"

Trudy took a sip of her hot coffee and relaxed a little. Neil went on to their room to read his comic books and stretch out on the day bed that he was using.

"Gee!" Trudy exclaimed to Rosy. "I've got so much to learn about all of this. My realtor has been so helpful in telling me what I need to do. I've walked up to her office in Pacific Grove several times to ask more questions. I imagine I'll have to make several more trips before I know what I'm doing."

"Well," Rosy said sympathetically, "I don't know an awful lot about it yet but you can ask me, too. There are some things that you get to know, like getting the rooms ready as soon as you can and get them rented. That's your income. Then when somebody moves out, you got to clean the room up and get it rented right away, because you don't earn any money with it just sitting there."

"Well, that certainly makes sense," Trudy said. I haven't thought that far, yet.

"Then, another thing," Rosy cautioned. "Every now and then you get people who want to put a hot plate in, and they usually don't ask. They just do it. You have to keep your eyes open for it. Don't let 'em! Don't let 'em do it. Why? Because those hot plates use up a lot of electricity. They'll blow out all your fuses!"

"Really?" Trudy said.

"Do you know fuses?" Rosy asked, holding her hand up and making a circle with her thumb and forefinger. She thought for a moment that she had lost Trudy in the conversation.

"No," Trudy said. "I've never heard of them."

"Come over here and I'll show you," Rosy said, leading Trudy to a pantry door in her kitchen. She opened it and pointed to an electric panel on the wall. She opened the cover door and pointed to several rows of round, plug like things. "Those are fuses. All the electricity in your house has to pass through them to

get to the rooms. The part that goes from each fuse to a room is a circuit. If your tenant uses too much electricity at one time the fuse can't deal with it and it blows out and stops the electricity, and that keeps your building from catching fire. I learned all that from the electrician who was working on it."

"My goodness!" Trudy exclaimed. "I'll look for that in my place."

"And one blows up—you can tell by looking at the little window in the end of it—you unscrew it out, see what number it is, and screw a new one with the same number back in," Rosy continued. "You always keep spares because even storms can make them blow up."

"What about heat?" Trudy asked. "I don't know what kind of heat I have. Do I need heat in California?"

Rosy looked at Trudy and grinned, then broke into giggles. "Heat!" she laughed, then stopped and looked at Trudy. "I'm sorry. I shouldn't laugh. Sure you need heat in California! It usually starts in about October to maybe April or May, or even June sometimes. It can get plenty cold here at night. Sure, you'll need heat."

The next morning Trudy and Neil rode the bus right out to downtown Pacific Grove because Trudy wanted to ask Madge about the heat system she had, and she wanted someone to teach her how to use it.

"Well, I'm sure it's steam heat with a stove oil furnace," Madge answered. "All those old houses in that part of town are set up about the same way. You'll have to phone Pacific Oil & Burner to send someone out to look at the system and make sure it's all right, and maybe get some more oil. It's been a while since anyone has turned it on."

Trudy phoned while she was still at Madge's office and was told that a man would stop by that afternoon. On the way to her house, Trudy let Neil go on ahead so he could walk along the beach, while she walked through the dime store and the department store to see what they had. Holman's, the department store, had a sale on drapes and curtains, but Trudy had not brought the measurements with her. She would have to walk back to the store a little later.

On the way out of the department store, she spotted a furniture store that was about two blocks down Lighthouse Avenue toward Monterey, but still in the same direction that she had to walk in to get to her house. Trudy took a little extra time to look through it to get an idea about what was available, and at what price. Before she bought anything she would look at the used furniture places, too. It had been so long that she had been able to do any shopping that she had no idea any more what things would cost, and with the war going on there were so many rationed things that she didn't really know what she could buy.

After hearing so much about shortages Trudy almost expected the furniture store to be empty. She was surprised to find a selection of beds and furniture, and the salesman told her that the shortages were mostly in products made of

91

metal, like stoves and refrigerators, but the store did have a line of "Victory" stoves that were small and efficient, and they did sell ice boxes that were made of wood, but were white and looked like refrigerators. The line of stoves started at $57.95 for a gas stove. She was told that the store also maintained a used appliance department.

When she looked at the furniture, the store had a selection of mattress and spring sets that started at $55.95. Trudy thanked the salesman and walked home. At least, she thought, she knew what to expect to pay for things, and she knew what she might save at the auctions and used furniture places she had heard about.

That afternoon when the furnace man came Trudy grabbed the ring of keys that the title company had given to her, and led the man outside and around the house to the basement door and let him in. Neither Trudy nor Neil had found the time or had the inclination to explore the basement, so they followed the man into the darkness beneath her house with curiosity and interest. The man walked directly to a large old furnace, reached above it and pulled on a string to turn the light on.

Trudy was amazed at the sight of the furnace because everything above it was a maze of pipes of all sizes. As the man tinkered with the furnace, Trudy and Neil peered around in the darkness, trying to see into the darkest corners.

"Neil," Trudy said as she looked around the basement. "This reminds me that Rosy said we need to get some spare fuses and now that I see all this, I think we need to buy a flashlight—maybe two—so we can look around a little."

"You know," the furnace man said, "I remember this old boiler. It's a little old, but it's well made and it should last you quite a while. I need to check the oil tank and see how much you'll need. Let's see—yeah—the tank is right over there in the corner."

He swung the beam of his flashlight over to a corner, revealing a large, black steel tank.

"Oh! My goodness!" Trudy exclaimed when she saw the tank. The tank stood on end and looked to be about six feet high and three or four feet in diameter. Her first thought was that it would take a fortune to fill it. "Oh my Lord!" she said, "Do you fill that, too?"

The furnace man paused and looked at Trudy. "We'll have to see how much oil is in there first. Then, before you can buy oil you'll have to get a ration book. I'd start that right away, Ma'am. You'll need oil for the winter and that tank holds 500 gallons. I don't think they'll let you fill it but I'm sure you'll need more than you have now."

"How much oil is in the tank now?" Trudy asked.

"I just checked it," The man said. It looks like about 150 gallons. I can bring you another 150 gallons or so before it gets cold, and that should see you through until after new years if we have an average winter."

"Hallelujah!" Trudy said. "I thought I was going to have to fill that whole tank up—another expense!"

"Well, I'm going to start this thing and see if it's working right," the man said, "then I'll come upstairs and we'll have look at the radiators, so I'll see you up there."

Trudy and Neil both had the impression that he wanted them to leave while he fine-tuned the furnace, so they turned and walked back around the house and went inside to wait for him. In a few minutes, they heard the furnace start and run for a while, then shut down. Neil went to the front door to let the man inside.

"Show me where your thermostat is and we'll see if the furnace works from it," the man said. "That's the way it should be used."

Neil and Trudy watched him turn it off and on from the thermostat, then followed him around from room to room as he checked all the radiators. Trudy watched for several minutes, then told Neil that would be his job.

Trudy had begun writing down a "to do" list because she had discovered that she was forgetting to do too many things. High on her list were to buy some basic furniture for herself and for Neil. Neil had already claimed the linen room at the top of the stairs for his own room because it was too small to rent, yet large enough for a single bed, and it had some built in cabinets. It would be just the right size for him. In fact, he wanted his mother to buy a folding wooden camp cot for his bed. He had seen them in the stores and they were cheap and would suit him.

Trudy had spotted a very inexpensive bedroom set at the furniture store that appealed to her, even though it was obviously built as "wartime" furniture. It was still an attractive set that seemed to have a western style. She remembered looking at the cardboard bottoms in the drawers and wondered if they would even last a year. The salesman had called the cardboard "chipboard", but it still looked like cheap cardboard to her. He assured her that the company would never sell anything that wasn't serviceable. Still, for about eighty or ninety dollars she could be sleeping in her own bed and in her own house. She would miss the constant contact with Rosy, but she would save the cost of rent and eating out, especially if she could find a good gas kitchen range.

Trudy resolved to go out and buy what she needed so she and Neil could move into their own home. She was delighted with Neil's willingness to take on the responsibilities she had given him and thought that life would be easier for them if they lived where they were trying to work. Trudy didn't understand a thing about the furnace and was glad that Neil had accepted the job of working with the radiators. One thing that Trudy had not considered was that Neil associated working with the heating system, and similar work with "man's" work, although he didn't openly say it, and was more likely to take it on.

During the days ahead, Neil continued to clean the upstairs rooms, the hallway, the upstairs community bathroom, and the stairway down to the outside

door. Just cleaning everything, washing the woodwork and the wooden floors took a week. When he was through he talked with his mother about the crazy-quilt color patterns that were now visible on the floors where people had painted around carpets, and the dark green color of the walls in the bathroom that made it look like a cave in the woods. They realized that there would be more time spent while they painted.

On Thursday of the first week that she owned the house, Trudy bought the bedroom set that she had seen several days before, and she bought Neil his camp cot and a two-inch thick cotton mattress that was available for it. Neil set it up in his room as soon as he got home. They moved out of Rosy's inn on Saturday, which was the same day the furniture company delivered Trudy's bedroom set. She made her rooms in the maid's quarters.

Trudy noticed a used furniture store just two blocks from the inn and stopped in to look things over. The first things she saw were several stoves and refrigerators. Wooden chairs were stacked up behind them making it look like a restaurant when they cleaned the floors. When she asked about gas kitchen stoves, then man showed her two apartment-sized stoves and three larger stoves. "The apartment stoves move pretty fast," he explained. "Everyone is building apartments wherever they can and putting those little stoves in."

"Well, I need one for my house," Trudy explained. "I just moved here and I need a stove and a refrigerator. I need full-sized ones."

"Good refrigerators are hard to find. Both of these need work and we're waiting for parts," he said. "But I have some stoves. Prices are fifteen to thirty-five dollars, but I don't think you'd want the fifteen dollar one. It dates from the twenties and doesn't have a pilot light, which means that you'd have to light it every time with a match. It even has the old oven sitting up on the left side. I've got one for twenty dollars that's more modern."

"Can I get you to deliver and set it up?"

They came to an agreement for the oldest stove and the man delivered it after he closed that day. With Neil's help, he had the stove in place in less than an hour after he arrived. After he left, Trudy worked another hour cleaning it up and realized that having the stove gave her more needs. She and Neil had to go shopping at the dime store for a coffee pot, a pressure cooker, frying pans and some cooking pots, then buy food and use the cooler in the pantry until they could find a refrigerator.

One day soon afterward, Trudy had a chance to reflect on her life in Pacific Grove compared with her life before. It occurred to her that most of her old friends and relatives would take one look at her new life and tell her that she was roughing it. Even the man at the used furniture store raised his eyebrows at her settling for the oldest stove, but she had always had to light her stove with a match and she didn't think that was an inconvenience. She was sure that lots of

people would wonder why she was living the way she was. After giving the matter some thought, Trudy decided that she enjoyed what she was doing because she thought that she was working on her own terms for a better life. Moreover, each new day brought some improvement in her life, and that brought her closer to having an income from rental rooms!

Before Saturday was over, Neil walked into town to a hardware store and told the hardware man that he wanted to paint a room and asked the man how he should do it. The man patiently explained how he should paint the rooms, doing the walls and woodwork first, and the floors last. He sold Neil some basic tools to work with, like several brushes, solvent, sand paper and scrapers, and a can of primer paint. He carried it all home in a box because it was so heavy. As Neil waked down Central Avenue with his box, he wondered why he hadn't taken the bus because his hands and arms were getting so tired! When he walked in the house, he put the receipt and the change on a counter in the kitchen, then carried it all upstairs and got started on his view room project. He felt good about himself, because he thought he had done the right thing and he knew what to do, thanks to that hardware man!

After sanding and cleaning the woodwork for about an hour, Neil opened his can of primer paint and began spreading it on the woodwork the way the hardware man had directed him to do. Just as the man had said, the paint was covering all the various shades of colors and imperfections and Neil could see that if he took his time and was careful, the room would come out looking very nice.

By the time the light was starting to weaken as the day ended, Neil had painted all the moldings and baseboards and was halfway through his first of two large windows, his mother shouted his name from the kitchen. Neil took a deep breath, dipped his brush once more and laid it on the paint can lid. He wiped his hands and called back that he was upstairs.

"Come down here right now," she shouted back.

Neil came down stairs, wondering what was going on. When he opened the door from the hall to the kitchen, he saw his mother standing looking at the receipts he had put on the counter. She still had her hat and coat on. "What's all this?" she asked angrily. "Did you go out and buy all this without asking me first? What gets into you? Do you think I'm made of money?"

Neil was flabbergasted and just held his hands in the air. He had the impression that his mother wanted him to take an interest in her house and do the work that she asked for. He thought that under the conditions that they were facing, if he could do the job he should try to do it. Neil just stood by the door, feeling his energy and ambition fade away while his mother had her say.

"You know that we don't have much money and that we have to get these rooms rented—or at least one or two of them so we can get the ball rolling," she said.

"I don't know what I did wrong," he answered. "I thought we had to get the rooms painted so we could rent them."

"Yes," Trudy answered. "That's right, but going to the hardware store is the most expensive way to buy the paint! Why didn't you go to the dime store? They have the same thing the hardware store has, but half the price!"

"I went to the hardware store because I needed someone to tell me how to do it," Neil said.

"Don't be silly," Trudy said. "Paint is paint. It's all the same, and you can get it cheaper up at the dime store! Now, here's the receipt. I want you to take it back and get your money back, then go get it at the dime store."

"I can't do that," Neil said. "I've used up half the can of paint, and I've used the tools, too."

"Hell-damn!" Trudy growled. "Don't you ever do that again! Next time you buy your paint at the dime store! I'm not made of money!"

"The man at the hardware store was nice enough to take a little time and show me about painting," Neil commented. "It isn't right to buy the paint in another store."

"I don't care about that!" Trudy said. "You can get all that information at the dime store. They know all about it."

Feeling dejected, Neil went back upstairs and cleaned up his paint brush and put the lid back on the paint can as the hardware man had told him. It was too late to do any more painting. He locked two windows in an open position to air the room, and went out in the hall, closing the room door behind him. The entire upper floor reeked of paint fumes so he went down to a quickly assembled dinner that his mother had put together, took a dollar of his money and went to the movies in Pacific Grove, hoping to get in a different mood for working with his mother the next day.

The following day was Sunday and few stores were open, but Neil managed to stay away from his mother and finished putting the primer paint in the room with the fireplace. When he had finished, the paint looked terrible with streaks and generally uneven coverage but the hardware man had warned him that the primer coat wouldn't look very good. The finish coat should look much better because of the primer that he had painted on. As he cleaned up the dribbles and drops of paint, he wonder what his mother would say if she saw it in this condition. He decided he didn't want to know and finished what he had to do and told his mother he was going down to the beach for a while.

The problem that neither Neil nor his mother recognized was that the last time she had lived with Neil as mother and son was almost two years earlier in Delake. Now, Neil was 13 years old instead of 11, but having lived a year on a ranch, he was fairly mature for his age, and Trudy had not dealt with children of any age, much less a teenager, for two years.

The next morning before going down to breakfast Neil opened the door of the room where he had been working and decided that the paint was dry enough to put a finish coat on. He hated to tell his mother that he needed paint but he knew that he had to deal with her sooner or later. Might as well get it over with, he thought. His breakfast was usually a bowl of dry wheat cereal with milk and sugar and maybe some toast.

"Good morning," Trudy said as she nibbled on toast and drank coffee. "What are you going to do today?"

"Well," Neil said. "I want to finish painting that room. I need paint and I suppose you want me to go to the dime store for it."

"I certainly do," she answered. "I told you that we can't afford expensive paint. What color are you going to paint the woodwork?"

"I was going to ask you," Neil answered as he ate.

"I think you should buy an off-white color. You can ask if they have some kind of cream. I think you should get enough for both rooms," Trudy said.

"After I paint the woodwork, I think I should paint the floors—even the hallway floor," Neil said. "What color do you want the floor?"

Trudy thought about the floors for a minute, and then said, "Something dark to cover all the other colors and something warm. Maybe you can find a dark brown—and both of those should be enamel."

"What's enamel?" Neil asked.

"It's a shiny surface that's supposed to wear well and is easy to clean."

When Neil walked up to Pacific Grove, he walked down the busy sidewalk and was about to turn and go in the dime store when he paused and looked down the street at the hardware store. It was a block and a half farther down, and located on the other side of the street next to an old hotel. Neil liked the man in the hardware store because he had taken the time to tell him about painting, and he regretted that his mother would not let him go back there. He was sure that the man took time with people to build his business. The sign above the window read, "Roy Wright Hardware". Neil would give him his business when he could. He remembered how his uncle would say, "Nobody but a damned fool would treat a man badly who offers to help!" Neil concluded that he didn't want to follow his mother's ways because she didn't seem to appreciate help.

At just 13 years of age Neil didn't understand that he wasn't seeing the whole picture, and that his mother was reacting to the pressure she felt because she was worried that she might not have enough money to get her rooms rented. He had an innate and immature sense of fair play that would get in the way in his relationship with his mother until his mid teens when he began to understand her problems. During those same years, Trudy tended to make decisions that were often influenced by a fear of not having enough money. Consequently, she often bought things that were too cheap, and tried to accomplish things the cheapest

way she could, and never balanced cost against quality. In time Neil saw that there was almost no meeting ground between him and his mother, so he would just do what she wanted, and make suggestions only when they were needed.

Neil bought an off-white enamel paint for the woodwork in both rooms, and a rich dark brown floor paint for the floors and had the work done in three days. When the floors were finished he watched over the work and insisted that no one walk on the floors for days, saying that the paint need to cure. He had noticed that the dime store paint was a fairly good quality, but he never did tell his mother that he bought the premium quality! Privately, he thought that it cost about as much as the paint in the hardware store, but he kept that a secret from his mother, too!

Trudy busied herself with trips to used furniture stores where she located a kitchen table and chairs, a secretary with a fold-up writing table, a bedside table, a larger writing table, and two beds that were just bed frames, springs and a mattress each. She had them delivered the day after Neil finished painting the hall floor. Neil refused to let anyone walk on his hallway floor, so the men who delivered the furniture stacked everything in the artists studio downstairs.

After the delivery, Trudy walked into her empty living room and looked at the sunlight streaming in on the wood floor. "I'm so worn out from looking in furniture stores," she told Neil. "I really need a davenport so that I could have somewhere to relax in that sunshine."

"Okay, when you see one why don't you get it?" Neil said. "Used ones don't cost much, do they?"

Several days later, after Neil thought it was okay to walk on the painted floors, Trudy noticed the walls in the middle room, as she had started to call it. "I don't think I can rent this room," she said. "The wallpaper is terrible. What on earth makes it look so bad?

Neil looked at the wall and had to agree that he would think the room was pretty shabby if someone wanted to rent it to him. The paper was ragged on the edges and even torn near the door. The design on the paper was partly worn away next to the light switch where it had been soiled and wiped clean too many times. "What do we do about it?" he asked.

"I don't know," Trudy said. "Maybe we can paper over it."

Neil looked closely at the wallpaper in the room and saw that it was put up in strips that were about two feet wide and that it was glued on cheesecloth. "I don't know anything about this stuff," he told his mother.

"Well," she said. "It's time you learned. "I want to walk up to Holman's and see what they have."

An hour or so later in Holman's department store, Neil gave the paint and wallpaper clerk the room dimensions and Trudy selected a pattern that she thought would work. The clerk gave Neil some quick instructions on hanging wallpaper

saying, "It isn't very hard to do. Just cut the paper to fit—or maybe leave it a little long and trim it later. Then you paint the paste on the back of it and hang it up, holding it at the top. You stick it on and wipe all the bubbles and wrinkles out with a clean rag. Oh yeah, and you overlap it a half-inch or so, and try to match the pattern. It goes pretty fast."

"What do I cut it with?" Neil asked.

"A single-edge razor blade. We sell them here," the clerk said. "You need something to measure with, a straight edge for cutting, a trough for water, a brush and some paste."

Trudy bought everything, but refused to buy the paste, saying she had it at home. Neil was going to say something but let it go.

When they got home, Neil took everything upstairs and began laying out the wallpaper. He measured and cut the paper where he could see what the lengths were. In the meantime, Trudy stayed downstairs in her kitchen. Neil was almost finished cutting the paper and going over the walls for pins and nails, and whatever else people stick in wallpaper, when Trudy came upstairs carrying a pot of gooey, cooked oatmeal.

"Here's your paste," she said. "See? A man told me how to do this once. It'll save us some money."

Neil stared at the pot of oatmeal as she set it on the floor. The smell of cooked oatmeal filled the room. "You can use it as soon as it cools," she said.

"But mother," Neil said. "I don't think the paste cost as much as the oatmeal."

"It does not," Trudy said in a kind of automatic response, looking at him without expression.

Neil could see that she had not even thought to compare the price. It was just that someone told her it would work. Neil waited for the oatmeal to cool, then painted it on the back of a piece that he had cut that was small and fit on the wall under the window. He hung the piece of paper and smoothed it out in case it did work, then cleaned up and went down to the beach.

The next morning Neil got up, washed and dressed, then poked his head in the middle room to see what had happened to the piece of wallpaper he had stuck on the wall with his mother's oatmeal paste. He had thought about it before going to sleep because the piece he had pasted up would have been out of place. The man who had sold him the paper said that you put up the first piece, then the next one aligned with the first piece so the pattern and seams will always look right. But he was almost certain that the oatmeal paste wouldn't work. So, when he looked in the room and saw his piece of paper lying on the floor he had to smile.

A few minutes later, when Neil walked into the kitchen he saw his mother sitting at her kitchen table eating coffee and toast. "Your paste doesn't work," he said matter of factly.

"We have to go buy some."

"No! Really?" Trudy said with a bite of toast in her mouth. "You mean to say that you put up wallpaper yesterday and it's fallen off?"

"It was laying on the floor when I looked in there this morning," Neil said.

"And here I thought I was going to save some money," Trudy said. "All right, get something to eat and we'll go."

After breakfast, Trudy and Neil walked up and bought paste, then Trudy sent Neil walking home while she took the bus to Monterey to look through the big used furniture store again. Trudy needed to find some used carpets. but she really wanted to find a good davenport to put in her living room. On the bus, Trudy remembered that she had not talked with Rosy since she left the inn almost two weeks earlier and decided to stop by before she did anything. After getting off the bus, Trudy walked over to the inn and found Rosy at a table in her apartment looking at her bookkeeping papers.

"Hi!" Trudy said. "I came downtown to look at the used furniture store but I thought I'd stop and see you first."

"Hello!" Rosy said. "I'm glad you did because I was going to go out right after I looked at this book."

"Do you have time to look at my house?" Trudy asked.

"Sure!" Rosy said. "I was just going to the store and maybe visit friends or something. You know, you get tired of staying in all the time. Only I drive. I can't walk like you do. Were you going to do something else, too?"

"Well," Trudy said. "I came down here to look at that furniture store, too. I need some carpets and a davenport."

"That's right," Rosy said. "You told me that when you came in here. Well, we can stop there, too. Have you gone to the auction place in New Monterey? They get a lot of stuff, too. They get new things every week. In fact, I'll bet I bought half of my furniture there."

"Really?" Trudy said. "Well maybe we should go there."

"It depends," Rosy said. "They don't have auctions every day."

As it worked out, Rosy drove toward Pacific Grove on a route that would pass the auction and a sidewalk sign said, "Auction Today". Rosy parked quickly and she and Trudy crossed the street to go in. Trudy was discovering that she liked to shop and found the atmosphere at the auction very exciting. In forty-five minutes she won the bid on two carpets that were large enough to cover most of the floors of each room, and she bid on a comfortable-looking davenport, two end tables and a table lamp and got those too because she accepted them as a package deal. Trudy was ecstatic. They were just what she needed. What's more, the auction people agreed to deliver everything the next day!

"Come on and look at my house now and I'll offer you some coffee!" Trudy said.

Trudy's House

Rosy parked right in front of Trudy's house, near the front door. Before going in, she stopped for a moment and looked up at the front of the house, then down the side toward the garage. "Life is funny, you know," she said, "I'll bet I've been past this house a thousand times in my life and I always wondered who lived here. Now I know!"

Trudy let Rosy walk in first and asked her to give her opinions. They walked into Trudy's long living room where Trudy wanted to place her davenport, and Trudy watched as Rosy wandered around and looked at things. Then she followed her into the kitchen, and through the kitchen into the maid's quarters where Trudy slept. Rosy looked around a little, then came back out and looked at the kitchen again.

"Well," she said, gesturing toward the maid quarters, "I don't think I would live in there because you're too far from the action. You want to be where you can keep an eye on things and hear things, you know? When you have the time and money, that room where your bed is now could be a good little apartment. You'd have to remodel the bath and make a small kitchen just inside that door back there, and they have their own private entrance. That's a natural."

"What are you going to do with these rooms?" she asked, pointing to the pantry and laundry rooms they were next to the kitchen. "You can't do anything with those, you know. You have to add them to another room somehow."

Trudy led Rosy upstairs and showed her the rooms that Neil had been working in, and the other rooms upstairs.

"Now you're talking. Now you're talking," Rosy said. "Oh, boy! You've got the views! You want to rent the room with the fireplace first, then the one next to it?"

"Yes," Trudy said. "I thought I'd rent the easiest ones first to get some money coming in, then start on the harder rooms to fix up."

"Sure!" Rosy said. "That's the way. Who's doing your work?"

"Oh, my son." Trudy said. He's in that other room hanging wall paper right now."

"He is? Cheez, Trudy! You're lucky to have someone in the family who can do this stuff!" Rosy said. "Now, what do you have in these other rooms?"

Rosy looked in the large front room over the front entrance. "Trudy, this is ideal for two people who aren't a couple. You know, two sisters or two men, or who ever because you have lots of room and two closets. When you furnish it, I think you should have two beds in here and some kind of room divider. You know, two of everything. Too bad it doesn't have its own bathroom."

Trudy led Rosy across the hall to the added-on wing and showed her the long "verandah" room, as Trudy called it, and the other room with its own bathroom.

"Another big room with two closets," Rosy noted. "Too bad you can't make two rooms, but I don't think that could be done. But this room has it's own bath!"

"Come on down," Trudy said, "I want to show you another room."

Rosy followed Trudy down the steps to the artist's studio room. "Oh! Trudy. What a room—but no bath! There's no bath in here? Well, wait a minute. Where are those rooms off your kitchen? You have one on the other side of the wall—right. It would be a job, but I'll bet you could put a bath in there. Hey! Your stairs are doing me in. I think I need that cup of coffee and then we can talk about this."

Later that afternoon after Rosy had gone, Trudy sat down to make notes to herself about the things that Rosy had told her. As she sat the doorbell rang and Trudy rushed to answer it. When she opened the door she found a slender, clean-cut middle-aged man standing before her. He took his hat off revealing a graying, balding head when she opened the door.

"Mrs. Anderson?" he asked.

"Yes?"

"I've just come from the Forest Avenue Realty, and the lady I talked with said that she thought you might have a room to rent."

CHAPTER EIGHT

Trudy stood looking at the man through the screen door until he began to look for another way to greet her. Trudy finally collected her thoughts saying, "Well, yes. I'm Trudy Anderson and I rent rooms—but, I won't have any to rent for several days yet. I—I mean, they're not really ready yet. Come on in and I'll show them to you."

The man came in the bare room and looked at her as if he wanted to question her. Trudy noticed his quizzical expression as they walked across the room to the hallway door. "I've just bought this house and you're the first one to see all this since we started fixing it up. We're just getting two rooms ready now before we start on the others."

"That's what the lady at the real estate office said," The man said. "From the looks of things you're going to be busy for a while."

Trudy led him upstairs to the rooms that they had been working on and showed him the one where Neil had been working on the walls. Trudy was surprised to see that Neil wasn't there, but that the papering had been done.

"This looks nice," the man said. "Will it be furnished?"

"Oh yes," Trudy said, "in fact until a little while ago my son was working in here fixing the walls."

The man looked around and said, "Everything looks okay. Maybe a little trimming here and there."

"Well," Trudy said, clearing her throat, "this room will have a carpet and a table, a bed and a chair, and I'll furnish the linens."

"Okay, and how much is it?"

"I was thinking of asking $8.50 a week without kitchen privileges."

"I don't need kitchen privileges. I work as a baker," the man said.

"Are you planning to have a better rate if I rent by the month?"

"Well, yes," Trudy said," I think so."

103

"I believe they usually figure four and a half weeks in a month, so that's—what—about $38.00?"

"Oh, golly," Trudy stammered. "I'm terrible at arithmetic. I'll have to sit down with a pencil and paper. Let's see, if I reduce it by six dollars that would make it about $32.50. Does that sound all right?"

"Certainly," the man said. "There is something else; I go to bed very early because I get up at three in the morning to go to work. Will that be a problem?"

"I don't think so, but I'll be sure to let the other tenants know," Trudy answered. "I'd like you to print your name in my book downstairs. Oh, and the bath is here just across the hall."

The man followed Trudy back downstairs and Trudy watched as he printed his name and contact information in her book, and wrote a check for $32.50. She was so pleased with everything that she felt like telling everyone that she got her first tenant.

"When will the room be ready?" he asked.

"I think we should have everything ready in about three days," Trudy said, turning to read his name. "Herbert Knight. Thank you, Mr. Knight!"

"Certainly,' he said. "And, will that side door be for the tenant's use?"

"Oh!" Trudy said. "Yes, and we'll have the furniture in and everything should be ready for you. I'll give you keys then, too."

Trudy watched Mr. Knight go out and get in his car. It was a fairly new car by wartime standards, and it seemed very well maintained because it was clean and polished. As he drove off, Trudy went back upstairs with her note pad to see what she needed to buy. She had to get Neil to finish his papering job, which seemed almost finished, and she had to get the furniture in the room and curtains on the windows. Then, she walked around the house looking for Neil.

Trudy strode around the house impatiently, searching for her son and feeling certain that he had run off to the beach again just when she really needed him. Finally, after a half hour or forty-five minutes had passed, Trudy went to her kitchen to get a cup of coffee and plan the things she needed to buy the next day. As she sat drinking coffee, she noticed that the house had become very quiet. Then she heard someone, somewhere on steps. The door that led to the laundry room and basement from the kitchen opened and she jumped with a start, nearly spilling her coffee. "What on earth!" she cried.

It was Neil, who had gone into the laundry room to wash his paper hanging tools and dump the unused paste out. Then, curious, he had gone down the steps into the part of the basement that he could get to from the laundry room to see what was there. The furnace and oil tank were in the newer half of the basement that was under the east wing of the house.

"Boy!" he said. "I've been wanting to see what was down there. Have you been down there? That's a scary place with a lot of dark corners. Nothing much is any

good though. What's down there is dusty and full of rust. I'll bet any metal this close to the bay will rust no matter what you do." He looked at his mother for a minute and said, "What's wrong?"

"Ooo! You scared the life out of me! I thought you were down at the beach."

Neil shook his head at his mother's tendency to frights. "Who was here? I heard a man's voice."

"Well," Trudy said, "Madge sent a man down here and I rented the middle room to him."

"Great!" Neil said. "I need to finish trimming and then we can put the furniture in there."

"I tried to find you earlier because we still need to buy a few things, but I guess there wasn't time anyway. We need to put a window blind in there and hang some curtains, and I haven't bought any yet."

"You need locks on the doors, too" Neil reminded her.

"Heavens!" Trudy exclaimed. "I forgot all about that! Can't you do that?"

"Mother," Neil said. "You have to get someone to do that. I don't know anything about it and I don't have any tools. Before you think about getting me the tools, I think you ought to think about it. It probably costs more for the tools than it would to have someone install the locks for you."

Trudy looked at Neil, tightened her lips and shook her head.

"Mother," Neil said, knowing what her expression meant, "you can think whatever you like, but I can't do it! I wouldn't even know how to start."

"Well," Trudy said, "We'll have to get going early tomorrow and see what we can get done."

Trudy slept well that night and awoke the next morning feeling refreshed and ready to deal with the day. Renting her first room amounted to a culmination c⸱ all that had happened since she had lived in Delake on the Oregon coast a year ago. Things that had seemed so hopeless before were finally happening. She remembered how she had wondered at the time if her plans were all a dream. Impatiently, she had wondered if she was able to do anything for herself. Now, she had a room rented and things seemed to working in her favor!

Trudy dressed quickly with the intention of going out early and getting what she needed for the rooms. When she opened the door to the kitchen, she was surprised to find Neil sitting at the table eating his way through a bowl of *Pep* dry cereal and milk.

Now that she had experienced how quickly a room could be rented, Trudy was a little more inclined to invest a little money in the things she needed. For instance, she knew that Montgomery Ward had sales on rebuilt sewing machines and bedding and she needed both. She and Neil could go to Wards in Monterey that morning and be home in time to meet the truck from the auction in the early afternoon.

"Good morning, Mister!" Trudy said in a tone that suggested that she felt good about everything, which was in contrast to her moods of the past few weeks.

"Mornin'," Neil responded, unsure of her mood.

"We'll have to go down to Monterey when you're ready," Trudy said, making herself some toast and coffee. "I have to buy a few things and I'll need your help to get them home."

"There's something in the paper that says that school starts in P.G. and Monterey on Monday, the 13th, Neil said. He had learned some of the local expressions for places and things. P.G. was what everyone called "Pacific Grove." "Sometime," he continued, "I'll need shoes and some school stuff."

Trudy's mood stiffened a little. "What's wrong with the shoes you have?" she asked.

"I'm wearing the boots I wore in eastern Oregon!" he said. "They're worn out and they're beginning to hurt my feet."

"They are not," Trudy said as if she were stopping a rumor. She could see a greater drain on her money coming up. "You know, shoes are rationed now. Show me where they hurt you." She said, hoping to stop the drain for at least a week or two.

Several hours later, Trudy and Neil were riding back to Pacific Grove on the only public transportation available, which was the Bay Rapid Transit Company bus that ran one of two routes to P.G. from Monterey. At two to five miles, depending on where a person wanted to go, it was a little too far to walk, and certainly too far if you had a lot to carry as Trudy and Neil did. The nice thing was that Trudy's house was only a block down hill from the bus top.

Trudy and Neil got off the bus with several large paper bags and a heavy box that Neil carried down the hill to Trudy's house. It was a half-price sewing machine that Trudy had decided she really needed. They arrived home in time to have lunch and be there when the men arrived with Trudy's auction purchases.

Trudy had the davenport, table and lamp placed together in her living room where the sunshine streaming through the course of west-facing windows would fall on it. Trudy saw that as her sanctuary. It would be a place to relax on warm afternoons. It would be a place to think about where her life was going, and where it had been. It would be a place where she could sit down with a cup of coffee, read the afternoon paper, and daydream if the mood struck her.

Trudy had the carpets laid down in the two rooms upstairs, and she and Neil worked most of the afternoon moving furniture upstairs and into the rooms. When they had finished, Trudy looked at the rooms and discovered that she still had to buy a chest of drawers for each room. She decided that she would go to the used furniture stores in the morning and try to find two chests of drawers. She would have Neil begin painting the bathroom in the morning, and after that, she wanted the large room over the front of the house fixed up to rent.

106

Before she went down to fix dinner, she found Neil studying the bed in the room with the fireplace. "What's wrong?" she asked.

"I've never seen beds like these before," he said.

"What's wrong with them?"

"There's no head or foot on them," he said. "Aren't you supposed to have a head board and a foot on the beds? What holds them up?" he said.

"That's something new," Trudy said, fibbing to hide her thriftiness. "It's called a Hollywood style bed. The springs and mattress just sit on a frame with castors on it."

"How do you keep the pillows on the bed?" he asked.

Trudy looked at the bed and couldn't understand what he was talking about. "Never mind that," she said. "It's time for supper."

The next morning, Trudy was out early and walked to Pacific Grove and found two chests of drawers in a used furniture store near the city hall. After buying them and arranging for the delivery, she went to the dime store to have shades made for the room, then walked to Holman's to buy material and hardware for drapes on the windows.

By the time she had returned, Neil had cleaned most of the bathroom walls for painting, and was busy sanding down the bad parts. He had heard his mother come in and was thinking about stopping for lunch because he could get a lot of the bathroom painted that afternoon, and finish it the next day. He knew it had to be done before the rooms could be rented. As he was putting things down and getting ready to wash up, he heard his mother open the door from the kitchen and call upstairs, "Neil! Come and have your lunch!"

Trudy had discovered that she had a penetrating, loud voice and found out that it was much easier to step out of the kitchen and call up the stairs to get Neil than it was to go look for him. She had learned from experience that it seldom mattered whether Neil was upstairs or in the basement, when she called up the stairwell, he would hear her. Neil thought she had a penetrating voice, too, and found it irritating to be called that way, particularly when her voice was so loud. He wondered what would happen when she had tenants.

Shortly after they finished lunch, a telephone company truck pulled up in front of the house. An older man dressed in neat work clothing got out, pulled a few things out of the back of the little truck and walked up and knocked at Trudy's front door. Trudy and Neil had seen him drive up and were watching him from her kitchen window. When Trudy answered the door he told her who he was and that he was there to install a new telephone. In 1943, telephone companies provided the telephones and leased them to their customers. While the man went down in her basement to hook up the telephone wires, Trudy looked through the paper work the phone man had given her and Neil thumbed through the new phone book. When the phone man left a short time later, Trudy

had a working telephone, and she felt that she had passed another milestone on her goal to renting rooms.

That afternoon Trudy retired to her davenport to relax in the afternoon sunshine—if there was any! Rosy had told her about the year around weather in Pacific Grove, which was really very pleasant if you were used to weather in other parts of the country. But in Pacific Grove in the summertime, Trudy found out that as the temperature increased inland a fog bank was created on the coast. So for the summer months Pacific Grove often had morning and afternoon high fog. In mid-morning the fog often rolled back to a point about even with the downtown area, giving Trudy sunshine, then rolled back in late in the afternoon.

Trudy was disappointed when she learned about the fog, but tolerated it when she also learned that the fog usually disappeared in September and didn't return until the following May or June, depending on the weather inland. Sometimes "inland" was only ten miles or so! The local people were unconcerned about Pacific Grove's summer fog. They considered it to be nature's air conditioning!

Anyway, Trudy relaxed on her davenport for the first time. She placed her coffee cup on the little end table and sat down, letting herself sink into the comfortable cushions. There was even enough sunshine coming in to create the effect that Trudy had wanted. Trudy sipped some coffee and closed her eyes for a moment and thought about something that Madge had said in one of their conversations. Madge could not understand the difficulty in getting a telephone installed. Since the war had started it took weeks and months for some people to get telephone service in their homes and Madge said that she had heard lots of complaints. She finally confided to Trudy that she thought the delay was a ploy used by the phone company to avoid installing and disconnecting telephones on short notice since families with the military were often in the area a short tim :.

After a short but relaxing trial with her davenport Trudy got back to work putting the finishing touches on her rooms and trying not to interrupt Neil who was getting the bathroom painted. Sometime in the middle of the afternoon Trudy telephoned Madge to let her know that she had a phone and to give her the new number. Madge had a little extra time so she hung up to come down and see the progress that Trudy had made.

When Madge arrived a few minutes later she walked through the house with Trudy. Madge was impressed with their progress and gave Trudy a few ideas on how to rent her larger rooms, like Rosy had. Madge advised Trudy to keep all her receipts in a box and write down all the money she takes in and all that she spends so when tax time comes around Trudy will have something to show a bookkeeper.

By the end of the day, Trudy and Neil were both exhausted with all the little details that they had taken care of. Towel racks had been installed. Beds were made and towels were laid out on the beds. Neil had painted most of the bathroom,

and Trudy had made narrow decorative drapes for the windows. Neil would put up window blinds in the morning, and Trudy tried to remember how to show the rooms and deal with rent so she wouldn't be embarrassed by the next person who came to the door.

The next morning Trudy ate her usual toast and coffee and a half of a grapefruit. As she ate she was thinking that she was really ready for business when the doorbell rang, startling Trudy so much that she dribbled coffee on her table.

Trudy peeked outside from her kitchen window and seeing nothing, she walked quickly to her front door and opened it. She found herself face to face with an older woman with a broad smile on her slightly wrinkled face. "How do you do?" the woman said with a pronounced English accent.

"I'm Miss Elizabeth Wembly. Is Mrs. Anderson in please?" she asked politely.

"Oh!" Trudy exclaimed, caught off guard by the woman. "Yes! I'm Mrs. Anderson."

"How do you do, Mrs. Anderson," Miss Wembly said. "Mrs. Flynn at the Forest Avenue Real Estate office informed me that you might have accommodations to let. I'm inquiring, please."

"Uh, oh!" Trudy hesitated. "You're asking if I have a room to rent. Yes, I've just finished getting it ready. Would you like to see it?"

"Yes I would, thank you," Miss Wembly said.

Trudy opened her screen door to let Miss Wembly in. "Come on," Trudy said. "I'll have to lead you through my bare living room to the inside hallway. It's up these stairs."

"Quite all right," Mrs. Anderson. "I understand that you are just now turning this house into rental rooms. I'm sure it takes a lot of time."

"And money!" Trudy added. She noticed that Miss Wembly climbed up the stairs easily. "Around this way, and this is the room."

"Oh my!" Miss Wembly exclaimed. "What a lovely view!"

"The bath is just across the hallway," Trudy said. "At the moment, I just have the room next to this one rented. We'll be working on the room at the end of the hall next, so in time there might be one or two more people using the bathroom.

"Quite all right," Miss Wembly said. "I've been in service for nearly fifty years so I'm quite used to sharing."

"In service?" Trudy asked, puzzled by the expression.

"Yes!" Miss Wembly said. "I've been a private tutor all my working life!"

"A private tutor?" Trudy repeated. "Is that like a private teacher?"

"Yes," Miss Wembly replied. "Just the same. What about kitchens? Do you offer kitchen privileges?"

"Yes," Trudy said. "I realize that most people would need that, but you're only my second tenant, if you rent here, and I really haven't thought about it yet. I have a large kitchen downstairs and it wouldn't be a problem for me to allow kitchen privileges. I guess I just haven't thought about what I need to do."

"I see," Miss Wembly said. "I believe all I would need is a small cupboard—or, even a part of a cupboard—to keep my utensils and a few things in. I certainly wouldn't have company or guests, so just a place for my needs. I understand that some landlords schedule a time for the lodgers to come for their food, but that would be up to you. As for costs, my last landlord charged me two dollars fifty a week."

"I think I've heard that amount, too," Trudy said. "That would be all right."

"Now, as far as the rent is concerned, I'd like to point out that I am permanent here, unlike the military who come and go all the time. I pay the rent on time and the room will always be occupied, and I can give you references."

"Oh, well, that will be okay," Trudy said, not really sure why Miss Wembly was telling her all that, but she had a suspicion that she was looking for a little cheaper rent, which she was planning to offer anyway. "The rent for this room will be ten dollars a week, and we'll try the kitchen privileges at two-fifty a week."

"Well!" Miss Wembly said. "Yes then, I'd like to rent the room. Oh! By the way, do you have a cover for that fireplace? The room would be cold without one."

"I'll have my son find it. I asked him to take it away the other day." Trudy said. I'd like you to give me some information. You can print it in my book downstairs."

"Of course," Miss Wembly said. "When can I take the room?"

"Well, let me think a minute," Trudy said. "We're going to have a chest of drawers delivered and we still have to have window blinds put up, and the fireplace cover. Oh! I have to have a man put locks on the doors. I'd say in three days or so. When is the best time for you, and I'll start the rent on that day, too."

"Oh my," Miss Wembly said. "How very kind of you!"

"I can tell that you're English," Trudy said. "I was born in Canada and I used to hear English accents a lot as a kid."

"Yes!" Miss Wembly said. "I was born near Sheffield in the midlands. Have you been?"

"No," Trudy said. "I've never been anywhere. I'd love to go traveling someday."

"Oh my," Miss Wembly said. "You're still young. Perhaps one day you will!"

After Miss Wembly had left, Trudy went back in the kitchen to finish her toast and coffee. Cold coffee was as good as hot coffee to Trudy, and she was often seen drinking cold coffee. As she sat at her table, munching her cold toast, Trudy began to relax a little and thought that she and Neil needed to get her other rooms ready because she had rented two rooms in a month! How she wanted to tell that to her cautious sister, Jean! She was elated, but also felt like she was

110

missing an opportunity to earn more money by not having all her rooms rented! The idea made her feel apprehensive, or anxious, and she realized that she had to contain her feelings or she would be riding Neil too hard.

After finishing her cold breakfast Trudy told Neil she would be out for a while and walked down to the lumber yard that was located six or eight blocks back toward Monterey, and talked to the man at the counter. "I bought a house down the street," Trudy said, "and I want to rent rooms but they tell me that I need to put locks on the doors. Do I really need more locks when the doors already have skeleton locks? Isn't that good enough?"

"You need real locks on the doors, Ma'am," the counter man said.

Trudy reluctantly made arrangements for a man to come down and do the work. It was an expense that she hated to pay out, but it seemed to be necessary.

Trudy went home after making arrangement for locks and telephoned the only ice company in the phone book and asked about something Miss Wembly had told her—that they sell iceboxes and have regular ice deliveries for people who cannot buy refrigerators. The ice company informed her that they rent iceboxes that look like refrigerators and that they provide regular ice service. Trudy ordered the service and an icebox, relieved that another problem was solved.

After lunch Trudy allowed Neil to go down to the beach for an hour or so, then come back and do more work on the large front room upstairs. While Neil was down at the beach, Trudy retired to her davenport to drink another cup of coffee and do some reading. In a short time Trudy came to appreciate the time spent on her davenport as a place where she could read in peace and quiet, take a nap, relax in the warm afternoon sunshine, or do her best planning. The davenport would indeed become her retreat from the world.

Several days later on a Sunday, Trudy got up early expecting that Mr. Knight and Miss Wembly would be moving in sometime during the day. Trudy dressed and went upstairs to look things over. She wanted to be sure that she had not forgotten anything because the past few days had been so busy that she had not had time to look at the work that Neil had done, and she had not had time to look at the lock work that was done. She had the man put locks on all the doors of the rooms that she intended to rent, and looking at them, she thought he had done a good job. The man had even cleaned up his own sawdust and wood shavings. She could see how Neil thought the work was too much for him.

As Trudy walked into the big front room she realized that she still had to make some drapes or curtains for the windows. The large center section of each window had a shade that could be pulled down, but there were two narrow end sections and several smaller windows that had no shades and needed something. Trudy also noticed that the door hinges squeaked on all the doors and that two

of the window hinges had rusted so badly in the salt air that she could hardly open them.

"Neil!" Trudy called out in her loud voice. "Neil! Come up here!"

Neil opened the hall door to the kitchen and called, "What is it? I'm eating breakfast."

"Come up here, now please. I want you to look at this right away!"

Thinking that his mother needed help, Neil trotted up the stairs.

"Look at this," Trudy said. She swung the door showing him how it squeaked. "Now come in here," and she showed him the rusted hinges on the window.

Neil looked at her and said, "I was eating my breakfast. This could have waited. I was going to do something about them, but it doesn't have to be done now, does it? What's going on?"

"Listen to me," Trudy said impatiently, "Mr. Knight and Miss Wembly will be moving in sometime today. Mr. Knight goes to work at three in the morning and he goes to bed at seven or eight in the evening. "We'll have to think of them and be quiet."

"Well, I should still be able work during the day," Neil said. "You know," he added, "I don't think you should yell up and down the stairway like you do because I can hear you all over the house. That would really bother the tenants."

"All right," Trudy said. "I'm glad you told me. Now be sure to fix the window and the door hinges sometime today. Now go finish your breakfast."

"Mother, if you want me to do very much of this stuff I'll need some tools—and I still need shoes," Neil said feeling miffed because his mother had taken him away from eating his breakfast when she could have told him later, and because he had mentioned new shoes days before and he still wasn't getting them, yet, she was getting what she wanted because of his work. While he was too young to identify problems in dealing with his mother, Neil was coming to the conclusion that she operated more on emotions than with logic.

Miss Wembly arrived by taxi later that morning. Neil helped the cab driver get Miss Wembly's steamer trunk up to her room while Trudy held the door open for them. After all her luggage was placed in her room, Trudy invited her down to have a cup of coffee and relax for a while. Besides, she was curious to know how Miss Wembly got along at the present time.

"Oh my!" Miss Wembly exclaimed when she saw Trudy's kitchen. "This is a lovely kitchen! It's big isn't it?"

"Yes," Trudy said, offering Miss Wembly a chair and putting a plate of cookies on the table. "I like it, too. Of course, I guess we grew up with large kitchens—didn't you?"

"I had two sisters and a brother," Miss Wembly said, "so, at times it seemed a bit crowded if we were all in there together."

"This is still real coffee," Trudy said. "I just bought it at the Safeway in New Monterey the other day. It was only thirty-two cents a pound there."

"They're talking about rationing it, you know," Miss Wembly said. "It won't matter, because I've already gotten used to Postum, so it's a real treat for me to have a cup of coffee!"

"How interesting!" Trudy laughed politely. "Since you're English, I would have thought that you'd prefer tea."

Oh, I still love a good hot cup of tea," Miss Wembly said. "But I lived in France for such a long time that I got used to a good cup of coffee, too!"

"France!" Trudy said, seeing a chance to learn something about Miss Wembly. "My goodness! You lived in France? Which part?"

"Just outside Le Mans. I worked as a tutor for thirty-three years for a lovely family. We lived in the country on a large estate. The French countryside is magnificent there. I tutored their children and their grandchildren, and I would have been quite content to stay there."

"Heavens!" Trudy exclaimed. "Why did you leave?"

"I'm afraid that wasn't entirely my doing," Miss Wembly said with a shrug. "My employers saw the war coming and they knew the Germans would be there in no time, so in 1939 they sent me to America. They thought France and England were lost."

"So," Trudy asked. "Do you do tutoring over here?"

"No, since I've been in this country I've been a professional baby sitter."

"Golly," Trudy said. "Babies! They'd have to carry me away in a straight jacket if I had to look after babies all the time!"

Miss Wembly smiled at her. "Well," she said. "We all have to work, don't we? There seems to be a demand for a good, responsible baby sitter. I'm capable, so that's what I do. Actually, I'm quite used to it and don't mind the work at all.

"By the way," Miss Wembly continued, "I'm often out until late at night, and there are times when I spend a week-end at one of the parent's houses when they have a large gathering of some sort, but I'll let you know if I'm going to be gone for any length of time."

"Oh," Trudy said. "That's a twist." Trudy went on to tell Miss Wembly about Mr. Knight's hours. She made a mental note to tell Mr. Knight about Miss Wembly, too.

"I should also tell you that they always come by and pick me up, then drive me home at night, so you won't have to concern yourself with my safety," Miss Wembly said. "But, would you mind if I gave them your telephone number in case there are any scheduling changes? I think I can promise that they won't bother you often, but when they do perhaps you could just write down the information on some paper and slip it under my door."

"Sure," Trudy said. "That won't be a problem for me. I think that there will be a lot of that sort of thing when I get military people in here."

Trudy had decided that she liked Miss Wembly, which was a good thing because Miss Wembly would rent her room for many years to come.

The next day was Monday and Trudy sat at her kitchen table with her usual coffee, toast and grapefruit half, expecting Miss Wembly to join her at any moment. When she didn't Trudy realized that she probably had not had a chance to bring her things down to the kitchen, and was still unpacking in her room. In the meantime, Trudy thought about the day ahead and all the little things that had to be done. Neil needed some tools and she knew that she'd have to buy him some shoes. She had seen an ad in the paper for a sale on shoes at Montgomery Wards in Monterey with prices starting at $6.50 a pair. She would take him there and maybe look at socks, too.

A large truck pulled up in front as Trudy was cleaning up after breakfast. Trudy looked out her kitchen window and saw a "Union Ice Company" sign on the side of the truck. Realizing that they were already delivering her icebox, she rushed to the back door at her own quarters, thinking that would be a good place to bring the icebox in. She caught the deliveryman as he got out of his truck with a handful of papers and asked him about the best location for the icebox. After looking through her kitchen he suggested that she put the icebox in her pantry where it would be cool and out of the way. Trudy read through the papers he had handed her while the deliveryman went back to his truck for the icebox.

Trudy looked up from her papers as he brought the icebox up the steps on a hand truck. "My Goodness!" Trudy exclaimed, looking at the large white icebox. "Is that a refrigerator that you're bringing me?"

"No Ma'am," The man said as he struggled through the door. "They don't make the old wooden iceboxes anymore. I think they want them to look like refrigerators so people will be comfortable with them and feel like they're living in the modern world."

When the man stood the icebox where he wanted it he showed Trudy how it opened and closed, and where the ice went. Trudy knew about iceboxes so she half-listened while she looked at the icebox. It looked a lot like the refrigerators that were made before the war, because it was shiny and white and had one big door on the front with a refrigerator-like latch and handle.

Within an hour Trudy had her food in the icebox and she felt like she jumped another hurdle in getting her house ready to live in. In this case, however, the ice was delivered twice a week and she had to give the iceman a key to the door.

Perhaps the worst thing about an icebox was that it held people to a schedule in that someone had to empty the drip tray every day. The icebox and the deliveries weren't a great imposition on Trudy's life because she had dealt with ice boxes most her life. However, she also realized that with other people using the kitchen,

she really needed to find a refrigerator somewhere, and with the war restrictions new refrigerators simply were not available, and when used refrigerators were repaired and put back on the market they sold like hotcakes.

Labor Day was on Wednesday and both Mr. Knight and Miss Wembly had moved in. Mr. Knight had forgotten to tell Trudy that his weekend was on Monday and Tuesday of the week. On Thursday, Trudy's priority had shifted to getting Neil ready for school so they both took the bus to Monterey and bought his shoes. Neil tried to talk his mother into a few more clothes, but they came home to get Trudy's big front room ready to rent.

Without knowing a thing about them, Neil spent Friday working on door and window hinges and latches to get the rust out of them and make them stop squeaking. He discovered that the pins that joined the two halves of a hinge could be taken out easily. He sanded the rust off and put a coat of oil on the pin and put it back. He was surprised that he had fixed the problem, but he also knew that the salt air from the ocean would make them rusty again in no time. What he needed was something heavier than oil, but he had no idea what he could use that wouldn't make a mess.

Before noon, Rosy stopped by to coax Trudy out to lunch. Before they left Rosy came upstairs to see how things were going and saw Neil working with hinges. "Hey," she said, "my father was a carpenter and he told me things about keeping a house up, you know. He said that you always put a little Vaseline—you know, like petroleum jelly—on hinge pins and latches and they never give you problems."

"Oh yeah," Neil replied with a smile. "I'll bet that would work. Thanks!"

Neil ran down to the bathroom and found a small jar of petroleum jelly and ran back upstairs to lubricate all the hinge pins and door latches. He had a bigger problem with all the windows because they all had two smaller windows on either side of a larger central one. The smaller windows would open and be locked in place with a thumb screw on a metal rod. He tried to clean the rust on the rods but they were exposed to the outside air and rusted quickly and nothing seemed to be able to prevent the problem. Neil tried sanding and painting the rods, but the set screw would break through the paint and the rod would get rusty again. Years later when they could afford it, he replaced the window hardware with brass and stainless steel hardware.

Trudy tried to get Neil to do more work getting the rooms ready, but soon realized that he had to get ready to start school, and she was discovering that 13 year-old boys would not put in a days' work like a man would.

Neil stopped working on the house on Sunday so he could get himself ready for school. He had to think about registering for school because he knew his mother wouldn't bother. He had to find the school and learn his way around the area before he started. Neil was only entering the eighth grade but he really

didn't know what to expect in a California city school after attending a tiny rural school the previous year. He had ridden a horse to school every day in Oregon, and put his horse up in the school barn for the day with the other horses that had been ridden to school.

There weren't enough kids in the entire school to play games during recess, and there was no space for a playground, anyway. Instead, the kids talked about farm animals, and problems on the farm, or saw to their horses in the barn. Neil was fairly certain that school in Pacific Grove was not run the same way! He imagined that recess activities would be like they were when he last went to a large school on the Oregon coast.

Trudy had put out a "Room for Rent" sign on Sunday morning and had several inquiries before the churches let out and filled the street with traffic. Most of the people were looking for rooms with kitchenettes, small apartments, covered off street parking, etc., then a thin little woman came to the door asking to see the landlady.

"Yes?" Trudy said. "I'm the landlady. I'm Trudy Anderson. Can I help you?"

"I saw your sign and I thought I'd see what you're renting." the woman said.

"Yes," Trudy began, clearing her throat. "I have a large room that's right above us. Would you like to see it?"

"Yes Ma'am. My name is Wilma Fristler," the little woman said as she followed Trudy across the living room and up the stairs. "Actually, I'd like to rent a small apartment if you have one."

"I just have this one room for now," Trudy said. "But it's a pretty big room."

"Yes, Ma'am. I'd better have look anyhow because I'm discovering that any kind of room is hard to find around here. It might be better than the one I have now."

Trudy stood by the doorway as the woman walked through the room, looking out of the windows and studying the space. Trudy had furnished the room with a double bed, several straight back chairs, a used writing desk, and a few small rugs, but the room looked almost empty because of its size.

"You know," the slender woman began in what Trudy took as a southern drawl, "I like this room. It's light and airy, but I have one problem, and that's why I've been looking for an apartment. I have my 16 year-old son with me and we're expecting my husband to be rotated back to Fort Ord sometime soon. Is there any chance you could put a single bed in on the other side of the room with some kind of screen for privacy?"

"Yes," Trudy said, wondering what she should do. "I'll tell you what; give me a day or so to see what I can come up with. Can you stop by or call me back tomorrow or the next day?"

"Yes I can," the little woman replied. I hope you'll remember my name—Fristler—because I like this big room."

Trudy's House

Trudy spent the next day searching through the used furniture stores for a screen and nobody had anything like that. She did locate an almost new single bed at one of the stores in Monterey and the man had a free-standing bookcase that was three shelves high and four or five feet wide, so she bought both and arranged for the man to deliver them for her. Finally, Trudy phoned Madge and explained that she had searched all over for a privacy screen.

"Well," Madge chuckled, "you can stop looking. I have one I'll give you! You'll have to cover it though. I'll bring it over later this afternoon. But you know, Trudy, I would be careful about going out on a limb for a prospective tenant, unless it's someone you know or they've made some kind of commitment to rent. Renters are notorious for not following through."

"Well, yes," Trudy said. "I thought about that but then I could probably use the furniture somewhere else in the house if they didn't come back. I appreciate your advice though, Madge. I have so much to learn about renting rooms!"

Wilma Fristler did return the next day and she did rent the room leaving Trudy and Neil just a day or so to get everything ready. Trudy worked hard making curtains for the windows and cutting denim fabric to cover the privacy screen that Madge had given her. By the end of the day, the room was finished and Trudy retired to her davenport to relax before nightfall and drink a cup of coffee. As she sat sipping her coffee, she heard Neil's footsteps above her as he moved through Fristler's room. She knew he was gathering up all his tools and cleaning things and moving them across the hall to the other big room in the east wing, which is where he was going to work next. The Fristlers would be moving in tomorrow, she thought, and she'd soon be used to hearing movement upstairs.

Trudy walked out into the hall where the stairs were to call Neil for dinner, but thought better of it because she remembered that she had tenants. Just then, Neil came out of the east room at the top of the stairs and Trudy motioned for him to come downstairs. He started to close the door to the empty room, but as he did the entire hallway went dark. Trudy had been in the habit of leaving the upstairs doors open to light the hallway and stairs, but with tenants the doors were closed and when Neil closed the last one the entire upstairs hall was dark.

Trudy had never explored the hallway lighting but flipped a switch by her living room door and a light went on the ceiling over the top of the stairway. She left it on and Neil came down to clean up and have dinner.

"We'll leave that light on 'til ten or eleven o'clock," she said. "Then turn it out for the night."

"I don't think you can do that, mother," Neil said. "It's pitch black at night up there and you have people living there. I'll bet there's some law that says you have to keep the light on."

Trudy looked at Neil and thought about his comment. "I don't think they need a light at night," she finally said. "All they're doing is going to the bathroom and

they have light in their rooms and the bathroom, and they're only going across the hall. It would cost me a fortune to leave a light on all night in the hall."

"Okay," Neil said, "what about Miss Wembly coming in late at night, and Mr. Knight going to work at three in the morning? They sure need a light to get down those stairs."

Trudy sat quietly for a moment before answering. "I'll think about it," she said at last.

"Yeah, and while you're thinking about it, think about getting sued and losing everything because one of them fell down those dark steps!" Neil retorted. "Gee whiz, mother! You have to have a light in the hall!"

"Well, I can't do anything about it tonight!" Trudy snapped. "I'll look into it tomorrow."

"Okay," Neil said. "While you're out, I need some stuff for school. I went up and registered yesterday and they wondered why you weren't there. All the other kids went with one of their parents."

"What?" Trudy said. "What did they need me for? You did it didn't you?"

"Yeah," Neil said, "but I need a notebook, some pencils and stuff. Can't you just give me some money and I'll go get it."

"Don't they give you all that in school?"

"No," Neil said. "We buy our own stuff and they furnish the books. Oh, and I'm taking a wood shop class and I'll have to give them some money for insurance and supplies before I start."

"My Goodness," Trudy said. "It certainly wasn't like that when I was in school. Well, talk to me about it tomorrow. We'll have dinner now."

CHAPTER NINE

The next morning Trudy left Neil working in the large east room while she walked up to Pacific Grove to ask Madge about keeping a light on in the hallway. Most people would probably have shrugged and left the light on, reasoning that with people living in the rooms the lighting would be a necessity. After all, who could predict who might have to use the stairs at night—and it was already known that Miss Wembly and Mr. Knight did! But Trudy had slept badly after talking with Neil about the hall lighting. She could visualize an electric bill that she would dread to see each month because of lights burning all night. She was beginning to be penny-pinching without the sense of planned economy. Some would use the old saying of "penny wise and pound foolish".

Trudy stuck her head in Madge's office door and asked if there was some sort of law about keeping the hallways lighted.

"Good God!" Madge exclaimed. "Trudy, that property was laid in your lap like a gift from above. Don't jeopardize it! If I were you I wouldn't worry about a little thing like lighting. Listen, you can get small bulbs at the store that hardly make a change in your electric bill and they give enough light for people to see. Get some fire extinguishers too, and keep the fire department happy."

"Okay!" Trudy said. "Thank you, Madge!"

Trudy walked down the block and across to the dime store and looked over their stock of light bulbs. Sure enough, she found some 15 watt bulbs and was about to walk out when she spotted a box of seven and a half watt bulbs. Trudy bought a half dozen of each and walked home. She found Neil working on the walls in the big east room.

"You know what?" Neil said when his mother came up the stairs. "This wing isn't built like the rest of the house. The walls in here are all plaster. The main part of the house is wallpaper on cheesecloth that was stretched over planks. I think this is newer construction. I'll bet this was even built by a different builder."

119

"My goodness," Trudy said, neither caring nor interested in Neil's observations. "Well, I bought some new bulbs and I want you to put the smallest ones in all the sockets that we have to keep on all night. Do it today, please, before you forget."

Neil looked at the tiny bulbs and screwed them in the hall light sockets, and in an outside light that hung above the side entrance steps. He was anxious to see if they gave enough light at night, and was surprised when he saw that they did. Trudy was content with the seven and a half watt bulbs and bought a dozen more to have on hand.

With the hall lighting solved, Neil turned his attention back to getting the east room ready to rent. It was a large room that was about the same size in square feet as the room they had rented to Wilma Fristler and her son, but her room was almost square with a window on three sides and faced south, getting a lot of sunshine. The east room was about twice as long as it was wide and had a large window facing the bay and a smaller window facing east. Both rooms had two closets, but the east room had its own bathroom with a bathtub.

Aside from cracks in the plaster walls and a few nail holes to patch, Neil's job in the east room was mainly painting. He had learned from the month or so of painting experience he put together on his mother's house that he couldn't ignore dirty or greasy spots on the walls and woodwork because the new paint either wouldn't stick or wouldn't cover those spots. Consequently, he had become very thorough in preparing whatever he had to paint. Following through with his reasoning, Neil also wanted to paint with good paint so his job would last because he felt that he had done a lot of work in getting the job ready and he didn't like the idea of doing the same job twice. His attitude eventually and inevitably caused friction with Trudy who had no intention of using expensive, quality paint because she thought the result was the same no matter what paint was used.

On the Friday before he was to start school, Neil was finishing getting the east room ready to paint when Trudy came upstairs with a brown paper package and set it on the floor by the door. "Oh! This is heavy!" she said. "My arms are worn out. I carried that all the way from Pacific Grove."

"What is it?" Neil asked, looking down at the package.

"That's the paint for the walls. The man told me that's what you use on plaster walls," Trudy said. "I'll go down and find you a pail and a stick to mix that."

"What?" Neil exclaimed, feeling his enthusiasm drain away. He knew that if his mother bought the paint that it must have been cheap. "What is this stuff? What am I supposed to do with it?"

"It's called calcimine," Trudy said as she was going back down the steps. "You mix it with water until it's as thick as paint, and when you're finished you clean everything with water."

Neil picked the package of calcimine up and looked at it, then put it back down, grabbed a jacket and walked down to the beach to throw rocks at the waves

for a while. When Trudy came back with a bucket and mixing stick she saw that Neil was not there and put the bucket and stick down by the package of paint. She thought Neil had probably walked down to the beach, so she went back down, made some coffee and made herself comfortable on her davenport.

When Neil came back from the beach an hour or so later, he found the pail his mother had left, washed it out and mixed the calcimine until he had a mixture that seemed to be about the right consistency. He was determined to go ahead and paint the walls with it and if it turned out badly, then he would have an arguing point.

To Neil surprise, it went on the wall just about like paint did and it seemed to cover well enough. Trudy had chosen an off-white color and it seemed to cover the pale green that had been on the walls before. He went ahead and painted all the wall surfaces, but didn't paint the woodwork because he wanted that to be done with real paint since he had put so much work into it, and he knew that real paint would wear well.

The next morning, Neil looked in the room and decided that the calcimine would do. The walls still looked good, so he decided to go down and have some breakfast and try and persuade his mother to buy a gallon of paint for the woodwork. After pouring some milk on a bowl of dry cereal, Neil sat down and told his mother about painting the woodwork before he starts school.

"I just gave you paint for that room," Trudy said. "What's wrong with it?"

"Mother," Neil started, "I just spent a couple of days getting that woodwork all fixed up to paint, and if I paint it with gloss oil base paint it'll hold up for years, and I won't have to work on it again for a while. The paint you bought is cheap wall paint and it won't wear well."

"How do you know it won't wear well? You haven't even tried it, have you?"

"No I haven't," Neil said, already feeling like he had lost the battle. "But the man at the hardware store told me that wall paint won't wear like gloss paint will. He said that was the purpose of woodwork—to take the wear and tear—and that it should be painted with better paint."

"Well, I got a lot of that other paint and I want you to paint the wood with it, too. I'm not made of money and we've been spending an awful lot on these rooms," Trudy said. "You go up there after you've finished your breakfast and finish painting the room."

Neil felt like everything he had told his mother meant absolutely nothing to her and that she was treating his information as just so much babble to keep the job from getting done. Trudy did hate to see more money going out without good reason, and it didn't occur to her that Neil was trying to get the job done in a way that he thought was better and more permanent. She had simply drawn a line to stop the drain on her money without the understanding of saving through quality.

Neil left his mother sipping coffee in the kitchen while he went upstairs to try to finish painting the room. While he worked in the room Miss Wembly went downstairs to have her breakfast and visit with Trudy.

"Good morning," Miss Wembly said as she walked into the kitchen, closing the hall door behind her.

"Good morning, Miss Wembly," Trudy said cheerfully. "How are you this morning?"

"Well, to be quite honest," Miss Wembly said, "I slept well when I did sleep, but that terrible bed—I can't make the pillow stay on it!"

"Really?"

"I don't understand why it doesn't have a foot board and head board like a proper bed!"

Miss Wembly complained. "I've never seen anything like it! Why on earth would anyone build one that way?"

"Well," Trudy said. "I'm expecting a truck load of furniture any day now and I have a regular bed in there. When it comes I'll have them set it up in your room."

"Oh, thank you!" Miss Wembly exclaimed. "I would be so grateful, because I need my sleep at my age."

"I would imagine that taking care of someone else's kids would wear you out," Trudy said. "I know I couldn't do that kind of work for long."

"Oh, they really aren't too bad," Miss Wembly said, "but I had one several nights ago that wouldn't go to sleep. He was a real blighter, he was. I finally read a story to him and he went off."

"Just imagine!" Trudy said. "When that truck arrives I promise you can have that bed. It should be down here any day now."

Trudy noticed that Neil got the painting done quickly. He came down for a late lunch, cleaned up a little and said he was going to the beach for a while. Since it was Sunday and the next day was a school day, Trudy decided to let him enjoy himself while he had a little free time. Trudy sat on her davenport for several hours reflecting on things in general and pondering on the progress of her rentals. One thing she was thinking about was how much time would his school work take each day, and how much time Neil would be have to work around her house.

Trudy was certain that if Neil had his way he'd only work on Saturdays and holidays, but she only had four rentals and she had to get as many as she could. There was still a lot of unused space in the house. There was still the verandah room, as she called it. She had the large artist's studio with a fireplace, and she had her large living room and dining room to make something with. She needed the living room for relaxation—perhaps there was a way to build a bathroom somewhere close to the dining room so she could rent the maid's quarters where she slept now. These were what Trudy called "hazy ideas", but someday she would

Trudy's House

find someone who could help her. She wished she had some male friends because to Trudy's way of thinking, men knew about fixing things.

That brought her around to thinking about Neil again, and she wondered when he would become knowledgeable about maintaining things. She had also been wondering if she should just automatically begin giving Neil an allowance because he seemed to need money now and then. She had no idea how to deal with a teenage son. She wondered if he would still work around the house if he had an allowance. She felt like she absolutely needed Neil's help getting her rooms ready to rent and that she couldn't jeopardize his willingness to work She secretly dreaded the possibility that Neil would become rebellious and couldn't even think of a way to control him if he did. Trudy thought that she would have to give up renting if Neil didn't cooperate with her. She decided that she would write a letter to a nephew who had just become a minister and ask him if he knew what she could do, even though at that point Neil had given Trudy no indication that he was at all rebellious. In fact, he had seemed to be willing to do the work, but Trudy knew from her observations that teenagers were notoriously unpredictable!

Trudy went to the kitchen to make a cup of coffee and get a piece of dry toast to nibble on. She decided that for the moment she would make a work schedule for Neil to work an hour or two after school and whatever he could do on Saturdays and holidays and give him a small allowance to encourage him, and see what happened. When he showed up for dinner she would explain it to him. Trudy went back to her davenport to sip her coffee and read.

Neil came back and hour or so later as it was getting dark. "Come in here," Trudy called when she heard him in the kitchen. "I want to talk to you."

Neil came in the living room and sat in a chair and looked at Trudy. "I'm here," he said. "What do you want?"

"I've been thinking," Trudy began. "Now that you're starting school again I want to talk with you about doing a little work for an hour or so after school, and on Saturdays because we need to get these rooms ready."

"Okay," Neil said, listening.

"I guess you won't know anything about homework until you spend a few days in school, huh?" Trudy asked.

"They told me that the first day will probably be a short day because they'll just walk everybody through their classes so the teachers can meet them and tell them what they'll need, and stuff like that," Neil said. "I guess it gets more serious on the day after that."

"You know, I'd appreciate it if you could come home and do a little work," Trudy said. "I really need to get more rooms rented here."

"What are we doing after we get the east room finished?" Neil asked. "The verandah?"

"I suppose so," Trudy said. "I want you to begin thinking about how we can use the dining room and the artist studio."

"And the laundry room?" Neil said.

"And the laundry room," Trudy repeated. "I think I could rent the maid's quarters where I sleep and let them use that other door as their entrance. But then, I'd need to have a bathroom off the kitchen somewhere."

"Maybe it would pay you to have someone build a bathroom in the laundry room," Neil said.

"Well," Trudy said after thinking about the idea for a moment. "That's a good idea. Why can't you work on that?"

"Mother! Where do you get these ideas?" Neil said waving his arms in the air. "I wouldn't know where to start on a thing like that! Can't you understand? Men make a good living because they know how to do those things. I just don't know anything—not anything about it!"

Trudy tightened her lips and shook her head, exasperated with her son for the moment because he didn't even want to try. "Well, I guess I'll start dinner now. You'll have to get some rest tonight. What time do you have to be at school?"

"Eight a.m.," Neil said as he got up to go upstairs to his room.

Trudy had not forgotten to offer Neil an allowance. She was too upset with him to make the offer. She recognized that at just 13 he was doing pretty well to do the work he did, but believing that all men can work on houses, she wanted to give him a chance to do the work and save her some money. The thing that Trudy didn't like was that Neil flatly had told her he didn't know a thing about it, and wasn't willing to try! For Trudy, hiring someone to do the job was unthinkable because she was sure that they would take advantage of her somehow and that she would wind up paying an outrageous bill for the work. After all, she would freely admit that she didn't know a thing about buildings. If Neil didn't do the work, she was sure she would find someone who could.

Trudy's truckload of furniture arrived on Tuesday afternoon, and Trudy invited her friend in who had driven the old truck down all the way from Oregon. She was still visiting when Neil walked in from his first full day of school, grinning from ear to ear. Seeing his father's old truck was like seeing an old friend.

"Neil," Trudy said, "would you help Mr. Vogel unload the truck? His name is Richard and he has just arrived with the furniture."

'Sure," Neil said. "I just have to put on my old clothes."

While Neil changed, Richard Vogel drove the truck around the corner and parked it in the side driveway off Fifth Street so they could unload without worrying about traffic. They went right to work and unloaded the truck into the artist's studio, finishing the job just after dark. Neil and Trudy looked over everything, finding familiar furniture that they had missed using.

Trudy recalled that she had promised Miss Wembly the bed with head and foot boards, and Miss Wembly agreed that she would be just as happy if they changed the beds the next day.

The following day Trudy and Richard Vogel moved furniture around in her house, trying to make sure there was a fairly even distribution of the load from the truck. However, Trudy's house was much larger than any other place she had lived in and all the furniture from the truck fell short of fulfilling Trudy's current needs. They moved the large and bulky furniture after Neil got home, giving Miss Wembly her bed, and placing the one she had been using in the east room along with enough furniture to furnish the room so that it was ready to rent.

Neil saw an old couch that his father used to sit on, and Neil used to sleep on when they lived on the Oregon coast. He persuaded his mother to place it in the large artist's studio downstairs—which until then had no furniture—where he could do his homework in the afternoons and listen to the radio, which was also in the truckload of furniture. Neil enjoyed listening to the serial radio adventure programs that started in the late afternoons when the kids got home from school. He even liked to listen to the evening programs like *The Green Hornet*, *The Shadow*, and *I Love a Mystery*, which his mother would not listen to.

Vogel left a day or two later, heading for a life in Arizona, after Trudy paid him for his trouble by signing the old truck over to him and giving him the remainder of the gas stamps. Neither Trudy nor Neil ever saw him or the old truck again.

With Neil going to school every day, Trudy's daily activity changed. For a week or so she made drapes and curtains and altered clothing. She had to make curtains for the long course of windows in the verandah room, and after starting the job, realized that she had to make heavy drapes because the room would be cold with so many windows. The windows faced south so the room must have been used as a sunroom, or sewing room. She could see no other purpose for the number of windows in the room.

Trudy kept Neil on a schedule of making over the verandah for a rental room, but she was beginning to notice that as they moved into autumn the nights were cooler. She had begun to wonder if she would be able to rent the verandah room when the weather was cooler. Trudy decided she would go ahead and get it ready to rent, but not really try to rent it unless someone really wanted it. She would probably just try to rent it when the weather was warmer. That left her wondering about which part of the house she should work on next.

The following Saturday as Trudy was finishing her coffee and talking with Miss Wembly, the doorbell rang and Trudy trotted into her living room to answer the door.

"Good morning!" a young man in a Navy officer's uniform said. A pretty young woman was with him. "We've been told that you might have a room or apartment to rent,"

"Yes, I do." Trudy said. "I have a room to rent upstairs. Would you like to see it?"

Trudy knew they would like the room because it had two closets, a good view of the bay, and it's own bathroom, so while the young couple looked through the room she went back downstairs to get her notebook and receipt book.

They were Thomas and Dede Wilson. Thomas Wilson was a new ensign and was involved in advanced flight training at the Naval Air Station in Monterey. The couple had just arrived from Florida where he had completed flight training. He told Trudy that he would probably be in the area for three or four months before he was transferred overseas, and then Dede would probably return home. Trudy was beginning to think that three or four months was about the time that anyone in the military stayed in one place.

Trudy soon noticed that Tom Wilson was a no nonsense pilot who's training routine was to leave the house before dawn and return home in the early evening when he and Dede would go out to dinner. He would return home and study all evening. It had occurred to almost everyone in the house that Tom's dedication to flying might interfere with his marriage, but he and Dede spent weekends together and seemed to enjoy their marriage. Another aspect of the Wilsons was that Dede was easily the most attractive young woman in the area, and she seemed to be dedicated to the idea of keeping herself in that position. When her husband was on duty, Dede often went downtown dressed as if she were going to a country club to play tennis. Speculating about the Wilsons became a morning topic at Trudy's breakfast table.

Wilma Fristler decided to have kitchen privileges too, and began coming down to join Trudy and Miss Wembly for breakfast. Aside from discussing whatever interested them, Trudy decided that she would also use the opportunity to get feedback on her plans to develop the rental rooms in her house. She didn't do it consciously, but it amounted to the same thing. Trudy was so concerned about getting more rental rooms that she would just start talking about a project that she had in mind, and listen if Wilma or Miss Wembly expressed an opinion on it.

One idea that Trudy had was to make a rental room out of the artist's studio. The others quickly pointed out that that she would have to build ten feet of wall and put a door in it to make the studio a room. Then there would have to be a closet, and they pointed out that the room had no bathroom. Would people climb up those stairs in the night to go to the bathroom? Would they want to go all that way in a robe to take a bath? And what of the people who already had to share that bathroom? Wouldn't they be crowded out? Trudy decided that she had to abandon that project for the time being because of the bathroom problem.

Trudy could move out of the maid's quarters to rent that space to someone, but where would she sleep? Perhaps she could change the dining room into a bedroom. And then she would have to use the upstairs bathroom and add to the

crowding there. Finally, Trudy decided that more than anything, she would have to have one or two bathrooms built in the laundry room because she needed bathrooms and she didn't need the laundry room.

During the remainder of September Trudy fell into a routine of seeing Miss Wembly and Wilma Fristler almost every morning for an hour or so and gossiping over toast, coffee, and whatever anyone had for breakfast. The talk ran the range of subjects of things they had seen in the last few days to stories about their past lives and plans for the future—although talk of the future was usually not popular with military wives.

Wilma said that her husband had been in the Army since 1939 and had been in, the invasion of North Africa. The last thing Wilma had heard was that he was being rotated back to the states to be a basic training instructor. He was a master sergeant and knew enough about Army planning to say that he probably would be shipped to Fort Ord. Wilma explained that because of his rank, wherever he was sent he would be given military housing. When anyone asked about her future plans, Wilma would only say that she knew enough about military life not to make plans like that, which was an attitude that Trudy found very sobering.

Miss Wembly would often talk about life with the people she had worked for in France, and how much she felt that she was a part of the family. She had tutored several generations of the family and had seen the oldest ones go on to start university study. In fact, Miss Wembly had talked so glowingly about her life as a tutor that Trudy began to wonder if Miss Wembly was covering up something. As far as Trudy knew, Miss Wembly never heard from people she said had been such close friends with in France, but of course there was a war going on there and very little news got out.

Trudy told her stories too, but often with a slant that didn't reflect the truth. The others might not have guessed, but Trudy's stories changed a little from one telling to another, and when asked, Neil often gave still another answer. The truth was that Trudy felt that her life prior to moving to Pacific Grove was uneventful and not worth remembering so when she talked about those earlier times she was careless about portraying events and people, and tended to skim over her own life in vague terms and generalities. In fact, if she were forced to tell the truth about her earlier life, putting everything in strict order, she probably would not be able to do it.

Neil was having his own problems in school and he didn't know what he could do about it. Although he didn't know it at the time, the year he had spent on his uncle's ranch in eastern Oregon had matured him physically and mentally, but that was a formative year for him and he was finding himself out of step with his classmates in school. Ball games were the most important extracurricular activity to his classmates. They played ballgames in season just about every time they got together. Neil had played some of the ball games when he lived on the

127

Oregon coast, but in eastern Oregon they were looked on as a monumental waste of time and energy. Neil would have been surprised if a football existed within thirty miles of the ranch (it was forty miles to a town where the kids did play ball for fun). Consequently, he was an anomaly in Pacific Grove. He was a large muscular boy who had no interest in ball games!

Neil also had not developed social skills while in eastern Oregon. There was no reason to, since there were no girls attending the tiny school he went to. In Pacific Grove the other kids his age played endless social games that mystified Neil. They included all kinds of activities that involved hazing, social activity with girls, and special "pecking order" head games with other boys that eventually led to establishing social leadership. Neil thought the other kids were foolish and frustrating and resulted in his withdrawing from social activity to concentrate on things that were important to him. He wanted to see his mother's house developed so that she could operate it at it's full potential. He thought that her renting rooms would benefit him, too, since he was her only son.

One day late in September the sky clouded over and it began raining while Neil was still in his morning classes. The rain caused a stir of excitement among the students and there was talk about a "rainy day session". Neil had no idea what was going on but instead of a lunchtime break, the teachers announced the rainy day session and all the students went through an abbreviated afternoon schedule and let the students out for the day at one o'clock. Neil reasoned that they had changed the school hours so the students could go home early to stay dry. But when Neil went outside it was still raining! He assumed that the purpose was to help the students, but they still got wet. He went home in the rain, like he would have done in Oregon, and wondered if rain at noon usually stopped by early afternoon in Pacific Grove!

Trudy was content with Neil's work in the afternoons to get the verandah ready to rent. By the end of September he had painted most of the room. One strange thing about the room was that the interior wall was shingled indicating that at one time that wall had been exposed to weather. Neil finally decided that the room had originally been built as a second floor porch and someone, sometime, had decided to enclose the porch and make it into a sun room, or something like that. He didn't like the room because it was awkward to work in, and it was not insulated at all. It was hot in the summer and cold in the winter. He had expressed his thoughts to his mother, and Trudy simply said that she wanted it finished. Someone might need it and it would be there to rent. Trudy wondered about ways to make it warm during the winter months and dismissed the thought of electric heaters at once. She thought that they would be far too expensive to operate.

"Well, y'know," Wilma Fristler said when they talked about it at breakfast the next morning. "I stayed in a place in Texas one time where the only heat

was from a kerosene heater. I had to light it whenever I wanted heat, but it sure warmed the place up."

"Really?" Trudy responded. "What was it again?"

"Just a kerosene heater. It was portable—stood, oh, two or three feet high. It was round and black and had a teensy window on the side so you could see the flame. It was flat on top too, so you could heat water for tea on it."

"Oh?" Trudy said, interested. "And you say it was a good heater?"

"Yes Ma'am!" Wilma said. "It would drive you out of the room after while."

"But, aren't those dangerous?" Miss Wembly asked. "I think I've heard about them starting fires, suffocating people in rooms, and all that."

"That's true, too" Wilma said. "It's best that you set them up on a metal tray that's made for them because they can burn the house down if you knock them over. You don't want to put anything flammable around them either because they get so hot. But as for suffocation, I'd think all those windows in that room would let enough air through to take care of that!"

"Thank you so much," Trudy said to Wilma. "I'm going to walk up to town this morning and see what there is."

Later that morning, Trudy walked into Pacific Grove and after going through several stores, found the kerosene heaters at Wright's Hardware. She priced the heater, the pan it stood in, and a few gallons of kerosene, wrote it all down, bought a two-gallon can of kerosene and decided to send Neil after the rest when he got home. By the end of the day she relaxed on her davenport with another problem solved.

After dinner Trudy relaxed in her living room and read for a while before going to bed. Sitting down with a magazine or a book in the evenings was a new habit that Trudy had gotten into and found very relaxing and more natural than any other lifestyle she had had in the past. It all began with an interest she thought she had in short stories, but after a month or so of that, she decided that was a hangover from the past when she thought she could write short stories. Her interest turned to articles and then to inspiring stories of people who had beaten the odds in life and had somehow risen up to find a new life. Often the stories were religious, but she also liked the ones where people had succeeded because of some twist of fate.

As she read in the evenings she could hear movement in the house and she would stop to listen. As Trudy would admit many times, she enjoyed the noises the tenants made because it made her feel like she was not alone. She got to know the comings and goings of her tenants by following the footfalls through the house in her mind. All the tenants seemed to be considerate of each other because they knew that sound carried in an old wood frame house like Trudy's, and Trudy knew that she would soon have to put padding of some kind on the steps and carpets on the floors to make the house quieter for her tenants.

She was prepared to chastise Wilma's sixteen year old son, Frank for making noise but he seemed to be as quiet as the others. She had also expected Neil to begin running around with Frank, but that had not happened and she really couldn't understand why. They were barely three years apart in age.

If she had asked Frank or Neil they could have told her that they rarely saw each other because they attended different schools and had different friends. Frank was a big city boy and proud of it and Neil was "small town" to "ranch". That, by itself set them worlds apart. Whenever they did see each other Frank took the older brother position with a "when you get to be my age" attitude. Neil could take him in small doses because he knew he had a lot to learn, and when he got tired of Frank, he would simply leave.

Frank had a subtle effect on Neil though because before they met, Neil lived pretty much the way he had lived in eastern Oregon. He didn't bother shining his shoes, or even cleaned them. His clothing preference was always denim pants and a colored tee shirt, or a very casual button up shirt with a collar. Sometimes, if it was cool enough, he would wear a jacket or a sweater. He never thought about his hair, other than combing it quickly in the mornings. In eastern Oregon his uncle was the family barber and cut his own and the boy's hair the same way, by running his fingers through their hair and cutting off every hair that rose above them, then trimmed the edges. Neil's mother cut his hair in Pacific Grove and did a presentable job. Neil neither cared nor showed an interest in anything that could be considered "dressing up". Bathing was a sometimes thing that he would do to get the paint off, or prepare for some occasion.

Frank believed in dressing up, and Neil always suspected that Frank had some kind of private income to finance his lifestyle. Whenever Neil ran across Frank in the house, Frank was primping to go out somewhere. Neil would watch curiously as Frank combed his hair carefully, shaved until all the stubble was gone, dressed without wrinkling his clothing, and most curious of all, tucked the tails of his shirt in his pants by folding the excess material at his hips so that the front of the shirt showed no wrinkles. "Just remember that you're not dressing just to have some clothes on. You're dressing to make a good first impression on the ladies you'll meet out there today," he would say.

Neil would go back to his room and look over his own clothing and think about all the trouble Frank went through to get ready to go somewhere. Neil couldn't decide if all the trouble Frank took to go out was right, but he made a point to remember all the things that Frank told him until he was in a better position to decide what was right or wrong.

Neil had known for years that it would be up to him to learn the truth about things in life. He cringed at the few times he had asked his mother about what things were. One time when he was very young he had heard someone talking about bombs in a radio play and he asked his mother what bombs were. She had told him they

were big things made of cast iron that were dropped from airplanes to destroy things. He remembered trying to imagine what might be made of cast iron and all he could think of was frying pans. When he asked if they were like frying pans filled with dynamite, she had replied, "Something like that." Neil had uncomfortable memories of the gales of laughter when he talked about bombs with his friends.

On another occasion, when he was about nine years old, he thought it would be good to become a songwriter in life and asked his mother how songs were written. Instead of telling him she didn't know, or something else that was sensible, she told him that all popular songs were based on, *Don't Sit Under The Apple Tree*! Neil recalled that he thought about that for months, and even remembered telling a few of his friends about it—to more laughter. After that, Neil had learned his lesson and decided to do his own thinking. That attitude was a seed that grew into a self-reliance that served him when he was forced to live with his aunt and uncle in eastern Oregon. It served him after his father died, and it served him in Pacific Grove dealing with his mother.

One morning late in September, Trudy was talking with Wilma and Miss Wembly and eating a breakfast of toast and coffee when the telephone rang. Trudy answered it and was surprised that it was Rosy who wanted to know if Trudy wanted to go over to Salinas with her and do a little shopping.

"My Goodness!" Trudy exclaimed. "Of course I'd like to go with you! Are you going to pick me up?"

Rosy picked Trudy up within the hour and they were on their way to Salinas. "Why, I didn't know you drove all over like this!" Trudy said. "How far is it to Salinas?"

"Oh, about forty-five minutes," Rosy said. "I think it must be about 25 miles. I don't go very often because of the gas coupons, but once in a while I like to go see what's going on. Things are different over there, you know. It's more down to earth. Sometimes I can find good sales there."

"Really?" Trudy said. "Well, whenever you want some company just give me a call. I'll be glad to pay for the gas."

"Sure!" Rosy said. "I can give you a call. The prices are a little better in Salinas. It's been like that ever since they made such a tourist spot out of Monterey. Now, with all the soldiers and sailors around the prices are really going up. I drive over here every couple of weeks and stock up."

Trudy didn't buy much in Salinas, but she learned that it was a good place to go to get away from things. Just driving over for a few hours lifted her spirits and improved her outlook on things. When she got back and saw Rosy off, Trudy went into her kitchen to make some coffee and relax for a bit before Neil got home from school. The doorbell rang as she was getting ready to sit on her davenport. She opened it and found a tall, slim Army man at the door with a fortyish woman on his arm.

They introduced themselves as Master Sergeant Elmer Johnson and his wife, Nettie. He was just back from Europe and was being assigned to Ford Ord. Nettie explained that they were waiting for records to catch up with them, which could take up to six weeks. When his records arrived they would get military housing, so they would need a room or apartment for as much as two months.

"I have one room," Trudy said, "and I don't know if it's what you want because it's sunny and warm during the daytime, but cold at night. It's not too bad right now, but it will be if the nights get much colder."

"Isn't there any heat in it?" Nettie asked.

"There isn't any built in heat, so we have a kerosene heater." Trudy said.

"Okay, that's no problem for me," Nettie replied. "We've both had to live with those things. Can we see the room?"

Trudy led them through her living room to the stairs and up to the verandah room. She opened the door and watched as they walked and explored the room. The sunlight streaming across the floor through the heavy curtains gave the room a cozy feel, and it had enough floor space to give the feeling of a large room.

"It seems plenty warm enough right now," Nettie said. "I kind of like this room."

"Yeah," her husband said softly. "It's okay."

"Well, it cools down quite a bit at night," Trudy said. "Don't forget that this is only the end of September. We haven't tried the kerosene heater yet, but I imagine it will keep the place warm."

"Sure it will," Nettie said. "Say, I don't see the closet. Do you have a closet here?"

"Oh, heavens!" Trudy exclaimed. "I completely forgot about it. We'll have to do something about that right away!"

"They don't build closets in Italy," the sergeant said. "Everyone has cabinets of some kind. Maybe you can find something like that and save building it."

"Yes," Trudy said. "I'll see what there is."

"We still have some time before we have to move," Nettie said. "Can we come back in a couple of days and look again?"

"Sure! That will be all right," Trudy said.

As the Johnsons left the house Trudy put on her hat and coat because she thought she had seen "wartime" clothing cabinets (meaning that it was built from cardboard or cheap, flimsy wood) in the Montgomery Ward catalog and she had enough time before they closed to go see. Trudy rushed to the bus stop in time to catch the bus to Monterey with only a short wait. When she got to Ward's she rushed to the catalog counter, thumbed through the catalog and found wardrobes made from wartime materials that were strong and durable. She ordered one because it was shipped in a "compact, easy to handle package",

but stopped by the used furniture stores on the way home just in case a real wardrobe was available. She could always use the one she had just ordered in another room. Trudy went home and waited for the Johnsons to call back because she thought that they might take the room with the promise of a place to hang their clothing.

Chapter Ten

The Johnsons did call back two days later and rented the room on the condition that Trudy would provide them with a place for their clothing to hang. Trudy received a phone call from Wards several days later and was told that her order had arrived, so when Neil came home from school she gave him the money to go after it and bring it home on the bus. Seeing that he didn't have much time before the store closed, Neil rushed to take the bus to Monterey and trotted over to Wards to pick up the order.

When the clerk brought the packaged wardrobe out to him Neil took one look at it and felt overwhelmed. The entire package was five feet high, forty inches wide, and about four inches thick, and it was almost all corrugated cardboard and bound with heavy cord. He couldn't imagine the bus driver even letting him on the bus with a package that size, yet without transportation he had no choice but to struggle with it. He knew his mother needed it to rent the room. Neil hefted the package and guessed that it weighed about 45 pounds. To make carrying the package easier on his hands Neil bought a pair of work gloves in the hardware department, then came back to claim his package. The clerk sympathetically wished him luck as he picked it up and headed for the door.

Neil maneuvered his bulky package between the counters and the store customers, muttering apologies as he worked his way to the doors Once out on the sidewalk, Neil put his package down to rest for a moment. He pulled himself together psychologically, thinking that everyone was faced with a challenge like that at one time or another, and this was his time. He picked his bundle up and headed for the bus stop. When the bus came along he let everyone else get on then dragged his package up into the bus and paid his fare while the bus driver stared at him without speaking. When Neil felt certain the bus driver was going to let him ride on the bus with his package he walked back just past the rear door of the bus with the package and stood instead of sitting, holding on to one

of the stanchions for support. When he arrived at his street, he rang the buzzer and thanked the bus driver who was watching him in his big overhead mirror. The bus driver somberly nodded back to him.

Neil dragged his package off the bus and walked down the hill the long block to his house. When he arrived inside Trudy's living room Neil stood the package against a doorframe, took his gloves off and rubbed his sore, cramped hands together gently until he could straighten his fingers again. Finally, he told his mother that he would never again try to bring a package that size home on the bus again because he felt certain that the bus driver would tell him to find some other way to get home.

Trudy had the good sense not to say anything because she didn't think she would want to get on a bus with a package like that either. "Let's take it upstairs and open it up. I want to see what it looks like first."

It took Trudy and Neil about an hour to assemble the wardrobe. When they had finished they had a cardboard box that was a little over five feet high, about two and a half feet deep from front to back, and about forty inches wide. They studied it for a few minutes and decided that it would serve the purpose until they could find something better. The package had become a fairly serviceable wardrobe that had a wood grain exterior printed on it. It had a metal rod with wood supports to hang clothing on, and it had a cardboard top and bottom and cardboard doors that would keep the dust and dirt out.

"Well," Trudy said as she looked at her wardrobe, "All it is a box with doors, but I guess we can't expect more during the war."

The Johnsons weren't very happy with the wardrobe either, but they recognized that everything seemed to be a sacrifice at the time. Sergeant Johnson kept his uniforms in the cardboard wardrobe and he eventually accepted it as "all right".

The Johnsons moved in the room a day or two later and settled in. With five rooms rented and more planned Trudy was feeling much more satisfied in being a landlady. In fact, she had taken the time to write a letter to her older sister, Jean, who had been so doubtful about Trudy's move to California. Since Jean had always taken the position of being like a second parent, Trudy couldn't resist digging at her a little with "I told you so's". She had to admit that Jean was usually right, but on the rare occasion when she wasn't, Trudy liked to let her know that she had been wrong. Still, as Trudy was quick to admit, she still had to make use of the rest of the house.

One afternoon, several days later, Trudy was sitting in the warm sun in her living room sipping a hot cup of coffee and thinking about the one problem that had been keeping her from moving ahead, and that was how to put another bathroom or two in the house—and where to put them! She was not feeling quite so financially squeezed as she had in the past because with five rooms rented she was able to put a little money back in the bank and still pay her bills.

To this point in becoming a landlady—and property owner—everything had been an adventure into the unknown and Trudy had never had the sense that she was moving ahead in a successful venture. Everything she had done was new to her and the only yardstick she had to judge if she was sinking or swimming was the amount of money she had in the bank. When she rented the first room to Herb Knight her bills were paid but she had a little over two hundred dollars left and she was afraid that she would lose everything! With five rooms rented her bank account was increasing and she still had her bills paid!

It still had not been a year since her husband had died and Trudy had wondered what she would do to earn a living. She never, ever thought that she would become a property owner and a landlady! She recalled back in the years when she had sat at her old typewriter trying to write short stories to earn money and escape from her marriage and her humdrum home life to find fun and adventure in living, and be surrounded with interesting people. As Trudy sat in the late afternoon fading sunlight she tried to remember what it was that she expected to find when she left the Oregon coast. She couldn't remember. Perhaps it was just the change that she wanted.

Trudy heard a car pull up outside. She heard men's voices, saw someone go past her front window and heard the car drive off. She heard someone coming up the side steps, open the side door and come in. Then there were footfalls going up steps—a few stumbles—and then someone going in their door upstairs. Sergeant Johnson, she thought. Coming home off duty, and sounding very tired. Taking that as a cue, Trudy decided it was time to get some dinner ready for herself and Neil.

Trudy didn't move right away, feeling too comfortable in the warm sun to bother getting up to go into the kitchen. As if enjoying a good dream, Trudy thought again about her incredible good fortune in becoming a landlady. She would even own her property outright by the time she was—what—41 or 42! Aside from her sister, Jean, no one in her family had ever owned a house! To complete the dream she actually owned the property in California! She was born and raised in the frozen winters of Saskatchewan in Canada, and as a girl, a place like California was held in the same esteem as Fairyland, and the chances of ever seeing it were just as remote!

She heard Neil in the hallway as he opened the door into the kitchen. Trudy sat up, then stood up saying, "I'm in here! I was just about to go get some dinner."

"They just announced on the radio that the Allies have landed in Sicily at Salerno, and they're having a big battle with the Germans!" Neil announced. "Maybe they can push them all the way back to Germany!"

Trudy didn't know where Salerno was and didn't care, as long as they kept the war a long way away. In fact, nothing about the war was really an inconvenience to her. She didn't have a car so gas and tire rationing didn't concern her. Shortages

were no bother as long as something was available. She really liked having coffee, but she could get along with something else. Butter was impossible to find, but she had been able to get along on margarine. She really didn't care if it was served white, as it came from the store, but Neil was happy to add the coloring and work it in to the white margarine with a fork. It only took a few minutes and he thought it looked more appetizing.

If she had to complain about something, Trudy would talk about the coloring she had to put on her legs so it looked like she was wearing stockings. Another thing that she didn't like was that no silk was available—and, she probably would enjoy a good cut of meat now and then. But Trudy had put up with not having things all her life and she was used to shortages. Even the shortage of sugar had not been a problem because she seldom ate sweets, or used sugar to sweeten anything, but she would admit that as she got older, and as money became more available to her, she might enjoy a chocolate candy or something like that now and then. She kept some sugar for Neil for his cereal, and some for people's coffee or an occasional dessert.

Trudy had begun to notice that Neil's clothes really didn't fit him anymore. He was growing out of them and she remembered that he had already told her that he needed some clothing. Trudy had noticed that several stores were advertising fall sales, and two of them were J.C. Penney's and Montgomery Wards. So she decided that she would buy him a few things since she had the extra money. When Saturday morning came she told Neil at breakfast that she would take him downtown and buy him a few things. Later that morning, Neil and Trudy walked home and Neil had a pair of denim pants and two cotton shirts from the National Dollar Store, and a pair of cords and a jacket from Penney's. Neil felt like he had finally got some recognition for the work he had been doing around Trudy's house, but he was disappointed with the denim pants because they looked like work pants. He had told his mother that the school fashion was Levi pants with the cuff turned up exposing the tell-tale blue and white seam—proof they were Levi's (not to mention the red tag on the hip pocket and the leather patch above the pocket with "Levi's" printed on it!). They were status symbols in school and status symbols didn't mean a thing to Trudy. She couldn't understand why Neil thought they were so important.

As Neil and Trudy walked from Monterey around the end of the Presidio and up the hill into New Monterey they became aware of a lot of activity down below them along Cannery Row. The canneries that had been so quiet during the late summer months when Trudy had first arrived in Monterey, had suddenly come to life. Steam and smoke drifted from the tall metal stacks above the canneries and trucks and people moved around on the streets near the canneries. As Trudy and Neil walked across the side streets that led down to Cannery Row, they noticed that each street had its own kind of activity.

They noticed women wearing rubber aprons and rubber boots and hairnets were walking down the hill from the houses above. As they crossed Lighthouse Avenue, they walked on down the hill toward the canneries in groups of three and four and gestured animatedly as they talked. Obviously, they had to process a catch of fish. But, the most noticeable thing about it all was the almost overwhelming smell of fish. As Neil and Trudy walked closer to Pacific Grove, the fish smell grew stronger and Neil searched the faces of people they passed for signs of alarm due to an accident of some kind. He never dreamed that the fish canneries could create such an oppressing smell of fish! People were not alarmed. They were happy and talkative.

When they got home Neil went to his room to look at his new clothing. Trudy went into the kitchen to make some coffee and a snack and found Miss Wembly and Wilma Fristler talking over some coffee. Mrs. Fristler had just come in too, and was complaining to Miss Wembly about the oppressive fish odor that she noticed as she got off the bus. "I've never smelled anything like it!" she complained. "I thought something had overflowed somewhere!"

"It's the fish canneries, I'm afraid," Miss Wembly said with a smile. "The sardines are running now and this is probably their first big catch of the season." Miss Wembly had an advantage over the others in that she was the only one in Trudy's house who had lived on the Monterey Peninsula for more than a year.

"Do they can sardines here?" Trudy asked. She had never thought to ask what they did in the canneries.

"Oh my, yes!" Miss Wembly replied. "Didn't you know? This area is quite famous for its canned fish—especially the sardines. I've heard that they ship them all over the world."

Miss Wembly paused for a moment to dab a little jam on a cracker, then ate it in several bites. "Those great, huge fishing boats that you've seen in the harbor go out in a long line early in the mornings, then come back in the afternoon with their catches. I can lie in bed in my room upstairs and watch them come and go. It's really quite interesting to watch."

"Well, what do they do with their catches when they bring them in?" Wilma asked, getting wrapped up in Miss Wembly's explanation of the process. "I suppose they must unload the fish into trucks that haul the fish to the canneries, huh?"

"No," Miss Wembly said. "If you look out in the water behind the canneries you can see what appear to be rafts floating out there. But they're not rafts. They call them hoppers and the fishing boats gather right up to them and unload their catches right in them.

"The way it was explained to me is that they haul the fish up out of the boats with the boat's derrick and drop them into the hopper. Then, somehow, the cannery sucks the fish up through a great tube, or hose, right out of the

bottom of the hopper and up into the cannery! It's really marvelous how they must do it! The fishing boats gather around each side of the hopper and lift the fish in—seagulls flying all around to get a piece of fish!"

"Well, I'll be darned," Wilma said. "And, if they're anything like other canneries I'll bet they hire a lot of help. Back home we have canneries, too. They can meat. Some can fruit and vegetables and they're always hiring because the work is so temporary. Some crop or another comes in and they want people right now to get it canned. Then they're slow again for a while. Well, shoot. You can't depend on work like that for a living, but it sure is handy if you want to earn a little money for a week or two!"

"Yes," Miss Wembly said. "I understand that there is steady work down there when the fish come in. I'd apply if there was anything I could do, but you have to have cannery experience and the desire to earn money, because I hear they can fish until they've finished with the catch. That means long hours and youth or stamina—or perhaps both!"

"Well," Wilma said. "I haven't got anything to do except get in trouble. And, God knows, I can always use the money. I'll tell Frank about it, too. He's usually looking for ways to earn extra money."

Trudy sat sipping her coffee and listening to the conversation. She was thankful that she had her house, and she thought that if she could just manage to do things right and manage her money well, she would never have to think about working for someone again. The idea of going down to the canneries to get any kind of job didn't appeal to her at all. So, she just listened to the conversation and now and then made comments like, "Really!" and "Gee", and sipped her coffee and otherwise stayed quiet.

"What about you, Miss Wembly?" Wilma asked. "It sounds like you still work."

"Oh yes," Miss Wembly said. "I'm a professional baby sitter!"

"You are?" Wilma exclaimed. "I didn't know there was such a thing. Everyone I ever knew just busted their buns trying to get their kids potty trained so they could get a little relief from watchin' kids every minute. How in the world did you get into that kind of work?"

"Of course that wasn't my first choice," Miss Wembly said, "but as things have evolved it's what I can do to earn a living and I really don't mind it."

"Well, I'll be darned!" Wilma said, but was interrupted by Miss Wembly who had discovered that she usually gained a little more respect or prestige by telling Americans about her colorful life as a tutor to European nobility.

"You see, I'm still a British citizen and I have to fend for myself over here," Miss Wembly continued. "To emigrate to this country I was sponsored by a family in Colorado. I suppose I could go back to them and they would have to support me, or put me in a position where I could earn my own living, but I

prefer not to do that. I like living here and I can get along as a baby sitter, and that's what I do!

"Actually, if the war hadn't begun I'd still be living in France. I spent 33 years there as a tutor for a French marquis and his family. We lived in a splendid chateau in the Loire Valley. Really, it was such an idyllic life for me." Miss Wembly's train of thought appeared to be interrupted by some memory of the past and she paused and looked out the kitchen window.

After a few moments she regained her composure and looked back at Trudy and Wilma and smiled. "I'm sorry," she said softly. "For a moment I thought about the children again. Blast this damned war! I haven't thought about them for years!"

Miss Wembly's drifting off the subject erased the doubts that both Trudy and Wilma were beginning to feel when Miss Wembly told them that she had lived in France with nobility. Such claims amounted to wishful thinking by star-struck American teen-agers, but Trudy and Wilma quickly realized that living somewhere on the European continent was probably not all that uncommon for a well-educated young English woman.

"For heaven's sake!" Wilma said, "Did you have to leave France right in the middle of raising children?"

"Oh!" Miss Wembly said. "I didn't intend to mislead you. The children are adults now, and have children of their own. I believe that I was working with one generation or another of them all the time! It's just that it was such a good life for me, and the children were so loving and well mannered. I hated to leave them. After all, their home had become my home.

"However, the Marquis said that war was coming and that it would not be good for me to stay there since I have a British passport. Life would be very difficult for me with the Germans running things, so they made arrangements to get me out of France before the Germans arrived. I came over on the S.S. Normandie on her last crossing, and arrived in New York in the late summer of 1939."

"How interesting!" Trudy said. She had wanted to stay out of the conversation so she could learn about Wilma and Miss Wembly, but she was so interested in travel that she found it impossible to stay aloof. "My goodness! Haven't you led an interesting life!"

"I suppose so," Miss Wembly said. "I really haven't done very much traveling. Until I came here I had only been from my home in England, to France and one or two other places. Someone told me that's the distance from here to Los Angeles. Isn't that incredible? Anyway, I was busy with the children all the time!"

Wilma looked at her watch and stood up. "Miss Wembly, I've enjoyed talking with you, but I've got things to do. I have to pick up Frank at the high school so we can get over to the Presidio and have dinner."

Trudy's House

"What's at the Presidio?" Trudy asked, thinking there might be a restaurant there she hadn't heard of.

"Oh, we just go to the PX up there and have dinner with the rest of the dependents," Wilma said. "I guess a lot of them rent rooms around here and don't have place to eat."

"Really?" Trudy said, now knowing what she had been wondering about—where the military people go to eat. "That's a good idea, isn't it."

Later that afternoon, Trudy was relaxed in the sunshine on her davenport and going through the afternoon paper, her ever-present empty coffee cup beside her, when she heard a car pull up in front and the sound of men's voices again. She saw Sergeant Johnson walk past her front window, then listened as he climbed the eight or ten steps to the side door. She heard him open it, then listened as he climbed the inside stairs to his room, and again heard him stumble on the steps, mutter something and go on up the steps to his room. Trudy couldn't help wondering why he was stumbling on the steps. She wondered if it was a war wound that caused the problem, or was he drunk? She couldn't tell. Trudy had never lived around alcoholics, but the thought he might be one frightened her a little. She decided to talk with Rosy about it to gain some insight.

Trudy thought about it for a few minutes and dialed Rosy. "Oh! Hey, how are you, Trudy?" Rosy answered cheerfully when she heard who was on the phone. "How are you doing over there? You know I was going to call you and see if you wanted to go to San Jose for the day with me. They have a pretty good little department store up there, you know. Sometimes they have real good bargains."

"Sure!" Trudy said. "I told you I'm ready to go anytime. Just let me know."

"Okay," Rosy replied. "Maybe in two or three days. I have to check my book first. You know I write everything I have to do in my notebook. I call it my memory because the one I was born with is no good!"

Trudy listened to her giggle at her own joke, and then said, "The reason I called is to get some advice. You know so much more about renting than I do."

"Sure!" Rosy said. "What is it, Trudy?"

"Well, I rented my verandah room out to a soldier and his wife until they can get base housing. They said it shouldn't be more than about six weeks."

"Yeah." Rosy said, "Uh, huh. That comes up every once in a while. I've had a few like that and they only stay about a month—maybe two."

"Well, I wonder if this soldier is a drunk, because I hear him stumble on the steps when he goes up to his room," Trudy explained.

"Oh!" Rosy said. "You know he could be, especially just coming back from overseas. It's so hard for them to adjust, you know. Does he fight with his wife or shout, or anything like that? Because if he causes trouble you can call the M.P.s, you know. They come right away."

"So far, all I hear is that he goes into his room. He's very quiet. Maybe he just goes to sleep. I don't know," Trudy said.

"Well," Rosy said. "I think it's up to you. If his wife watches him and he doesn't cause trouble maybe he's all right. Are you sure he's a drunk?"

"Gee," Trudy said. "I've never been around drunks. I don't know."

"Why don't you stick your head in the hallway after he goes through and see if you smell the booze?" Rosy suggested. "Or maybe you could look in their garbage for empty bottles. Now and then a bottle is okay because everyone has a little drink once in a while, but if you see a lot of bottles—that's another thing! How long do you expect them to be there?"

"They've only been in there a week or so," Trudy said. "Well, I'll keep and eye on him and see what develops."

Trudy had Neil working in the yard after he had finished working on the rooms that they could easily convert into rooms to rent. He worked an hour or two after school to make the yard look more presentable. Trudy had given her large yard almost no attention since she had moved in and all the planting was overgrown, and what wasn't planting was patches of dry grass that was almost two feet tall. Again, Neil persuaded his mother to walk to the second hand stores and hardware store with him so he could get some tools. Trudy could see that Neil would need things to work with so she agreed to buy a hoe, a shovel, and a few other tools. Trudy balked at buying tools that seemed to duplicate each other like a square edged shovel and a pointed shovel. To her, different kinds of shovels were just a matter of personal preference, so she told Neil to choose one or the other. When it came to cutting the tall grass, neither Trudy nor Neil knew what to get. They both looked at scythes and cycles but Trudy thought they looked too dangerous and Neil didn't think there was enough room between the planting to swing them. The patches of grass were too overgrown and too small for a lawn mower, and good lawn mowers were almost impossible to find because they used scarce war materials. A hardware man finally suggested a weed cutter.

"There you go, young man!" he said, handing one to Neil. "You just swing it back and forth because it cuts both ways, and try not to cut any rocks!"

Neil spent several days cutting down the tall weeds in the yard and raking the grass up in piles until Trudy could decide what to do with the yard debris. "Can't we burn this grass?" he asked his mother.

Trudy had no idea if they could have yard debris fires in Pacific Grove and imagined all kinds of things that could happen if they tried. "Why don't you keep all that in a pile away from the house, then put as much as you can in the garbage cans just before they collect the garbage?"

Neil did as he was told and the trash pile was eventually hauled away in three or four garbage collections. Neil had chosen to stockpile the yard debris in a far corner of the yard, and continued to add to the pile, and top off the garbage

Trudy's House

cans with the debris that he collected there. It took him almost a year to get rid of all the garden trash, and he resolved to find a better way, no matter what his mother thought.

One afternoon Neil was trimming a hedge near the side entrance of the house that the tenants used, when Frank Fristler came home from school and the two boys stopped and talked for a while. As they talked, their attention turned to a deeply tanned young woman wearing a brief pair of shorts and a tee shirt, as she cross the street below and began walking up the sidewalk toward them. Her energetic stride and perfect appearance kept their attention as she walked toward them.

"Hi!" she said with a smile as she passed.

Frank grunted a hoarse "Hello" and Neil smiled at her. He knew she was Dede Wilson, but Frank apparently had never seen her and didn't know she was his neighbor. He turned to look after her as she bounded up the steps and went through the tenant's side door of Trudy's house.

"My God!" Frank said. "Did you see the jiggles? Does she live here too?"

Neil smiled at Frank. "She lives across the hall in the big east room. Her husband is a Navy pilot."

"With the drunk Army guy?" Frank asked.

"No," Neil said. "In the other big room. Her husband's Navy."

"Oh! Yeah, yeah," Frank said. "You said that, didn't you. My mind was still on the woman. Damn! Isn't she something? I think she'll replace Rita Hayworth as my idea of a perfect woman."

Neil knew that his mother was wondering about the Army sergeant and he had just heard Frank refer to him as the "drunk", so he told her about it when they met for dinner. "Oh heavens!" Trudy said. "I hope he doesn't cause problems."

"Well," Neil said. "I think I'd worry about him tipping that heater over."

"He could burn us out," Trudy said. "Well, if we live through this I'll know better than to rent to a drunk in the future!"

"I never hear him after he goes in his room," Neil said. "He must just go to sleep."

"Maybe so," Trudy agreed. "I think he must get up at four and four-thirty."

The next morning Trudy was up early, too, because she was going to San Jose with Rosy. Rosy had phoned and told Trudy that it was eighty or ninety miles up to San Jose and that the trip took about two hours or more each way. If they were on their way by nine there would be enough time to have lunch and shop a little before coming home. "It's a little like Salinas," Rosy said. "The town isn't too big but they had some good stores that have to serve a lot of people. Besides, it's a good place to go when you get bored with Monterey!"

The drive to San Jose did Trudy a lot of good. It was relaxing and the weather was sunny and warm. It also gave Trudy a chance to see the countryside, including a final twenty miles that led down a flat two-lane highway from San Martin to

143

San Jose that was lined on both sides with huge old walnut trees. According to Rosy, the old timers said that the Spaniards originally planted the trees years ago and that they called the road, "El Camino Real"—The Royal Road—which was a system of roads that connected the missions and pueblos that the Spanish built throughout coastal southern California.

Rosy pulled off the highway into a wide parking area and joined a dozen other people who were poking through the fall leaves on the ground. "You like walnuts?" she asked getting out of the car to stretch. "Get a couple of bags off the back seat and lets pick some up."

Trudy grabbed two bags and followed Rosy. In ten minutes they had two bags of walnuts and Trudy was amazed. "Just imagine coming up here and getting all these nuts!" she said. Doesn't someone own them? Are we going to get into trouble picking these up?"

"It's all right," Rosy said. "These belong to the people. I get some every year. I get enough to last all year."

Rosy was soon on her way again. Along the way, she had been telling Trudy about her childhood years in Monterey and how the area had changed. They arrived in Downtown San Jose in time to have a quiet lunch, and as they had planned, shopped through the several stores that made up the downtown area in 1943.

"I like to drive up here earlier in the year, too," Rosy said. "There are usually lots of fruit and vegetable stands along the highway where you can stop and buy fresh things. If you stop now they don't have anything fresh."

Rosy dropped Trudy off at her front door in the late afternoon. Trudy thanked her for the ride and went in her kitchen and made a hot cup of coffee. In another few minutes she was sitting on her davenport, looking through the afternoon paper and sipping coffee. After while, she put the newspaper down, kicked her shoes off and lay back on the davenport to reflect on the trip to San Jose. Inevitably, her thoughts drifted around to her ever-present problem of how to develop the rest of her house so she could get more rent money coming in. She considered the need to build bathrooms in the unused laundry room a number one priority, but until she thought she could afford to have the work done, or find someone who could help Neil do the work, she had to delay what she was sure would be an expensive job. But, she thought, maybe there were things that could be done—something she hadn't thought of—before she built bathrooms.

Still sitting on the davenport, Trudy looked around to study her big living room and attached dining room. She really wasn't using the dining room. That could be her bedroom if she had a bathroom to go with it. Then she could rent the maid's room that she was sleeping in now. The opening between the living room and dining room was what Trudy considered old fashioned. It was wide enough to stand in the middle with both arms extended out to the sides. When

Trudy's House

she was young, they built sliding doors between the two rooms that slid back into wall cavities to make the dining room open, or they could be pulled closed to make it private. In this case the doorway might have been made for hinged doors that someone had removed. Trudy decided that it wouldn't be too hard for Neil to build across the opening and put a regular door in, and then she'd have that much done toward having her own apartment.

When Neil came in the kitchen and washed his hands for dinner a little later, Trudy called him from the living room. "Neil!" she called. "Come on in the living room. I want to talk to you."

Wondering what he had done wrong, Neil walked in the room where his mother was sitting on her davenport.

"You see this big doorway between the living room and the dining room? I want you to build a regular wall there and put a door in it instead of having this big opening. Then I could make the dining into my bedroom and we could rent the maid's quarters."

"Are you kidding?" Neil said. "I don't know anything about building walls and putting up doors!"

"You do so know," Trudy said. "You've been working around this house for a couple of months now. You must have learned something about working on it. What have you been doing all this time?"

"More than anything else, I've been learning about painting and cleaning up the yard," Neil said.

"Well," Trudy said, "I think you could build that wall if you put your mind to it. You know I'm not made of money. I have to get more money coming in so I can pay the bills and so I can hire someone to build the bathrooms that we need. That will be a terrible expense for me to handle."

"Mother," Neil said, "I don't even know how a wall is made. I wouldn't know where to start." Actually, Neil had started taking a woodshop class in school, but the teacher has just been talking about different kinds of wood and how to use different tools. The direction of the class was to teach the students how to make lamps, bookcases, and other wood products for the home. But, Neil noticed that there was a small scale model of a house in the woodshop, and the teacher did say that he would advise the students in any wood project they had. Neil was careful not to mention the class to his mother because he was afraid that she would want him to start a project that was over his head.

"Well," Trudy said. "You're so stubborn! How do you know you can't do it until you've tried! You certainly take after your father's family—all thickheaded farmers and teachers! Why don't you take off a couple of boards where it doesn't show and see how it's put together?"

"Yeah," Neil said. "I guess I could try it, but I think I'll have to get more tools."

"All right," Trudy said. "Decide what you'll need and we can go looking on Saturday. Now, go get ready for supper. I have a stew almost ready."

Several hours later, after Trudy and Neil had finished eating, Trudy returned to her living room with a hot cup of coffee, pulled her drapes closed and turned on the lamp by her davenport to read the afternoon newspaper. The evenings were getting cooler as time moved through October and approached Halloween. Trudy had discovered that the heat from a small fire in the fireplace could be very pleasant, and warmed the whole room. Neil had cut dead limbs for her to burn and she rolled sections of the newspaper into tight rolls that would burn almost like wood.

Trudy had just finished her coffee when she heard a car pull up in front. As she listened she heard men's voices, a door close, and footfalls on the side door steps and she knew that Sergeant Johnson was home. She listened carefully and heard him mumbling something and climbing the indoor stairway. He stumbled several times and Trudy thought that he was probably a little drunker than usual.

Dede Wilson had also heard Sergeant Johnson coming up the steps. She had been waiting for her husband to come home because they were going out to dinner to celebrate her birthday. So, as if acting on cue, Dede complicated things by rushing to the door and opening it to greet him. Instead of her husband, Dede found herself almost face to face with the evil smelling, disheveled, dissolute, Sergeant Johnson who was searching his pockets trying to find his room key. Startled, the sergeant looked at her and saw a very pretty young woman in a black cocktail dress, standing in a doorway with a dimly lighted room behind her. He abruptly stopped searching his pockets, drew himself up to his full, six foot-three height, pulled his uniform straight and took an awkward step toward her, taking her small hand in his.

"Why, hello, you lovely little thing," he said in drawl with a broad smile. He looked at her from head to foot and said, "My Gawd, doll, do you know how much you can make off me this evening?"

Sergeant Johnson chuckled hoarsely and wrapped his arm around Dede's shoulders and led her back into her room. In his drunken haze, he mistook her squirming resistance for teasing and play, causing him to laugh again, pull her closer and plant a lingering kiss on her neck.

"Oh, Lordy," he cooed in her ear as she tried to push him away, "You are a tender, shapely little thing aren't you? Hey! You got anything we can drink in here?"

At first, Dede was too shocked and surprised at Sergeant Johnson's drunken mauling to respond. Nothing in her sheltered experience had prepared her to deal with a drunken professional soldier who seemed to think he was playing with a bar girl. Finally, after he planted a wet, alcoholic kiss on her mouth, Dede reacted by slapping the man across the mouth as hard as she could.

Sergeant Johnson was surprised at her violent resistance and stepped back to look at her. "What the hell!" he said, and reached for her again when a voice behind him yelled out, "Elmer Johnson, you miserable bandy-legged jackass! You get your sorry Army ass over to your room where you belong and leave that woman alone! Do you hear me?"

Sergeant Johnson froze as if someone had thrown a switch. As he turned around slowly, Dede backed away from him, and looking past the man, saw a thin woman's shape in the hallway light. Dede took several more steps away from the sergeant and watched, as he turned from being a revolting lecher to an obedient, submissive husband who had been caught stepping over the line. He tugged his uniform into shape and faced the tiny woman who was still standing in the hallway.

"Jesus! Oh, Jesus!" Sergeant Johnson muttered softly. Taking little steps, he moved out of Dede's room and toward his own next door. He took no notice of the other tenants who were standing in the other hallway beyond the stairs.

"I came out in the hall because I thought I heard you at the door," Nettie said to him in a strong, steady voice, "and what do I see but you makin' a play for this poor woman. Just where do you think you are, dummy—back in North Africa?"

Sergeant Johnson was speechless. He pulled off his hat and rubbed his face. With his mouth hanging open, he looked down at his wife. When his eyes looked beyond her at Dede he said, "No! Oh, no!"

"Now, I want you to tell this woman that you're sorry you bothered her," Nettie said, "and you'd better hope to hell that she understands."

Sergeant Johnson looked at Dede and said, "Mrs, uh—I'm really sorry—uh."

"All right," Nettie said, "now get in our room and let's put an end to this!"

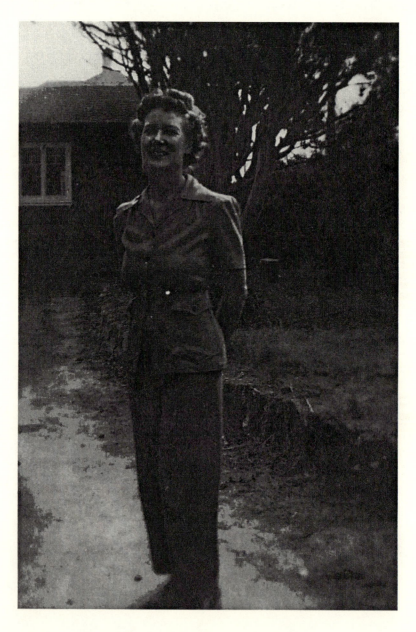

*Trudy in about 1944, in her side yard
with her garage in the background*

Trudy in about 1946.

Trudy and Neil with his dog, Jiggs, standing near the maid's quarters entrance.

Trudy in about 1948.

Trudy's house (right) on Central Avenue, facing west.

Trudy in about 1949.

Trudy (right) with youngest sister, Ellen (left0 with their mother (taken in about 1945.).

Trudy with Will Baker, on the maid's quarters steps.

Trudy's house, showing the main entrance on Central Avenue. (Note the original fence at the bottom of the photo

Another view of the front of Trudy's house taken in later years.

Trudy with Holden. The second story windows behind are the location of the verandah room

CHAPTER ELEVEN

Once back in his room, Sergeant Johnson sheepishly apologized to his wife who listened without saying a word to him, showing neither anger nor sympathy, then helped him out of his fatigue jacket so he could lie down and sleep it off. Nettie waited until she was pretty sure that her husband had dropped off to sleep then rushed next door to talk with Dede before her husband came home.

She knocked softly on Dede's door. When Dede answered, Nettie asked, "Can I come in for a couple of minutes? I need to talk with you about all this."

Dede opened the door wider and let Nettie come in. Dede gestured to a chair and Nettie walked over to it, saying, "I want to apologize for my husband," she said. "I am really sorry that he did that to you. Did he hurt you or just scare you?"

Nettie sat down and watched Dede shake her head for a "no", but assumed that Dede really didn't know what to say. She watched Dede daub a delicate hankie on her eyes to catch the moisture, but Nettie also noticed that Dede's eyes weren't red or swollen. She didn't look like she had been crying.

"Well, you know, as these Army guys go Elmer is really a pretty good man, all considered," Nettie continued. "Elmer's problem right now is that he's just back from the European front. He's seen an awful lot of war in North Africa and Sicily and he's having a problem living with it. He's really good when he's sober, but when he and his friends that he came back with get together he drinks too much and then he kind of goes off the deep end and thinks he's back in the war zone again. He got to be a problem overseas so they shipped him back here. The Army doctors have been working with him but they really don't know what to do. They've got him in a low-pressure job but he still drinks and goes nuts. I'm worried that they're going to give up on him and send him to another combat unit in the Pacific. I suspect that's what he really wants, anyhow."

Dede listened sympathetically as Nettie talked about her husband. "He really did scare me," she admitted. "I've never had anyone treat me like that. I didn't know what to do—yet, I guess it was kind of exciting."

"That was the woman in you coming out," Nettie said. "You're still so young, so maybe you don't know about basic feelings—kind of animal feelings. I was like that too. I didn't know what to expect when I married Elmer and became an Army wife. But I found out that most of these men have fast, hard lives—especially in wartime. Their friends come and go so fast that they don't even know their names, and their own lives are often so short that they don't even think about tomorrow."

"That's what my husband tells me," Dede said. "These are such awful times. We can't even think about settling down and raising families."

"Please," Nettie said, placing her hand on the girl's arm, "It would be nice to settle down finally—somewhere. I want you to know that I have nothing but respect for you and your husband, but maybe I could offer you a little advice, coming from years of being a military wife."

"I suppose you could," Dede answered.

"I think you're a very nice girl and you're very pretty. But, I'll be blunt. You'll find that life on a military base will be a lot easier for you if you wear "sexy" at home, and dress in more common clothes when you go out. Military bases are like fertility camps. The men walk around thinking sex 24 hours a day, and they're all so randy that they'd jump on any woman who gives them any kind of look. I imagine you'll think I sound crude and nasty, but I'm trying to do you a favor—okay?

"Believe me, just like you, I used to have little outfits that I thought were so cute and I wanted people to see me in them so that I'd look pretty. There was a time when I wanted to show off my legs and let men know how tiny my waist was, and on and on. The truth is that all that doesn't really matter. It's just being feminine, that's all. Most of those guys would try to get you in a dark corner if you wore boots and dressed in your grandfather's overalls."

Nettie hesitated and wondered if she was getting through to Dede. She studied the young woman's face for a moment, and then continued, "so wearing frilly, sexy, revealing clothing on a military base is like waving a red flag at a bull. Command doesn't like it and you'll find that you don't need it to get attention. It just draws a lot of attention to yourself that you don't need."

Nettie looked at Dede again and thought she saw resistance building to her and decided that she probably had already said too much. She realized that being much older, Dede might just think that she was being envious of her youth and beauty. However, Dede had accepted Nettie's advice and realized that she had to change her lifestyle to fit in as an officer's wife. In fact, she had decided that

after hearing Nettie out, she would not mention the incident to her husband. That would only complicate an already awkward situation.

Of course, Trudy was aware of the incident and gave it a lot of thought. Since it didn't directly involve her she wasn't sure what she should do. It also had only indirectly affected her house and her rentals. She and Miss Wembly talked about the incident the next morning and all Miss Wembly could suggest is to ask the other tenants if they were bothered by the incident. In the end Trudy decided to talk briefly with Mr. Kinght and Wilma Fristler and apologize for their inconvenience because she was supposed to be managing things. She did talk briefly with Mr. Knight who said he was not bothered by Sergeant Johnson's antics, as long as he didn't start a fire. Trudy never did get around to Wilma Fristler because she didn't seem bothered by what had happened, and Trudy would be the first to admit that she really wasn't inclined to apologize for other people's deeds. She had no desire to police other people's lives!

The incident between Sergeant Johnson and Dede turned out to be a lesson in Trudy's education about becoming a landlady however, because she was learning that there were hazards in renting rooms in your house to strangers. Trudy had always been the kind of person who enjoyed having interesting people in her company just about all the time. When she started renting rooms one of the things she enjoyed was having friendly people living so close to her all the time, and earning a living with it! Now she was beginning to understand that she couldn't rent rooms her way—to interesting and friendly people. There was an element of risk, and Trudy found that fact disappointing.

The rest of the week was fairly quiet, but Trudy thought that she would talk with Madge about Sergeant Johnson and see if she didn't know a way to screen the people who wanted to rent. After all, Trudy reasoned, if she could rent to drunks and not see the potential problem, the same thing could happen with people who could commit more serious crimes. One thing, Trudy thought, she had been in her maid's quarters bedroom and not heard the ruckus between the Johnsons and Dede when Nettie went after her husband. She decided that somehow she would have to move her bedroom into her unused dining room so she could hear what was going on in her house, and that would make the maid's quarters available to rent, too. Trudy phoned Madge and asked if they could talk, and was told she would be in the office that afternoon.

"Hi kid!" Madge called as Trudy walked into her real estate office that afternoon. "How's the rental business?"

Trudy sat down and told Madge about the incident with Sergeant Johnson. Madge listened as Trudy told her the story and what she thought about it. "Well," Madge said. "First of all, if you want to get them out you have to give them notice in a special way. As a rule, if they rent by the week then you have to give them a week's notice to vacate. If they rent by the month, then you give them a

month's notice. But, if they're destructive or threatening you can get them right out—probably with the help of the police. And—listen to this, Trudy—you can call the military police, or if you have time, call their unit commander and they will take care of it. But, don't do that unless they're a big problem. It really gets them in trouble with the Army—or whatever service they're in."

"Isn't there a way to find out if I'm renting to someone who would be a problem renter?" Trudy asked. "How will I be able to avoid drunks?"

"Sure," Madge said. "We all have to check our crystal ball! No—you have to develop some kind of sixth sense. It's almost like the police when they question people. You have to look for signs that they might not be good tenants. You know—red, bleary eyes, the smell of alcohol on them, red nose and cheeks, and so on. I think it's a good idea to talk with the people for a few minutes. You can't come out and ask someone, 'Are you a drunk?' or, 'I don't rent to spies and robbers. Are you one of them?' You just have to talk with them for a few minutes and see if they seem to be honest, or devious. Somehow you have to find ways to judge them. And, if they don't seem right for whatever reason, just tell them that you've promised the rental to someone else and you have to wait to hear from them before you can talk with anyone else—something like that. Sometimes, to protect yourself you have to lie a little."

"Well," Trudy said, "I guess I thought being a landlady was a snap."

"Everything we do has its drawbacks," Madge said. "A lot of people who rent use agents and referral services because they usually screen the renters and get references and guarantees. The military rental offices usually have some kind of guarantees, but they also inspect your rentals and set prices."

"I guess I'll have to think this all over," Trudy said. She didn't say anything to Madge, but she had decided to talk with Rosy next and see what she could tell her.

"So," Madge said. "How's the rental business, otherwise?"

"Well, I think I'm doing okay," Trudy said. "This drunken soldier sure shook me up, though."

"Well, you don't have a man in the house, either," Madge said. "That would make things easier for you. How many rental rooms do you have now?"

"I have five rooms rented," Trudy said. "I've got to get more bathrooms built in there so I can have more rooms to rent, though."

"You've come a long way since—what—August?" Madge said.

"July," Trudy said. "That was when I couldn't imagine myself as a landlady!"

They laughed together as Trudy thanked Madge for her help and walked out onto the sidewalk. The fog that hangs over the Monterey Peninsula all summer goes away in the fall, allowing the sun to warm the area until cooler weather starts in November and December. Trudy thought the weather was so pleasant that she decided to walk home and get a little exercise.

About ten days after the drunken event, Sergeant Johnson failed to come home at all. Nettie Johnson was concerned about him but said nothing. After all, it was wartime and the military often moved troops without notice, or held drills or nighttime exercises without notifying families until afterward. It was something that military families had to deal with.

Trudy, Miss Wembly and Wilma all had noticed that he had not come home and knew that something had happened. One morning Trudy sat eating an egg and dry toast and sipping her ever-present coffee when Wilma came downstairs and into the kitchen to make herself a small breakfast. They sat quietly at the table eating and talking when a car with Army olive drab coloring pulled up in front. Trudy and Wilma fell silent and watched as the car stopped. The driver got out and walked briskly around the car to open a rear door. A man got out wearing a dark Army uniform and carrying a leather briefcase. He straightened his uniform, looked left and right up and down the street, and then walked over to Trudy's front steps.

"Oh-oh," Wilma said softly. "He's a major. He's from headquarters. Something's up or he wouldn't be calling here."

Trudy got up from the table expecting to hear the doorbell ring. When it did, she trotted into the front room to the door and opened it. "Good morning," the man said in a matter-of-fact voice. "My name is Major Petrie. I'm, looking for Mrs. Nettie Johnson. Can she come here, please?"

Trudy assumed that he wanted Nettie to come down to him so Trudy invited the major in and ran after Nettie. Half-way up the stairs, Trudy called, "Yoo-hoo, Mrs. Johnson! There's a man here to see you!"

Trudy climbed up the rest of the stairs and rushed to Nettie's door to knock if she had not heard Trudy calling, but Nettie opened the door to see what was going on. "There's someone to see me?" she asked. "Where is he?"

"He's in my living room," Trudy said. "You can see him down there. I'll go finish my coffee."

Trudy went back down to the kitchen and sat to finish her coffee. As she did, she heard Nettie come down behind her and go in her living room. Trudy and Wilma were quiet as they listened, but could only hear the sound of voices and not spoken words.

"This isn't good for Nettie," Wilma said. "I'll bet that sergeant has done something really bad."

Miss Wembly came down to have breakfast, too, joining Trudy and Wilma at the table. "What on earth is happening?" she asked. "I was laying my bed asleep when I heard Trudy shouting on the stairs."

"Heavens!" Trudy said. "What on earth is wrong with me? I shouldn't have shouted like that! I'm so sorry! I'll bet you were out late again, too!"

"Well, I was out 'til one I guess. I have enough rest so perhaps it's a good thing that you did wake me!" Miss Wembly said. "I'll be getting positively lazy!"

Trudy's House

"Listen!" Wilma said. "I just heard your front door open and close." The three women sat at Trudy's kitchen table and watched the major walk away from Trudy's front door to his car, get in and drive away. He was gone in just two or three minutes. "Boy!" Wilma said. "He was all business!"

They heard a light rap at the kitchen door and turned as Nettie walked in. Trudy poured her a cup of coffee that she quickly accepted and sat down. "Well," Nettie said, taking a deep breath. "I guess you're all waiting to hear about Elmer. Well, that was an officer from Elmer's battalion headquarters. He said that Elmer and his friends got drunk at the Soldier's Club, then walked back toward their company area when they decided to give a guard at a pistol range a bad time. They took the guard's pistol away from him and shot up a target on the range. Nobody was hurt, thank God, and they didn't do much damage but fooling with the guard got them thrown in the stockade for the night where they could sober up.

Trudy and Miss Wembly were having a hard time following Nettie's explanation because they didn't know Army terms for things, but they did understand that Sergeant Johnson had managed to get himself in a lot of trouble and that it was going to affect Nettie. Wilma however, understood because she had been an Army wife a long time.

"That sounds bad," she said. "I guess they got his stripes to begin with?"

"Yeah," Nettie said. "They said that they might take his stripes, but they would cut orders today for duty in the Pacific area. His company commander is going to see him tomorrow."

"Damn!" Wilma said. "That's tough! That would mean the end of his master sergeant's pay and privileges."

"Well," Nettie said. "Not for long. They said he's going to Camp Stoneman before the week is out, and that he'll get his stripes again right away because they're so short of sergeants."

"Then, you're saying that your husband isn't coming back here again?" Trudy asked, still trying to follow the Army lingo—but getting better at it.

"That's right," Nettie said. "They said that they are confining him to the base until they can cut orders and arrange transportation to Camp Stoneman for him. I imagine that could be as soon as the end of the week. They won't let me see him now but I'm going to try and get all our stuff ready, then I'll head out as soon as Elmer goes to Stoneman. When they ship him out, I'll head for home until he comes back."

"What's at Stoneman?" Trudy asked. "Is that another Army base?"

"That's Camp Stoneman," Wilma said. "That's one of the Army's embarkation points for duty in the Pacific."

"My goodness," Trudy exclaimed. "It's all so complicated. This all must be very upsetting for you."

Nettie understood and smiled at Trudy. "I come from moonshine country," she said, "and I've dealt with drunks all my life."

"How awful!" Trudy said. "I guess I've never had to deal with them."

Sergeant Johnson settled Trudy's problem for her and she prayed that she'd never get another drunk in her house because she still didn't know how she would deal with the problem. Trudy said good-by to Nettie and cleaned up the verandah room wondering if she should just put off trying to rent it until the cool winter months were over. She decided to lock the room and just see what happens during the coming months.

During the next few weeks Trudy fell into a routine of getting things done in the morning so she could enjoy relaxing on her davenport in the warm afternoon sunshine. For Trudy, her time spent reading and napping on her davenport was not only relaxing, but it was therapeutic. She swore that the time spent there could heal any pain caused by the travails of the world. It was also the place where she felt that she could do her best thinking, and she would often stretch out on the length of the davenport and plot her future, or plan the development of her house before taking a mid afternoon nap.

Trudy had no idea what to expect as the weather in Pacific Grove changed through autumn and into winter. Of course she expected it to get cooler, but when she asked people like Rosy or Miss Wembly, they would only say that they were coming into the rainy season. Trudy came to the conclusion that reactions to the weather were different from one person to another. The rainy season on the Oregon coast could mean weeks of rainy, blustery days with a few cool, sunny days before the rain started again. She didn't think it would be the same thing in sunny Pacific Grove!

By the last week of October the days and nights were noticeably cooler, but Trudy was pleased that there had only been a few rainy days. The shady north side of her house that faced the bay was cool most of the time and Trudy avoided doing any outside activity there. When it was warmer she would sometimes decide that she needed to get outside and go pull weeds or rake the garden debris up. After it grew cooler, Trudy went for walks on the sunny side of the street instead of venturing out on the shady side of the house!

One thing that she had been thinking about was whether or not she should do anything with her tenants—especially the ones who had kitchen privileges—during the coming holidays like Thanksgiving and Christmas. Miss Wembly had brought up the questions one morning when they were having breakfast together. Her question had caught Trudy off guard because she had never been a person who was bound by traditions. She and her husband had celebrated holidays when they were close to friends and family in Portland. In the later years when they lived on the Oregon coast, they had closed the garage on Thanksgiving and Christmas for Neil's sake, but Trudy had never

Trudy's House

felt any special need to celebrate those holidays. If it were solely up to her she would ignore them.

Another thing that Trudy had been mulling over in her mind was that she had no private life. She had put all that behind her while she was trying to get her rooms rented, but in the three or four months that she had bought her house and moved to Pacific Grove, she only knew a handful of people. There were the ones that she had rented rooms to, but Madge had warned her about developing close ties with her tenants. For that matter, she hadn't met any that she would have wanted to know if she had not been renting to them. There was Madge and Rosy, who had been very helpful to Trudy, but Trudy didn't consider them much more than good friends. Trudy had met a few clerks in stores that were a little more interesting, but none that she would really go out of her way to know.

When she lived in Spokane at the beginning of the year, she was just starting to socialize with a few friends. Since then, her world had been turned upside down and her goals and interests had all changed. As she lay on her davenport, hashing things out in her mind, she began to hatch a concept that she would work with for years to come. Trudy had grown up with the belief—perhaps given to her by her mother because *her* husband was a traveling salesman and was rarely home—that all men knew how to fix all things around the house. Trudy used faulty logic to create her concept, but to her it was workable. Trudy wanted to build bathrooms in her useless laundry room so she could rent more rooms, and so she could move her bedroom to the useless dining room. Neil could not do the work because he was too young and he didn't know how. Trudy didn't want to take Rosy's advice and hire someone to do the work because she thought that would be an extravagance because any man could do the work. Trudy wanted to restore her private life and meet a few friends. One of her new friends would be a man who would help her by building new bathrooms for her! The next step for Trudy was to get out and meet people and develop friendships and perhaps find someone who could build her bathrooms!

About a week later, a few days before Halloween, Trudy decided to treat herself to an afternoon in Monterey to look over the sales that a lot of the stores were having. She took the bus downtown instead of walking so she could save her energy for walking through the stores. When she went into Montgomery Wards, she passed one of the women clerks who she had made friends with, as the woman was walking out the front door. "Trudy!" the woman called.

Trudy turned and waved and walked back outside with her. They stood at the edge of the sidewalk to visit for a minute. "Angela!" Trudy said. "Gee! What a surprise! I was just going in to look at the sales before I go home."

"Oh, well, I just got off for the day," Angela said. "Are you looking for anything special, or just checking things out?"

"No, nothing special," Trudy said. "I'm just looking."

"Well, this is a coincidence," Angela said. "Didn't you tell me that you're single?"

"Yes. Why?"

"I'm just on my way over to sit down for a while and have a Coke with my boyfriend," Angela said. "We both work standing on our feet all day, so lots of times we meet, sit down and relax, and talk over a Coke or two. It really helps my feet and legs. Anyway, I think he has his friend along. Do you want to meet someone?"

"Well, I don't . . . ," Trudy began.

"Come on," Angela coaxed. "He's a nice guy, and he's about your age."

"Sure!" Trudy said at last. "Why not? I don't really know anyone here, yet."

Angela's boyfriend's friend was clean-cut man in his thirties and both men were in the Army. The four of them had dinner and went dancing at the USO in Monterey by Lake El Estero. Ralph turned out to be friendly and easy-going, and he was about the same age as Trudy. Trudy noticed that Ralph had a bald spot starting on the back of his head and imagined that in the Army he must have been the object of a lot of cheap jokes. However as the evening went on, Ralph made several references to his bald spot to let everyone know that he wasn't sensitive about it. Trudy enjoyed the evening out. It was the first time she had been out in months.

Trudy saw Ralph a half dozen times during the next few weeks. They went to dinner, went dancing, and went sight-seeing in Carmel, which was barely half a dozen miles from Monterey and easy to reach by bus. Trudy enjoyed herself and felt invigorated by just getting away from the concerns of her house for a few hours at a time. She stopped seeing Ralph after he mentioned that he had been a grocery clerk in New York City, and really didn't know a thing about working on houses.

Several weeks before Thanksgiving Trudy began asking her tenants if they had any plans for a turkey dinner because she wanted to make plans for Neil and herself. Everyone except Wilma and her son, Frank, had plans to eat elsewhere, and Wilma wanted to keep that day free in case her husband returned. Trudy decided to get a small turkey for herself and Neil. That way, there would be enough food in case someone changed their mind.

Several days before Thanksgiving Trudy received a phone call for Wilma, but Wilma was not in. The caller only gave a phone number and a name and asked if Trudy would be kind enough to leave a note for Wilma. Trudy wrote the number down on a piece of paper and slid the paper under Wilma's door.

Several hours later Trudy was sitting on her davenport with a cup of coffee when she heard Wilma come in and go up to her room. Anticipating that Wilma would want to use the phone, Trudy opened the door to the hall and waited. Wilma came down in a few minutes, glanced at Trudy with a weak smile and

sat down to use the telephone. Trudy went to her kitchen so Wilma could have some privacy.

A little later, Wilma came into the kitchen saying, "Well, I guess I'm going to have to give you notice, too."

Trudy looked up at her, paused, and tactlessly said, "He hasn't been killed, has he?"

"No," Wilma said. "But he was wounded in Italy. I don't know how bad, but it must be fairly serious because they're going to ship him home."

"Heavens," Trudy said. "How awful!"

"I gave them your number because they're going to contact me in a couple of days and give me more information."

"Don't they know all about that now?" Trudy said. "Gee, you'd think they would give you all the information at once."

"I've talked with other wives about this," Wilma said. "It gets complicated because they have to get them out of the area where they were wounded, and to a rear area hospital, then they get them stabilized, I guess, and send them on to another hospital where they have room and have the kind of treatment they need. I think they have hospitals in North Africa and in England, and then I think they put them on ships to bring them home. Then, when they're back in the states they are sent to hospitals for special kinds of treatment, and if it's just recuperation, I think they send them somewhere near their homes. It gets pretty involved. Anyhow, they won't be sending him here, or anywhere on this coast. I'm sure of that!"

The next morning another call came from the chaplain's office at Ft. Ord while Trudy and Wilma were having breakfast. Wilma had a pencil and paper with her when she answered the phone and began jotting down notes as soon as she picked up the receiver. Trudy couldn't tell what Wilma was talking about because all she heard was "yes", or "yessir". Finally, Wilma hung up the phone and walked slowly back to the table as she went over her notes.

"Well," she said. "They say he was in a truck that drove over a mine somewhere in the hills outside Naples. They said he has a broken leg, concussion, facial wounds and an arm wound. They're going to let me know what the doctors say in a couple of days, but since they were going to send him home anyhow, this is probably when they'll do it."

"I suppose you'll want to meet him when they send him home," Trudy said, having no idea how the Army does things.

"Sure," Wilma said. "But, I think it will depend on how bad his wounds are. He told me in a letter I got a couple of weeks ago that they want him for training the new men. So, I suppose he could even do some recuperating on the job! Damn! You might even see me again!"

Wilma got another phone call several days later, and the information was what she expected. Her husband had been flown to an Army hospital in England where

167

they would do the medical work that he needed and let him recuperate several months, then send him back to a hospital near his home for more treatment and recuperation. They expect that it would probably be Fort Knox in Kentucky where he would recuperate before being reassigned. Wilma decided that she would move back home and get established there again so she could be with him.

Wilma and Frank moved out on November 12, the day after Armistice Day because she wanted to be with her family for Thanksgiving. Wilma had left her apartment pretty clean but Trudy heeded Madge's advice, that when someone moves out it's always a good idea to clean it over again so there were no surprises. Trudy had Neil help her clean up Wilma's apartment and get it ready for a new tenant.

Thanksgiving came and went uneventfully. Miss Wembly had a dinner with one the families that she worked for, even though she insisted that she didn't mind if she had missed a turkey dinner because she hadn't known Thanksgiving as a holiday until she came to America. They didn't celebrate Thanksgiving in England or in France where she had worked for so many years. Instead of bothering with cooking, Trudy and Neil had a Thanksgiving dinner at a Chinese restaurant in Pacific Grove.

Life returned to a routine for Trudy and Neil after Thanksgiving Day had passed. Neil concentrated on his schoolwork and socializing with his new friends, and Trudy returned to getting things done in the mornings so she could sit on her davenport in the warmth of the afternoon sun and relax. However, a day or two after Wilma left, Trudy began to feel old anxieties coming back when no one came to look at the room right away. A week or so later, Trudy had a terrible night tossing and turning and unable to sleep well. Once, she woke up in a sweat because she was having a nightmare about being escorted from her house by bank officials with documents in their hands, with Madge, Rosy, Faith, and Miss Wembly standing watching and shaking their heads. Trudy finally awoke with the rumble of morning traffic going past her house. She sat up slowly, holding her throbbing, achy head. She got half-dressed and put an old chenille robe on so she could go into the kitchen and make some coffee and dry toast. The morning sunshine was streaming into parts of her yard and across a corner of her kitchen table. What a difference, she thought, between her home on the Oregon coast and the house she owns now. This time of year, she thought, the Oregon coast would be gray and rainy.

A half hour later Neil came downstairs for breakfast before walking up the hill to school. Trudy was drinking her third cup of coffee and eating a second piece of toast and was beginning to feel a little better. She had been thinking about her nightmares since she got up and recognized that the problem was that she had rooms to rent again and not as much money was coming in. Then, there was the problem of having a verandah room that she really couldn't rent in the winter months. At least she had to get Wilma's room rented again. That would help.

Trudy's House

"Neil!" she called in a loud voice. "When you get home from school I want you to take another look around Wilma's room and make sure everything is all right. I want you to make sure that the lights and everything else works up there because I have to get that room rented right away. We need to get more money coming in!"

Trudy was not one for pleasant "Good mornings" and passing the time of day with people when she thought she had to get something done. Some people thought that she was being direct and outspoken, while others who knew her better thought that she was just being bossy. That included Neil who thought that his mother was giving him orders that he should just follow blindly, rather than working with him because he had thought that since there was just his mother and him in the family, Trudy's house was a cooperative family enterprise. In fact, as Neil got more established in Trudy's new home he was coming to the conclusion that he wasn't actually a part of the rental room business at all, but rather a convenient handyman who worked for no pay for a headstrong, bossy woman. Trudy's failure to understand his feelings caused Neil to lose drive and begin steering away from work on Trudy's house. He saw other kids in school earn money doing after school jobs for people, and he saw friends in high school take part time jobs to earn extra money. But for now, Neil just grunted at his mother in acknowledgement and went on with his breakfast. He decided he would talk with her after she rented another room.

As for the tenants, breakfast at Trudy's house had evolved into a conversational free-for-all that was shared by whoever happened to be there in the mornings. Usually, it was Trudy and Miss Wembly, and sometimes, Neil. But anyone who had kitchen privileges was welcome. Trudy enjoyed the breakfast sessions because they usually involved a lot of talk and gossip about the neighborhood or the town. With Wilma gone Trudy felt like something was missing and she hoped that the next tenant would complete the group at the kitchen table again.

Neil wasn't interested in the kitchen table gossip at all and avoided it for the most part. He would have preferred a quiet family breakfast but since it had been so long since he had experienced anything like that, he could only imagine what it might be like. The closest thing to it that he could remember was the break-of-dawn ranch breakfasts he had at his aunt and uncle's in northeastern Oregon. It was their biggest meal of the day and all the talk revolved around ranch concerns—hardly the intimate family gathering that Neil thought everyone had in the mornings. Going on fourteen, with a limited family background, Neil thought it was normal to have friendly family breakfasts and he did not know that there were other ways to live. He did not know that Trudy was not a caring, nurturing person. Again, he expected that it was normal to strive for a unified, friendly family and he did not know that independent people with selfish ambition existed. Neil would have to learn how to deal with such people in his own way.

After Neil had rushed off to school, Trudy sat alone in her kitchen sipping coffee and thinking about what had to be done that day. Suddenly, she realized that she had not hung her "Room For Rent" sign out in front and she cursed herself for being so foolish. She might have had Wilma's room rented by now! Trudy grabbed up the sign from her closet and rushed outside and hung it on hooks that Neil had placed there.

Rosy called her at a little after ten in the morning and asked if she didn't want to go over to Salinas with her again. They would be back at four or five o'clock that evening. "I need the company!" Rosy laughed, not realizing that she was answering Trudy's prayers for something to do that day.

"My Goodness!" Trudy exclaimed. "How nice of you to think of me! Sure, I'd like to go over to Salinas. I need to get out of this house for a while!"

The trip to Salinas to shop through the store was just what the doctor ordered for Trudy to get back on track again. As she and Rosy went through the day in Salinas Trudy began to brighten up. By the time they were driving back to Pacific Grove, Trudy was relaxed and talkative. Even Rosy noticed the difference. "You need a car, too," she laughed. "You need to get someone to teach you how to drive so you can get out of the house once in a while."

Trudy had to agree with her, but Trudy wanted to have more money in the bank and more rooms rented before she thought about a car. Until that time she would have to rely on friends giving her rides, and the transportation system on the Monterey Peninsula. Those thoughts made Trudy wonder if anyone had seen the sign she had hung out that morning.

When Trudy got back to her house it was so late in the afternoon that the sun was getting low in the winter sky. She had wanted to spend a little time resting her feet on her davenport in the warm late afternoon sun and think about the events of the day, but she had missed the sun and the big living room was getting cool in the waning sunlight. When Trudy put her purse down on the table by the door she saw a note that had been written on a piece of tablet paper. Trudy turned on a wall light above the desk and read the note. It had been written by someone in the Navy who was asking about the room she had to rent, and they wanted to know if there was anyplace on Trudy's property where they could set up some woodworking tools.

Trudy went searching for Neil and found him sitting in the big studio room listening to his adventure radio programs. Ever since the arrival of their old truck full of furniture that brought along an old radio, Neil had spent his late afternoons and early evenings listening to serial radio adventures that Neil thought were almost as entertaining as going to the movies. He often built a fire in the fireplace in the studio room and did some of his homework as he listened to the programs.

"Neil," Trudy called, looking down on him from the landing that was five steps above the studio room floor. When he looked up at her she continued, "I want you to come up here right now. Where did this note come from?"

Trudy's House

"I don't know a thing about it," Neil said, still sitting on the couch. "It was stuck under the door when I came home. I don't know who left it. I just stuck it up on your table."

"They want to know where they can do woodworking." Trudy said. "Can they do woodworking in the garage?"

"Yeah," Neil said. "I think so—as long as they don't need any heavy electrical power. There's plenty of room out there."

"Everything is ready to rent, isn't it? I'll tell them that if they want to rent the room, they can do woodworking in the garage. If he rents the room you should see what you can learn from him about carpentry. Maybe he can show you how to build me a wall," Trudy advised. "I'll have dinner ready in an hour or so."

The next morning Trudy phoned the number that the sailor had written on the note and left a message that he was welcome to stop by and see the room that Trudy had for rent, and he could look at the space that he could use for woodworking. When he and his wife stopped by that evening they rented the room and seemed pleased about the garage space where he could do his woodwork. Trudy was relieved to have the room rented again.

CHAPTER TWELVE

Trudy awoke after a good night's sleep. She had rented Wilma's old room the day before, and that morning—a Saturday morning—seemed like a day to get out and do things. She was rested and relaxed and was looking forward to the day ahead. When Trudy walked into the kitchen Miss Wembly was there ahead of her, contentedly spooning her way through a bowl of Wheaties and milk.

"Good morning!" Miss Wembly said between slow, rhythmic spoonfuls.

"I rented Wilma's room yesterday!" Trudy said happily. "Hallelujah!"

"Indeed?" Miss Wembly said as she "pinged" her spoon against the sides of her bowl as she ate the last bit of Wheaties and milk. "Who do we have now then?"

"Henry and Vivian Knox," Trudy said, reading the names from her logbook. "Their home is Albany, New York. He is in the Navy, and his hobby is woodworking. I'm going to let him use my garage as a shop."

"Isn't that interesting," Miss Wembly said as she daubed at something on her chin with a paper napkin. "Isn't it marvelous how they can bring people here, or move them about, in this vast nation. It's a modern miracle, really. They've come all the way from New York State!"

"Yes," Trudy said. "Mr. Knox works at the big gray building by the pier at the other end of Cannery Row. I wonder if he does woodworking in the Navy, too."

"Now, you say 'woodworking'," Miss Wembly said. "Does that mean that builds things—structures—or is that the kind of work that goes into furniture work, picture frames, and that sort of thing?"

"Why, I don't know," Trudy answered.

"Yes, while the English and American are so much alike," Miss Wembly said, "they can be so different at times."

"I guess I could find out, if you really want to know," Trudy said, not really caring what kind of work Henry Knox did. Her interest in Henry and Vivian Knox ended in their paying the rent.

Trudy's House

"No, that's all right," Miss Wembly said looking out the kitchen window as she talked. "I was interested in those things at one time, but not any more. I say, there's a car pulling up in front with a load of belongings in it. Are these your new renters?"

"Oooo! I'd better tell them to unload at the side of the house!" Trudy rushed to the front door to tell them.

From her position at the kitchen window, Miss Wembly could see about fifty or sixty feet of Central Avenue, from the front of Trudy's house on the right (that was almost at the corner) to a point that was just opposite of where she sat, on the left. An old six-foot boxwood hedge grew all along the sidewalk for 75 feet or so to the far left, and beyond view from the kitchen window, to Trudy's garage on the other corner. While the hedge blocked the view of Central Avenue from Trudy's kitchen, it did cut down on some of the street noise.

With nothing better to do, Miss Wembly nibbled on toast and drank her breakfast tea and watched Trudy talk with her new tenants as they began carrying things to Trudy's garage and to the side entrance of the house. In a few minutes, Trudy returned to her coffee and toast in the kitchen, and chat with Miss Wembly.

"I asked him if he did woodworking in the Navy and he said that he was a machinist in the Navy," Trudy said. "He said that when someone talks about 'woodworking' they usually mean they make things out of wood for themselves. He said he's just learning about it, but just enjoys working with wood as a hobby."

"Thank you," Miss Wembly said. "Thank you for asking about it."

Trudy watched Miss Wembly clean up after her breakfast. As she always did, she washed and dried her bowl and spoon and carefully put them away in her cupboard. Before Miss Wembly walked back to her room, Trudy began talking again. She felt like she needed to get Miss Wembly's thoughts on things that had been bothering her.

"You know," Trudy began, "I'm glad that I got that room rented so soon after Wilma moved out. It really upsets me to have a vacant room when I need that money coming in."

"Yes," Miss Wembly said, turning to look at Trudy. "We know, and you have no reason to worry because there just aren't enough rooms to serve this area. Of course, we all do our very best to stay out of your way when you're being pressed like that."

Trudy was shocked. "Really?" she said. "I didn't think anyone paid any attention to me!"

"Oh my yes," Miss Wembly said. "Haven't you noticed that your own son won't even stay around you when you're in one of those moods?"

"Really?" Trudy said again. Her gaze drifted to something outside as she thought about Miss Wembly's remark. "I didn't know that. Well, as you know, I

started this house on a shoestring. I need to get more money coming in because anything I do seems to be so expensive. When one room is vacant I really notice it. I can't help it. I start worrying all over again."

"Yes," Miss Wembly said. "I would expect it would. But, really, you're using so little of this house. I suppose you've already thought about it, but I would think that getting more of your rooms rented would help considerably, wouldn't it?"

"You know, I've given it all a lot of thought," Trudy said, "but I keep coming around to that, too. For instance, I don't need the dining room. I think I'd like to make that my bedroom. Then I could rent out the maid's quarters where my bedroom is now. They'd have that bathroom but I wouldn't have a bathroom."

"Yes," Miss Wembly said. "I've wondered about that, too. You could change the great wide doorway to the living room into a proper doorway, with a door in it, and then you'd have your own private bedroom. That's what I would do if I were you—can that be done?"

"I think so," Trudy said. "What else have you thought about?"

"Well," Miss Wembly said, pausing for a moment to think about it. "You could wall off the kitchen from the place where you sleep now, and rent the whole place out as a big room or a small apartment. I mean, the space is there now. It only has to be done, doesn't it. Perhaps you need to bring in a carpenter and let him give you some prices."

"Carpenters cost so much money," Trudy said. "I can just hire a man to do it all for me."

"Rubbish!" Miss Wembly said. "You'll want a good, reliable carpenter to do that work for you."

"Oh, Heavens!" Trudy said. "I can't afford that! Don't you think I could just hire a man to do the work?"

"Of course it's your house and you can do what you like, but I never married because all the available men were always down at a pub with their pints. For them, it was sweet Fannie Adams all day, and the louts were too big-headed and full of themselves to bother learning a trade so they could get out and earn an honest shilling!" Miss Wembly said. "If I were in your position, I'd want to find someone who can do a proper job of it!"

"Uh," Trudy said. "They what?"

"Sorry," Miss Wembly said. "They were lazy—did nothing. I lapsed into English!"

"Oh, anyway, I've thought about it too. The maid's quarters would just be a room for a while," Trudy said, "until I could catch up with all the costs."

"Yes, of course," Miss Wembly said. "And then, you have these two rooms off your kitchen that are useless to you. I don't think anyone uses laundry rooms and pantries any more in this country do they?"

"Heavens, no," Trudy said. "Well! Maybe on farms or in big families, I don't know."

"All right," Miss Wembly said. "I'm afraid that I don't have any suggestions for those rooms, but I would think that you'd have to deal with your dining room first."

"If I turn the dining room into my bedroom," Trudy said, "I have to have a bathroom nearby, and I think it would be in the laundry room. I can't be running upstairs to that bathroom because it already has enough users. What if someone is in there and someone else has to go? I think I have to build the bathroom first."

"Yes." Miss Wembly said. "Perfectly right! However, your Neil is a bright, capable lad. Maybe he can try his hand at that dining room wall."

"Yes," Trudy said. "That's what I thought. I don't think he wants to try, but I think I'll tell him to see what he can do."

Miss Wembly left the kitchen to get ready for an afternoon babysitting job, leaving Trudy to ponder ways to add to her income. It looked like they were going to have another nice day and Trudy wandered into her living room with a fresh cup of coffee. She sat on her davenport with the intention of reading a new magazine, but looked up at the opening between her dining room and living room again. She studied the boards and tried to visualize a regular door and wall there and finally decided that she would have Neil get started on the project. It didn't have to be done right away so he could work on it at his own pace. If he succeeded in doing the job, then that much would be done. The bathroom was the important thing and she knew that she needed an estimate of the cost. For Trudy who had never had work done like that, the job seemed almost impossible.

Trudy kicked her shoes off and put her legs up on the davenport to relax. She sipped her cooling coffee and studied the wide doorway across the room as if concentrating on it would get the work done. She could easily imagine a plain wall with a single doorway in it as if it were done. As she thought about it she became impatient for Neil to come in. She wondered if he had come downstairs early, had a quick breakfast, and left for the beach. Maybe he hasn't come down at all! Maybe he skipped breakfast and went to the beach with his friends. Trudy had no idea where he was, but wanted to talk with him about getting her wall and door done. She emptied her coffee cup and set it on the table beside the davenport so she could read.

As Trudy read, the sun began streaming into the living room and soon made its way to the davenport. Trudy had begun to take an interest in articles about psychic phenomena and had read a dozen pages or so when she heard Neil's steps coming to the door. She put down her reading as he opened the door and walked in.

"So!" Trudy said. "There you are! Have you been down to the beach?"

"Yeah," Neil said. "I walked out to Lover's Point."

"Well, sit down for a minute. I need to talk to you," Trudy said. "I'd like you to try to work on this wall. I want that opening closed off with a door in it."

"Mother, I told you before that I don't know what to do. You need a carpenter for that," Neil said, sitting down in an easy chair. "From what I've heard, building a wall is one thing but it's really hard to put a door up. Why don't you ask about it at the lumber company office? They could probably just send someone over for a day."

"Listen to me a minute," Trudy said. "You can think of all the ways to spend money! I want to do this so we can earn more money. I need to move in here so I can rent the room I'm in now. We need the money and that room has its own bath. I can get good rent for that. Now, changing this wall is only part of it. I need a bathroom, too, and I'll put it where the laundry room is now. I know you can't build me a bathroom, but I think that you can take your time and see what you can do with this wall."

Neil shook his head and looked at the opening. "Mother, I told you that I don't know anything about doing work like that. I don't even know where to start. I think you want the wall to look good, and I don't think I can make it look right."

"You know," Trudy said, her patience getting short. "I'm asking you to try it. I'm all alone here. When I bought this house I was expecting you to help out. This place is too big to take on all by myself! Now, I need a regular door and a wall put in that space so I can have a bedroom there. I think you can at least try it. Right now, there's time for you to work on it and learn."

Neil took a deep breath and turned to look at the opening where his mother wanted to build a wall. "I'll ask my shop teacher about it. One thing for sure, I'm going to need more tools," he said. "While we're talking, all the other guys my age and older have part time jobs and they earn spending money. I'd like to earn some spending money, too, and it looks like I have a job. I'd like to be able to take myself to a movie once in a while, or buy myself a candy bar or a book. Sometimes I need school supplies, too."

"So you think that with all my other expenses that you need an allowance, too?" Trudy asked. "Do you think I'm made of money? Here I am trying to make ends meet, and with winter bills coming up, asking you to help me make more money, and you've got the gall to ask me for an allowance!"

Without responding to his mother outburst, Neil got up and left the room. He would follow through on the things he said, including talking with his shop teacher because he had told his mother that he would. He would also start working on Trudy's wall when he knew what tools to get. He was sure his teacher would tell him what he would need. However, he had just about decided that he would try to find a part time job somewhere. He was sick of never having money.

Neil talked with his shop teacher early in the week and got a list of what tools he'd probably need and was told what he might expect to find when he pulls boards off to start the job. He showed the list to his mother so she would know how much she was spending. She gave Neil some money and told him to stop by the stores on the way home to see what he could find. Neil went straight to Wright's Hardware in Pacific Grove, where they had given him good advice when he was doing so much painting. He told the clerk that he was shopping for new tools and he was told that they didn't have a very good selection because the war effort was using so much steel. They suggested that he look in the second hand stores where he might find used tools. Eventually Neil found what he wanted and had the tools sharpened and cleaned up. By the following Saturday Neil was ready to start on Trudy's wall.

Trudy collected all the receipts on what he did, unaware of their value as tax deductions. Trudy collected the receipts to control Neil's spending to see where her money was going.

Following his shop teacher's instructions, Neil began the wall by carefully removing the trim boards—the boards that finished the original job—and pounding the nails back out and saving them. Good nails were in short supply because of the war and many people straightened their old nails and used them again. He saw at once that the old house was built using different construction methods than his teacher had told him about. The wall was made of a vertical double thickness of 1x12 rough-cut redwood planks that were sandwiched together to cover the cracks between the boards, and both sides were covered with cheesecloth so they could hang wallpaper on them. In houses built in the 1920s and later, it was common to find walls made of 2x4 inch boards that were nailed to form a structure that had wallboard or plywood on either side. He decided to stop and consult with his teacher.

"Hell-damn!" Trudy said when Neil told her that he had to stop until he talked with his teacher. "What's there to talk about? This building has been here for fifty years and it's still standing. Can't you go on working without talking to your teacher? We need to get this done!"

Neil looked at his mother's angry face. He knew that she was anxious to get the work done, and not necessarily angry with him. Nevertheless, He didn't like to have her pushing him, especially when she had told him that there was time to work slowly and learn about it. Neil went on and tried to do the work as best he could.

Everything in carpentry was done by hand in the 1940s. Also, the board sizes that were used when the house was built were no longer available. Power saws were almost unheard of on small jobs, and since the wall that Neil was trying to change was thinner than a standard wall, he had to cut a lot of wood down to a smaller size. Everything had to be adapted to existing old sizes. Consequently, Neil spent a great deal of time and energy cutting and sawing boards. After a few

bad starts, Neil eventually built a framework for the wall and door that would work. Two weeks after he started his project, Neil had built the wall and made it match the existing wall so it would look like a smooth wall.

It took him almost two more weeks to put a door in the wall and finish the project to Trudy's delight and satisfaction. Neil even used his leftover lumber and scraps and built his mother a six-foot clothes closet in the bedroom he had created. After it was painted, it looked like the new bedroom had never been a dining room. Trudy wasted no time in moving things in the new bedroom so they could begin on the maid's quarters.

One day, several weeks earlier, when Neil was just starting to work on his wall he had pulled some boards off the original wall. The boards were in his way and Trudy wanted them out of the living room because it made everything look so cluttered. Neil walked around the outside of the house looking for a place to store them out of the weather and finally settled on the part of the basement near the oil tank and furnace. He carried the boards down and stacked them on two old sawhorses that he had found in the basement.

As he carried boards outside he noticed that the day was much darker than usual and that the water in the bay was getting dark and choppy. By nightfall the wind had come up and he could hear it whistling through the house. Neil walked around the house before it got too dark to make sure all the doors and windows were closed. Trees around the house were bending and swaying with the strong gust of wind.

"What's going on?" Trudy said rhetorically as she looked left and right out the windows from where she sat on her davenport. "Are we having a wind storm? Neil! Do we have any candles in the house?"

"I don't know," Neil replied from the other room. "Should I go get some?"

"Gee!" Trudy said. "Look at it blowing! We had a windstorm like this once when we lived in Delake, and all the lights were out for several days. Yes. I'll give you some money and you can run out and buy some candles. I think we're going to need them! Maybe you should see if you can find a flashlight or two and some batteries while you're out."

Neil put on his jacket and started running toward New Monterey because he thought the stores were a little closer in that direction. As she waited for Neil to return, Trudy walked around through the parts of the house she could get to and closed blinds and drapes to keep the drafts down and help hold the heat in the house. Huge gusts of wind made the house creak and groan and were usually followed by the sounds of things falling down or blowing apart. Outside, Trudy could hear the sounds of bushes blowing against the house, and heard wood splintering and cracking as limbs broke from trees and either hung down, still attached to splintered tree trunks or fell to the ground free to be blown through the streets. Vehicle traffic on Central Avenue had almost stopped.

Trudy's House

Inside the house, sitting on her davenport, Trudy could hear the usual sounds of people running water and moving around in their rooms. One thing for sure, Trudy thought, the tenants are staying put and not venturing out. It would be dangerous for anyone to be out after dark with limbs and debris flying through the air. In fact, Trudy was getting concerned about Neil.

Just after dark the lights flickered once then went out. Trudy had a small fire in the fireplace and could see around her living room in the light that the fire made. She walked across the room and opened the door to the hall and stairway to allow light from her fire to illuminate the inside stairway. As she did, she heard steps and voices outside. The door opened, bringing wind with it, and Tom and Dede Wilson stepped inside quickly and closed the door after them.

"Good evening!" Trudy said from the stairway landing. She wanted to let them know that she was there. "Isn't this a terrible storm? I'm afraid that all our lights are out."

"Good evening!" Tom Wilson said. "Yes Ma'am! I think the lights are out all over—on this side of the peninsula for sure!"

"Really?" Trudy said. "How awful! I wonder if this is a hurricane? I sent my son after candles and he should be back any minute now. I'll see if I can't leave one burning in the hall, if I can find a safe way to do it."

"Don't worry about it," Tom said. "I have a survival light that I can leave burning in the hall. It'll last until early morning sometime, and this is just a storm—not a hurricane. The Navy says we get these big winds every now and then."

"Oh! My Goodness," Trudy said. "Thank you."

"By the way, Ma'am," Tom said. "Do you know anyone who has a boat in the harbor? The Navy says they expect a lot of damage down there tonight."

"Oh! That's awful!" Trudy said. "Really?"

"Yep," Tom said. "It's supposed to move through our area pretty fast, but they thought it would do a lot of damage. We flew a lot of planes out of the area this morning. The rest are pretty well protected."

Trudy heard her front door open and close and knew it was Neil. She went back into her living room and found Neil just taking off his wet jacket and hanging it by the fire. He picked up a wet paper bag and handed it to her. "A dozen plain candles, a flashlight with extra batteries, and your change is in the bottom of the bag."

"Well, light a candle for yourself and stick it on a plate. We don't want a fire on top of everything else," Trudy said. "There's a dinner for you in the kitchen. Maybe you'd better sit down and eat it before something else happens."

Neil found a plate for his candle, ate his dinner, and decided to go up to bed where he'd at least stay warm. It was still early in the evening but as he went upstairs he noticed that the house was quiet aside from the blowing wind outside. It seemed like it was late evening. Everyone else had probably decided

to go to bed, stay warm and try to sleep with all the strange sounds inside and out that the wind caused. Neil lay awake for a while and listened to the damage that the wind was creating. Once, he heard crumbling noises above him and crunching noises in the yard below. He wondered which tree or which bush had been ripped from the ground, but fell asleep with his head buried in the covers before he could go look.

Neil awoke early from a restless sleep. He stretched and wrapped his legs in the covers to stay warm. He remembered how he slept back on the ranch in eastern Oregon. It was cold in the house in mid-winter. His uncle tried to keep a fire burning in the kitchen stove at night, but the firebox in the stove wasn't big enough to have a fire that would heat the house. The kitchen was warm and they always hoped that some of the heat would make it to the bedrooms. It helped a little but Neil and his cousin wore heavy socks and long underwear and slept on their bellies to sleep warm. Neil learned from his cousin that once he was laying on his stomach to raise his feet up and allow the blankets to tuck under his feet when he brought them down again. That maneuver by itself kept his feet and legs warm all night.

Neil had gotten cool in the night and stayed warm enough by staying wrapped up in his blankets and tucking his feet in the covers like he had done in eastern Oregon. He listened for a few minutes, but heard no wind—only the surf on the beach. Neil got up and dressed, feeling chilly in the crisp morning air, then went downstairs and outside to see what had happened in the storm. It was only six-thirty in the morning and almost no one was up.

Looking around, Neil was amazed to find broken limbs hanging down from the tall cypress and pine trees When he walked up to the corner, he saw whole limbs laying in the middle of Central Avenue, along with boxes, trash can lids, and rags. The town was a mess! He walked across the street and looked back at his mother's house. Everything looked fine until he noticed that patches of composition shingles were missing and some of the bricks were missing from her chimneys. The rest of the house looked okay. No broken windows as he had expected. Neil crossed back over the street, walked passed the front of the house and down to the opposite corner, looking everything over and seeing only a few broken branches in the trees in front of the house.

Neil walked down Fourth Street to the back of the property, then down through the back yard toward Fifth Street again. Halfway through the back yard he stopped dead because he had just noticed that the entire back porch—the porch that served Trudy's laundry room and pantry—had blown down and lay in a crumpled, splintered heap on the ground. He quickly realized that his mother or anyone might open the laundry room door, and it looked like it was 10 or 12 feet to the ground and the broken up porch! Neil quickly went back in to put a barricade across the door inside.

Trudy's House

When he went into the kitchen his mother came walking in from her bedroom. "What's up?" she said when she saw him.

"I went out early to see what had happened to the house," he said. "Don't try going out through the laundry room to look because you don't have a porch there anymore."

"What?" Trudy exclaimed. "Oh, no! Not another expense!"

"I guess so," Neil said. "It's completely gone. I was going to block it off somehow because you don't want anyone opening that door."

"No!" Trudy said. She rushed back into her room to get dressed. "Is it raining?"

"No," Neil said. "Just a little cold."

Trudy put an old coat on, went outside and around the house and stood looking at the broken remains of her back porch. "Hell-damn!" she cursed. "How could this happen when I'm trying to get ahead!"

Trudy turned to Neil, who had followed her outside, and said, "Maybe you can clear all this up before someone hurts themselves on it. I guess you'll have to stop working on your wall until we can get this fixed.

"I have to check and see if there's school today," he said. He went back inside and phoned the school to see if there were classes and found out that school was closed for the day.

"By the way," Neil said when his mother came in, "The wind tore up a few shingles on the roof and blew some bricks off the chimneys."

"It blew bricks off the chimneys?" Trudy asked. "Are you sure? How could it blow bricks down?"

"I don't know, Mother," Neil said. "Maybe a limb blew down and hit the chimney. Maybe the bricks were loose and the wind caught them, but you need to get them fixed."

"Can't you get up on the roof and fix those things?" Trudy asked.

"No!" Neil said. "I don't know anything about fixing bricks and working on roofs. You'll have to get someone who does know about it. Besides, that's a high roof and I don't have anyway to make it safe for me to be up there."

"Well, let me think about what I can do," Trudy said. Fears about money swarmed through her head. While Neil made himself some breakfast, Trudy took a hot cup of coffee into the living room and sat on her davenport to sip the coffee and ponder the situation. Trudy felt overwhelmed and dejected. No sooner had she begun to feel like she was getting somewhere as a landlady when an expensive catastrophe happens and upsets everything. She could bar the laundry room door and just not use it. She didn't need to use it anyway, so the expense of dealing with the back porch could be put off for a while. She would have to have someone get up on the roof and make sure it wasn't leaking and patch it, if that's what it took. She wasn't sure about the chimneys so she would have to

181

have that looked at, too. How much would she have to spend, she asked herself. Maybe it might come to one or two hundred dollars. She had the money to pay for it, but it would certainly cut into her savings.

"Hey!" Neil called from the kitchen, "The lights just came back on!"

The sound of Neil's voice startled Trudy. "Neil," she called in her loud voice. "Would you look and see if that laundry room door is locked? Maybe you should put something over it so it can't be opened. Maybe you should nail a board across it so it can't be opened. I can't afford any more expenses. If this keeps up we'll be out on the street! Imagine!"

"Let me finish eating first!" Neil said.

A few minutes later the telephone rang and Trudy answered it. "How did you like that wind and rain?" the voice said. "Did it remind you of the Oregon coast?"

Trudy realized it was Rosy and her spirits rose a little. "Just like the Oregon coast!" Trudy laughed. "Wasn't it awful? We had wind like that every winter up there."

"Yeah, we don't get those too often but when they come you know about it," Rosy said. "I think I lost a little tree, but the building is okay. How about you?"

"It blew my back porch off," Trudy said. "And we had a little damage on the roof. I don't know about anything else."

"Well, you're real exposed out there in Pacific Grove," Rosy said. "I expect there's damage all over P.G. You know, the fishing fleet really got hit—washed big boats up on the beach in Monterey. They're going to try to get them out of the sand with bulldozers. It's real bad. They say some of the boats got tossed into each other and they're wrecked. The news on the radio is already calling it the 'The Big Storm of December, 1943!"

"Oh, how terrible," Trudy said. "I suppose it will ruin those fishermen. It sounds like they're losing everything if their boats are tossed up on the beach."

"Oh, maybe some," Rosy said, "but I think most of them have insurance. You know, you should call your insurance agent right away if you haven't done it. You want them to get started on your claim!"

"Oh heavens!" Trudy said. "Something just came up! I'll call you later." Trudy had completely forgotten about insurance and she was so ashamed of herself that she couldn't tell Rosy! She was thankful that Rosy mentioned it, though. Trudy was not accustomed to ownership and things that went with it, like insurance, was not a thing that she'd automatically think of. Trudy decided to phone Madge, feeling relieved that she probably wouldn't have to pay for the damage after all.

"Trudy! Hi! How are you doing?" Madge said.

"Well, I thought I'd better give you a call because I had some damage from the storm last night," Trudy said.

"Did you?" Madge said. "I was about to call you to see how your place held up. It was pretty windy and the fishing boats sure got caught. Why don't you tell

Trudy's House

me about the damage. I'll write it down and have someone come by and look it over. Okay?"

"Okay," Trudy said. "Well, the first thing is that my back porch blew off. Then my son said he could see some roof damage and bricks missing from the chimneys."

"Have you noticed anything else, Trudy?" Madge asked. "Are you planning to be home today? I'm going to send a contractor that I always use. His name is Joe Scattarelli and he drives a red pickup truck. Okay? I'll talk later. 'Bye."

Trudy hung up too, realizing that Madge was probably really busy. Trudy made up her mind that she didn't really have any place to go so she'd just stay home and wait for the contractor to come. The condition of her roof was her major concern because she didn't want leaks if it rained. Trudy thought the other damage could wait, so she went back to her davenport with a new cup of coffee to read until Madge's contractor showed up.

It was early afternoon when he stopped by. Joe Scattarelli parked in front of her house and got out to look around the yard and study the house to look at the storm damage. Trudy came to the door when she saw a red pickup park in front. By the time Trudy caught up with Joe, he was in the back looking at the wrecked porch. He looked up as she walked down the sidewalk. "Are you Mrs. Anderson?" he asked.

"Yes, but everyone just calls me 'Trudy," she said. Trudy saw Joe as a very businesslike, capable, trim man with an obvious Italian heritage in that he was dark and medium sized and seemed to have Italian mannerisms with lots of hand gestures.

"I'm just taking notes on what has to be done, Mrs. Anderson," he said. "I'll have to submit an estimate for the work that has to be done, and Madge will get an okay to do the work. It doesn't take long for them to act on it, though. To begin with, you're going to need a new porch, so I'll measure that out, then I'll get you to tell me about the other damage"

Trudy looked around the rest of the house while Joe measured and took notes. Like Neil said, she didn't see any other damage. When she came back around the house, Joe was looking for her. "You said there was damage on the roof?" he asked.

"My son said there were some missing shingles and some bricks had fallen down," Trudy said.

Trudy watched Joe get a ladder off his truck and stand it up and extend it by pulling on a rope that hung on the ladder. He leaned it up against the roof above the verandah room and climbed up to examine the roof. He disappeared from her sight as he walked around the roof looking at the damage. After ten or fifteen minutes, he reappeared on the roof and descended the ladder to the ground. Joe lowered the ladder and tied it back on his truck, then walked over to Trudy with his notebook.

"Well, I'll tell you," he began. "The porch is the biggest thing. It'll take three or four days to rebuild it—and it'll take that long because there are so many steps in it. I counted sixteen. Your roof needs some new composition shingles but it shouldn't leak if it rains because there's the old roof underneath it. That might take half a day, and another half day to put new mortar in some of your chimney bricks. You didn't lose the bricks—they're still up there. So, I'll be in touch with you when I hear back from Madge. Do you have any questions, Mrs. Anderson?"

"No, I guess not," Trudy said. "How long do you think it will be before you get back here?"

"Oh, I think it might be between Christmas and New Years," Joe said. "Do you want me to haul the old porch away?"

"No," Trudy said. "I'll have my son knock it to pieces and cut it up for firewood."

"Okay," Joe said, "You really shouldn't try to burn that, you know. You shouldn't burn painted lumber."

"Really?" Trudy said. "Well, you can leave it anyway."

Joe tipped his hat to her and said that he'd see her in several weeks. Neil went back to work on his wall.

CHAPTER THIRTEEN

After finishing the wall that divided Trudy's living room from the dining room, Neil and Trudy realized that placing a door to the living room was one thing, but she still needed a door between the kitchen and dining room—now Trudy's bedroom. Neil had learned that there was a standard for door widths in a house. Outside doors were wider than inside doors, and closet doors were narrower than inside doors. Inside doors were usually made lighter and thinner too. So, Neil walked through parts of the house looking for a door that wasn't being used that was a standard inside door size, and found one in the maid's quarters. The style was a little different because it was coming from a newer part of the house, but that didn't really matter. The door was seldom used because it separated a small anteroom from the main room, and no one ever closed it. Neil saw that the door fit but the hinges didn't match, so he spent a day putting new hinges on it and fitting it in.

Trudy got Neil to help her move all her belongings into her new bedroom, realizing that she was pushing things by having her bedroom where she wanted it, but no bathroom. She would have to use the big bathroom upstairs or continue using the bathroom in the maids room until Neil was able to get the room ready to rent. Trudy decided that since they had not even looked at the maids room yet, it would be at least a month before she could rent it. Any inconvenience was all right because it was a step toward getting another room ready to rent, and who knew what might happen in a month as far as more bathrooms were concerned? Trudy was becoming an optimist in some things concerning her house. After all, it had only been months since she was talking with Faith about what she could do to earn a living, and now she was a landlady!

There was another big reason that Trudy wanted to have her bedroom where the dining room was. It was close to the middle of her house, and in the months that she had been thinking about it, she was convinced that she could hear almost

everything that was happening in her house while sitting in her living room. It was important to her to be able to hear people coming and going, and she could tell by the footfalls she heard just who was on the move. In fact, the incident with the drunken Sergeant Johnson had made her certain that she wanted her bedroom where her dining room used to be. When she was in the maids quarters, she could only hear noises outside and noises above her.

One afternoon after Neil had finished the wall in the dining room and moved all his mother's things into her new bedroom, he looked for his mother and found her sitting on her davenport reading a magazine. "It's about ten days before Christmas," he said. "Are you going to get a Christmas tree?"

Trudy put down her reading for a minute and looked at him. "I don't see how we can afford to get a tree and all the trimmings, do you? I mean, we're still trying to get started here. It's only a few months since we bought this house and all we've been doing is paying for things. Aren't you old enough yet to live without a Christmas tree?"

Trudy had not cared about Christmas since she was a teenaged girl. She always looked on it as a scheme that is promoted by businesses to increase sales for the year and she could never understand why anyone got sentimental over the holiday. In 1943 in particular, she thought that Christmas cards, decorations, and all kinds of presents were an expense that she could ignore.

"You know, my last family Christmas was back in Delake several years ago," Neil said. "My aunt and uncle had a Christmas tree in eastern Oregon. They had presents and all that, but I didn't really feel like I was a part of their family. I thought it would be nice to have a tree and put it up in the artist studio by the big window so the tenants could see it as they went by."

"Well, I don't know," Trudy said, obviously interested in getting back to her magazine. "Maybe if you could get one for nothing, or next to nothing, but then we'd still have to decorate it. Why can't we put all this off until next year? By then we'll be able to pay for it. Now, let me get back to my magazine."

Neil went back to working in the maids quarters, going to school—which was due to be out for two weeks through Christmas and New Years—and visiting with his friends, but the approaching Christmas holidays weighed on him. He did miss having a tree, or some kind of Christmas decorations. He did think that there should be some decorations on the house, like at least a Christmas wreath on the door if not a tree for people to see. He missed not having spending money to buy things with. He thought he should buy something for his mother and several of his friends. He might even buy himself something. If he were in Oregon, he could go out in the forest and cut himself a small tree. There was some pine forest just beyond the P.G. city limits, but he knew he's be arrested or fined if he cut a tree there! For the time being, Neil forgot about celebrating Christmas and just continued his life.

Trudy's House

One morning a few days later, Trudy came into the kitchen from her new bedroom and found Miss Wembly at the table quietly eating her breakfast. "My goodness!" Trudy said, "aren't you up early!"

"No, not really," Miss Wembly said. "It's after eight. That's when I usually come down when I haven't worked the night before."

Trudy squinted against the bright sunlight coming in the kitchen window. "Why is the sun so bright in here this morning?" Trudy asked.

"Yes," Miss Wembly said. "I wondered about that, too. It seems much brighter than usual, doesn't it?"

"I think a limb used to block the light," Miss Wembly said. "Now it's direct sunlight." Miss Wembly was wearing sunglasses and peered up toward the sun using the window frame to help block the strong sunlight. "Yes," She said. "I see it now. The top of one of those trees across the street has been cut. It used to block the sun for us."

Trudy peeked around the edge of the window at four or five cypress trees in the empty lot across the street, with her hand over her eyes. "Where?" she said, "I don't see anything different. Oh! For heavens sake, look at that. I see it now. That last tree is shorter than it was."

Trudy stopped talking, glanced at Miss Wembly muttering, "Hell-damn!" and walked out into her side yard through her front door. In a few minutes, she came back up the path dragging what looked like a ten-foot limb. Trudy dropped the limb on the path and came back in the house. She went straight to the hallway and called upstairs, "Neil! Come down here, please!"

Miss Wembly, who had been watching Trudy with curiosity, suddenly understood what had happened, finished her breakfast and was washing up when Neil came down the steps and walked into the kitchen.

"What's the matter?" Neil said. "Why did you call me?"

Trudy looked at him and said, "What's the meaning of the limb in the yard?"

"You won't buy a tree," Neil said, "so I thought I'd cut the top off one of those trees and use it for a Christmas tree, or make wreaths, or something. It's no good, though. It's not filled out all the way around. It's like a limb."

"We have that holly tree in the back yard," Trudy said. "Cut some twigs off that for decorations if you want. Cut enough for the tenants, too, in case they want some. Just make sure that each twig has some of those pointy leaves and red berries on it."

After he left, Trudy dunked a piece of Melba toast in her coffee and tossed it in her mouth. "It's peaceful and quiet now," Trudy said, relaxing. "Neil has been pestering me to buy a tree and I told him I'd think about it. But I don't want a tree and get involved in all that rigmarole. I'd think he'd be old enough to see all that for what it is."

187

"What poppycock!" Miss Wembly exclaimed indignantly.

"Poppycock?" Trudy repeated with surprise. "Really?"

"Yes, of course! Never mind yourself! You have your young lad to think of! He may work like a man, but he's a young boy! He still needs his visit from Father Christmas!" Miss Wembly said in an outburst, then immediately regretted it. "Oh dear. I'm terribly sorry. I shouldn't . . ."

Miss Wembly obviously felt like she had stepped out of line by commenting on something that was none of her business, but to her surprise Trudy took her comments as nothing more than heated conversation and advice. Trudy continued talking as if Miss Wembly had never raised her voice.

"Well," Trudy said. "Maybe you're right. He certainly can be a big help at times." That afternoon Trudy took Neil with her and they bought a tree and some basic trimmings at the dime store. Neil put the tree in the artist studio where everyone could see it.

Christmas Day was quiet and unremarkable for Trudy and Neil because Trudy had made her feelings about lavish Christmases very clear to everyone. Until she felt comfortable with her financial position, Trudy let everyone know that she did not want to spend money unnecessarily. She established a pattern for giving that she would follow many times in the future. Neil received gifts that were things he always needed, like underwear and socks, and he was never given anything that was unexpected or things that might be considered a luxury gift.

Neil expected this kind of giving the first year but not in future years when there was more money, but he continued to receive necessary, practical things. He was used to skimpy Christmas gifts because he grew up in the depression years and his family rarely had extra money. When the country went to war in 1941, it was just emerging from a deep nationwide depression and many families were too poor to give their children gifts, and the children understood it. In his own case, Neil's father was a skilled, factory trained automobile mechanic who could not make a living in Portland, but did well where he lived on the coast. Unfortunately, his fortunes began to increase as the country was going to war. In many ways, Trudy's thinking was influenced by her struggle to make ends meet as a depression-era housewife in the 1930s. As she became established as a landlady and enjoyed some prosperity, her thinking remained unchanged.

On Tuesday morning, two days after Christmas, Joe Scattarelli drove up in his red pickup truck with a load of lumber on the back. In less than ten minutes he was hard at work rebuilding Trudy's back steps and porch. Trudy and Neil weren't aware that he was working there until they heard pounding on the back of the house. Neil put his jacket on and went out to see what was happening and found Joe hard at work.

"Good morning, my friend," Joe said pausing in his work. "How are you today?"

Trudy's House

"Fine," Neil said. "I guess we're getting a new porch."

"That you are! It will be a helluva lot better than the last one. I personally guarantee it!"

Neil smiled and said, "I'll tell my mother that you're here. Do you need some help?"

"Yeah," Joe said, sizing up Neil. "I think in a couple of hours I'll need someone to help me put the stair horses up. You look strong enough. How's your back—strong, too?"

"Yessir!" Neil said with a grin. "I'll be out in an hour or so to give you a hand,"

"You're a good man," Joe said, and waved as Neil went back inside to tell his mother that she was getting a new back porch.

"So soon?" Trudy said. "Isn't that wonderful? And here I thought I would have to pay for that porch and it wouldn't be done for months! Hallelujah!"

Neil had found his mother relaxing on her davenport sipping coffee and munching Melba toast when he told her that Joe was working on the porch. Trudy had been looking through the newspaper for after Christmas bargain sales, and the newspaper was still spread out around her feet.

"What are you going to be doing today?" she asked.

"Well, Joe asked if I would help him in an hour or so. After that, I'd like to go down to the beach before I start working on that room."

"Yes," Trudy said. "Be sure to help him if he needs help. Maybe you can learn something watching him. I guess I should go out and help, too."

Trudy and Neil walked around to the back of the house to see the progress. What Trudy really wanted was to get all the cut off wood for her fireplace before Joe tossed it out. He had already rebuilt part of the porch structure using old and new wood. "I use some of the old with the new," Joe said. "That way, I save the insurance company a little money so they'll hire me again—but, I don't use it if it isn't good lumber! No Sir!"

"So, do you get most of your work from the insurance company?" Trudy asked, thinking about her bathrooms.

"Not all, but enough to make me a busy man," Joe said. "Especially after this big storm! I'm glad those don't come our way too often. My brother lost his boat when it was tossed up on the beach in Monterey."

"Oh, my goodness!" Trudy said. "That's terrible."

"It's not so terrible," Joe said. "It was an old boat that was going to cost him a lot of money. It wasn't a good boat because it wasn't built very well and it needed a lot of work. It's like you and your back porch, here. It wasn't built very well. It needed work and God got rid of it for you. You have insurance to get it fixed, and so does my brother, Sal. We'll build him a good solid boat, and I will build you a solid back porch. Besides, my brother tells me that this is a lousy year for fishing!"

189

Neil chuckled at Joe's colorful speech, but Trudy remained deadpan because she had stopped listening when Joe started talking. Instead, as he was talking, Trudy was thinking how handy it would be to have someone like Joe around the house. She also noticed that Joe was in good shape for a man that she guessed was in his forties.

"The sun doesn't get to this side of the house so it's usually cold back here," Trudy said. "Come on in for some lunch when you're ready, and get warm again."

"Thank you, Mrs. Anderson," Joe said. "It is pretty cool out here so I'll take you up on the offer. I'll be there in a couple of minutes, as soon as I'm finished with what I'm doing."

Trudy went on in to heat up a can of soup, and told Neil that he could have a sandwich while she talked with Joe. Trudy rushed around the kitchen and got a lunch ready in time to meet Joe at the front door and show him in.

As Trudy led Joe from the front door to the kitchen, Joe looked around at the rooms saying, "I think I've driven past this house almost every day of my life and you know, this is the first time I've been in it."

"I'd show you through the house but a lot of the rooms are rented," Trudy said. "I can show you the studio, though." Trudy led him out through the kitchen door to the hallway and down the steps and into the studio room.

"My God!" Joe exclaimed. "Just look at this. You know, this could be turned into a nice rental room. All you need is a wall separating the room from the traffic coming through this outside door. Simple!"

"Maybe simple for you because you're a carpenter and you know about these things," Trudy said with a friendly grin. "There's just me taking care of this house, and my 13 year old son who is still a schoolboy."

Joe looked around the room and shrugged his shoulders. "You need to put a little money into this place and you'll have a gold mine. Now, I have to get busy! Where's that soup you were talking about?"

Trudy led Joe into the kitchen where she put out some soup, lunchmeat and bread since she had no idea how much Joe would want. When he asked where the bathroom was, Trudy pointed the way for him to go upstairs to the big community bathroom. When he came back down, Joe sat down to eat. Trudy had a cup of coffee while he ate, expecting him to comment about the bathrooms at any moment.

When he had finished his soup he leaned back and looked outside for a moment, then said, "You know, I would say that you need two more bathrooms. You need one for yourself and one for that big studio room you have there." As he ate, Joe suggested other things that should be done to make her house better. When he finished, he thanked Trudy for the lunch and went back to work on the porch, never once offering to help build anything, to Trudy's consternation.

It took Joe two more full days of work to finish the porch with Neil working now and then as his helper or "gofer". When they worked together they talked and Joe found out a few things that he had been wondering about, like how they had found the house and how they had paid for it and that Trudy didn't have much money to hire work done on the house. Joe was a practical man and was always interested in promoting jobs where he could and Trudy certainly had the work to do, but perhaps not the money to work with. Well, he thought, he didn't have to charge her full price. After all, Trudy was an attractive woman!

On the third day Joe finished the back porch by putting a final coat of paint on everything then cleaning up the mess he had made. When Trudy came out to look at the porch, Joe looked at her for a moment and said, "You know, I'm a single man and I don't have anyone to take to the New Year's Eve ball at the San Carlos Hotel. Would you like to go with me?"

Trudy had already decided that she liked Joe and had been wondering if he was single because they appeared to be close to the same age. But most of all, she was really interested in the fact that Joe knew about repairing houses and seemed to be able to deal with any kind of repair work. Meeting him seemed to be an answer to her prayers!

Surely a man who was raised in Monterey has some girl friends!" she teased, fishing for information about him.

"Yes, and all my girl friends got married years ago and have a houseful of kids!" Joe said. "I was married to one for eight years but she was a smoker. She got a cancer in her lung and died in less than a year. That was ten years ago and I still hate cigarettes! Now, I guess I am at an awkward age where the girls I used to know are all married, and they won't start leaving their husbands for another ten years. Even that's no good because they won't be divorced. The Church doesn't allow divorces. That makes a very difficult situation for middle-aged Catholic bachelors because that only leaves a few widows."

"And I'm a widow," Trudy said with a smile, "but I don't think you're middle-aged yet."

"Oh boy!" Joe said. "I really stepped in it didn't I? What I meant was that the number of ladies I can date is really limited. Protestant men can get serious with divorcees, though. There are a lot more of them! As for saying I'm middle-aged, it gets more sympathy!"

Trudy agreed that she would go to the New Year's Eve ball. Trudy thought that Joe was probably a strict Catholic and didn't really mind. She was not a Catholic and had always been scornful of some the demands of the church, but she respected them, and she could tolerate members of the church as long as she wasn't brought into it.

"It'll be nice to get out of this house for an evening," Trudy said.

"I need to get out and kick up my heels, too," Joe said. "And this year, I'll have the next two days after New Year's Eve to listen to the big football games. It will be a big weekend for me. I'll be living next to my radio!

"Listen, I'll phone you and let you know when I'll pick you up to go to the ball, but I just remembered that I have to get up on Mrs. Anderson's roof and fix a few things up there. Will you excuse me, please?"

By the end of the third day of work at Trudy's house, Trudy and Joe had had a lot of opportunity to talk, and the talk was mostly about her house and the things that needed to be done. While Joe was finishing the work on her house, Trudy sat on her davenport and thought things over. She was looking forward to New Year's Eve dancing and visiting, but she thought that Joe's big interest in sports was an ominous sign. Trudy had never had much to do with anyone who was consumed with sports but she had certainly heard about them and they seemed to be the most boring people she had met. With those people, Trudy thought, all their efforts and money went into sports one way or another, and all their conversation was about sports. She had known several women whose husbands were immersed in sports and the women were very unhappy with their lives.

Trudy shifted on her davenport to get a better look at a pair of seagulls that were gliding on the wind. She wanted to be lazy and think about things that weren't important, but she forced herself to think about the work that had to be done. She needed some idea of how much the bathrooms and other improvements she had been thinking about would cost, but now after Joe's comment about the studio room, she wondered how much that wall would cost. Then she thought that maybe a bathroom for the studio room, and a wall to enclose the room were really one job. She had already decided that she couldn't have one without the other! That thought left Trudy wondering how much she could rent the studio room for, and was the expense and trouble worth it?

Trudy tried to remember how much money she had in the bank, and how much cash she had hidden in various places. Trudy had discovered that she was always needing cash for something, so instead of running to the bank for extra cash, she had started keeping some money in a perfume box in her vanity drawer, and several hundred dollars split up in several caches pinned to the insides of clothing hanging in her closet. All her life Trudy had always felt that she was short of money and now she enjoyed knowing that she could put her fingers on fifty or a hundred dollars at any moment. As Trudy mentally added up the amount of money she could put her hands on to hire someone, she dozed off in the comfort of her davenport.

When Neil unlocked the front door and hour or so later, he woke Trudy from her nap and she sat up with a start and placed both feet on the floor as if she were going to stand up. She blinked her eyes and scratched her scalp and

watched Neil come in and close the door behind him. "So, it's you!" Trudy said. "Where have you been?"

"Uptown," Neil said, walking toward the kitchen. Trudy followed him in the kitchen to warm her coffee pot.

"I saw Joe out there just as he was leaving," Neil said. "He said he would phone you in a day or so."

"He left already?" Trudy asked. "I wanted to talk with him about building a bathroom."

"Oh?" Neil said. "Is he going to build a bathroom?"

"I don't know," Trudy said. "I wanted to ask him how much he'd charge, because I don't know if we can afford that right now. If I hired him we wouldn't have much money left if we needed something. Suppose one of us got sick or had an accident? What would we do? We need to have money because as you'll find out, you can't do anything without money!"

"I know, Mother. You won't give me an allowance. Remember?" Neil said sarcastically.

"Well, you don't need money," Trudy said. "You have everything given to you!"

"Maybe it's time for me to get a part time job somewhere," Neil said, "because I do need money."

Trudy gave Neil and angry look, started to say something, and stopped. Finally, she said, "Well, let me think about it."

"For whatever it's worth," Neil said. "I think you should have your bathroom because it would mean that you wouldn't be using the big bathroom upstairs, and you wouldn't be using the one in the maids quarters and you could get that rented."

"Those bathrooms will cost a lot of money," Trudy said.

"Well, you can just do them one at a time, can't you?" Neil said. "I guess you might have to do the plumbing for both under the floor, but above the floor you could just build on for now."

"I suppose so," Trudy said. "I have to see how much money I have before I start to do anything." Trudy just looked at Neil for a moment, thinking that she needed to talk to Joe or someone so she had a better idea about what could be done. She wasn't sure that Neil knew anymore than she did. She sipped her cold coffee and looked out the window at that passing traffic until Neil went upstairs.

On New Year's Eve Joe picked Trudy up early enough to go have a nice dinner in Monterey, and from there it was a short walk to the San Carlos Hotel. The San Carlos was the tallest building in Monterey, and the only building with more than five stories. In fact, the hotel had about ten stories and was obviously intended to be the center of social activity in the area when it was built years before the war started. As Trudy walked up to the hotel entrance with Joe, they passed a long, outdoor fishpond near the entrance. Trudy looked up at the tall,

elaborate façade of the building and imagined that even the lower floors offered a wonderful view of the city and the bay.

The opportunity to have an evening on the town was invigorating for Trudy, and the dancing and celebration amounted to a feeling of *déjà vu* because the carefree atmosphere reminded Trudy of her feelings and goals when she still lived in Spokane a year earlier. The evening out with Joe and the gaiety of the ball actually helped Trudy put the development of her life during the past year, and the sweeping changes in her lifestyle into a perspective that she could understand and deal with. Without consciously considering it Trudy had rounded off what had been a single dimension, unbalanced life into a multi-faceted lifestyle. She had moved from a desire to return to a carefree life, through a period of self-absorbsion, exploration, and introduction to responsibility and maturity, to experience first hand, a glimpse of one possibility for the future. In other words, in time, Trudy would come to understand that responsibility and maturity had its own tangible rewards.

Trudy wanted to talk with Joe about her bathrooms. Neil's ideas and her planning were one thing but she really wanted to get the views from someone who know what they were talking about—and get some idea of the costs, too! However, true to his word, Joe wouldn't even answer his phone for several days after their New Year's Eve date. He was completely immersed in football! When Trudy did catch him about a week later, he was still talking about the games with his friends, and anyone else who had followed the games. Trudy was amazed at his addiction to football because when the subject came up, Joe's face lit up and he would stop whatever he was doing to talk about a football play. He was so involved with the game that he would go out of his way to go to a movie theater to watch the plays on the *Movietone News* segment that was shown between the featured movies.

When Joe and Trudy talked again, there was less talk about football games, but Joe said that he had at least another month's work repairing storm damage, then he was obligated to spend several months helping his brother build a boat. It would probably be April or May before Joe could even think about building bathrooms for Trudy. Sometime in the early months of 1944, Trudy lost all patience with Joe Scattarelli and looked for better prospects.

Trudy's short relationship with Joe had brought her around to considering going to church again because Joe and all his friends and family were Catholics and went to mass every Sunday. While no one ever said anything to her, they assumed that she went to church somewhere, too. She wondered if a situation would ever come up when someone might ask what church she went to, and what she would say. She would be put in a defensive position and be forced to say something, and she didn't want to say that she never went to church to a religious group of people.

Trudy's House

Trudy had never been religious and it wasn't that she didn't believe in God, because she did. It was more that she didn't find the tradition and trappings of organized religion very appealing. Trudy was drawn to the metaphysical and occult kind of religion, instead. She liked the idea that her way might give her in-roads and answers to the mysteries of life, which Trudy felt were also created by God and that her interests were just in another part of religion that was not as popular to the general public.

Now that she was getting established as a landlady, Trudy was also becoming aware that she was living in the kind of place that many people dream about and she was in daily contact with interesting people. Trudy was beginning to think that she had gotten very lucky and fate was responsible. In Trudy's mind fate was also a province of God's and was therefore a part of religion. She didn't question it further. She didn't tell herself that fate was a predestined event, or course of events, that were planned or not planned by God. She didn't even claim that she had become one with the universe or that she had found the true path in life. She might have called it destiny, but to Trudy the concept of destiny didn't include the occult sciences of fortune telling, astrology, telepathy, and anything else that could be considered fate.

Like almost everything that Trudy did, she never took an in-depth serious interest in the occult. Aside from a few times in her life, she never attended meetings with spiritualists or astrologers or consulted with anyone about the future. That would have cost money, and Trudy was not that serious about fate and destiny to go through the inconvenience and expense of attending meetings and follow teachings. Instead, she preferred to talk about the occult with friends and claim that whatever happened in her life was due to fate. Beginning when she began to feel established in Pacific Grove, and continuing for years, Trudy began buying books and magazines on the occult and read about people's mystic experiences in her leisure time on the comfort of her davenport. While she still subscribed to the local paper and thumbed through it every afternoon after the paperboy tossed it on her steps, and still read a few articles in the women's and home magazines that friends passed on to her, the bulk of her leisure reading was in the fate and mystic experience books and magazines.

One sunny afternoon in February, Neil came walking home from school and saw his mother sitting on her front steps talking with a soldier in uniform, as all military men had to be in the war years. The soldier had been leaning on the front fence, but turned and faced Neil when Trudy called out. Neil saw that the man was slim and muscular, and reminded him of the ranchers he had met in eastern Oregon who were hardworking outdoor men.

"Oh, Neil!" she called when she saw him. "Come over here. I want you to meet Arnie Sorenson. Mr. Sorenson is in the Army!"

"Hi!" Neil said, shaking the man's offered hand.

"Howya doing, kid," Arnie said with a big familiar grin. "Boy! You're a big guy! Watch out—the Army will be wanting you!"

Neil laughed and went on in the house, recognizing that his mother had found someone else who she would try to persuade to do some work for her. A few days later, Trudy told Neil that Arnie was indeed a farmer from Wisconsin, but that he worked as a mechanic in a motor pool at Fort Ord.

"He's a farmer. Imagine!" Trudy said. "I'll bet he knows about building things!"

"More likely he knows about hard work on the farm," Neil commented, knowing full well what kind of work Arnie was used to as a farmer.

Chapter Fourteen

Neil was still a few months short of his fourteenth birthday and he was just beginning understand the concept of dating. Only a few months earlier he had thought that dating was a silly practice that young people did to dress up and go dancing. His limited experience with socializing included a juvenile rapport with his classmates in grade school and a social vacuum on the ranch in Oregon, and now he was beginning to feel handicapped getting along with his friends in school.

Most recently, he had been trying to get along in the eighth grade and had found that anything he had once known about socializing simply wasn't working. His classmates were his own age and they were about to move on to high school where socializing was a different thing again, and Neil had no idea what to expect. Friendships that he had made were based on qualities other than the accepted norms for his age. His friends and acquaintances in school had learned not to invite him to social functions that were based on ball games and structured school events, because Neil thought that ball games and dances were foolishness. Instead, they were friends because they liked his friendly attitude or willingness to help with their projects. However, as Neil was approaching his fourteenth birthday he was beginning to notice the girls and he was beginning to think more seriously about dating as a way to socialize with the ones he thought he might like.

Neil's physical maturing also had the effect of altering his understanding and toleration of the events and interactions of the world around him. Although he was a long way from being worldly, he was beginning to understand that everyone, no matter what age or station in life, had goals and needs that they wanted to satisfy to fulfill some demand or expectation that they had placed on themselves. Neil was also learning that these goals were not the same for everyone, but each goal and each person's need was as valid as any other was and therefore was not to be ridiculed or condemned, but was to be respected.

Therefore, in Neil's world as recently as six months ago, he might have been critical about his mother's going out with different men a year after his father's death, but he was beginning to understand she not only needed to get her house set up to rent more rooms and get more money coming in, but that she was still relatively young and needed male companionship. He thought that she was foolish in expecting that most men could do construction work on houses, but he also had the nebulous idea that his mother was more interested in meeting men than in finding competent help in fixing her house. Consequently, he developed a casual "wait and see" attitude about her friendships. The fact that he had been introduced to Arnie Sorenson so soon after making friends with Joe Scattarelli did not really bother Neil because he was beginning to understand life.

Within a week, Arnie was stopping by fairly often just to visit for a half hour or so, or to stop and have dinner with Trudy and Neil. He seemed like a friendly, outgoing man who Neil thought had the best qualities of a farmer in that he seemed quiet, patient and good humored. He told Trudy that he was a mechanic in one of the motor pools in Fort Ord, but he missed his farm.

"By golly," Arnie told Trudy soon after they had met, "this sure is a big house you have here, but how in the world do you take care of it when you don't even have a car? Don't you ever have to run errands or just go after things? You know, the way the government has the rationing set up, if you can show that you need a car to run your business you can get a little extra allowance for gas and tires."

"Yes, but I live here," Trudy said. "I'm just renting out some rooms in my house. Can I still call this a business?"

"Of course you can, Trudy," Arnie explained. "Renting rooms is your business. It's the way you make money to live."

"Well, but I don't have a store. I don't sell anything here," Trudy said. "I don't think that's the same thing, is it?"

"Trudy," Arnie said, "it's whatever you do to make a living. It doesn't matter if you sell things or make things, or have a business washing out milk cans. Whatever you do to earn money, unless you work for someone else, that's your business. And, if you use your car to go out and buy the soap and brushes to wash out the milk cans, that's an expense for you! If you earn a dollar or ten dollars to wash out the milk can, it's your business. If you don't earn anything then you need to raise your prices!"

Arnie chuckled at his own joke. "Seriously, though," he said. "I think you need a car here. I don't see how you can get along without one."

Arnie stopped by Trudy's house late on Sunday morning, just before Valentine's Day, and gave Trudy a small box of candy. Neil, Trudy and Miss Wembly were chatting at the kitchen table after they had eaten their breakfasts when Arnie rang the doorbell. Miss Wembly rinsed her breakfast dishes and left before Arnie came in, and Neil left after saying "hello". He knew that his mother

would take Arnie on what was becoming a ritualistic tour of her house, hoping to inspire him to roll up his sleeves and build something, and Neil felt that he would be more comfortable at the beach. With his growing maturity he also joined the ranks of those who thought that Trudy should just hire someone to do the work that she needed. He had a growing conviction that his mother was wrong in her expectation that any man could do plumbing and electrical work and her persistence with that idea was getting embarrassing.

"Well," Arnie said to Trudy as he looked at the long, narrow laundry room, "Yeah, I think this would be a good place for a bathroom or two. You could build a wall right across the room and have space for two bathrooms, all right. But you know, I don't know nothing about that stuff. I can nail up boards to keep my stock in place or make boxes for chicken nests—that kind of thing. But, I'd hire a carpenter and a plumber to do this. Yessir, I would! It's your place and you want things done right!" Arnie's normally smiling expression suddenly looked very serious.

"You can so do this kind of work," Trudy coaxed, trying to play the reluctance out of him, and at the same time paying no attention to his advice. Trudy missed his serious expression.

"No," Arnie persisted. "The Army made me a mechanic and I can farm. That's it. Now, I can see that you need a good car and I want to help you get one, whether you think you need one or not. I think you're a nice lady and that you need a little help. I intend to do what I can."

Trudy was speechless. She had never expected anyone to offer to help her with a car. She hadn't even been thinking about a car! "I, I don't even know how to drive," she said.

"I will teach you how to drive," Arnie said. "Now, if you have a little money to buy a good used car I will fix it up for you and teach you how to drive it. Can we do that?"

"Well, yes that's a deal," Trudy said, "but how much money do I have to have?"

Trudy finally realized that Arnie was not a man that she could manipulate and she also quickly realized that a car would give her a lot of freedom—even with the gas rationing. Trudy loved her house, but now and then she felt like getting away from it and doing something for herself, like exploring the neighboring towns or just looking through stores.

"I think we can probably find a car for three or four hundred dollars, and maybe less! We'll have to go looking and see what there is." Arnie said. "What we would do is buy a car that suits you, then I would take it out to the post for a week or so and go over it and make sure everything works then I'll teach you how to drive it and you can get a driver's license. Okay?"

"Yes," Trudy said. "Okay"

During the next week or so, Arnie came by several evenings and made plans with Trudy about her car and how much she could spend on it. Since no new cars were being built during the war, Trudy's choice was limited to whatever used cars they could find in the newspaper ads and in the car lots around Monterey. They had agreed at the start that they would not mention a car to Neil because they thought he would be bothering them with questions and suggestions that they didn't want to deal with.

At the end of the week, Arnie finally located a car that he thought would be ideal for Trudy, and was in good enough condition to fix up. Trudy bought the car and Arnie drove them around in it for an hour or so as a driving test because doing that, he could tell more about the condition of a car. Finally, he stopped at Trudy's house and let her out, promising that he would bring the car back in a week or so and he would have it in first class condition for her. Until then, he told Trudy that she had to buy insurance on the car and go to the Motor Vehicle department to get a driver's manual. He told her to study it, and get a learner's permit if it was required.

Trudy followed Arnie's instructions almost to the letter, but took one look at the driver's manual and thought it was too complicated and put it aside. She didn't see or hear from Arnie all week, then on Saturday morning he pulled the car up to the curb and Trudy, who had been sitting in her kitchen window watching the passing traffic, saw him and came outside. Arnie came over to her fence at the edge of the sidewalk, smiling proudly.

"Here's your car, as promised," he said.

"It looks wonderful," Trudy said. "It's gleaming it's so clean. Did you have to do a lot of work on it?"

"Yes, I did," Arnie said. "It needed a lot of fixing up. I worked on it all my free time but it's in perfect shape now and it should last you years if you take care of it."

"Really?" Trudy said. "How wonderful! I'm sure that I must owe you money for the work you did, don't I?"

"Not much," Arnie said. "Maybe fifteen dollars is all. Most of it was adjusting and repairs, then I washed and polished it out at the fort."

Neil came around the house and saw the car and looked at Arnie. "Your car?" he asked.

"No," Arnie said. "This car belongs to your mother."

"Yeah?" Neil said looking at his mother. "You bought a car? Neat! It looks like a—what? A '37 Plymouth sedan?"

"And solid as a rock!" Arnie said proudly. "It's a good car for your mother. But, it's not going anywhere until your mother learns to drive it, and gets a drivers license. She has to get a driving manual and read it, and you have to help her because you'll be driving soon! Right?"

Trudy's House

"Well," Trudy said. "I got the driver's manual but I still have to read it."

"Make it easy on yourself and just do one section at a time," Arnie said, "and let Neil quiz you on it and that way you'll remember it."

Arnie took Trudy out on a ride in the car and taught her some things about the controls as he was driving. Seeing that she had to read the booklet, Trudy spent the next week going through it, thumbing back and forth through its pages until she was sure she understood the instructions. Then, taking Arnie's advice, she gave Neil the booklet and asked him to question her on the rules. Finally, Trudy told Arnie that she was ready to take the learner's test and Arnie got off work early and drove her to the Motor Vehicles Department for her test.

A couple of hours later, they pulled up in front of her house with Arnie driving. Neil was cultivating the front yard inside the hedge when they arrived. Trudy got out of the car and walked through the gate, then turned back toward her front door when she saw Neil. "Well?" Neil called after her. "Did you get your license?"

"Hell-damn!" Trudy said. "I guess I'll just have to study that book!"

Arnie walked in behind her holding his finger to his lips so Neil could see that he should not be asking questions right now, and Neil nodded his head and went back to the garden work. Once inside the house Arnie reminded Trudy that she need to study hard because the car would give her freedom to come and go as she liked and she wouldn't have to ask friends to ride to San Jose or Salinas. Trudy made them some hot coffee and settled down as they drank and talked.

"Maybe you should ask them if you could bring your coffee with you the next time you take the test," Arnie joked.

Trudy spent another week sipping coffee and relaxing on her davenport. Typically, she would sit down to read her driver's manual for a while, then put it aside for some reason and read the newspaper or a magazine, or anything else that looked more interesting until she began to feel a guilty conscience about the driver's manual and read that again. Trudy thought she would see Arnie again the following Saturday, and asked Neil to begin quizzing her on the driver's manual again on Thursday. She arranged to meet Arnie again on the following Monday afternoon for another test and she received her learner's permit, which allowed her to drive with a licensed driver.

After that, Arnie came by whenever he could get free and took Trudy out for a drive. Eventually, they took side trips to all the near-by towns and Trudy did all the driving. Finally, Arnie made Trudy drive up every hill he could find to make sure that she understood the fine art of starting out on a hill with a manual shift car. After six weeks of taking drives around the Monterey Peninsula Arnie told Trudy that she had become a good enough driver to start driving on her own but reminded her that she had to get her driver's permit, and he took some time to explain to her that for the test, she would go driving with someone who

would judge her ability to drive. "It won't be a long drive—maybe five miles or so—but they will want to see how well you drive the car," Arnie told her. "It will be a driving examiner and they will ask you to park the car, go up a hill and stop and start, and maybe go through some traffic. They will watch you to see if you're watching the other cars and all that. Now, don't get nervous. It only takes an hour or so. Just keep your head and I think you will be okay. Is there anything you think we should go over first?"

"No," Trudy said. "I think I can do it."

They went down to the driver's license office and Trudy took her driving test and passed it with only a few minor mistakes. Arnie was delighted and took Trudy out to a dinner that evening to celebrate her getting a new license to drive. "Well, Trudy," he said. "You've done it! In just a couple of months you have bought a good car and you've learned to drive it! Now you can drive it wherever gas rationing allows you to go!"

"Gee," Trudy said. "I certainly couldn't have done it without your help! You're a good friend to have."

"Thank you, Trudy. I'm glad I was able to help you." Arnie said. "This war has uprooted almost everyone and changed all our goals. I wanted to have a good life on a good, productive farm. Now I'm here in a place I never thought I'd see, working as a mechanic and my father is running my farm. You had your whole life turned upside down when your husband died. Sometime soon, the Army is going to ship us out and I guess I'll be seeing another place I never thought I'd see. I wanted to take you out to dinner to celebrate your getting a license, but also because I probably won't be seeing you again. They'll confine us to our work areas pretty soon, so this is also a good-by dinner. I want to wish you good luck, Trudy, but I don't think you'll need it. I predict you'll have a good life where you are."

Trudy was deeply touched by Arnie's kindness and sincerity, even though she had decided early in their relationship that they really didn't have much in common and so to her, Arnie was a bore. In fact, she had pushed through her driving lessons with him and concentrated on her getting a license to drive because she looked forward to the freedom she would have in driving her own car.

While she was grateful for his help in getting her a car and seeing her through the process of getting a driver's license, Trudy didn't miss Arnie and she never heard from him again. Since he had never tried to contact her Trudy assumed that the feeling was mutual for Arnie, or that something had happened to him when he went overseas.

Trudy used her car as often as gas rationing would allow, and in doing so she came to cherish her car and worried about it. It occurred to Trudy that she should have a good safe place to keep her car and began to wonder if there was still some room in the garage that she had rented to Hank Knox a few months

earlier. Late one afternoon she noticed that the garage windows were open and knew that Hank was working on something. Wood shops didn't interest Trudy at all and she had left Hank alone with his hobby until now, when she decided to find out if there was room for her car.

"Yoo-hoo, Mr. Knox!" she called from her garden outside.

"Yes?" a voice called from inside the garage. In a minute, Hank stuck his head out of one of the windows. "Someone calling me? Oh! Mrs. Anderson! Were you calling me?"

"Yes," Trudy answered in musical tones from where she was standing in the garden. "I was wondering if there is still room for my car in the garage."

"I'm sure there is," Hank said. "I have some things that I'm working on scattered around, but I can fit them into one side of the garage. I'm sure there is plenty of room. Here, I'll open the door so you can see."

Trudy walked around the garden path and up to the side door of the garage and waited while Hank moved things around inside to open the door for her. In a few minutes, Hank opened the door for Trudy to look inside. She saw what appeared to be a half-dozen wood projects scattered around the floor in various stages of construction, and something that Hank appeared to be working on under a light near some windows.

"I really only use half of the garage," Hank said. "This is a two-car garage and so there's plenty of room on the other side for your car. I'll just make sure that there's nothing in your way when I close this place at night. That way you can just open the other garage door, there, and pull your car in." Hank opened and closed the door for Trudy so she could see how it worked.

"That's looks easy enough," Trudy said. "I'll be sure to keep the door closed, too."

"I would appreciate it," Hank said. "I have some sharp tools that kids could really hurt themselves with. By the way, as long as I'm talking with you, we are having a man transferring into our shop. He and his wife are traveling this way now from the east coast and we expect that they'll be looking for a place to live. Is it all right if I have them check with you when they get here?"

"Sure!" Trudy said. "When are they coming?"

"We think they'll be arriving in about a week. Judging by his rank and his ti ne in the service, I don't think they'll be young people. More like 30 or 35, I'd think, so they shouldn't be a problem," Hank said.

"How wonderful!" Trudy said. "Thank you for telling me."

Trudy took Hank's inquiry as a personal favor to her instead of what it was—a favor of helping the new man and his wife find a place to stay, because Trudy still wasn't thinking of her rental rooms as her personal business. Trudy continued to think of her house as her home in which she rented rooms, rather than a building where the business was renting rooms.

Trudy looked at the things that Hank was building before she left the garage and asked about them. "What are you building? The wood looks awfully nice."

Hank looked around the garage to see if he had anything that was almost finished to show Trudy, but almost everything was in pieces waiting to be assembled. "Well," he said, "we don't have redwood where I come from, so I'm on a project of building a lot of small pieces of furniture for ourselves out of redwood. Redwood is pretty, especially when it's finished, and it has the same properties for repelling bugs that cedar has."

"Really?" Trudy said. "Do you think you'll have time to build me a hope chest so I'll have a place to keep my good woolens?"

"Sure I can," Hank said. "I've got to finish a few things first, but I'll talk to you in about a week to get some measurements and all that. Is that okay?"

"Sure," Trudy said. "Just knock at my door when you're ready—and when your friends arrive, too!"

Trudy walked back through the garden to her front door feeling glad that she had talked with Hank. She had managed to get quite a bit accomplished, and the first thing she wanted to think about was the new couple that Hank was going to bring to her in a week. She needed to talk things over with Neil. She wanted to know how much more work he had to do to get the maid's room ready. Then, she thought, there was the bathroom problem again. Trudy and Neil had been using the bathroom in the maid's room to avoid crowding the upstairs bathroom too much. She had to do something because she had been wrestling with the problem for months. After eating dinner that evening, Trudy was still thinking about the problem sitting on her davenport with a hot cup of coffee. She was beginning to think that she would have to hire someone to build her bathrooms—and after spending money on her car! Well, she realized that Arnie was right. She needed the car and she would not give that up!

The telephone rang early in the evening interrupting her thinking. At first, she didn't know who it was, then realized it was a sailor she had met a few weeks earlier when she was shopping in Monterey. He was stationed at the Navy base in Monterey. Since then they had gone to lunch together and talked a while at various times. Trudy had noticed him because he was about her age, handsome, and wore a sailor's uniform that made him stand out among all the Army uniforms in town. He had never asked her out so Trudy didn't know much more about him. It even took her a few minutes to remember his name, but then it came to her as he talked—Holden. Holden Miller. She recalled what he had told her one time over coffee at a little café. "Everyone calls me 'Holden', which is short for 'Holden' and is pronounced, 'Hol-den," he had told her with a good-natured smile.

"I wanted to ask you if you'd like to have dinner with me somewhere," he asked.

"Well, I guess so," Trudy said. "Just let me know when. I'm generally not busy."

Trudy's House

"How about Saturday, then," Holden asked.

"Okay," Trudy said, "Come by early and I'll show you my big house."

Holden came by Trudy's house in the early afternoon, because "he didn't have anything else to do" he told Trudy later. Of course Trudy was pleased because it gave her a chance to show Holden around her house and explain all her goals to him. Later in the afternoon Holden and Trudy sat in her living room talking over coffee and some cookies. Holden told her that before he went in the Navy he had been a volunteer fireman in his hometown of Grass Valley, California. He spent the rest of his time earning money repairing and rebuilding old houses!

Trudy was so surprised at hearing him say that that she nearly choked on her coffee and had to ask him again what he had just said. When he did, Trudy just sat looking at him for a moment, and then asked if he knew about plumbing and electrical repairs in houses. Holden said that he had done a lot of that kind of work and Trudy had a passing thought that someone was playing a joke on her.

Trudy cleared her throat and asked Holden if he would mind taking a look at something she had been planning. She wanted to see if it would work, then lead Holden back through her bedroom and across her kitchen to the empty laundry room. She explained that she had just one large bathroom upstairs for four rooms to use and that she needed a bathroom of her own to avoid using the bathroom upstairs.

Holden turned on the ceiling light in the laundry room and paced through the room to the back door and deck, then went down the stairs into the basement and peered around in the darkness under the laundry room. "What do you use the laundry room for now?" he asked.

"I don't use it for anything," Trudy said.

"Well, you can put a bathroom in here pretty easy, but it's a pretty big room for a bathroom," Holden said.

"Do you think I can get two bathrooms in here?" Trudy asked, "because, I have another room that backs on this and it needs a bathroom, too."

"You do? Where?" Holden asked. "Do you mean that big room with the window and the fireplace?"

"Yes," Trudy said, "That needs a wall to make it a private room, and it needs a bathroom."

Trudy watched as Holden turned this way and that to get his bearings in the house, and then pace off the floor. Finally, he stopped and looked at her. "I think you can get two bathrooms in here if you put in showers instead of tubs, and have room left for a little hallway by the door, there. If you do it that way you can add a little kitchen on the other side of this other wall and have a little apartment."

"Really?" Trudy said. "How much do think it will cost?"

"Oh, not more than five hundred dollars per bathroom—probably less than that," Holden said. "It might cost about $150 for the work in that room. That would include the wall, a door, a closet, and steps to the bathroom."

"Oh, Lord!" Trudy said. "So much!"

"Maybe," Holden said. "But don't forget that you're also creating income."

"Creating income?" Trudy said.

"Why sure!" Holden said. "How much will that room with a view and a fireplace bring, compared to other rooms? If you do it right, maybe $20 a week. Then, having your own bathroom means you can go ahead and rent that maid's room. You could fix that up, too."

"I've got someone coming to look at the maid's room in a couple of days," Trudy said.

"Then you need a bathroom fast," Holden said.

"I guess I do," Trudy admitted.

"I'll tell you what," Holden said, "I love doing this stuff. We can go out and get something for dinner, come back and measure all this out, and I can do the noisy work tomorrow. What do you say? By the way, the Navy pays me so all you need is enough for the parts."

"Really?" Trudy said, thinking that at last she had found someone who could help her get her house set up for rentals.

That evening Trudy treated Holden to a fish dinner on the wharf in Monterey, after which they went back to Trudy's house and planned out the two bathrooms and the hallway that led to the laundry room door from the studio room. Holden had a carpenter's pencil that he made marks on the walls and floor with. When he had finished several hours later, he knew exactly where the dividing wall between the bathrooms would be, and he knew the exact positions of the toilets and showers and sinks, and he knew exactly what he would do with the pipes. Trudy was impressed with his work and gave him another cup of coffee and some cookies when he was finished for the evening. Holden slept on Trudy's davenport that night to avoid driving him back to the Navy base and having to pick him up again the next morning.

The next morning was Sunday, so after breakfast Holden and Trudy got a flashlight and some paper and a pencil and while Holden called off the parts he would need, Trudy wrote them down on the paper. By noon they finished their list and went out in Trudy's car to try to find a place that was open that might have what they needed. Trudy and Holden started out looking around Pacific Grove for a hardware store that would be open on a Sunday afternoon, and after half an hour or so they realized that almost nothing was open in Pacific Grove on a Sunday except the churches and turned their attention toward Seaside and the other little towns near Fort Ord.

They soon found a hardware shop that had opened at noon and they bought several cardboard cartons full of pipe and drain fittings that Holden could begin working with, and brought them back to Trudy's house in her sagging, weighted down car. As they drove, Holden explained to her that he would have to order

some lumber and nails and several lengths of pipe that they couldn't carry in Trudy's car. That would have to be delivered during the week and he wanted to have it near where he would be using it.

"I'll leave you a detailed list of what I'll need and you'll have to take it to a lumber yard and pay for it and tell them you want to have it delivered—I'd say by that back porch off the laundry room," Holden said. "It'll probably cost $200. Is that okay?"

"Yes, I think so," Trudy said, mentally adding up the cash she had left. If she had to, she would take some out of her meager bank account. The important thing was that she was getting her bathrooms built!

When Trudy walked into her house with Holden, she found Neil in the kitchen making himself a peanut butter sandwich. "Oh!" Trudy said. "Neil, this is Holden Miller. He is going to build the bathrooms for us. We've just been out buying pipe parts."

"Hi!" Neil said, shaking Holden's offered hand. "Nice to meet you."

"Nice to meet you, Neil," Holden said, looking Neil in the eyes. He stood at least a head taller than Neil. "Do you have a little time after you eat that sandwich to help me unload the car?"

"Sure!" Neil said. "I don't have anything I have to do."

With that exchange, Neil and Holden got off to a good start. Neil helped Holden all afternoon as he worked to rough in the drain lines for both bathrooms. Trudy was delighted that Neil and Holden got along so well and she was in a good mood all afternoon. Late in the afternoon, Trudy began to think about making dinner for Neil and Holden and settled on spaghetti as a good solution that she was sure would satisfy everyone.

As she puttered in the kitchen, Miss Wembly came down to get her evening meal. "Good heavens!" she said. "What can it be? I was trying to relax and read a book and I kept hearing all this commotion from somewhere in here, I thought! I decided to come down for my dinner and find out what you're up to!"

"Hello Miss Wembly!" Trudy said as she was stirring her spaghetti sauce on the stove. "How are you? I haven't seen you for a few days."

"We've been missing each other, I suspect," Miss Wembly said.

"I suppose so," Trudy responded. "That noise you hear is Neil helping a man build the two bathrooms I need so bad. They are in the basement building the plumbing or something."

"Good heavens!" Miss Wembly said. "Is it Arnie down there, or someone new?"

"No, Arnie is gone. He has been sent overseas," Trudy said. "This is Holden Miller. He is in the Navy and knows all about building."

"How marvelous!" Miss Wembly said as she spooned some soup and crackers. "Aren't you fortunate! You seem to have fallen in with a band of angels!"

Miss Wembly's comment caught Trudy's attention for a moment. "How do you mean?" Trudy asked, and continued stirring her spaghetti sauce.

"Well, I mean you seem to be the luckiest person I have ever known," Miss Wembly said.

"You came by this property by luck just when you really needed it. You've had no problem getting people to rent your rooms. You needed a car and in just several months you have one. Now, you needed bathrooms built so you could rent more rooms, and here you are getting it done! Don't misunderstand me because it's not that I envy you. I just think it's amazing—really—that you only have to mention it and it's here! You're blessed, you are!"

Trudy paused in stirring her sauce and looked around at Miss Wembly. "My Goodness!" Trudy said. "I never looked at things that way!"

Holden came by several times during the week and worked a few hours on the bathrooms, being careful not to work very late out of concern for Herb Knight's bedtime. Trudy respected Mr. Knight's needs because he never complained and he always paid his rent on time.

After the lumber delivery Holden spent several days alone doing the carpentry for the bathrooms. Everything was delivered on Tuesday morning and Neil piled it up on the back porch outside the laundry room that afternoon. When he looked in on the project after school on Wednesday, Holden had framed the wall that separated the bathrooms. When Neil looked in on Friday, the wall had pipes and electric wires threaded through it, but it still wasn't covered, and a second wall had been framed up to separate the other bathroom from the hallway by the back door and Holden had started to build the doorway to the studio room. On Saturday morning the lumber company delivered a load of gypsum wallboard to cover the bathrooms walls, and a wall, yet to be built, separating the studio room from the tenant's entry.

Holden worked most of Saturday connecting the drains and pipes to the bathrooms and setting the toilets and building the shower stalls. Trudy was so grateful for his hard work that she insisted that he stop early so she could treat Holden to dinner on the wharf again. By Sunday, the toilet and sink in Trudy's bathroom were ready to use, but Holden had more work to do on her shower. That meant that Trudy was no longer relying on either the upstairs bathroom or the one in the maid's quarters, because she had her own at last. It was just in time too, because Lovey and Moe Goodman showed up at Trudy's door late Tuesday morning asking about a room. They said that Hank Knox had told them about the room.

Trudy stood looking at the couple on the other side of her screen door without connecting on who they were because her mind was on the work that Holden was getting done for her. It might have been that Trudy was startled by the appearance of the couple because looked like they had just been standing on a street corner in New York City a moment before. Both had traditional Jewish

appearances almost as if they had been type cast for a movie. The woman had a mature buxom figure and wore a tailored pin stripe suit. She was about as tall as Trudy and wore high-heeled black shoes. She was so overdressed that she looked completely out of place in Pacific Grove. The man was a little taller and heavy set and wore an enlisted man's Navy uniform.

A moment later, Trudy's mind clicked in and Trudy said, "Oooh! Of course! You must be the couple that Hank told me about! He said you were being transferred here."

"Yes!" The woman said. "We're the ones. We arrived here on Sunday and we're staying at the transient quarters on the Navy base until we find something—it could be worse! We understood that you might have a room—I suppose no one has flats here."

Trudy unlatched the screen door, saying, "Come on in and I'll show you what I have. I'm Trudy Anderson and I just bought this house last summer."

"Yeah?" The woman said. "So you're kind of new here, too? Do you like this part of the country?"

"I love the sunshine," Trudy said. "I moved here because my husband died and renting rooms is about all I know how to do. I have a fourteen year old son to support, too."

"Oh, that makes life hard!" the woman said. "We're the Goodmans. I'm Lovey and this is Moe, and yes, Lovey is my real name."

"It is?" Trudy chuckled. "What a funny name! Did your mother ever tell you why she named you 'Lovey?'"

"She never said," Lovey replied with a grin. "I always wondered if it wasn't a Yiddish word she liked, translated—or maybe she just wanted to give me a life-long complex!"

Trudy laughed with her and realized for the first time that Lovey and Moe were actually Jewish.

"No," Moe said. "It means woman with a fat mouth!"

"Shaddup, Moe," Lovey responded with a giggle, "or you'll get the fat lip!"

"She would, too!" Moe said. "She's a tough customer from Flatbush Avenue. So I joined the Navy for protection from her!"

Trudy laughed with them. "Well, let me show you the room because I imagine you want to get all this out of the way. Follow me through here. The house is still kind of torn up because I'm still getting rooms ready to rent." Trudy led them through her kitchen to the maid's quarters. She hadn't seen the room herself since Neil was painting in there and hoped that he had cleaned up. Trudy generally led people straight through her bedroom from the living room to the kitchen. She could take them through the door at the end of the living room to the hallway, and from there to the kitchen, but never did. It was shorter through her bedroom and she didn't care what anyone thought about it.

209

Lovey and Moe rented the room because they had their own bathroom, rustic as it was, and they had lots of storage room and lots of light. They also took Trudy up on the kitchen privileges that she offered and that gave them living quarters that were almost as good as an apartment. Since Moe had to work all week, they said they would move in over the weekend. That gave Trudy time to furnish the room.

The following morning Neil and Trudy had breakfast together. Before Neil ran off to school Trudy asked Neil if he had any commitment to that afternoon to help Holden because she wanted him to go with her and buy some furniture and things for the Goodman's room.

"I don't think so," Neil said. "I think he wants to come over and tile the inside of your shower, and I don't know if he's coming tonight or tomorrow night. Are you going to pick me up at school when I get out?"

"Yes," Trudy said. "I can do that. I'm going to make a list this afternoon for what we need. Have you finished the painting and all?"

"I think so," Neil said. "It's been a week since I looked in there."

"Well, go look before you go to school," Trudy said. "Neil, this is your house, too, and you really should keep track of everything that has to be done!"

Neil went back in the maid's quarters and looked all around and thought that everything looked ok, then came back and told his mother and went on to school. Trudy made a list of furnishings she thought she'd need, and wrote another list for furniture. She sat on her davenport for a while that afternoon and studied the list, wondering what she could get away with in some used furniture, and beside each item jotted down the price she expected to pay for each one. The bathrooms that Holden was building had taken almost all her available cash. She had a reserve in a checking account but she didn't want to touch that money. She thought about it a long time with her stomach almost twisting in knots worrying about her money. Finally, she got out some paper and a pencil and counted all the cash she had in her account and in caches squirreled around her bedroom. Then, she wrote down the rents that she expected to take in during the next week. Well, she thought, she barely had enough money if she was very careful about buying things. Suddenly she remembered that the Goodmans had paid her a month's rent and that meant that she had enough money! Feeling greatly relieved, Trudy got ready and went to pick Neil up after school. After all, she thought, Holden had told her to go ahead because she was creating income!

CHAPTER FIFTEEN

One day in mid March, Trudy was sitting on her davenport and leafing through her driver's manual, sipping a hot cup of coffee when she began to hear sirens. Generally, she ignored those things because Central Avenue seemed to be the preferred route through Pacific Grove for ambulances and she heard sirens at one time or another almost every day. At first she ignored the sirens, but after one went by her house going toward Pacific Grove, she heard another, and then another. She began to look around for smoke, or for people running, and noticing nothing went back to her reading. Soon the fire signal at city hall was sounding its horn and Trudy looked out the window again and saw nothing alarming. Neil and the other students at school heard the commotion, too.

Pacific Grove, like most cities its size had a volunteer fire department that was overseen by a several professional firefighters. The city had a unique way of signaling to the volunteers to let them know when there was an emergency and where it was. They used an air horn on top of city hall and blasted out a code of longs and shorts that could be heard all over the little city. They also published a little card with the code printed on it so the volunteers and concerned citizens would have no trouble in tracking down the emergency area, allowing everyone to keep up with the city's exciting dilemmas. When someone phoned in an emergency of some kind, there was another person in city hall who was charged with the duty of sounding the air horn with the right number of longs and shorts so the volunteers would know where to meet the fire equipment.

So, one Wednesday morning early in March, 1944, Neil was sitting in a classroom trying to make sense of an introduction to another level of math when he heard the air horn sound out an emergency near Lighthouse Avenue and 17 Mile Drive Avenue (according to the code cards that many of Neil's classmates kept in their pockets). The teachers were allowed to excuse any of the students who lived in the area of the emergency on the off chance that it was their house that

was burning down. Of course, several other students left the class too, telling the teachers quickly made-up yarns about how the emergency might involve them.

In an hour or so Neil hear someone say that an airplane had crashed and that was the reason for calling out the fire department. When classes were finished for the day, Neil headed off toward Lighthouse and 17-Mile Drive, which was at the western end of town and he lived on the eastern end of town—several miles out of his way but he was curious. He thought that all most certainly that if there had been a plane crash, it was probably a military plane because that is all anyone ever saw around Monterey. Navy planes took off and landed every day at the Navy Air Facility that had been Monterey Airport. It was wartime of course, and almost no one knew for sure, but most people thought that the airplanes were there for some kind of advanced training. Neal wasn't positive, but he didn't think he had ever seen private aircraft in the area.

When Neil arrived at the intersection of Lighthouse and 17 Mile Drive everything looked normal. Traffic was flowing down Lighthouse Avenue and there were no crowds to speak of. He was about to go on home when he looked a block beyond Lighthouse on 17 Mile Drive and saw a policeman directing traffic away from a wooded lot behind a large old Victorian house. Looking carefully in the darkness under the tree canopy he was able to make out movement. Then he saw that the movement was sailors wearing blue dungarees and blue sailor hats—which was the Navy enlisted uniform in the war years. They seemed to be poking around in the small trees and underbrush under the tall trees that grew there. His eyes searched for an airplane shape in the dark brush but he couldn't see anything. When he started to walk toward the wreck he was interrupted by a sailor who told him that he could go no further and to go home. As he turned away and started home, Neil spotted a policeman removing the film from a man's camera, and he was finally struck by the gravity of what he had seen.

It was almost dinnertime when he got home and he told his mother where he had been. She told Neil that she and Miss Wembly had seen the gray ambulances go by with several Navy fire engines and they assumed that it was either an airplane or boat that was in trouble. After dinner Neil went into the artists studio to do some studying and turned on the radio to hear the news. He usually had a radio on in the evening to hear the news and listen to adventure programs to have something to listen to while he did some of his homework. He liked to follow the war news too, but that evening he wanted to hear about the airplane crash in Pacific Grove. He listened for over an hour and heard some local news, but nothing about an airplane crash.

Sometime around nine in the evening Tom and Dede Wilson came in and started upstairs. Neil greeted them as they opened the outside door and asked Tom about the crash.

Trudy's House

"Yeah," Tom said. "The Navy put a lid on that. Officially, one of planes had engine trouble, crashed, and we lost three good men. I don't think you will hear any more about it than that."

"I know," Neil said. "There's nothing on the radio about it."

"No," Tom said, taking Dede's hand. "The Navy has a saying about that, 'There are old pilots and there are bold pilots, but you don't find old, bold pilots!' Good night!"

The next day, Neil was walking down Central Avenue on his way home after school. A large Navy truck drove past pulling a large lowboy trailer with the muddy wreckage of an aircraft fuselage tied down on it. Neil stopped to watch it pass, and saw several smaller trucks following with torn aircraft pieces loaded on them.

Weeks later, Neil heard that the pilot of the plane lived near the crash site and was trying to buzz his wife and clipped a tree because the plane wasn't as maneuverable as he thought it might be—or maybe that's when the engine failed! He never found out the truth.

About a week later Tom Wilson stopped by Trudy's door and said that he expected to be transferred out by the end of the month for sea duty and that Dede would be going home until he got back. He told Trudy that he would let her know as soon as he knew all the details.

Lovey and Moe Goodman began moving in on Saturday and finished on Sunday. Trudy and Neil had just enough time to run around town in her car buying things from the second hand stores to furnish the maid's room. Trudy had found a bed and dresser at the auction on Wednesday afternoon, and they had been delivered on Saturday morning when the Goodmans started moving in. After they had unloaded a carload of belongings, Trudy invited Lovey and Moe into the kitchen for coffee

"So," Trudy said to Moe, "I hear you work down at the Navy pier with Mr. Knox."

"That's right," Moe said. "Of course, you understand what life is like in the Navy, don't you? I mean I didn't know Knox before I got here. This is just another duty station for both of us. The way they try to work it in the Navy is everyone is supposed to spend two years at sea and two years on land. Now, that gets all messed up because not everyone puts in his two years all the time because things come up. They just try to stay with that schedule, that's all. I just spent twenty-seven months on a ship in the Atlantic Fleet, and they sent me here because there was an opening and I was available. I should be here for about two years."

"Yeah," Lovey said. "And I just spent two and a half years working in the garment district waiting for this bum to come home again. So he gets off the boat and says, 'Guess what? I'm transferred to California for shore duty for two years! Do you want to stay here or go with me? Hah! I should stay in the bowels

213

of New York City while Mr. Love and Protect is suffering in California? Not a chance! Especially while the U.S. Navy is paying the bills!"

Trudy laughed at Lovey's colorful speech. "You mean the Navy pays for you to go where Moe goes?"

"Yes they do!" Lovey said. "Moe is in the top enlisted grades and the Navy pays for me too, as long as it's not in a combat theater."

"Yeah," Moe said. "In wartime, it has to be within the continental limits, I think. It wouldn't work anyhow because you never know where a ship is going."

"Well, that's pretty good isn't it?" Trudy said. "You're always together that way and you both get to see a lot of places."

"What about you, Trudy?" Lovey asked. "The other day when we were here and rented the place, you gave us the impression that you're not a Californian either."

"That's right!" Trudy said. "My husband died a year ago last February. I lived in Oregon then and I moved down here because I'd always wanted to see California."

"But, Oregon's not that bad for weather, is it?" Moe asked, (pronouncing the name, 'Oregone') "We've always heard it was rainier, but not bad."

"Well, yes. I guess that's right," Trudy said, clearing her throat. "But I wasn't raised up there. I'm originally a Canadian—I mean I was born in Canada. I have my citizenship here now. I lived in Winnipeg until I was 15. They have such awful winters in Winnipeg! When I was a young girl I used to wonder if there wasn't a better place to live."

"Yeah, who needs it," Lovey said. "Ice and snow. That's okay when you're a kid. I used to look forward to winter so I could play in the snow, but I don't care about it now. The only thing it's good for in New York is to give you a relief from the summer."

"You said it!" Trudy said. "Who needs it is right!"

The kitchen hall door opened quietly and Miss Wembly came in. "Good morning, all," she said. "I thought I heard voices down here."

"Oh, Miss Wembly!" Trudy said. "This is Lovey and Moe Goodman. They've rented the maid's room. Moe is in the Navy. Miss Wembly has a room upstairs and also has kitchen privileges, so I imagine you'll soon know each other real well."

"How do you do?" Miss Wembly said politely. "Welcome to Trudy's house. We're all one big happy family here."

"My God," Lovey said. "Such formality—and what a British accent! It sounds real!"

"Very real, I assure you," Miss Wembly said with a grin. "I've had it since I was born—or since I could talk, anyway!"

"It's a beautiful accent, Miss Wembly," Moe said. "Am I sitting in your place?"

Trudy's House

"Yes, I usually sit there because my cupboard is right above your head," Miss Wembly said. "Hold on! Perhaps it doesn't matter. I could just reach over you, . . ."

"That all right! I don't mind moving! I'll sit over by my beautiful wife, Lovey," Moe said, and quickly moved out of Miss Wembly's place while Trudy got another kitchen chair for him.

"Oh, cut the oil, Moe," Lovey said, "cut the oil. Are you trying to butter me up? For what? I know. You've got a trunk for me to carry, haven't you, you Mr. Slick Talker"

"Come on, Mrs. Nasty Names," Moe said. "We have work to do. We have to get moved over here by tomorrow night, and Miss Wembly wants to eat her lunch."

After the Goodmans left to get another load of belongings, Trudy and Miss Wembly talked for a while and finally decided that the Goodmans would be refreshing to have around after all the unhappiness that the Johnsons and the Fristlers experienced.

Since Trudy provided clean sheets and towels on a weekly basis for her tenants, maintaining them and keeping them clean was easy enough to deal with when she had four tenants—even in the winter months—because the weather was usually cooperative and they were able to wash everything and hang them out on a line and expect everything to be dry when it was needed. Trudy usually did the wash and had Neil carry it out and hang it on clotheslines that he had put up in the back yard. They had four lines, each about thirty-five feet long, and they generally filled them. When the sun was shining and a gentle breeze was coming in off the bay, everything would dry in several hours.

As she got more tenants, however, Trudy and Neil had to buy more bed linens and double up on the washing. They tried ironing everything and soon found that to be too time-consuming, so Trudy bought a mangle and that not only speeded the job up, but also did a neater job. After the Goodmans moved in, and with the prospect of renting yet another room when Holden finished the artists study, Trudy realized that the laundry was becoming a burden. Neil saw it coming too and stopped in the Grove Laundry one day after school and got prices for having the sheets, towels and pillowslips done professionally. He was surprised how cheap it was and made it a point to tell his mother about it.

Trudy was skeptical, but decided to try it after a lot of talking on Neil's part. The bad thing about the deal for Neil was that he had to haul the sheets to the laundry once or twice a week in a big, unsightly bundle. This was an aspect that Neil had not considered and for some reason, neither he nor Trudy ever considered getting a large laundry bag. Instead, Neil would put all the sheets and towels into one sheet and tie the corners together and carry the whole thing to the laundry on his way to school. The laundry would have it all ready to be picked up in one

neat bundle in two or three days. This became Neil's chore until the war ended in 1945.

Holden's work on Trudy' bathroom meshed perfectly with the Goodmans moving in. Aside from finishing her shower—which was time-consuming tile work—Holden had the bathroom sink and toilet working before they moved in. He had built a wall separating the two bathrooms, and a wall separating the artist's studio bathroom from the hallway where the outside back door was, and he had marked out where the doorway and steps leading down into the big artist's studio, but he had not cut through the wall yet. He had enough work to do when he came to visit Trudy, but he had to wait until she accumulated more money to buy the expensive things before he could finish the work. Yet, he was able to do a little carpentry and detail work which he loved doing. The delay waiting for more money gave Holden time to nose around the building and make little repairs and correct work that had not been done properly. It doesn't have to be mentioned that Trudy was grateful for any work he did on her house and they were soon spending a lot of time together.

About two weeks after Tom Wilson had talked with Trudy, he came downstairs to her door with Dede who was still crying when Trudy answered her door. "Well," he said, "we have to give you our notice because I'm going to sea. I leave this weekend. Dede is going home while I'm overseas."

"Oh my Goodness!" Trudy said. "How difficult that must be for you."

Dede turned and ran back upstairs while Tom said, "I guess she thought this day would never come. We'll be okay. Well, we've enjoyed staying here and I think we'll always remember the view."

"Thank you," Trudy said. "Good luck to both of you I guess you don't know where you're going do you?"

"No, we'll find out when we get there." Tom turned and trotted back up stairs to finish packing. A week later Trudy rented the room again to another Army couple—Richard and Kay Keppler who were from western Pennsylvania.

When Trudy saw Neil a little later, she told him that after the weekend he would have to look over Tom and Dede's room and get it ready to rent again. "After we rent that room again," she told him, "I guess I'll be able to give you a weekly allowance. The money has been so uncertain, but now we have more rooms rented and we can start an allowance. Gee! It'll soon be your fourteenth birthday, won't it?"

Neil was doubtful and a little suspicious of his mother's motives. "After all this time begging for an allowance, how come your going to start one now?" He said.

"Well, I just told you," Trudy said. "Besides, you're all I have, and you know I love you."

Still doubtful and suspicious, Neil asked how much he would get.

Trudy's House

"We'll start at $3.50 a week," she said. "That way, you can go see a movie or two and get some candy or popcorn."

Neil thanked his mother and went down to the beach to throw some rocks at the waves for a while. Walking the path that led along the land above the beaches, or just throwing rocks at waves or sticks was a kind of therapy for Neil. It gave him a chance to work off frustrations and nervous energy, and mull things over in his mind. The allowance that his mother offered him wasn't too bad, but Neil felt that considering the work he contributed, he would have thought it could have been more, unless she was willing to give him more for special occasions. He decided to wait and see.

On the other hand, Trudy had said $3.50 in a moment of weakness. She had intended to offer Neil $2.50 a week, but said $3.50 feeling compassion for him. She was already regretting it because she was trying to save money for Holden's work. She needed the two bathrooms that he was building and she had faucets to buy, a toilet, and whatever else Holden needed, including the lumber. Trudy decided that she would keep her word to give Neil $3.50 a week, but she reminded herself that she would have to be more careful with her money. If she ran out of money she would have no place to turn for help.

Just the promise of receiving a weekly allowance made Neil feel a little more comfortable about his situation of living with his mother in Pacific Grove. Since his father died he often felt that he had been given an awkward path to follow. If one parent had to die, or otherwise be removed from his life, he would have preferred that it had been his mother instead of his father, because as far back as he could remember he had a much better relationship with his father and his father's family, than he ever did with his mother's family. In fact, he had never met some of her family and was never sure what the relationships were between them because of certain marriages and divorces. However, the facts were there and Neil was a realist.

Still, he had never felt any particular attachment to her, and he didn't think she really had any for him. He did feel indebted to her for keeping and maintaining him. As a result, he had never pressed her for an allowance—beyond asking a few times. Instead, when he felt that he had earned some money working on her house, he would asked her for some spending money, or for enough money to go out and buy a certain item.

Neil quickly made use of his new reliable income. He had learned to enjoy going to the movies on Friday evenings, providing it was his kind of movie—a western or a good adventure movie did the trick. Living in eastern Oregon he had done without movies because there were no movie theaters within dozens of miles of his uncle's ranch. The usual evening on the ranch was spent reading for an hour or so, with everyone sitting in a circle around a large round dining table with a glass oil lamp standing in the center, then to bed because morning came early!

Neil had been out of touch with the world when he lived in eastern Oregon and he didn't like to talk about it because the kids his age in Pacific Grove equated that kind of life with being a hillbilly and the association embarrassed Neil. However, in his later life Neil came to value that part of his life as having given him first-hand experience at living like the settlers did in the last part of the 19th Century. After all, he had lived without electricity and public transportation in an existence of self-sufficiency in a remote place just like the pioneers did! How many people in the 20th Century can claim that!

Neil was starting to enjoy seeing a good movie with a bag of popcorn or a candy bar. The usual fare was a double feature with one good film shown first followed by a cartoon and a newsreel, and then a second feature film that usually wasn't as good as the first film. If they were normal length films—about 90 minutes—the house lights would be turned on after the second film allowing people to exit the theater, then the first film would be shown again. If the films had popular actors like Humphrey Bogart, Rita Hayworth, John Payne, or Linda Darnell they were even better!

If Neil ran into some friends they would meet and talk and watch the film. Most of the time he just went to the movies by himself and let himself be entertained by the movie. It was Neil's escape, and he looked forward to it.

One day early in May Trudy was relaxing on her davenport going through old newspapers looking for anything that she might have missed. The sun was coming in the course of windows behind her and warming the room. The doorbell rang and gave her a start. She put everything down and answered the door. It was a tall, husky young soldier and a young woman who Trudy thought was probably his wife.

"Hello, Ma'am" the soldier said. "I'm stationed at Fort Ord and my wife just arrived from home and we're looking for an apartment or a room."

"Gee," Trudy said. "I'm sorry I don't really have anything to rent except a room that doesn't have heat. I mean it's a room with furniture and all that but it gets pretty cold at night."

"Well, gee," the soldier said. "Can we see it? We're both from Montana and we're used to cold nights."

"Sure," Trudy said. "This late in the year it might be warming up. I know it gets warm up there during the days. Come on—I'll show you the room."

Trudy stood out in the hallway while the couple looked around the room and talked about what they could afford. She could hear enough of their conversation to get the impression that they couldn't afford very much. In a few minutes the young soldier came out in the hallway to talk with Trudy while his wife stayed back to get the feel of the room.

"Uh, the truth is that we don't have much money because I'm just starting some training out at the fort," the soldier said. "I just got out of basic training

and I don't make much money as a private, so while this room may not be the best in the world it's probably all we can afford—and it is a room where my wife could feel secure, and all that. Do you have a kitchen facilities, too?"

"Yes I do," Trudy said, understanding exactly how the couple felt. Trudy decided that she would offer it to them for the same rate as the Johnsons. She was sure she wouldn't be able to get much more for the room, no matter how warm the weather was.

The couple decided that they would rent the room and Trudy told them they could move in anytime. They signed in her logbook as Sam and Marilou Hughes and gave Trudy a deposit on the rent to hold the room. They told Trudy that they were in temporary housing and that their luggage was supposed to arrive in two days and they could move in then. Trudy agreed saying that would be fine.

The next day, Trudy went out with Holden to buy a few things that he needed and realized at once that she was still needed more money for the work that she wanted done. She knew it would be coming in soon as rents became due, but she missed the luxury of going to a cache somewhere for what she needed. She thought that with her big house and all her tenants that she should be able to deal with problems as they arose without feeling pinched.

Later that day, Trudy sat on her warm davenport sipping hot coffee and thinking about the money problems. Nothing she was doing was an extravagance, she thought. She needed the work done on the bathrooms, and it was being done at a nice price for her. She needed the car, too, which had been another big expense. She thought about her rents, and that led to another thought about renting too cheap. She had an impulse to raise her rents, then thought about the wartime price controls. She wasn't sure if that included her, but then she had rented pretty cheap to the Hughes—and they hadn't even moved in yet! Surely, nothing in Pacific Grove could be rented for the rent she offered them.

Trudy dropped off in a nap in the warm afternoon sunshine before she could do more thinking about her money problems. Sometime later, Neil rattled the door unlocking it to come in. "So it's you!" Trudy said sitting up and groggy from napping. "I wanted to talk with you about the yard."

"Mother," Neil interrupted. "I just walked in the door and I have a pile of homework and some reading to get done."

"All right," Trudy said. "Go on then and get your studying done, but at least take out the garbage for me before you start."

Trudy didn't see Neil any more until he came down for supper. For that matter, she didn't see anyone. She spent the rest of the afternoon reading and stewing about her money and convincing herself that she had rented her room too cheap when she needed the income so bad! That evening before she went to bed Trudy decided to satisfy her concerns and wrote a note to Sam Hughes

explaining that she had made a mistake and for that she was sorry, but the rent would be one dollar more each week than she had told them.

Feeling much better about things, Trudy read over the note, folded it neatly and went upstairs and slipped it under their door. This was the first time that Trudy had communicated with her tenants by slipping notes under the door, but it was a method that she found to her liking because she repeated it hundreds of time in the future. It was an easy way for her to express something to a tenant and a pain in the neck for the tenant because it usually concerned something that was trivial compared with a busy tenant's daily concerns. With that load off her mind, Trudy went to bed, read for a while and forgot about the money shortage she had been worrying about.

Trudy got a surprise in the mail the next day in a letter from her older sister, Jean. Jean had some vacation time coming up late in June and wanted to know if she could come down and spend a week with Trudy. Trudy had been corresponding with her younger and older sister all the while, so they knew that Trudy was getting established in Pacific Grove, and that renting rooms seemed to be the right thing for her to have done to make a living.

Trudy wasn't anxious to have Jean around for a week because Jean had always been the bossy older sister—more like a parent than a sister as far as Trudy was concerned! She would have been more receptive if Ellen was coming, but perhaps that was yet to come. She could keep Jean occupied seeing the sights and taking walks. The next problem was where to put her since she wasn't sure she'd have a room for her. Finally, Trudy decided to let Jean know that she could come and wrote a reply letter with information about the weather, and bus and train information. Fortunately, the Greyhound Bus came right to Pacific Grove, passing in front of Trudy's house.

When Sam Hughes arrived on Sunday afternoon to move a load of clothes into the room, Trudy wasn't home. Using the keys she had given him he went inside the side door and up to his room with a load of clothing and a suitcase. When he opened the door to his room he found Trudy's note on the floor. Sam Hughes read the note, then put down his load and read it again. He slapped his hat down on a chest of drawers, unbuttoned his jacket, and exclaimed, "That woman! That damned woman! Who the hell does she think she is!"

Trudy had just returned home and had tossed some newspapers and her purse on her davenport when she heard the commotion in her hallway. Before she could reach her hallway door, Sam Hughes was hammering on it with the side of his fist. Thinking there was some kind of emergency, Trudy unlocked the door and opened it to find a red faced Private Hughes standing in the hall.

Sam Hughes held Trudy's note up in front of her face and said, "Lady! What the hell is going on here?"

Trudy's House

Trudy took several steps back into her living room, still looking at Sam Hughes, his face beaded with perspiration. "You raised the rent we agreed on, and we haven't even moved in this damned place yet!"

"Oooo!" Trudy said. She wheeled around and ran to the front door that was still standing open, pushed open the screen door and ran out on the sidewalk just as a Pacific Grove police car was approaching. The car pulled over to the curb and the policeman got out, looking for whatever was upsetting Trudy.

"What's wrong?" the policeman asked. "Are you all right, lady?"

Trudy looked around at the policeman unable to talk and looked back at her open front door, her heart pounding wildly. "No!" she exclaimed. "There's a crazy man in there. He's trying get me!"

"Stay right here," the policeman said. He gestured to a military police car that had pulled up behind his police car, indicating that he was going in the house. A military policeman in an Army uniform ran up behind the policeman and they walked inside Trudy's house very slowly, not knowing what to expect. Moments later, they emerged from her house with Private Hughes in handcuffs.

Lovey and Moe had heard the commotion in the house, looked outside and saw the people, then came out their own door. Lovey walked over to Trudy who was standing next to fence gate watching all the activity with a stunned look on her face. "My God, Trudy," Lovey said quietly. "What the hell is going on? Did this guy attack you or something?"

"No," Trudy said. "He's just very angry. I,—I guess I did something stupid."

Lovey looked at Trudy without speaking and wondering what could have happened—wondering if she should even ask. She didn't have to. The Pacific Grove policeman walked over to Trudy after talking with Private Hughes and looked at her for a moment. The military policeman was standing on the corner talking with Hughes.

"Are you feeling alright, Ma'am—good enough to talk with us for a moment?" the policeman said.

"Yes," Trudy said. "I can talk with you."

"Well, Ma'am," he said. "We've had a talk with this gentleman and he tells us that he was just about to move into one of your rooms that he thought he had rented from you several days ago."

"Yes," Trudy said. "That's right. Mr. Hughes and his wife stopped by, looked at the room and said they wanted to rent it, and that they would move in later—today."

"And today it's not right?" the policeman asked. "Private Hughes told us that you put this note under his door telling him that you wanted to raise his rent after you had agree to it." He showed her the note.

"Why don't you tell us what happened, Mrs. Anderson?" The policeman asked. His polite attitude that Trudy had noticed before was disappearing.

221

"Well, I realized that I was renting it too cheap and I . . ." Trudy started to say.

"That's what I suspected," the policeman said, interrupting. "Are you another one trying to make a profit on these people? You know, almost all these kids have the same story. They were sweethearts in school. He gets drafted before he can figure out what life is all about, and is sent off to war. They're in love. They marry—maybe have a kid, and try to get as much of a life as they can before he gets shipped out. He could get killed or wounded and that would be all they get for a life together. Then people like you who don't understand that he's putting his life on the block so you can be safe, come along and you try to get another buck a week out of him! Good God, Lady!"

Trudy didn't know what to say. She didn't know how to respond. She glanced around her and saw dozen or more accusing faces looking at her, waiting for a response. "This is terrible," she said at last. "I, well I was talking with my lady friend in Monterey who rents rooms too," she stumbled. "She said I was renting too cheap and I . . . ,"

"Lady," the policeman said, "I hear people's stories all day long and I don't believe your's for a minute. Now the M.P.s have taken that boy, Hughes, to their car and he's handcuffed and sitting in the back. I don't think he's done anything wrong. What they will do is bring him back to their lockup and all this will go in his record. He may or may not continue his training, but for sure his marriage will be ruined. He will be sent overseas and he might be hurt and he might get killed. Now, I think he looks like a good kid who is having a bad day because of some whim of yours, and I don't think he deserves all that for a dollar a week!"

"No," Trudy said quietly. "He doesn't. I'm terribly sorry for all this."

"Now, that M.P. told me that he looked at that room and he said it wasn't much. He said it might be better than sleeping under a tree," the policeman said. "You know this boy has already made sacrifices for you."

"For me?" Trudy said.

"He has probably been drafted. He left his home to serve. He might have planned to go on in school, but that's on hold now. He might have had a promising job. He has a wife, but his family is on hold. His whole life is on hold until the war is over, Lady!" Don't you know about the war, and the sacrifices these boys have to make?" The policeman was so angry with Trudy that his voice was shaking.

The policeman paused and looked at the faces around him, then looked at Trudy. "I guess I've said enough. In fact, I guess I've said too much. I've said enough to get myself in a whole lot of trouble but situations like this really aggravate me! I don't know how anyone cannot know about this war!"

The policeman stood up straight and took a few deep breaths. "Mrs. Anderson," he said in a softer voice. I am sorry that I said those things to you. I meant every word of it, but I shouldn't have said it in front of all these people and embarrassed you like I did."

He paused and thought for a moment. "Listen, Mrs. Anderson," he said. "We have to tell these M.P.s something so that they will release this boy without charges. I'd suggest that you apologize to him for trying to raise his rent before he even moved in, and offer to let him stay there at the original rent—or, offer to refund what he has given to you for rent or deposits if he doesn't want to move in. Whatever you do, make sure those M.P.s understand that he is blameless and that you don't want him charged with anything. Can you do that?"

Trudy was confused. She didn't really understand why she should apologize to the soldier. After all, she was the widow with a son to raise and was faced with making a "go" of being a landlady after investing all the money she had in the world in an old house. The soldier might lose his life in the war and he might not, but she had already lost a husband and that had completely upset plans for their divorce and another life. But, she had to admit that she should not have tried to raise the rent like she did.

"Well, Mrs. Anderson?" the policeman asked.

"Yes," Trudy finally said. "I suppose I'd better apologize to him."

Trudy walked down the sidewalk to the M.P's car and told them that she was new to the business of being a landlady and in this case had used very poor judgment in dealing with Sam Hughes, and that she didn't want to see him detained. The M.P.s were eager to accept her apology and released the young soldier who was still agitated over what had happened. He stepped out of the car and rubbed his wrists where the handcuffs had bruised his skin. He straightened his uniform and looked back at the two M.P.s who were talking with the city policeman.

Sam Hughes looked at Trudy and said, "Thank you. I guess you have saved me from a lot of trouble.

"Well," she said. "I'm sorry it came to all this. Of course, you and your wife are welcome to stay in that room for the price we agreed on, or I can give you your money back."

"Ma'am," Hughes said. "I'd move on if I could, but right now we don't have a choice. We don't have any other place to go, but we'll be lookin'. Right now, I'd better go finish movin' in."

Trudy stood by her gate watching the policeman drive away, followed by the two M.P.s in their car. She looked around and saw people going back in their houses. Lovey and Moe had gone back inside their room, and Miss Wembly was sitting at her place at the kitchen window. spooning soup. Trudy suddenly felt like she needed to go get a cup of coffee, sit on her davenport and think about things when she felt someone touch her arm. She looked around to see Madge standing beside her.

"Oh!" Trudy said. "I didn't hear you coming up to me!"

"Apparently not," Madge said. "What's going on?"

"Well," Trudy said, taking a deep breath. "I'm afraid that I did a stupid thing. Come on in and have some coffee and I'll tell you all about it."

Inside her living room, Madge sat and listened and Trudy talked about what had happened. Trudy was careful to tell the story as honestly as she could because she trusted Madge and really wanted hear her side of it, now that she had heard the policeman out. Trudy was beginning to realize that there was a lot she needed to know about almost everything, and she needed guidelines. She needed to know what other people expected and she needed to know when she was crossing the line in principles and business relationships.

After she had told Madge her story, Madge sat and thought for a few minutes, then said, "Well, you were wrong to try and change the rents. You know that now. It was really a small thing but you gave your word on it. Trudy, in business—unless you're a crook or a shyster—your word should be everything. If a person can't stand by their word they haven't got anything. They say, 'Your word is your bond' and believe me, that's true. When you told that soldier what you were going to rent the room for, then that's what it should be. The only time you should ever consider raising rent is when you are going to rent to a new tenant, or when your costs have gone 'way up and you can't stay in the black renting at the old rate, or sometimes when you want someone to move out. But always, always, with proper notice. Remember that! People are a lot more receptive to changes if they are done in a businesslike way"

After Madge left, Trudy made herself another cup of coffee and sat on her davenport to think about things. Sometime in the late afternoon, she gathered herself together realizing that sooner or later she had to go in the kitchen and see what Miss Wembly and the Goodman's had to say about her big mess. The kitchen was empty when she went in, then a while later Lovey came in to have some tea.

"Well, Trudy," she said. "How are you doing? I'll bet you feel like you did when the teacher got you up in front of the class to make an example of you, huh?"

"I sure learned a lesson," Trudy said. "And it was all my fault, too."

"Trudy," Lovey said. "You're okay. You gotta have guts to say that."

"I was so foolish to think I had to raise their rent," Trudy said. "I should have been a better listener when people were trying help me. Well, I won't try that again."

"That's right," Lovey said. "Now, put it behind you, for Christ's sake. You gotta live again tomorrow! Have a cuppa coffee and put your feet up!"

CHAPTER SIXTEEN

Trudy's life was on hold and she was getting impatient with the progress in her house. Holden came by often with time and the willingness to continue working on Trudy's house, and she wanted him to keep on developing more rooms to rent, but Trudy had to wait until she earned more money. She needed the money to buy supplies that Holden needed. He needed lumber for the new walls and he needed hardware for the windows and doors and bathrooms. Trudy had spent what she thought was safe to spend, leaving a little money untouched for what ever might come up. Holden had talked to her about getting a small bank loan so she could have the work done, but she refused to have anything to do with credit, preferring to believe the horror stories she had always heard about indebtedness, over the advice that Faith had given her about how a business relies on credit.

Instead, Holden repaired things like putting new putty around windows, freeing up rusty window latches and hinges. He couldn't build the walls and steps to finish the artists studio so it could be rented but he did study the house and tinker and improve things, like adding electrical outlets, until Trudy had more money to spend. It all amounted to a big help for Trudy, but it wasn't getting more rents coming in. Trudy's shower was finally finished and she had her own complete bathroom. Holden had even finished building the shower in the studio room bathroom, but lacked the rest of the fixtures to finish it.

Trudy enjoyed Holden's company but if someone were to question her about that she wouldn't be able to say whether she liked Holden for what he was or because he was generously giving her his time and ability in getting her rooms ready to rent. Nevertheless, with time on their hands until Trudy's money built up again and while Holden had access to gasoline because he was in the Navy, he and Trudy spent a lot of time driving around in her car, exploring the nearby towns and sightseeing. Trudy finally saw more of the area for the first time, expanding her knowledge of Monterey Bay and central California. She saw Santa Cruz,

its old mission and it beautiful beach for the first time, and explored the farm town of Watsonville. They drove all over the quaint artsy town of Carmel By The Sea—or just Carmel, as the natives called it—and saw its ancient mission. Then, on another day, they drove up Carmel Valley and drove all the side roads looking for farm stands until they decided that it was still too early in the year to find fruit and produce.

Holden had heard about Trudy's scrape with the law before she told him about it, because he had Shore Patrol duty that day. The Shore Patrol was the Navy's version of the Military Police. There were regular members of these units, and they were aided by certain number of men who were given that duty for a day or a weekend. It was a duty chore in the services that was like standing guard, or working in the mess halls and everyone had to do it at one time or another.

Neil had heard about Trudy's new tenant and the police. Both Miss Wembly and Lovey had seen what had happened but Neil had been in school. However, Miss Wembly had learned early in life that if she were to be a permanent member of any aristocratic family in France for very long she would have to learn to be an observer and not a reporter. Lovey was different and had no restraints on what she had seen or heard. With her, everything was open for discussion and she had talked with Neil about his mother's run-in with the law. Neil was not hurt or even surprised. The only thing he thought about was, since he was almost 14, what would have happened to him if his mother had been put in jail?

The entire incident was soon forgotten because so much was happening in the world. Neil listened to the news every evening and the war in the Pacific was bogged down in the jungles of New Guinea. The war in Europe seemed to be mired in endless skirmishes in Italy and the Brits were complaining about being awash in equipment and yanks. At home, Neil's graduation from the eighth grade was to take place on May 31st and he was staying busy getting his homework in and going through rehearsals for the event.

As anxious as he was to get through grade school and the eighth grade, he was getting apprehensive about going on to high school because he had heard that the high school upper classmen were planning hazing for his class of incoming freshmen in the fall. Neil had no idea what that involved since he had never heard of the practice until then. He knew that most of the other kids knew what to expect since many had older brothers and sisters or friends who had gone through the experience sometime before. Whatever it was, Neil thought that the idea was nonsense and couldn't imagine that a school would allow such a thing to go on, but then he also realized that he had picked up some old ideas on his uncle's ranch.

Neil graduated on a Wednesday night, and less than a week later, on the following Tuesday the Allied invasion took place on Normandy, on a north coast of France. The radio news talked about it for days with mile-by-mile reports

on the Allied advances into France. Neil followed the news whenever he was near a radio. Everyone on the streets talked about it as if the invasion were the anticipated big break-through that would allow the Army to march straight to Berlin. Of course, that didn't happen for another year.

Trudy was far more interested in her house. Whenever she accumulated enough money, Holden would buy something and he would spend more time working on some improvement. Since Neil was out of school for the summer, Trudy had a talk with him about working in the yard where she thought he could do the most for her. She showed him the difference in weeds and flowers and told him what she want to see in the yard and left the rest up to Neil.

Knowing his mother, Neil interpreted her gardening instructions as, get rid of the dry grass and weeds, save the flowers and make the place look good. The first thing Neil did was to create some off-street parking by making use of an old driveway on Fifth Street at the rear of the house and clearing out the garden area that the driveway led to. That gave him about a 20 by 30 foot area that was no longer a garden. He made a border of large round stones and created a space behind the house that two or three cars could park in. Following that, the yard became Neil's on-going job for the summer. Of course, it led to buying more tools that Trudy had not planned on but she thought that having a nice yard made it worth the money spent.

Neil enjoyed working out of doors in the sunshine, but discovered that working where his mother could see him led to quarrels with her because she didn't think he was getting enough done. The problem seemed to be that Trudy didn't know how long it took to do anything. She would see Neil raking dry grass in the garden, then go by him an hour later and find him still raking grass and wonder what he had been doing.

One day, Trudy saw Neil spading the garden and told him that the long hedge around the property was getting shabby. Several hours later, Trudy saw Neil spading another part of the garden and said, "Why did you move over there? I told you that the hedge needs trimming. Do it now please. It's terribly overgrown and makes the house look so run down!"

Trudy deduced from those encounters that Neil was getting rebellious but Neil was only thinking that since he had the tools out to spade the garden he would at least spade a section of the garden before turning his attention to the hedge, which needed a whole different set of tools. He wanted to tell her that but she didn't leave anything open for discussion. Instead, her comments were delivered more like ultimatums, making Neil wonder if she used that method in all her relationships. He thought that must have made his father miserable. One morning near the middle of June, Neil came down for his breakfast and found Lovey and Miss Wembly already at the table starting their own breakfasts. Miss Wembly was always dressed to go out anytime she was seen out of her room,

while Lovey wore a housecoat that buttoned down the front from her neck to the bottom of the housecoat, almost to her feet, until she went out. Neil found some *Pep* dry cereal and a bowl and was going after milk when he heard Lovey mention something to Miss Wembly about Trudy and Holden's wedding. He turned back to the table in surprise and asked Lovey what she had said.

Lovey glanced back at Neil and said, "You mean you don't know?"

"No," Neil said. "I haven't heard about it. Do you mean they're married now?"

"Jeeze!" Lovey said. "What is this, the Pentagon already? I've never lived in a place with so many secrets! Is somebody trying to give me a complex here?"

"Yes," Miss Wembly said. "Well, I knew, of course. I was there. They had a small ceremony in their living room. I'm surprised that no one has told you."

"When did they get married?" Neil asked.

"Oh," Lovey said, "it's been a week or two. I wonder why they didn't say something to you? Isn't that funny?"

Neil didn't know what to think. He had been completely surprised by the news, but with all of their driving around he should have guessed that there had been a change of some kind. If Holden was anything like her other boy friends he would have been dropped by now, he told himself. Neil decided that he would not let on that he knew about their marriage because he had given the idea a lot of thought before she had remarried. After all, he had decided, his mother was still a fairly young woman and he thought that it was very likely that she would remarry. Neil could see that what she did with her personal life wasn't any business of his! His ties with his mother had taken an unconventional turn sometime after they had moved from Delake. He had few emotional ties with her, but felt the need to work for her to help her develop her property in exchange for room and board until he was old enough and knew enough to live on his own. It always bothered him that she rarely gave him the consideration he felt that he should have as her son, and her wedding to Holden was a case in point. He felt that he should have been included as her son, but also he knew that was his mother's method. She didn't seem to have any genuine emotional ties or loyalties to him either and Neil thought that was just a fact of life. Before his family had separated, and before the war, he thought that such things would have shattered him, but his time spent on his uncle's ranch away from his parents had hardened him.

Every year when the weather inland warms to a certain point, high fog forms along the central California coast. The high fog moves in over the coastal communities in the mornings, and then retreats in the afternoon as the land cools. The people who live in the coastal towns call it nature's air conditioning because they live in cool comfort in the summers, while the people who live inland swelter.

One weekday in June, Holden got the day off and he and Trudy decided to go see San Jose again, and take Trudy's old friend, Rosy along for the ride. They

phoned Rosey first, and then stopped by Rosy's inn and picked her up at about 8:30 in the morning. Driving the legal speed of 35 mph all the way made it a tedious three-hour trip each way.

"So this is your new husband!" Rosy said as she got in the car, settled in the back seat and said, "And you have a nice, new car, Trudy."

"Yes," Trudy said. "This is my new husband, Holden, and the car is just new to me. I think it's about six or seven years old."

"Oh?" Rosy said, looking around the back seat, "well, it sure looks nice. It's better than my old clunker."

"Well, I think your old clunker, as you call it, is a pretty good car," Trudy said. "It's taken us on some nice rides, hasn't it?"

Trudy and Rosy kept the small talk going for a while, then settled down and let Holden drive in peace and quiet. Driving at the legal limit of 35 mph, it took them over an hour to reach Gilroy, going on the Prunedale cut-off to get there. They had reached the hot sunshine by the time they got to Gilroy, and then suffered with the windows rolled down as they drove on toward Morgan Hill and San Jose. They even stopped at a roadside stand near the walnut trees where Rosy and Trudy had stopped before, to buy some soda pop and cool off. As they visited, Trudy and Holden both noticed that Rosy was uncomfortable and seemed to feel the heat more than they did.

"I don't know what's going on," Rosy said. "The heat doesn't usually bother me like this."

"Maybe we shouldn't drive all the way into San Jose," Holden said. "Do you want to go back?"

"Oh no," Rosy said. "We can go on. I'm all right."

"It's a warm day now, and it just going to get warmer," Holden said, feeling concern for Rosy because she was older and seemed to be very uncomfortable. "We're only taking a ride. There's really nothing we have to do in San Jose." He looked at her face and didn't think she looked well at all. Whatever was bothering her seemed to be developing quickly.

"Well, of course it's up to you," Rosy said, blotting the perspiration from her face. "I don't mind either way."

Holden turned the car around and started back. The drive back seemed to take longer because it had gotten hotter and the fog line had withdrawn back almost to Monterey Bay. In fact, by the time they had reached Monterey again, the sun was coming out there, too.

Trudy and Holden helped Rosy out of the car and into her inn. When Trudy helped her into her easy chair, she said, "Are you all right Rosy? I could call a doctor if you'd like."

"No," Rosy said, making herself comfortable in her easy chair. "I think I'll be fine. I'll just take a nap and relax, and I'll be fine. I'm sorry I put you and

Holden to all this trouble. I'll just sit for a while and have my nap and my back will feel better, too."

As Trudy left Rosy's living quarters she turned and looked back. Rosy had already dropped off in her nap. Trudy thought Rosy looked small in her over stuffed chair, and she looked very comfortable. Trudy closed the door quietly until she heard the lock latch, then rejoined Holden at the car.

"Is she okay?" he asked. "She didn't look too good when you took her in the building."

"I don't know," Trudy said, "she seemed awfully tired and said something about her back bothering her. I'll try to call someone to look in on her later."

When they got back to her house, Trudy kicked off her shoes and made a cup of coffee for herself and Holden, then got out her telephone book and looked for Rosy's brother's name. To her astonishment there were dozens of "Silvera s", then she remembered that Rosy's name was *"Silviera"* and she had never married. There was a "Louis Silviera" listed, so Trudy dialed the number and got a woman's voice and Trudy thought that must have been Louis' wife. When Trudy told the voice who she was, the woman on the other end said that Rosy had told them about her and her struggle to turn her big old house into a rooming house.

"Yes, but I wanted to tell you about today," Trudy said. "We picked up Rosy to drive to San Jose for the day and when we got as far as Morgan Hill, Rosy seemed to be getting sick so we thought we'd better turn around and bring her back to her place. We offered to get her a doctor, but she just wanted a nap. She seemed to be awfully tired and she said her back bothered her. I left her asleep in her easy chair and came home to phone you. I'm kind of worried."

"Oh-oh," the voice said. "I hope she's not coming down with something—or her heart—she's had a bad heart in the past. Well, I'll get Lou and we'll go look in on her. Gee, thanks for letting us know. We'll let you know how she is—okay?"

Rosy called Trudy several days later and said that she had seen her doctor and he had advised her to cut back on her activities a little because her heart condition seemed a little worse, and he changed her medications.

"Goodness, Rosy," Trudy said, "I'm so sorry to hear that. I didn't know you had a heart condition."

"Oh yes," Rosy said. "I've had a heart problem for years. Everything's okay if I remember to pace myself and watch my diet, but the other day I was kind of tired that morning—I think, because the doctor changed my medicine, you know? I went over to my daughter's and played with my grand kids and they pooped me out! I have to learn to be more careful!"

When Holden and Trudy had married he moved into her quarters and lived with her, but Holden had to leave the house by 6:30 or 7am everyday to muster at 8:00am. Exceptions for him were his duty days—every third day—when he had to spend his nights on the base. Holden ate his lunches on the base but was

able to come home for dinner—unless he was on duty! That meant that Trudys and Neil's mornings were pretty much unchanged on weekdays. Holden spent his weekends at home—unless he was on duty!

One morning a few days later Trudy came out in the kitchen and started her breakfast at about the same time Miss Wembly did and they had a chance to talk for a while. "You know," Trudy began, "this trip we took with Rosy—when she got sick—has been bothering me. I like Rosy and I keep thinking that she could have died sitting there in the back seat of the car. Just think, if we hadn't stopped to get some pop and sat there and looked at her—what could have happened! She could have died that day, and we didn't even know she had a heart problem! Imagine!"

"Of course," Miss Wembly said. "Sooner or later it comes to us all—beggars and kings—and it can take you whether you are in a hospital bed or riding in the back seat of a car."

"Do you believe that there is some kind of life after death?" Trudy asked, steering the conversation to a more interesting topic.

"Yes, I suppose so," Miss Wembly said. "Perhaps not like this life, but something different."

"Then you think we go to heaven and meet God?" Trudy said, picking her words carefully because she was on unfamiliar ground. "My nephew is a preacher and he thinks that when we die we just sleep until we are called. Does that make sense to you?"

"No," Miss Wembly said. "I can't say that it does, but then how are we to know? There may be a way of existing after death that we can't conceive of. But I personally believe that each of us has two parts. We have a physical body and we have a soul that isn't physical. I could compare it with a man and his car. The car is like the physical body and the man is like the soul. The man drives the car and the soul drives the body. If the man is not there, the car is a dead thing. If the soul is not there, the body is a dead thing. The man sits in the driver's seat to operate the car. Where does the soul have to be to operate the body? Who knows? If you remove something from the car it can still be made to work—a fender, a door, the glass. If the body loses a leg or an arm it can still be made to work. Maybe the soul is in the head, because if you cut off the head, the body doesn't work. The executioner knows that!"

Trudy sat listening to Miss Wembly with her mouth open. She had no idea that Miss Wembly thought about such things. Trudy was so engrossed in Miss Wembly's thoughts that she had even forgotten to sip her coffee.

"So, what happens when a person dies?" Miss Wembly continued. "Well, if a person is made up of a body and a soul then it follows that if the body remains and turns to dust after a person dies, then the soul must depart. Do we dream? I doubt it because dreaming takes energy and it requires a living body. If the body

is dead I don't think it can dream. What happens to the soul and where does it go? I don't know. Perhaps I'll find out one day."

"Heavens!" Trudy exclaimed. "You're so full of wisdom! I don't think I've ever heard that said so well. How do you find time to think all that through?"

"Well," Miss Wembly said. "I'm much older than you and I've had time to do a lot of reading, and I've been a teacher all my life."

"Well," Trudy said. "You're right, of course. The way you said it makes so much sense."

"Trudy," Miss Wembly said, "You do realize that what I've told you is only my reasoning—it's not the church dogma."

"Oh! Of course," Trudy said, not sure exactly what "dogma" meant but since it had to do with "church" she thought that it probably had something to do with official church opinions.

Trudy's concerns about Rosy's health after the incident in the car, were soon forgotten and replaced by dozens of problems that pop up in every day living. Sometime late in June or early in July Trudy decided that she had finally accumulated enough cash to finish the bathrooms and she asked Holden and Neil if they would turn their attentions to finishing the studio room and its new bathroom. Neil was always the helper because he was just learning and he could do the tedious little jobs while Holden did the planning and the technical things like the electrical and the plumbing work. Neil admitted to knowing almost nothing about electrical and plumbing work so he measured and cut boards, cleaned things up, and generally did the assistant work.

Working together, Neil and Holden finished the second bathroom that w..s to be a part of the artist's studio room. When the bathroom was finished and working, they cut out the doorway to the studio and built the steps down to the lower floor level. The final part of the project was to plan and build an interior wall from the tenant's side door to the steps leading to the interior hallway and the upstairs, making the tenant's entry a hallway too. Holden conferred with Trudy on the wall location and they laid out the wall line, the interior entry door for the room, and planned a closet for the room almost as an afterthought. Holden placed an order at the lumberyard because Trudy didn't know how, and had it delivered. By the end of July, Holden and Neil had built the wall and painted it, and realized that they had not only created another room for Trudy to rent but they had also created a dark hallway that required a burning light bulb, 24 hours a day!

Trudy worried about having a soaring electric bill with the hallway bulb burning day and night, and began to have nightmares about it. To save on her electric bill Trudy began getting up in the middle of the night when she thought everyone had come in, and turned out the hall light leaving the lower hallway in total darkness. Miss Wembly complained that she couldn't see the steps when

Trudy's House

she came in at three or four in the morning. Herb Knight complained that he had to use a flashlight to keep from stumbling on the lower steps when he went to work in the early morning hours.

Finally, Trudy asked Holden to buy a door with glass panels in it so people could see in the hallway during daylight hours, and Neil put another tiny bulb in for a night light. When the electric bill came several weeks later, Trudy opened it expecting a huge amount due. To her surprise, the increase was barely more than a dollar. She had wanted to show the bill to Neil and Holden with a display of great indignation. Instead, she hid the bill and paid it quietly.

Now that Trudy had her studio room with its separate bath, she had to start saving again so she could furnish the room. One day when Holden was at work and Neil was working in the yard, she got up off her davenport and walked down into her new studio room with her coffee cup in hand. Trudy opened the door and walked slowly into the room, trying to take in all its details. The large artist's window dominated the room. It was straight in front of her when she opened the door. Standing just inside the room there was a pair of older double hung windows to her left that looked out on Fifth Street over the outside stairway.

Looking to her right and taking a sip of cool coffee, Trudy looked at a ten or twelve foot wall that extended from the right side of the big nine-foot square window to the corner of the room. Holden had built a two-foot wide bookcase between the room corner and the new doorway that opened on the little hallway and the new bathroom. To the right of that there was a freestanding fireplace and painted brick chimney and another three or four feet to the other corner of the room. Trudy's eyes followed the ten feet or so of wall that returned towards her and a closet door that was on her right.

Looking down, Trudy could see that the wooden floor still needed a coat of paint. The ceiling was twelve feet high and had a grid of imitation beams that suggested a hunting lodge room. To enhance the motif the walls were covered with heavy textured wall covering with printed hunting scenes on it. The entire effect was a dark, gloomy room that was illuminated by the big window by day, and the stars and moonlight by night.

Trudy's impulse was to buy a lot of yellow paint to brighten the room, but she resisted and decided to consult Madge, and anyone else she could find who would offer an opinion. In the meantime she made mental notes about what was needed to rent the room. She needed drapes for the windows above the stairway, and huge, long drapes for the big window. The big window had a shade that pulled up from a roll at the bottom that was mounted on the sill. She needed another bed and some chairs, and a desk or table of some kind. Then there was the floor, and Trudy knew she'd have to buy another large carpet. She'd have to find some fireplace irons in a second hand store, and she knew there would be paint.

Trudy had a quick look at the new bathroom and saw that it still needed towel bars and a rod to hang a shower curtain on. She went back to her living room, picking up a fresh cup of coffee on the way and sat and wrote a long list of things she needed. Trudy knew that she could rent the room quickly and could probably return money to her carefully held "reserve fund" right away, but she still thought about it at least an hour or so, weighing the pros and cons of the problem. Using some of her cash right away or trying to accumulate cash from the rents coming in, which might take several months with all she had to buy.

Madge stopped by later in the afternoon and made Trudy's decision for her. Trudy took her through the new room Holden had created, and showed her the two bathrooms in the former laundry room and Madge was bubbling with enthusiasm at the progress. "My God, Trudy!" Madge said. "I think this old place is really looking good! Holden has done a great job on the two bathrooms, too! You know, with some halfway decent furniture this studio room could bring quite a bit."

"How much do you think I could get for it a week?" Trudy asked.

"Oh, let's see," Madge said, studying the room. "It depends on how you set it up. Good furniture; nice drapes and some decent paint on these horrible walls—maybe $15 a week. How much do you get for your best room now?"

"$12 a week," Trudy said.

"Well, this one is your best one, I'm sure," Madge said. "If I were you, I'd try to get $15. If it won't rent for that, you can always bring your price down. Remember that. You can lower your price but you can't raise it—well, I guess you've discovered that!"

"I sure did," Trudy admitted. "Gee! That soldier scared the life out of me!"

"Then you know what I mean," Madge said. She looked at the studio room a while longer, then asked, "What color are you going to paint it?"

"I don't know. I was thinking of a nice bright yellow," Trudy said. "It's such a sunny color and this room is so dark. Another thing—I'm thinking about putting this off for a month or so until I earn more money from the rents, or do you think I just push through and get it done." "Trudy," Madge said, answering the question about the color first. "Don't ever paint anything in a house bright yellow. That's a color that's associated with the tastes of poor people from little foreign countries. It'll kill the value of your property around here. Besides, yellow doesn't make a room light and bright. Use an off white. Don't use white either because that's a refrigerator color. Off white or antique white works a lot better.

"Get it rented as fast as you can, Trudy," Madge said. "No one knows how long this damned war is going to last with our troops in France already! You know, 'make hay while the sun shines', kid!"

"Oh," Trudy said. "Gee, I'm glad you tell me these things!"

Trudy's House

The next day Trudy took Neil in the car and she bought several gallons of paint, including a gallon of floor paint, and since Neil was free all day on his summer vacation, he spent the next few days painting the room while she went shopping for things to furnish the room.

A few days later, Holden and Trudy were talking about the house and Holden said, "Trudy, have you ever given any thought to what you're going to do here when the war is over?"

"It won't make any difference will it?" she answered. "I'll just keep on renting rooms."

"I'm not sure that will work in peace time," Holden said. "Renting rooms works right now because there are so many people at Fort Ord, but that will end when the war is over. I think they'll keep on training troops there, but it won't be like it is now."

"How do you mean?" Trudy asked.

"The reason there's such a demand for rooms now is that we're at war," Holden explained. "The guys get drafted and come here for basic training. After a couple of months of basic they're either sent on to school somewhere or they're sent overseas. Since most of them get sent overseas and there's a good chance that they'll get killed or wounded, their wives and sweethearts want to come here and be with them while they can. Do you understand?"

"Sure," Trudy said. "I understand. I know all that. So what's different after the war?"

"Well, damn it, we won't be at war anymore and they'll be coming back without getting shot at! Besides that, there won't be anywhere near so many of the men training! That means that they will be renting small apartments and not rooms. There won't be a need for rooms. You might be able to rent rooms to people who come here for a weeks' vacation, or come here to escape the summer heat, but most of the time this house will be empty."

"Golly," Trudy said. "I've never really given that any thought. When do you suppose that will happen?"

"Maybe next spring or summer. It depends on how the war goes," Holden said. "Someday soon, for sure, and you should be giving it some thought now so you'll be ready to adapt to the post war changes."

"Golly," Trudy said. "I don't have any idea what I would do. All that I've ever done is rent rooms, but I suppose renting apartments would be about the same."

"Trudy," Holden said patiently, "That's why we're talking now. I think you're in a good position to make changes. I think you should stay with what you have now. I don't think you need to make any more changes for a while. But I think that in about a year or less things will change, and I think that if you stay aware of what's going on and listen to Madge, that you'll know what to do." Holden

235

paused and thought for a minute, then said, "I suspect that you might want to turn some of these rooms into little efficiency apartments, and I think it would be pretty easy to do—but, like I said, wait until the time is right."

"Well, I think that sounds like pretty good advice," Trudy said. "I won't have any trouble not changing anything because this studio room has put me in the hole. I'll have to collect rents for months to get all my money back."

"And meanwhile," Holden reminded her, "you have another room to rent. Has Neil finished painting it yet?"

"He hasn't said anything to me," Trudy said. "Let's go see."

They went to the studio room door and knocked in case Neil was working just inside. Hearing nothing, Trudy opened the door slowly and looked in. They could see he had been busy because the floor had been painted and was dry, and the dingy, dark walls were now a light beige and the entire room looked brighter, and reeked of paint. The side windows over the steps were open and the back door that used to be the laundry room door was propped open, and they could see that Neil was trying to air the room out. They closed the door and went down the tenant's side steps and found Neil raking dead grass into a pile in the other end of the yard. Trudy and Holden walked back to talk with him.

"Hi," Trudy said. "What are you doing?"

"I'm getting a burn pile together," he said.

"Can you do that here?" Holden asked.

"Yeah," Neil said. "I stopped by the fire department the other day and asked them. They said I had to have a hose out and connected, and a shovel, and that I had to wait for a cool day and phone them first to get their permission."

"Sounds reasonable," Holden said. "If you want to wait for a day when I'm here, I'll be glad to give you a hand. By the way, we looked in on your paint job. It looks really good. In fact, it looks like you're almost finished."

"It's almost finished," Neil said, "but the fumes were killing me. I had to go do something else for a while. I just have to finish some painting some trim and I have to scrape the paint off the windows."

"Gee," Trudy said. "I need to get busy and find the furniture for that room. If I don't I won't be able to rent it when someone comes by!"

Trudy drove around searching for furniture for her studio room for several days. On a Friday afternoon in late July, Private Hughes saw Trudy in her front garden as he was walking by and told her that he and his wife had found another room and could move over the weekend if Trudy didn't have any objections.

"No," Trudy said, "I'd don't have any objections under the circumstances. I understand how you feel. When you've moved you can just slip the key under the door if you want to. You've been a good tenant."

Private Hughes nodded his head and walked on, and Trudy never saw him again.

The next morning was a Saturday and Holden was helping Neil burn the trash and dry grass in the yard that Neil had raked into little piles. As each pile burned down, Neil brought grass from another pile and put it on the fire. Trudy had been helping, but had returned to her kitchen to relax with a hot cup of coffee. She had just settled on her davenport when someone knocked at her hallway door. Trudy put her coffee down on the end table and rushed to answer the knock. When she opened the door she saw Herb Knight standing in the hallway with his hat in his hand.

"Well, for heavens sake!" She said. "Come on in and have a seat. How are you?"

"Oh, I'm fine I guess, but I'm going to be moving," Herb said softly. "I hate to move because I like it here, but they offered me more money to work somewhere else."

"No!" Trudy said. "Gee, you've been such a good tenant—and you were my first tenant!"

"Yep," Herb said. "It's been a year already. Isn't that something?"

"That's right!" Trudy said. "My Goodness! A whole year already! Where are you going to be working?"

"In Santa Cruz. They're opening a new bakery in Santa Cruz," Herb said. "I'll be moving out next weekend, if that's all right with you."

"Yes, of course," Trudy replied. When Herb Knight left, Trudy went back to her davenport to drink her coffee. An hour later, the mailman delivered the afternoon mail and Trudy found a letter in it from her sister Jean saying that she was coming to visit for a week and would be arriving on the Monday evening Greyhound bus.

Trudy went back to her davenport to sip more coffee.

CHAPTER SEVENTEEN

A big Greyhound bus pulled up to the curb in front of Trudy's just before dinnertime on Monday. Trudy and Holden watched as the door swung open and a middle-aged woman stepped down on the sidewalk, holding the driver's arm. While she stood still looking left and right up and down the sidewalk, the driver opened the luggage door and pulled out a large, battered suitcase and left it on the sidewalk beside her. She watched as the driver got back on the bus, closed the door and continued on another mile or so to downtown Pacific Grove, which was the end of the line for him.

Trudy walked out the front door to greet her sister and bring her into the house while Holden followed her and picked up Jean's suitcase and carried it into the house. Trudy and Jean stood looking at each other for a moment, then Jean let her eyes wander around the large living room. "Land sakes," she said. "So this is your house—and I guess this man is Holden. How do you do, Sir!"

Holden took her offered hand with a wide smile and said, "How do you do? How was your trip?"

"Oh, it really wasn't too bad. I left Portland yesterday morning and rode the bus all the way down here. That bus has nice seats. My! I could lean back and be so comfortable, and I slept real good. But, I didn't know it would let me off right in front of your house!"

"Well, that's because this house is right on their route, I think," Holden said. "They'll stop if they don't have to drive off the route."

"That sure makes it nice," Jean said, grinning.

"Jean, why don't you sit down and relax," Trudy said. "You must be exhausted from all that travel."

"Oh, Trudy," Jean said. "I've been sitting for hours. I'd like to walk around and see your house while it's still daylight. Do you suppose we can we do that?"

Trudy's House

Holden stayed in the house and built a small fire in the fireplace as Trudy led Jean out the front door and down the garden path that led to the garage. He could hear them talking as they walked, looking at flowers and talking about the house.

"Land sakes!" Jean said as they walked. "You've got a huge house here. Does it cost much to heat in the winter?"

"No. But we don't have Portland winters either," Trudy said. "Here, look at the nice big yard that I have—and that's my two-car garage, too. I keep my car in there and I let one of my tenants use the rest for a wood shop. He likes to build things."

"Why, this place is like an estate!" Jean said, looking all around. "And look here," Jean said again, looking around at the back of the house. "Why, it looks like this house and land go all the way through from one street to another!"

"Yes," Trudy said proudly. "My property goes all the way through from Fourth Street over here behind us, to Fifth Street over there," she said, pointing from one street to another.

"Don't you have trouble paying for all this?" Jean said.

"I have seven rooms that I rent and I have about ten tenants when everything is rented," Trudy said.

"My Lord!" Jean said, looking at the back of the building. "Your house is three stories high—four, if you count the attic! Boy! I sure hope you know what you've gotten into here," Jean said. "I think your house is twice the size of mine!"

"This house is a lot of work," Trudy said. "Holden and I have been together about three months now and he has been a lot of help. He built two bathrooms in a laundry room I had, and he built a wall to make another room to rent, and he has done a lot of little things to the electricity to make it all work better. Neil has been a help doing what he can do."

"Neil!" Jean said, suddenly remembering her nephew. "How's he now? Where is he? I'll bet he's all grown up."

"I don't know where Neil is right at this minute," Trudy said. "He likes to walk along the beach so he might be there now."

"Oh?" Jean said, looking left and right at Trudy's back garden. "Well, I guess he'll be home for dinner. My Lord, but you have a lot to take care of here. Do you get enough money from your room rents to pay for all of this?"

"Sure!" Trudy answered, using a tone in her voice that suggested that her being a landlady was so successful that money was no longer a problem for her. Trudy had not forgotten how negative Jean had been when she was still planning to drive to California with Faith.

"Come on! I want to show you the new room we've just finished," Trudy said, leading Jean up to the side entrance of the house.

Before going up the stairs to the tenant's entrance, Jean pause to get her bearings. Straight ahead, the sidewalk led up to the corner of Fifth Street and

Central. Looking behind her Jean could see down Fifth Street to the wide street below, across rail tracks and an unkempt grassy strip and the heaving water of Monterey Bay. She shook her head in wonder that Trudy had managed to buy a house that was scarcely a block and a half from the sea!

Jean looked back through the back yard that she had just walked through and noted that the distance to Fourth Street was almost the distance to the bay. Jean shook her head slowly again, wondering how it was, in the great scheme of things that her younger sister who had never shown any particular ability to even successfully plan a days' activities, had come to own and operate a money making business and support herself and Neil in the process. Jean had worked hard all her life and was barely able to maintain her old house in southeast Portland and keep the bills paid.

Jean looked up the dozen or so steps to the door and wearily climbed up to the porch, entered into the new hallway that Holden had created when he built the wall to give the studio room it's privacy. She looked in the open doorway and found Trudy standing in the center of the room looking at the bay in the evening dusk. "There you are," Trudy said, watching Jean walk in the room.

"Boy," Jean said. "I'll bet you loose a lot of heat through a big window like that! Why on earth do you want to have a window that big?"

"Well, this window was built that way. It's an artist's studio and artists need a big window like that for lots of light," Trudy said.

"Well, it's that all right," Jean said, looking up at all the glass. "I guess that's why you have a fireplace in here, too. Does it work?"

"Sure it works," Trudy said. "I've got three fireplaces in this house and they all work."

"Land sakes!" Jean said. She turned and studied her sister for a minute, then said, "You've sure come a long way in a year and I've got to say that I didn't think you could do it. I guess I owe you an apology. How did you learn to do all this?"

"Well," Trudy said. "I kept my eyes and ears open and I worked my fingers to the bone getting these rooms ready."

Jean studied her sister again and smiled. She knew all her sisters pretty well because being the oldest, she had helped raise them. "Yeah, I'll bet. I know you better than that, Trudy. I imagine that Faith gave you a lot of advice, and I'll bet you have some friends around here who have pointed you in the right direction, too. Nobody gets this far without lots of help. But it's to your credit that you took their advice!"

"Well, sure," Trudy admitted. "Faith gave me some good advice, and so did Madge. She's the gal who sold me this place. Whenever I've come up against a problem, Madge and one or two others have given me some pretty good advice."

Trudy's House

"I guess I'm all tired out now," Jean said. "Now, how do we get back to where you live so I can sit down for a while?"

Trudy led Jean through the hallways to her kitchen where they found Holden and Neil talking about the house and what project should be done next while Holden made a salad for their dinner.

"Aunt Jean!" Neil said when he spotted her. "How do you like this house?"

"Hi!" Jean said with a big smile. "It's sure a big house, all right. What do you think about it?"

"I think it's a lot of work," Neil said. "How long will you be here?"

"Oh, I leave at the end of the week," Jean said. "I have to be back at work on Monday at eight o'clock in the morning."

Jean had dinner with Trudy, Neil and Holden, and tried to visit for a while but finally had to give in to her exhaustion and go to bed. Trudy had made up a bed in the new room where Jean would have her own bathroom and could be near Trudy. During the coming days Trudy took the time to drive Jean around the scenic spots on the Monterey Peninsula while Neil continued with the yard work and Holden continued with his regular Navy duties. Trudy was pleased that Jean seemed to be enjoying her vacation because she privately thought that her sister had one of the worst jobs a woman could have—sewing blue denim overhauls in a noisy factory. It was a daily ordeal that gave Trudy nightmares. Jean, however, thought that while it wasn't much of a job it gave her a steady income and she was thankful that she had it. She was the best kind of employee because she was never late for work and rarely took time off.

When the time came for Jean to return to Portland, Jean and Trudy rushed around gathering Jean's belongings and carried her luggage out on the front porch where they could easily load it in Trudy's car. With lots of time before Jean had to get on her bus, she sat down a relaxed for a few minutes. "My house has been a gathering point for the whole family," Jean said. "It's a big old house and I like having the family visit when they can, but I have always wondered about you and Ellen."

"Ellen and me?" Trudy repeated. "Why?"

"Because you two are different than I am," Jean said. "You've both always been kind of flighty; chasing rainbows and wanting things you aren't likely to get. I remember seeing it in you two when you were just kids, and mother was always wondering if you were going to take up with flighty men when you became young women.

"When I bought that house in Portland I thought that surely you'd come back there with kids some day and I'd have to put you up for a while until you two could get on your feet again. My father was just a working man and I guess I took after him. But your father was a traveling salesman and why mother ever married him has always been a puzzle to me. If she just had one kid by him then

241

you could say it was a love child, but she had two! Land sakes! I suppose she was just taken by him. I don't know.

"Anyway, before I leave I wanted to tell you that for the first time in our lives I guess I see a side of you that I didn't know you had. It looks to me that you've found a place for yourself here. I hope you can keep the ball rolling because I can't imagine you renting rooms so easy when the war ends. I'll bet everything changes here and there will be a demand for something else."

Trudy was surprised to hear Jean telling her all these private thoughts. Jean had never talked with her this way and she didn't know why she was saying it now. Jean was always the older sister who just made comments and gave orders without explaining "why".

"When I go back, Ellen will be full of questions," Jean said as she struggled out of her overstuffed chair. "I'll tell her about your house and this town and she'll want to come down here, too. Believe me, if I was you I'd make sure that she doesn't stay in your house. If she wants to stay down here, and I think she will, help her find a place to stay and get a job right off the bat, or she'll be hanging on your apron strings, too."

Trudy drove Jean up to the little magazine stand and Greyhound bus station next to the theater in Pacific Grove and watched her get on the bus and wave good-by from her seat by a window. As she waited for the bus to leave, Trudy watched Jean through the glass and wished that they could have talked a little more because she felt like Jean was accepting her on a one-to-one basis at last. Perhaps, Trudy thought, it was because Jean approved of the progress that Trudy had made in a year. Perhaps it was because Jean saw that Trudy was finally able to fend for herself.

Trudy stood on the sidewalk and watched the bus door close, and continued to watch until the bus turned the corner and drove out of sight. She had enjoyed Jean's visit, and looked forward to another visit sometime. In fact, Trudy realized that perhaps for the first time in her life she was actually going to miss Jean!

Trudy parked outside her garage in her own driveway and started walking through the yard to her house when she saw Neil digging in the lower part of the yard. He stopped and looked at her as she walked down the path along the east end of the house.

"I just took your Aunt Jean back to the bus," she said. "She'll be in Portland tomorrow afternoon and has to go back to work the next morning. Did you have a chance to say good-by to her?"

"Yeah," Neil said. "She sure is a kind person."

"Yes, it was nice that she came down," Trudy said. "Mr. Knight is moving out, if he hasn't moved already, and the verandah room is empty, so you need to clean them up so we can rent them again. Do it now, please, because you know how we need the rent coming in."

Trudy's House

"Mother," Neil said. "Stop telling me to do it now! I know you need it done, but I have the garden tools out and I want to get this little patch dug under. If you keep moving me around it makes more work because I have to get different tools out. Why don't you let me finish what I'm doing?"

"Listen mister," Trudy bristled. "You know that getting those rooms ready is what's important. That's the money we live on. Now, I want you to get them ready! We might have someone come by this afternoon and I wouldn't have anything to show them! Now, do what I tell you!"

In a rage of frustration Neil threw his shovel on the ground and stomped off to his room to change his clothes and begin work on the verandah room. It took him almost an hour to change out of his dusty garden clothes and put on some cleaner clothes. All the while Neil was angry at his mother's impatience but he also knew that she was right. He should always think about things that meant their livelihood and he knew it. He decided that life would be easier for him if he thought about work priorities in the future, rather than just starting to work on things without thinking about what had to be done first. As Neil mulled things over, he realized that it was his mother's tactless methods that bothered him more than anything else.

Trudy stood in the garden for a few minutes after Neil went in the house, and looked over the work he had done in the back yard. She had to admit that the yard was looking a lot better and she liked the way he had organized the garden and laid out the paths. Goodness knows what the yard would be like if he hadn't started working on it. But, the way that Neil threw his shovel down intimidated Trudy and she suddenly saw that Neil was growing up and was getting so big that she no longer felt comfortable arguing with him anymore. She began to wonder how much longer he would continue to mind her and maybe even become unmanageable in another year or two as he grew into manhood. She had heard about rebellious teens and she had begun to wonder about Neil. She decided to have a talk with Holden about Neil's behavior.

As she walked back toward her front door, she met Hank who was on his way to the garage to do some woodwork. "Hello, Mrs.Anderson," Hank said. "I've been wanting to talk with you because I have finished those things you asked about. Do you remember?"

"Oh yes," Trudy said, not really remembering what she had asked him to make. She only remembered that she had talked with him months before when she wanted to put her car in the garage. "Have you finished the work?"

"Yes, Ma'am," he said. "I have to finish everything because I hear that they may be shipping a bunch of us to Hawaii."

"Really?" Trudy asked. "You're going to Hawaii?"

"No one knows yet," he said. "We heard some scuttlebutt that with the war shifting to the Pacific, and that they might be increasing the size of the Navy staff

in Hawaii, so it's kind of like we've been put on alert. For now, all they want us to do is get ourselves in order. For me, that means I'll have to stop woodworking and get things ready to go. We might have to leave on short notice."

"Oh, I see," Trudy said, thinking that the military seemed to have a habit of keeping men and families off balance with all their moving around. "I'm not sure what you mean by scuttle—? Can you bring the things over to my door when you're ready?"

"Sure, and I'll try to let you know when we're leaving—if we leave!" Hank said. "You never know with the Navy! And scuttlebutt? That's Navy talk for 'rumors!"

That evening, Trudy waited until Neil went up to his room to go to bed before she asked Holden about Neil's behavior. They were looking over Hank's furniture that Trudy had made. Hank had made her a redwood hope chest, two redwood coffee tables, and a small redwood bookcase. Holden had declared that it was serviceable furniture, but not that well made. He told Trudy that it lacked a craftsman's touch.

Dismissing Holden's comments about Hank's woodworking abilities for the time being, Trudy sat down and began to tell Holden about her concerns about Neil, and her worry that he might become unmanageable. Holden listened carefully and told her that while he was here she shouldn't worry about Neil. "Has he ever gotten violent? Has he ever cursed you or threatened you?"

"No," Trudy said. "Never."

"And, he's what—fifteen?"

"A little over fourteen," Trudy said. "He's already bigger that I am, and he gets so angry with me."

"He's just a boy," Holden scoffed. "He's assertive and I don't think you'd want him any other way. If he wasn't assertive he'd be like a queer—a mother's boy!"

"You don't think I need to worry about him?" Trudy asked.

Holden studied her for a minute, thinking about how to respond. "I think you need to stop ordering him around. Don't treat him like a child. Treat him like an adult. Tell him what you'd like to have done and let him do it—then pay him something for it. I think that he learned to be an adult up on that ranch in Oregon and that he wants to remain an adult. You ought to let him be one because I think you tend to treat him like a child because that's what he was when you all went your separate ways."

"But, I want to have control on what gets done around here. It's my house," Trudy said, tightening her lips together.

"Maybe," Holden said, "but it's Neil's, too, isn't it?"

"No!" Trudy said. "It's mine! I've gotten all this work done! Neil was just a boy when we got here."

"A year ago," Holden said.

"Yes, a year ago!" Trudy repeated.

"Trudy," Holden said patiently. "I don't think you know your own son. He's more grown up than you think he is. He might have been a boy in a lot of ways a year ago, but he was grown up in a lot of ways, too."

Trudy sat quietly for a moment, then said, "I still don't know what to do if Neil gets rebellious."

"Why do you think he will?" Holden said. "I don't see any signs of rebellion in him."

"I'm afraid that I won't be able to handle him," Trudy said. "If you get transferred too, I won't be able to deal with him. Jean's son is a minister. I think I'll ask him for some ideas."

Holden shrugged his shoulders and went to get ready for bed, feeling a little frustrated because he didn't think that he was getting through to Trudy, but Neil was her son and he didn't feel that he was right to interfere in their relationship. Trudy stayed up a little longer and wrote a letter to her nephew.

Trudy hung her "Room for Rent" sign out several days later, although Neil hadn't completely finished with the rooms. Both rooms needed a thorough cleaning and some paint and Holden and Neil, who were both trying to practice Neil's new resolution of maintaining priorities to lessen wear and tear on himself and to keep Trudy happy, were busy building a clothes closet in the end of the verandah room. They had also planned to remove about the half of the long course of windows the next time the room was vacant because all the windows were hinged on the sides and swung open inwards, and they all leaked. Holden told Neil that if they leaked water, they would also leak air. Changing the windows would help keep the room warmer in the winter, but they would have to find some way to insulate the ceiling to really keep the room warm. Once the verandah and Herb Knight's old room were ready to rent again, Holden and Neil planned to get the new artist's studio room ready to rent.

Trudy showed the rooms to four of five different people, but no one seemed to be very interested. Trudy had noticed over the past year that the demand for rentals seemed to run hot and cold. Madge had once told her that was to be expected because Fort Ord was always transferring troops in and out, and the rental market would cool down whenever a large number of troops would leave the area then heat up again when more trainees arrived. Trudy lowered her prices a little and rented the veranda room to an Army couple named Muntz, who were from the east coast. They were in their late twenties and were not involved in training men and were delighted with the room because it was cheap and they wanted to save money.

Trudy rented Herb Knight's room a few days later to a retired mailman named Homer Ellsworth. Mister Ellsworth had retired two years earlier and had sold his home to live on the coast where he was sure life would be better because of

the cool weather. He had spent his life in one of the interior valley towns where he had gone through school, married, raised a family and worked to retirement in the summer heat and cool, damp winters in the San Joaquin Valley, with the life-long wish that it all could have been in the cool, moderate weather on the coast.

Trudy felt that everything was right again. She was back on track with the money coming in and the bills getting paid. Trudy was concentrating on the artists studio with the hope of finally finishing the room and getting it rented soon so she could restore her savings quickly and put an end to the marginal living caused by the heavy expenses in new bathrooms and all.

One thing that stuck in her memory however, was that her new tenant had what Trudy considered an odd mannerism and she wondered if it meant anything that she should be concerned about. When Mr. Ellsworth was looking at Herb Knight's room, he looked at everything and then stood in the middle of the room and pulled a key ring from his pocket. The key ring had several keys on it that looked like car keys, and it had a short chain with an ornamental golden fob attached to it that was triangular in shape. As Trudy watched he held the key ring by the keys with the fob hanging down from the ring. He looked at it for a moment, observed the motion of the fob and said with a smile, "It says 'yes', that I should rent the room."

Trudy forgot the key ring mannerism for the moment and rented the room to him. Late that day, as she relaxed on her davenport with a cup of hot coffee and thought back on the incident. Going back over his mannerism, she found that she couldn't relax and decided to talk about him with other people. She thought she had seen everything, including all the strange habits her artist-friends had in Portland, but she had never seen anyone seek approval from a watch chain!

The next morning she told Miss Wembly about Mr. Ellsworth as they were having breakfast. Miss Wembly chuckled for a moment, and then broke out laughing. "Well," she said when she had regained her composure, "you don't know, do you. It might be all perfectly safe and hardly worth mentioning. On the other hand, that poor chap might have gone right around the bend! I'm going to make certain my door is locked. Perhaps you should be asking for references."

When Lovey came in for breakfast she listened as Trudy told her about Mr. Ellsworth. Unimpressed, Lovey sat down and started nibbling on her toast. "I think he's all right," she said. "If that kind of thing worries you, don't go to New York. There you'll see all kinds, believe me. I used to walk by this "thing" who sold newspapers off the sidewalk from the same place for years. I never knew if it was a man or a woman because 'it' always wore the same thing—a dark green raincoat and a nor'easter hat with tattered plaid blanket material hanging out of the sleeves and around the bottom of the raincoat. You couldn't even see the face! Hell, I don't even know if 'it' ever got up to go poop! 'It' just sat there day

Trudy's House

in and day out, rain or snow or sunshine and sold papers from little stacks with weights on them. Wait! I take that back! I never noticed 'it' in the rain! Huh! I guess I'll have to ask."

Trudy listened to Lovey's story and waited for a correction in her story that never came. Finally, Trudy finished her coffee and said, "I think he'll be all right. He uses his keys for directions and other people ask a statue or a cross, or lots of other things, I suppose. A few years ago in Portland, I had a friend who wanted me to consult with tarot cards to plan my future. Just imagine!"

"Yes," Miss Wembly said, "and some people even consult with their lodgers!"

Lovey nearly spilled her coffee. "Sharp! Very sharp!" she giggled.

Neil went back to school on Monday, September 11, because that was the first school day after Admission Day in California, the day when Pacific Grove's children went back to school after their summer holiday. He discovered that the routine in high school, where he was starting as a freshman, was much different than the grade school he had been to. In high school the kids moved from room to room for each class period, and a different subject was taught in each room. The kids pretty much stayed in one room in grade school—except for the shop courses that were held in the basement. However, the workload in the courses was about the same, and he soon discovered that homework in high school was the rule rather than the exception. He had homework every evening.

The biggest difference in the schools, Neil discovered, was something he hadn't considered. When he was in the grade school he was among the oldest students, and in high school he was one of the youngest. What he found most interesting—and distracting—was that the girls were becoming young women, and that gave Neil a completely new outlook on life. Later, as he became more acquainted with the other students he discovered that the oldest students, the senior boys who were about 17 years old that fall, were apprehensive about their futures. World War II might have been winding down in Europe but there was still plenty of fighting going on in both Europe and the Pacific, and men were still being drafted into the services right after they finished school.

One morning Trudy was having toast and coffee with Miss Wembly and Lovey, when Lovey began getting curious about Trudy. "So, Trudy," she said. "I'm wondering, since you're from 'way up north in Oregon how the hell did you ever come here? What did you do? Did you get up one morning and say to yourself, 'I think I'll move to Pacific Grove and start a rooming house. Who knows about Pacific Grove? I'd never heard of it until I got here."

"Well," Trudy said. "I'm actually from Winnipeg, Canada. What do you think of that?"

"Good God!" Lovey said. "Back in New York they call that place 'Winterpeg' because it gets so cold there."

247

"They do?" Trudy laughed lightly. "Well, they aren't far off. When I was a little girl we used to go to the movies and see those scenes with movies stars standing around palm trees wearing next to nothing, and I thought that if there really was such a place I want to live there."

"So," Lovey said, "you hopped a freight train and headed south?—What?"

"No, my oldest sister married a man from Vancouver, B.C. and when she moved we all followed her. I was about 15 then. He died and Jean moved to Portland to get a job, and we followed her again. I met my husband in Tacoma, we lived in and around Portland, then he died and a lady friend and I drove to California to explore what was here and to see if I could make living here. We came across this place, so near to Fort Ord and all and I bought it."

"No kidding!" Lovey said. "So, did you know anything about this place before you came here?"

"Well," Trudy said. "I was like any young girl. I was star-struck and read about their lives. I knew about Hollywood and L.A. of course, and I guess I'd heard a little about the glamorous places they would escape to."

Miss Wembly had begun to notice that each time Trudy told someone about how she had arrived in Pacific Grove and started her rooming house, she left more and more out of the story about the help she had received from friends like Madge, Rosy, and Faith (whom Miss Wembly had never met, but had heard of many times in conversations with Trudy). Miss Wembly wisely kept these things to herself—which explains why she had been a trusted employee of a French noble family for so many years before the war. Miss Wembly wasn't sure why Trudy was altering the story, but guessed that she was gaining some self-esteem from owning and operating a rooming house and wanted a suitable support story to go along with it. Miss Wembly had noticed in her many years of service to others that money and self-esteem were usually at the root of such fabrications.

Lovey, Miss Wembly, and Trudy had breakfast together on most mornings and enjoyed their meetings to get the day started. Sometime in late August, before Neil started school again, Lovey complained bitterly about the horrible fishy smell that would start around noon and build in intensity into the evenings.

"What are they doing?" She said. "I haven't smelled anything like that since my father took me to a fish fry over in Jersey."

Trudy and Miss Wembly laughed at Lovey and told her about the fish canneries down on cannery row.

"Cannery row? Yeah?" she said. "I've heard about that somewhere."

"You've probably heard about it from us," Miss Wembly said. "It's a row of half a dozen fish canneries on a street down on the water front between here and Monterey."

Several days later Trudy received a thick letter from her nephew who was a young minister and was serving as an assistant in a church in a Boise, Idaho suburb.

Trudy sat down on her davenport with a hot cup of coffee to read it. She read through the letter several times because it didn't really have any clear-cut advice or solutions to potential problems. Instead he told her to work on such things as a positive outlook, religious training, parental support, and a harmonious home life. Finally, he mentioned that if Neil was impossible to deal with, his church did have a boarding school near Stockton, in California, and that the boarding fees were beyond what most people could afford.

Trudy rested her head back on the davenport cushions and wondered why her nephew had not written a letter that was helpful. Surely he must have understood what she was dealing with! When Holden came home that evening, Trudy showed him the letter and asked what he thought.

Holden read the long letter carefully, then put it down and thought for a few minutes before saying anything. "Trudy," he said at last, "I think it's like I said before. I don't think you have a problem. A boy expressing an opinion or objecting to something is not a boy in rebellion. He doesn't drink and he doesn't smoke, and he doesn't even hang around with a rough crowd. He does say what he thinks and I think you should listen—or, at least hear him out! He may have some good ideas."

Trudy stiffened and looked at Holden with her lips pressed tightly together. "He's just a kid," she said. "He's not even old enough to know what's good for him!"

"I think you're wrong, Trudy," Holden said, "but he's your son, not mine, and I want to stay out of anything between you two."

"Hell-damn!" Trudy muttered angrily.

Several days later Holden pronounced the new artist's studio room ready to rent. The paint was finally dry and Trudy had made long drapes for the huge window in the room, and all the necessary furniture had been placed in the room with a nice carpet that set the entire room off. Everyone agreed that it was an attractive room that should rent quickly, especially since it had it's own bathroom. It rented the next day to a new 2nd lieutenant and his wife, Milton and Anna James who were from family farms near Springfield, Missouri. They wanted the artist's room because Anna loved to dabble in the arts.

"It's so beautiful here," Anna James said when they were looking at the room. "I've never seen the ocean either. I can sketch and paint right here while my husband goes to the base every day. Does this big window face the north?"

"They tell me it does," Trudy said. "I've never checked on it." "Well, it looks like the sun sets over there," the young woman said, pointing to her left, "so that window faces north. How wonderful!"

Everything was rented again and Trudy, who privately thought the new tenants were not very interesting, was happy with everything rented and was even overlooking the differences in opinion that she had with Holden.

When Trudy rented them the room, the James said they would move in with what they had and look for the delivery of their belongings in a few days. For a week or two, Trudy saw Anna James walking down to the beach almost every day with sketch books in hand and came to the conclusion that the young woman probably was a serious artist, but almost everyone who lived in Trudy's house soon came to another conclusion; that Anna James was also pregnant, because she was starting to wake the entire house up at 4:30 or 5:00 am with bouts of morning sickness. Even Lovey and Moe were up early listening to Anna's wails coming through the thin walls of Trudy's old house. Anna's husband was so embarrassed by his wife's reaction to morning sickness that he tried to get emergency leave to take her home, but the Army wouldn't give it to him. In desperation he wired home asking his family if someone could take care of her. Finally, Anna's aunt who lived in Sacramento, showed up at Trudy's house and took Anna to live with her until they could make better arrangements. Trudy allowed the young husband to vacate the room without prior notice so he could move to officer's quarters at Fort Ord.

Trudy had a vacancy again, but not for long because Madge had told the people at the Marine Station on nearby China Point that Trudy rented rooms. The Marine Station was owned and operated by a large university and they used it as a location to teach marine sciences, drawing students from all over the world. Two young female graduate students rented the room for the school year, providing Trudy would supply them with another bed and a desk of some kind. Trudy made another trip to the second hand store and had everything in the room when the girls moved in. Trudy was delighted with her luck.

The differences between Trudy and Holden had taken a toll on their relationship and they both knew it. After several weeks, they were still angry with each other. For Trudy it was Holden's reluctance to deal with what Trudy saw as a potential problem with Neil—that somehow she expected would develop. For Holden, it was Trudy's apparent inability to see both sides of a problem. He thought that she was too single-minded.

Neil also saw that Holden and his mother did not work together well, but stayed out of what he considered their business. With all the rooms rented, he turned his attention again to cleaning up and organizing the big yard around the house so that he would continue to get his allowance. His homework wouldn't allow him to work after school anymore, but he tried to put a few hours in on Saturdays and Sundays. Since he had no interest in sports at all he did have extra time to work.

One afternoon in late September Trudy was sitting on her davenport with her feet up on the cushions reading a magazine. The weather was sunny and warm and she was thinking about taking a nap before she had to make dinner. She heard someone come in the tenant's side door and start up the hall steps when they stopped at her door and knocked. Trudy put her magazine down and

slipped her feet in her shoes and rushed to the door. When she opened it, she saw Hank standing there smiling politely.

"Hello, Mr. Knox, what's up?" Trudy said. "Come on in."

"Hi Trudy," Hank Knox said, walking a few steps into Trudy's long living room. "Well, I told you that I would let you know as soon as I knew. The Navy posted a long list of people who are going to be transferred to Pearl Harbor and we're on it. I'm being transferred in about ten days. So, I'll give you my notice now."

"Oh, all right," Trudy said. "Thanks for letting me know. What about your wife? Is she going with you?"

"Vivian?" Hank said. "I don't know. We haven't really talked about it yet. I suppose she'll be going home until I get back. Does Holden know when he's going?"

Startled, Trudy looked at Hank for a moment without answering, then said, "Holden? No, I don't think he does."

Hank left the room and climbed up the hallway stairs to his room, leaving Trudy to think about what he just said. It would be a shock if Holden were being transferred because he was being so helpful in getting her house fixed up, so Trudy didn't want to think about that. It was true that Holden didn't seem to understand that she had put everything she had into the house, and had worked hard to get the rooms rented. He didn't understand that living in Pacific Grove and owning that house represented everything she had ever wanted since she was a little girl in Canada. Maybe, Trudy thought, Hank didn't mean Holden at all. Maybe it was just a slip of the tongue.

Trudy went ahead and began making dinner. She had decided that she would wait and see what Holden said when he came in. Trudy had begun to wonder what things would be like if it was true that Holden was being transferred. She had all the rooms she could make in the house without going in to the attic or the basement, and they wouldn't rent anyhow. All she really had to think about was turning the rooms into apartments someday, and that could be years away. She wondered if she could get along with Holden when they weren't busy. She'd like to do some traveling someday and she had no idea if Holden liked travel. She thought that he seemed like a stick in the mud, as her relatives liked to say. The more she thought about their relationship the more she began to think that she had pressured herself into the marriage because he was a good-looking man with a good personality and was good company for her, but most of all because he wanted to do the work that she need to have done. With that thought, Trudy sat down heavily on a kitchen chair and tried to bring her life into focus by reviewing her life with Holden since they had met.

When Holden came home an hour or so later, they ate a quiet dinner and went into the living room to talk because he told her that he was being transferred

to Hawaii in three days. The next day, Holden packed all his belongings and sent some to his relatives for safekeeping, then moved back to the base. He and Trudy mutually agreed to see an attorney to have their marriage annulled with no demands or requests.

CHAPTER EIGHTEEN

It took Trudy less than a month to settle back into her old ways and with no more work to be done on her house, Holden was quickly forgotten. Those who knew Trudy and who wondered about her true feelings for Holden, finally had their suspicions confirmed. Miss Wembly for one had always thought it was a marriage of convenience.

"Under the circumstances," she once told Lovey, "who can say right or wrong? After all, it is wartime and there are a lot of strange alliances during wartime when nothing is normal. Perhaps it was the right thing for both of them at the time. Trudy certainly needed the work done, and I imagine Holden needed to do that kind of work to take his mind off the war. Who knows?"

"Yeah," Lovey wisecracked. "He was a visiting angel!"

Miss Wembly chuckled and said, "Perhaps it was also something more personal. After all, we are what the Good Lord made us!"

"Very true," Lovey said softly. "Very true."

Holden had written Trudy a few times to tell her what he was doing regarding lawyers and the annulment of their marriage. She answered his letters a few times, and then began to let his mail go unanswered. After a few months all communication between them was over and Trudy lived her life as though Holden had never been there.

Trudy never did sit down and tell Neil about her relationship with Holden, and he went along for three or four months thinking that he had a stepfather in the Navy in Hawaii. When he discovered the truth he became even more angry and distrustful of his mother. When confronted about the matter, Trudy would just say that she didn't tell him because she didn't think it was any of his business.

Soon after Holden had been transferred to Hawaii, Trudy began to phone Rosie and pass the time with her. She found out that the doctors had adjusted Rosie's medication and diet and told her that she had better start walking again

253

or she would die. That suited Rosie because it gave her an excuse to get out of her inn every day and go visiting. Trudy began walking down to Monterey again to walk through the stores, and she would often meet Rosie and go have lunch and coffee together.

For Trudy, that was what she had dreamed of all her life. The walking made her feel good and she enjoyed talking with Rosie. Trudy had discovered that Rosie was a good source of information about renting and she never exaggerated or talked about things that she didn't know about. Trudy could usually rely on the things she said, and if there was any doubt, she could ask Madge.

Her rental rooms seldom developed any problems and all her renters were quiet and paid on time. Neil had cleaned up the yard and burned yard trash after clearing with the fire department. Trudy marveled at how well life was going. The two young women who rented the studio apartment and attended the marine biology classes were quiet and studious. They often worked into the night studying sea creatures and making drawings of things they saw in their microscopes. Trudy, Miss Wembly and the others in the house noticed the girls working late because they could see them at their desks by the big artists window.

Trudy and the others often met Homer the retired mailman on the stairs or outside her house, and they often caught him referring to his key chain for decisions on which way to start walking, or where to go for dinner. Everyone quickly got used to Homer Ellsworth and his key fob, and considered him a mild-mannered, friendly little man.

Trudy rented her large room that Hank had lived in almost as soon as Hank had given his room keys back to her. Her new tenant was a man named Mike Tiga, who looked to be in his late fifties, and worked as a gardener. Trudy thought that if he was a gardener he would have a pickup truck, or at least an old car, but he didn't. He didn't even drive.

"My family were Latvians," he told Trudy when she asked about a car. "I grew up in Chicago in the twenties and thirties and no one in my whole family never had no need for a damn car. All they do is cost you money! Kids wreckin'it. Insurance, fixin' up, licenses, then a guy is forever watchin' out for da cops. Not me! I got me two good legs to get around, an' I know how to ride dem buses."

"Really?" Trudy said. "I couldn't live without a car. Don't you have to carry tools and sacks of fertilizer?"

"Nope," he said. "The people who hire me got all that stuff, and I use their tools. I keep it real simple. I own a knife and some trimmers, an' that's it. I'm a good gardener. If they want me to work, then they got to have all that stuff."

"Boy!" Lovey said when they met for coffee and toast the next morning. "You sure rented that room in a hurry! I thought it would be a week before it rented. Who rented it?"

Trudy's House

"Well,"Trudy said. "I wonder about it, too. I rented the room to a man named Mike, and he says he does gardening for people."

"Yeah?" Lovey said over a bite of toast. "Well, I still think you rented too quick. Can a gardener be a good thing? Doesn't a gardener need shovels and hoes, and maybe a coil of garden hose? You know—tools of the trade?"

"That's what I thought, too" Trudy said. "He says he just uses whatever he finds where he works."

"Yeah?" Lovey said again. "Well, maybe he's got it all figured out and doesn't need all that. Who knows?"

"Well, time will tell," Trudy said. "I've got things to do, so I'll talk with you later."

With seven rooms to rent in her house now, and everything rented, Trudy was able to start accumulating a little money again. When she felt comfortable with the amounts that she had in several cash stashes in her bedroom, Trudy started saving to make an extra mortgage payment with the hope of getting out of debt. She had been paying her mortgage payments regularly in cash and on time, and the bank officers were beginning to greet her when she came in the bank. Trudy saw them as a pack of greedy wolves whose sole ambition was to separate her from their money because she still, with all she had learned as a landlady, did not understand how banks could be useful and helpful to her in business.

For the time being, Trudy had free time and enjoyed visiting her friends during her almost daily walks to the stores in Monterey or Pacific Grove. Trudy went to all the store sales when she could, not only because she enjoyed shopping and loved to get out, but it was a way to get away from her tenants and be alone for a few hours.

Trudy had always loved to look through store sales, and when she had the money, buy something that she thought was especially attractive at a cheap price. Since she bought her house, however, Trudy had begun to transfer that habit to buying things in advance that she would eventually need for the house. As a result, she was beginning to accumulate remnants of attractive cloth that might make a nice pillow cover, or if it was large enough, drapes for a window.

In October of 1944, window-shopping was also a way for her to get away from the war news that seemed to be everywhere, and it was a way to get away from the election predictions about Tom Dewey and Roosevelt. The presidential elections were only a month away and political lapel buttons and paper flyers seemed to be everywhere—especially because both candidates had strong supporters.

Trudy wasn't really interested in any of the news. She didn't want to see the Germans or the Japanese win the war, but she could not bring herself to worry about the progress of the Allies. Likewise, she didn't really know enough about Dewey or Roosevelt to vote for either man. She also didn't know enough about the Republicans and the Democrats to talk about either party. She did know that

the people she respected voted a certain way and she made it a habit to agree with them. She had discovered that it saved her the trouble of trying to read about the candidates and their platforms, and understand it all. With all that, Trudy did vote because people said it was her duty, but once in the voting booth where no one could see what she was doing, Trudy voted against all the tax increases and school bonds because they affected her directly. She would vote for candidates if she had any information about them, otherwise her vote was cast without voting for them.

George and Carol Muntz, who lived in the verandah room, turned out to be very friendly and civic minded. They soon made friends with Miss Wembly, Trudy, and Lovey and Moe, and took and interest in everything in Pacific Grove. Trudy wondered about their motives until she found out that they had just become school teachers when George had to go in the Army. She also discovered that George enlisted instead of waiting to be drafted, with the hope of getting a better job in the Army. It wasn't long before George was able to pursue youth and adult school sports for Army dependents and contribute time to start programs in the local cities.

Trudy had wondered about Mike Tiga when she first rented to him, but after several weeks, she saw him go out to work early almost every morning, and come home at about dusk each evening, and thought that he might be a good tenant, too. However, after a month in the artists studio, the two girls who shared the room were, by far, just about the best tenants that Trudy had ever had. They were quiet and seemed to study all the time. Even Miss Wembly was impressed with them because whenever she had come in late after baby-sitting, she always saw them studying at their desks beside the big window.

One day in November, Trudy found a letter in the mail from her younger sister, Ellen. Just as Jean had predicted, Ellen wanted to come down and see if she could find a job working in some military office in the area. Ellen said she was coming down with her four year old daughter and whatever luggage they could carry, and wanted to know if they could stay with Trudy until they could get on their feet.

The next morning, Trudy sat re-reading Ellen's letter over toast and coffee and wondered what she could do. Miss Wembly and Lovey came in a little later and saw Trudy looking over the letter and said nothing.

Finally, when they were all seated and having their breakfasts, Lovey said, "So! You got a letter! So what are you going to do? Leave us puzzled all day, wondering who died? My mother—God bless her—used to pull that on us and let the suspense build all day until one of us would make demands. Then she would tell us what we should have known when the letter came. But, it gave her a chance to take the stage for the day, y'know what I mean?"

Trudy's House

"Goodness—really?" Trudy said. "Well, I didn't mean to tease you. This is from my youngest sister and she wants to come down here and get some work. She wants to know if she can live here for a while."

Miss Wembly and Lovey didn't say anything for a few minutes, but exchanged glances. They continued to nibble at their breakfasts while Trudy got up to get more coffee. "So?" Lovey said. "Is that good or bad? Do you think she'll want to roost here, or has she got enough oomph to get out on her own?"

"My heavens, yes, Trudy!" Miss Wembly said. "Do be careful. She might be a layabout."

"Well, that's what I'm thinking about," Trudy said. "My other sister warned me that this might happen. She said that I shouldn't let her live here."

"Well, she's your sister," Lovey said. "But I think I'd be damned careful. You might have a helluva time getting her out! Maybe you could find her a place to stay and rent it for her. It might be cheaper in the long run."

Trudy took care of a few things that she wanted to do that morning, and then retired to her davenport to think about her problems and have another cup of coffee. The thought of Ellen living in one of her rooms upset Trudy, even though they had gotten along so well in the past. For one thing, Trudy thought, this was her livelihood and she wouldn't have her hard work undone! Then, even worse, Ellen had a four-year old little girl and Trudy shuddered when she thought of the little girl running through the halls, screaming and keeping her tenants awake.

Trudy thumped her fist several times on the davenport cushions, raising little clouds of dust in the sunlight as she did so. Trudy's thoughts were interrupted by the sound of feet on her front steps and porch. A moment later, her doorbell rang and she got up to see who was there. When she opened the door she found two middle aged ladies at her door looking like they were braced for a confrontation.

"Hello?" Trudy said. "Can I help you?"

"Are you the manager here?" One lady said.

"Yes, I'm Mrs. Anderson." Madge had warned her to never tell strangers that she was the owner "I'm the manager."

"Well, we live in the next block up the street and we have a clear view of this house from our second floor," the lady said. "We want you to know that the man who rents upstairs doesn't pull his shades and he walks around with nothing on."

Trudy was stunned and just stood looking at them for a moment with her mouth open. "No!" she finally said. "Oh! That's terrible!" Trudy said again. "My Goodness! Thank you for telling me. I'll take care of that right away!"

"Well, we hope that you can do something about it. There are laws, you know."

Trudy didn't like their insinuation suggesting of going to some kind of legal action. "Say," she said. "That man has only been there a month and I can't tell what he's doing. I'm glad you told me about him and I'll certainly do what I can to fix this, but don't threaten me with law action because I don't know anything about the people I rent to."

"Well! It's your place!" one of the women said, and turned to leave.

Trudy watched the two ladies walk back to the sidewalk, cross the street and start back up the hill. She didn't know what to do and just stood thinking about the problem. The only thing that Trudy had noticed was that his bed linen seemed smelly but thought that was because the man did heavy physical work. He had given her his soiled sheets in exchange for clean ones every week, though. Finally, she phoned Rosie and talked about it.

Rosie giggled when Trudy told her what had happened. "Trudy, You're becoming a landlady!" she said. "You've come a long way. I think I'd follow through with it. Write a note to him and say you've had complaints. Tell him to stop, and then check on him. If he still does it, I'd ask him to move—I think I'd ask him to move anyway. If he does that, he might be doing something else, too."

Trudy decided to ask Rosie about having Ellen staying in her house while she got established and Rosie advised the same thing that Lovey did—to find a place for Ellen even if you have to help her pay for it. "Trudy, remember that house is your business and you can't mix business and relatives," Rosie said seriously.

After talking with Rosie, Trudy phoned Madge about her tenant. "Get him out fast," Madge advised. "For one thing, that's against national defense laws. I'm surprised that someone hasn't been knocking at your door to get you to pull your blackout drapes. For another thing, everyone up the hill can see him. Look, he's making trouble for you. Now remember, if he's renting by the month, you have to give him a month's notice, but if he's causing problems because of his lifestyle you might be able to get him out right away. You'd have to talk with an attorney about that, but I think you can do that."

After a lot of thought done relaxing on her davenport, Trudy finally composed a carefully written note telling Mike Tiga that she had complaints about his not covering the windows at night and that she would have to ask him to move if he didn't take care of the problem. Then Trudy mentioned the National Defense laws and the fact that everyone could see him. Just to be safe, she wrote the letter on her old typewriter and made a carbon copy and filed it away for safe keeping.

After she slipped the note under Mike's door, Trudy turned her attention to Ellen's letter, and wrote her an answer telling Ellen that all her rooms were rented, but that she would help Ellen find a small house to rent in a good area until she could get started. There was a small letterbox across the street, and Trudy put a three-cent stamp on her letter to Ellen and went out to mail it. As she was coming back in, she spotted Neil walking home from school and waited for him.

Trudy told him about the neighbor ladies who had complained about her gardener tenant, then about Ellen wanting to come to live there. "I think she'll try to move down before the weather gets bad in Portland," Trudy said. "Next week is Thanksgiving, so I'd expect her a week or two after that."

"Well, she's sure coming to the right place," Neil said sarcastically, remembering his own experience of living in the cold mountains and deep snow of northeast Oregon. "If this winter is going to be anything like last winter all she'll need is a good coat!"

"Yes," Trudy said. "Isn't it wonderful!"

Neil scowled at her and shook his head. He was still young enough to prefer snow in the winter.

Trudy saw his expression and said, "Well, I was raised in Winnipeg and I think that was the coldest place on earth. I'm so glad that I can live here in the winter!"

"What about the guy upstairs?" Neil said. "I think you need to get him out because I've never heard him even take a bath. I think he's a nut."

"Well, I just put a note under his door and we'll see what comes," Trudy said. "I'm a little afraid of him so I think you should stick around when he comes to talk about it."

"Huh!" Neil snorted. "He's bigger and stronger than I am! You need someone like Holden around."

"I thought there might be safety in numbers," Trudy said. "If you and I were sitting there talking when he came to talk—don't you think that's enough?"

"Who knows?" Neil said. "I think it depends on how nuts he is. How do we know he'll want to make a fuss anyhow? I think he'll just say 'okay' and move out. Otherwise, they'd have him in jail!"

"Maybe so," Trudy said. "All the same, I want you to be here when he comes home. By the way, I've been meaning to ask you if you want to go to a restaurant for Thanksgiving."

"Oh," Neil said, "I don't really care. A restaurant is okay with me I guess. There's just the two of us. If we were a family it would be different."

Trudy nodded and they sat quietly waiting for Mike Tiga to come down the street from the bus stop. About an hour later Neil was listening to the radio when Trudy saw the gardener walking down the street in the early evening twilight. She and Neil listened as he went up all the stairs, and heard him open and close his room door. They heard him walk around his room, and then they heard nothing else. Neil waited a while, then went out in front of the house and looked up at the room windows. They were all dark and Neil and Trudy decided that the man must have gone to bed.

Neil waited another fifteen minutes or so and hearing no movement upstairs, decided to go do his homework and go to bed, too. Trudy wasn't

sure what to do and finally sat down to read for a while. She was puzzled by Mike Tiga's not responding to her note and wondered if he would stop in the next evening. Perhaps, she thought, he wasn't feeling well, or was too tired to talk with her.

The next morning Trudy was awake a dawn and the first thing she thought about was her tenant upstairs, and she wondered if he would talk with her that day. She tried to go back to sleep, but couldn't and finally got up to make some coffee. When she went in the kitchen, she was surprised to find Miss Wembly and Neil having breakfast together.

"Well!" Trudy said. "What brings you two down here so early?"

"The same thing that brought you here, I suspect," Miss Wembly said. "Didn't you hear your tenant moving out this morning?"

"What?" Trudy said, astonished. "He moved out?"

"Yeah," Neil said. "All he had was a trunk of stuff. I helped him move it out, then he walked down the street with that old trunk on his shoulder."

"My Goodness!" Trudy said. "And I didn't hear a thing. Well, I guess that's that. We can all rest again."

"Wait 'til you see the room," Neil said.

"What?" Trudy said, suddenly aware that he might have done some horrible things. "What about the room?"

"Well, he left some work for me," Neil said.

Trudy stopped buttering toast and looked at Neil. "What kind of work?"

"The floor has scrap paper and food wrappers all over it, and several inches deep," Neil said. "He took all the cords off the lamps and attached them to one, which was the floor lamp. So now you just have a floor lamp with about a thirty-foot cord, and all those cords are joined with adhesive tape."

"Oh! My Lord!" Trudy said, sitting down heavily. "Really?"

"It's a wonder he didn't start a fire up there," Neil said. "I'll have to rewire those lamps. Can I buy a roll of lamp cord on the way home?"

Trudy was staring off into space and running her fingers through her hair. "What on earth could make a person do such a thing?" she mumbled. "I guess I have a lot to learn about people."

"I should think you'd be thankful that's all he did," Miss Wembly said. "He could have done so much more. We might all have been victims."

"Heavens!" Trudy said. "Well, I guess I'd better go look."

"Mother?" Neil said. "You didn't answer me. I'll need to stop and get some lamp wire. I should get a whole roll of it."

Trudy picked up several large folded grocery bags and climbed upstairs. The door to Mike's room was open and Trudy walked in slowly, looking at everything. She spent several hours picking up all the rumpled paper and trash that littered the floor. When she was done, she sat on a wooden chair for a while and looked

at the mess that was left. The mattress was filthy and it looked like he had just slept on the bare mattress with the bed unmade. His sheets had been used as chair covers, and the one easy chair in the room was in the center of the floor with the floor lamp beside it and all the extra cord lying on the floor around it. Worse, the room had a wild smell, like salty sage.

Trudy locked the windows open, picked up the bags of trash, and went back downstairs for a cup of coffee, closing the room door behind her. It would be a while before she could have the room rented again—probably a week, at least. Trudy sighed heavily and went to her davenport to mull everything over.

The weather had been cloudy with a warm breeze all morning. By 11:00 it started raining and depressing Trudy. She sat on her davenport and watched the rain come down for a while. Mike Tiga's lifestyle had caught Trudy off guard. It came about just when she was beginning to think that she was an experienced landlady. Now, she realized that people were capable of many strange things and the values that one person held could be completely foreign to someone else. The damage that Mike Tiga caused was minor, but the possibilities were enormous. Even Trudy, who had a very limited understanding of electricity, realized that if he had not made a good splice in one of the lamp cord wires there could have been a fire in all that litter that could easily have burned her house to the ground!

Trudy felt divided between thankfulness and anger, thinking about the room. She would make it a point to ask Rosie and Madge about screening tenants because Trudy thought that she had almost lost her house. She wondered if she had enough good judgment to rent to someone again!

Trudy was still watching the rain come down and thinking about the upstairs room when Neil came walking it, soaked to the skin. "Well!" she said, "you're home early, aren't you?"

"They called a rainy day session," Neil said, "so we're out early."

"Imagine!" Trudy said. "What's that supposed to do? You get out early for the rain and get soaked, or you don't have the session and get out of school at the normal time and soaked anyway."

"I know," Neil said. "I don't understand it either."

"So, what are you going to do now?" Trudy asked.

"Well, I didn't get the wire because it was raining too hard," Neil said. "Will you drive me up to get some? We might as well get everything—plugs and sockets—then, we'll know the lamps are good."

Several days later, Neil was cleaning the room that Mike Tiga had vacated when George and Carol Muntz came up the stairs and seeing the open door, they came in to look at the room.

"Oh!" Carol Muntz said. "This is a lot better, Hon. Why don't we find out if we can take this room. It's a lot roomier and more airy."

Neil paused in his work while they looked at the room. He had rebuilt the lamps and was washing woodwork when they came in. As they left to go talk with his mother about changing rooms, he glanced out the side window and could see the course of windows where their room was. It suddenly dawned on him that with winter coming on, Trudy would not be renting the Muntz' verandah room if the Muntz' moved over to the room he was working on. He could fix up the verandah room for himself and they could use the room he had been using for a utility room.

Neil thought about the verandah room and the things he could do with it if he made it his own room, and continued to clean as he thought about the possibilities. He decided that he would bring it up with his mother after he had finished cleaning Tiga's room.

The following day, Trudy told Neil that she had decided that the Muntz' could move over to the other room. "I think it's best that they do that with winter coming on, don't you?" she said. "That way we won't have to worry about that kerosene heater up there, and we get that other room rented right away—and there's the bed. We can just move their bed over there and throw out Tiga's mattress. Besides we already know that they're good tenants."

At that point Neil made his argument to make the verandah his room and use his old room for a utility room. To his surprise, Trudy agreed, with the stipulation that he could try to fix up that room while he was in it.

Trudy and Neil helped the Muntz' move the heavier things over to the new room, and while they were moving things, George Muntz' told Trudy, "You know, Mrs. Anderson, this war isn't going to last much longer because the Allies ha⋅e pushed the Germans almost back to Germany, and the Japanese are on a downhⅱll slide since the Battle of Midway. It'll probably go on for a little while—a year, maybe—but, have you thought about what you'll be doing with all these rooms? I think people will be wanting apartments, don't you?"

Trudy cleared her throat and said, "Well, yes. I've had several other people tell me that. So you think apartments would be better?"

"Sure!" George Muntz said. "People would want to have a little place to cook without going out all the time. Right now, there aren't any apartments so people are happy with rooms, but I think that will change soon. For instance, I think it would be pretty easy to build a little efficiency kitchen right over in this corner of the room." George was pointing to the side of the room where the window was that looked out at the windows in the other wing where the verandah room was.

'That big bathroom is just on the other side of this wall, making all the plumbing close by. That's one of the things you look for."

"My Goodness," Trudy said. "It's nice of you to tell me that. I wonder if Neil can do that kind of work."

"Oh, I don't know about that," George said. "There's a lot more to it than you'd think. I know I wouldn't try it."

Trudy stood still for a few minutes, looking at the part of the room that George was talking about. She tried to imagine what a little kitchen would look like in that part of the room, and finally turned away and went back to the things she had planned on doing that day. The war was still going on and Trudy knew that she had plenty of time to think about apartments. After all, she had just finished getting all her rooms ready to rent!

Neil spent all his free time for the next week fixing up his own new room on the verandah. The room only had a minimal roof—like something over a chicken coop. It was presentable on the inside, but it was thin. The roofing material was laid over the same boards that were visible on the inside and there was almost no way to insulate the roof. Consequently, the room was cold in the morning and too warm in the afternoons. Neil realized that he'd need to wear warm clothes in the winter months if he wanted to spend much time in his room.

Neil painted his room in colors he liked, then built in some bookcases for the textbooks and novels he was accumulating. He had learned to appreciate books when he lived on his uncle's ranch in Oregon. With movie theaters and stadiums thirty-five miles away, reading was the chief form of recreation on the ranch.

Neil moved into his room on the verandah by Thanksgiving, and by mid-December he realized that the long course of windows that looked over Central Avenue in front of the house had to go because some nights were getting very cold. When he read, or did his homework, he would often rest his eyes by looking at the thin, blue denim drapes that his mother had made a year before when she first rented the room. He could watch the drapes move with the gusts of wind outside and wondered what he could do to make the room warmer. Obviously, it would never be a warm room until they were able to rebuild the roof, but there must be things that a person could do to make the room more habitable. In the end Neil decided that just getting rid of all those badly fitting windows would be a big help. Doing that would cut down on all the street noise, too! A few days later he stopped by the Work Lumberyard and asked for an estimate to build two windows in wooden frames to fit a space, with the intention of filling in the rest of the old window space with a wall. Afterward, he talked with his mother about doing the work.

"Do you think you can rebuild the walls and put those windows in up there," Trudy asked.

"How much is it going to cost us?"

"I got a bid from the Work lumber mill," Neil said, handing the paper to her. "After that I'll need some 2x4s, a roll of tar paper, and a couple of bundles of shingles. I think I can do it all for about a hundred dollars."

"Well," Trudy said. "Maybe it's worth it to get rid of those old drafty windows. Are you going to start on it right away?"

"I thought I'd start working on it a little at a time, but I want to do it when it looks like a few days of good weather," Neil said. "I'd like to get the windows and other stuff done now so I can have them right here when I can do the work on putting them in."

"All right," Trudy said. "Let's order the windows and we can drive down and pick them up when they are ready."

Neil was surprised to find his mother so agreeable, but nonetheless, ordered the windows and picked up the things he thought he needed before his mother could change her mind. In the next few weeks, he began taking the inside of the wall apart, leaving the outside so the room would remain weatherproof. Temperatures didn't matter because he couldn't change anything. If was going to be cold out, it would also be cold inside. When he picked up the windows he painted them and had them ready to install when he had time to do the work.

Trudy got another letter from her sister, Ellen. Ellen was going to try to come down in mid-December, and wanted Trudy to find her a place to stay. Trudy contacted Madge to see if there was a place her sister could rent, and Madge called back in an hour and said that there was a tiny house that Ellen could rent or buy and it was just two blocks down the hill from the elementary school in Pacific Grove. Trudy took Madge's word on the condition of the house and paid a deposit to rent the house and secured it for her sister, thinking she might not get her money back but thought it was better than having Ellen in her own house.

Ellen came down on the train and Trudy took Neil along to meet her at the rail station in Salinas—about twenty-five miles from Monterey. As Trudy stood at the station waiting for the train to arrive she recalled that she had arrived in the area for the first time just a year and a half ago and mused on all the events that had changed her life since she had been a landlady in Pacific Grove. She remembered the terrible insecure feeling that swept over her when she looked through the empty shell of a house when she signed the papers and went down to take possession, and how overwhelming it seemed to buy furniture and to fix up rooms and rent them. She remembered that she had no idea what being a landlady was all about. She thought about her first tenants and the struggle she had making the rooms available to rent.

As Trudy reminisced, she heard the train coming and called to Neil who was watching the baggage clerk get ready to meet the train. When he pulled his big baggage wagon out on the platform, Neil walked back to Trudy.

They watched the huge steam locomotive chug past them, clanging its bell and letting out clouds of steam. As the train slowed down Trudy and Neil could see in the cars and noticed that nearly all the cars were full of men in uniform. When most of the rail cars had passed by them, the train slowed even more, then stopped with a car full of civilians in front of them. Trudy stood on her toes

and peered into the windows. It seemed like everyone was in motion; standing, squeezing by each other, gathering coats and hats. At last she spotted Ellen who was still seated, with her little girl next to her, and looking out the other side of the train. Trudy caught someone's eye and pointed to Ellen. They nudged Ellen's shoulder and pointed at Trudy. Ellen looked surprised and quickly gathered up her things and, daughter in hand, soon appeared at the door and stepped out on the platform.

"Hi Kid!" Trudy called. "How are you?"

"Oh, Trood!" Ellen said, using her pet name for her sister and laughing. "Gee! It's good to see you! I didn't realize that we were already here!"

Smiling, Ellen carried several small bags in one hand and pulled her young daughter along with the other, and walked toward Trudy and Neil. "Golly, the sun's bright here, isn't it? It was gray and raining in Portland when we left yesterday morning."

"Do you have some bags we have to pick up," Trudy asked.

"Oh!" Ellen said. "I almost forgot about them! Gee! What's wrong with me!"

"Come on," Trudy said. "We can take this to the car and come back for the rest of your bags. Neil! Will you take your Aunt Ellen's claim stubs and get her bags? We'll catch up in a minute."

As Neil walked back to the station, Trudy took Ellen and her little daughter to the car and stacked the things they were carrying in the back seat. "I found you a little house to rent or buy, which ever you want to do, and it's just two blocks from a kindergarten and elementary school in Pacific Grove. It has a nice little garden and a wooden fence and it should suit you and—and your little girl just fine," Trudy said, unable to remember her niece's name.

"For Pete's sake!" Ellen said. "I know you don't like kids, but I'd think you could remember you own niece's name! It's Sally!"

"Well, if I'd been seeing her every day, I'd remember," Trudy said. "After all, don't forget that this is the first time I've seen her!"

Ellen ignored her reply because she knew perfectly well that she had it right the first time. Trudy never did care about children. She changed the subject. "Maybe we should go get my bags. Neil must have them by now—boy, he sure h~s grown since I last saw him! He's going to be a six-footer!"

"Come on and get in," Trudy said. "A lot of the cars have gone and we can get closer now."

As Ellen and Sally got in and closed the door, Ellen said, "This is a nice car. Who's is it?"

"It's mine," Trudy said. "I had to learn to drive and a friend helped me buy it. I don't know how I ever got along without one."

"Yes!" Ellen said. "They are nice to have. A car makes life so much easier. I always think of our mother and how she used to walk to the store and carry those

heavy shopping bags back so she could feed us. I don't think I ever gave that a moment's thought when I was a kid. The food was always on the table and that's all we ever thought of. Her back and her legs must have killed her at night from all that walking and carrying groceries that she did for us."

"Yes," Trudy said. "Of course, we were just kids and didn't know anything then. She did a lot for us."

Trudy pulled the car up by the station's baggage room, and Neil brought out four suitcases and stacked two on the back seat, and put two in the trunk. Sally fell asleep as soon as the car started moving, while Ellen studied the scenery.

"Gee, doesn't it ever rain here?" she asked. "Everything looks so dry." A little later, as they were still driving toward Monterey, Ellen said, "Jean said that you get an awful lot of sunshine here, but I never thought it would be like this!" Later, as they drove into Monterey, Ellen said, "Gee! It's a lot greener over here. I guess we must be at the coast now, huh?"

"This is Monterey," Trudy said as she maneuvered the car off the two lane highway and into city streets. "Monterey is an old Spanish town so there are some old buildings here, like this one." She pointed to the old adobe wall on the right, with the tile roof of a building beyond barely visible from the car. Trudy turned a corner and drove alongside the building on the city street. "This is the old Customs House, and Fisherman's Wharf and the bay are just on the other side of it. We'll come down and look through it one day."

Ellen was busy looking left and right as they drove slowly along toward Pacific Grove. When she saw the fishing fleet at anchor by Fisherman's Wharf, she gasped because of the scenic beauty it made. "And what's this big field on the left?" she asked.

"Oh, that's the Army Presidio," Trudy said. "There are buildings and barracks up the hill above all that grass."

When Trudy drove into New Monterey Ellen said, "So I guess this is Pacific Grove?"

"No," Trudy said. "We're still in Monterey. They call this New Monterey. PG is still a mile or so farther. This is a street with businesses on both sides. The houses go up the hill on the left, and those buildings on the right are fish canneries. What do you think of all this?"

"Well, I think I like it here. It certainly is picturesque," Ellen said. "Who are all these people wearing big aprons with cleaning rags around their heads?"

"Those are probably the cannery workers. A lot of them live up the hill and walk down to work in the canneries. I think their husbands run the fishing boats and go out and catch the fish and bring them back here to be canned. It's seasonal, of course."

"For heavens sake," Ellen said. "They all look like they're Spanish or something."

Trudy's House

"I think they're Italian and Portuguese for the most part," Trudy said.

"No kidding!" Ellen said with a smile. "I wonder if any on them sing! I like Italian tenors!"

"Well, you'll have to find out on your own," Trudy said. "Monterey is full of Italians. Now, this is Pacific Grove. You see, there's just a sign to tell you where it starts."

Ellen was looking at all the houses when Trudy said, "And this one on the right is mine."

Ellen just barely caught a glimpse of it as they drove by. "Gee, Trood! That was your house? You have a nice car and that big place? It looks to me like you're doing all right down here! Why can't I just go to work for you?"

"Now," Trudy said, ignoring Ellen. "I'm going to drive into the downtown of PG, go back past the house I rented for you, then home so you can relax a minute."

Ellen remained quiet and watched as they drove through the business section of Pacific Grove which was only four or five blocks east to west, and three blocks wide, including driving both directions on Lighthouse Avenue because it was divided with extra parking in the center of the street.

Trudy drove a few blocks down Pine Street until they were in front of the elementary school. Then they turned left down a side street and stopped in front of the little corner house that she had rented for Ellen and Sally. "Gee!" Ellen remarked. "I think that's a cute little house, and it's handy to everything. I like it!"

Trudy drove on down the street to Lighthouse Avenue and turned right. "You see, the bus stop is right there on the corner. That will take you down to Monterey, then to Carmel, Fort Ord, or wherever you want to go. Turn left and the town is right there."

"Gee!" Ellen said. "How convenient!"

Trudy drove home and parked in her drive way. "Better hold on to your kid or she might run out in the busy street where a car could hit her! We can walk to the house on the other side of the hedge away from the street. It's a whole lot safer."

"Holy smoke!" Ellen exclaimed as she walked from the driveway to the garden path. "Look at all this! How much of it is yours, Trood?"

"All of it," Trudy said, realizing that she should be holding back because Ellen would be jealous. But, Trudy let pride of ownership take over, willing to deal with the consequences later.

"Gee," Ellen said, smiling, "You've gotten rich since you left Portland. You sure made the right move!"

"Ellen," Trudy said, "Every dollar I make goes right back into this place, and I'm so far in debt that I wake up depressed at night."

"Okay! But you have this big house and an income and someday you'll be out of debt!" Ellen said. "You sure found yourself a gold mine, here!"

"Ha! Well, we'll see what comes of it all," Trudy said. "In the meantime I'm getting along."

Inside the house, Trudy went straight into the kitchen to make some coffee, while Ellen got out some toys for Sally to play with. She found Miss Wembly sitting at the table enjoying a cup of tea, and while her water was heating Trudy told her that she had gone to the train station to pick up her youngest sister.

Ellen walked in the kitchen a few minutes later and saw Miss Wembly at the table. "Oh! Did you invite your neighbor in?" she asked.

"No!" Trudy said. "This is my best tenant, Miss Wembly. She lives right up stairs and she's from England."

"My gosh," Ellen said. "I'm Ellen Binkler. I'm Trudy's little sister."

"How d'you do?" Miss Wembly said. "You've just arrived, have you? Did you have a good trip?" She paused a moment and looked Trudy and Ellen. "I must say, there really could be no doubt that you're Trudy's sister. You two look very much alike. I'd say you're alike in stature as well as looks. Much more alike than your other sister."

"We had the same mother and father, while Jean had a different father from our mother's first marriage," Trudy said as she finished making coffee. "Come on," she said to Ellen, "we can sit in the living room and talk while we drink our coffee."

Trudy wanted to know more about her sister's decision to move to California with her, and find out what her goals were while she was here. Trudy was hoping that Ellen would get busy and find a job and settle in, without interfering in Trudy's rentals. She wasn't at all interested in babysitting her young sister!

Chapter Nineteen

In October 1944, General MacArthur returned to the Philippines with a massive troop landing on Leyte that caused the Japanese forces to retreat further toward their home islands. In Europe, the Battle of the Bulge broke out on December 16th, 1944, when German troops counterattacked in an effort to halt the Allied advance toward Berlin, and in the United States, people mourned the third anniversary of the lives lost in the bombing of Pearl Harbor.

Trudy was several months into her second year as a landlady, and ownership of a house that would have been beyond her horizon just two years earlier when she lived in Spokane and was learning how to paint airplanes. And, even though she was making a living renting rooms to the families of the draftees who arrived every day for training for war at Fort Ord, she still had almost no interest in the day-to-day gains in the war. She was content knowing that somehow the Allies were winning. If someone had asked her what was happening in Belgium, or how far the Russians have advanced, she would not have been able to say.

Trudy's focus was on her house and her rentals, not because she was a diligent workaholic—far from it—but because she simply wasn't interested in the war! Whenever possible, she would make a cup of coffee and some dry toast and go to her davenport in her living room and relax for a hour or two and mull things over in her mind. If she had tenant problems, they would be settled while she drank coffee. Problems with Neil were dealt with the same way. At the moment, Trudy had good tenants and Neil was busy with school. Her sister, Ellen was her concern at the time. She had helped her sister move into the little house that she had rented, and had seen Ellen almost every day since.

Since Ellen's daughter was too young to start school, Ellen had searched the area for a day-care facility that was affordable. Trudy had driven all around in their search, and in the process did a lot of window-shopping so that Ellen would know all the stores. Ellen located a day-care place that was located in a

269

large old house near the Pacific Grove/Monterey line. The problem of getting her daughter to and from the facility was solved when Ellen got a job as a clerk-typist for the Army in the Presidio, which was much closer than Fort Ord. One of her co-workers had a little boy and lived in her small neighborhood in Pacific Grove. So Ellen, like Trudy quickly found a workable situation and settled down. In a few months, Ellen decided to buy her little house because, like Trudy had discovered, the price was right. In fact, Ellen discovered that her house payments were not much higher than her rent had been!

As fall moved in to winter the weather was almost predictable. There were no violent storms like there had been the year before when boats were washed up on the beaches and Trudy's back porch got blown off. Instead, the days became shorter and the nights were colder and rains came with blustery winds, but there were still a lot of sunny days that warmed a person in the sunshine and froze them in the shade, and in places exposed to a north wind that came across the water.

Trudy waited as long as she could before calling for more oil for her furnace because she thought of her big oil tank in the basement as a bottomless money pit and dreaded to see the cost of the fuel oil. To keep the cost manageable, she asked for just one or two hundred gallons at a time, hoping that by some miracle the spring weather would be warm and that she wouldn't have to buy more oil!

When Trudy called late that fall to order more oil the older man who had delivered oil the previous year came in a pick-up truck and said that he had to examine the furnace first since it had been idle all summer, and that another man would deliver the oil. Trudy couldn't think of anyway to keep the service man from going over her furnace, and wasn't really sure she should try because she wanted the furnace to work, and to work well. As it turned out the man worked on it for an hour or so and said that there was really nothing wrong so he just cleaned it up at no charge. The oil delivery came the next day and the deliveryman told her that he was just out of the Army on a medical discharge. He quickly explained that a medical discharge could mean lots of things and most people were reluctant to talk about it. "Nah, with me it was my hearing. A shell went off too close to me in training and broke my eardrum. I can't hear a thing with my left ear."

"Really?" Trudy asked. "They let you out of the Army for that? Why?"

"Well, I can't hear directions. I just hear with one side and I can't tell where the sound come from," he said. "They tried me out on a couple of different jobs, and nothing worked out. I can drive though. When you drive a truck you can't tell where a sound comes from with two ears—but you still hear the sound!"

Trudy liked the man's easy, friendly manner and explained to him that she was just getting her rooming house going and that she was just recovering from the cost of fixing up the rooms. "Couldn't you tell me how much oil I have now and add enough to carry it 'til spring?" Trudy asked. "That way, I won't have to put out so much money."

Trudy's House

"Sure! Sure, I can do that," the oil man said. "But you know, the insides of this tank will corrode in this air without oil in the tank. It would be better if you kept more oil in it. I don't think you'd have to fill it, but more oil would help keep the corrosion down. Then, you could set up a rotating account with the office and pay them a small payment each month."

"No, I don't think I want to owe money to the oil company. Can't you just add some oil to what I have there," Trudy said. "How much oil do I have?"

"Oh, maybe 100 or 150 gallons," the man said. "This is a pretty big tank. Whatever you do, don't let the oil level go 'way down. There's probably a lot of sediment there all ready. If it got sucked up in the pump you'd have to pay to get all that cleaned out."

"Well, quit trying to sell me things," Trudy finally said. "Put some oil in there and come up to my front door when you're finished and I'll pay you." She turned and went back to her apartment before the oil man could answer.

When the oil man had finished a half hour later, he went up to Trudy's front door with his bill in hand, and knocked. Trudy answered with an offer of a cup of coffee. "Have a chair," she said. It'll just take a minute for the coffee, and I'll give you the money for the oil. How do you like your coffee?"

"Sure! Sure," the man said, "That's okay!" to the one thing. Then, "Just a little milk is fine," to the second thing about the coffee.

Trudy paid his bill in cash after giving him a hot mug of coffee, then sat down for a few minutes to visit. "Did you grow up here?" she asked.

"Yes, I did," he said. "I grew up on a ranch my folks own in Carmel Valley—by the way, just call me 'Will'. I've lived here all my life—except for those two and a half years in the Army. Everybody just calls me "Will".

"Really/" Trudy said. "How lucky you were! I was born and raised in Canada and just moved down here a year and a half ago after living in Portland. My husband died there in February, 1943. But I think this is the best place I've ever lived! I love the sunshine."

"Yeah?" Will said. "So, are you still single?"

"Yes, I am still single," Trudy said, planning on telling him the details later, if it came to that. In the meantime, she was beginning to wonder if she had found someone to go out with again but the conversation didn't get that far. Will drank his coffee, thanked her and left.

Thanksgiving came and left without fanfare. Neil had a few days off from school and he and his mother had a turkey dinner with Ellen and her daughter at the Chinese café in Pacific Grove. Neil wondered at the time if Christmas would be the same as it was the year before, or would his mother remember her promise to him and let him have a Christmas tree.

Neil didn't have long to wait. A few weeks after Thanksgiving Trudy kept her word with Neil about Christmas trees, although she still didn't think a tree

was all that important. True to her nature Trudy didn't rush out and buy one when they first appeared in front of the stores around town. Her friend Rosie had advised here that if she waited until Christmas Eve to buy a tree she could probably get a better deal. She gave Neil the money for a tree on Christmas Eve when the prices were reduced 50% so they could be sold quickly. Her delay had Neil ready to complain, but when he got the tree he admired it at first because it was the first fir tree he had seen since leaving Oregon. He went down in his basement shop and built a stand and trimmed the tree in Trudy's living room. By that evening he had a five-foot tree lighted and ready for Christmas Day! In the end, Trudy had to admit that the tree did look nice, and with Ellen and her little daughter living nearby, Trudy felt a little of the Christmas season.

For the first time since she had moved to Pacific Grove—in fact, the first time since she had lived in Delake—Trudy cooked a Christmas dinner for Ellen, her daughter, Neil, and herself. She had invited Miss Wembly, but as she had in the past, Miss Wembly was invited to one of the families that she baby-sat for. At the last minute, she invited Lovey and Moe because although they were Jewish and usually didn't participate in the celebration of Christmas, they did enjoy a free dinner and a social gathering, knowing that Trudy would not add any religious touches to the dinner. The Christmas dinner turned out to be a success by anyone's standard, except Lovey's.

"Would you look at this," Lovey said suddenly, startling Ellen who wasn't used to loud, outspoken people. "Back home people are freezing their butts off in ice and slush and we're having to pull the blinds because of the bright sunshine! It's indecent!"

"Whadaya talkin'," Moe said. "This is nice. This is a nice Christmas dinner with nice people, and you're going to complain because it isn't icy and cold enough outside? Are you nuts? I think I married a fruit cake here!"

"Yeah, I guess," Lovey giggled. "I just happened to think of my poor sister back home. She always forgot something and had to run down to the corner store for it. She hated the ice and snow on the sidewalks."

"I guess I would, too," Trudy said with a laugh. "Isn't this a nice, warm day? We're so fortunate here. Have some more turkey."

Will, the oil truck driver phoned Trudy and offered to take her out for a New Years Eve celebration. They talked about it over dinner one evening just after Christmas. Trudy was thinking that they might be going to some formal ball like she had done with the carpenter whom she had met the year before, Joe Scattarelli. Instead, Will said, "Nah, I was wondering if you wanted to come out to the ranch and meet my folks. My mother is a good cook and she likes to bring the whole family together for a big dinner on special occasions. That way, you can see the ranch, too. Well, my Dad calls it the ranch because his land goes

Trudy's House

way up over the top of the hills, but he can only use about 80 acres, and most of that is in fruit trees."

"Oh, golly Will," Trudy said apprehensively. "Your whole family is going to be there and we've just met! They'll think we're going to rush out and get married like a couple of teen-agers. I don't know if I'll feel right when your whole family is there!"

"No," Will said. "It's okay. They like to see people—well, my mother does, and my old man just goes along with it. His idea is to go along with whatever she wants. Don't worry; you're my lady friend! My cousin, Manny lives up in the city and he's always bringing ladies around."

"What about Neil?" Trudy asked. "You've only met him in passing. Is he invited, too?"

"Sure! Of course he is!" Will said. "I'm talking about an early afternoon New Years Day dinner. He won't be up late and we'll have him home before his bedtime so it won't screw up his school the next day. Okay?"

"So, I guess we can go if you're sure it's alright with your folks," Trudy said. "With all those people coming I wouldn't want her thinking I was in the way."

"Sure! Sure it's all right. They invited you!"

"They did?" Trudy said. "I've never met them."

"Well, I told them about you. I told them I would try to get you to come to the dinner," Will said. "I thought I could talk you into coming over. Wait 'til you try my mother's cooking! By the way, I ought to tell you that her real name is Maria, but no one calls her that. She always goes by her last name—Baker. Everyone just calls her 'Mama Baker', and that's what she likes."

"Maria sounds Spanish," Trudy said. "Baker is . . ."

"California Spanish," Will said. "She descended from the early Spanish settlers of California. My dad is from Scotland. He was born there and made his way over here in his teens. We think he was heading for the California gold country, but he says he wasn't. It was over by the time he got here anyway."

"Really? Well," Trudy said, "I'm certainly looking forward to meeting them."

Trudy and Neil went out to the "ranch" on New Year's Day and spent the afternoon with Will and a dozen or more members of his extended family, and they all enjoyed one of Mama Baker's sumptuous dinners. Mama Baker was jovial and expansive as she brought out the food and watched everyone as they enjoyed the result of her several days' of cooking.

After several visits to the ranch Trudy and Neil discovered that Mama Baker's hospitality was just slightly better on holidays than it was on Saturday evenings when the family gathered for an early evening meal and an evening of good-spirited penny-ante poker.

Trudy and Neil soon learned that the Baker family had refined the game over many years. They knew how long an evening's game would last and they had discovered that when everyone would buy chips for $3.85 when they started the game, that would generally give them enough chips for the entire evening or until someone was fed up with their luck and decided it was time to go home. They played a dealer's choice game around a big, round dining room table and it was almost impossible to win or lose as much as five dollars during the whole evening. Everyone enjoyed the warm, friendly game.

When the game started, Will's father was the banker and tossed everyone's money into an old cigar box. He gave each person their set of chips and went on to the next person until everyone had their set of chips and the game started. At the end of the evening, he bought back their chips and everyone was happy with the evening. Extra betting on exceptional hands was frowned on as being unfriendly and in poor taste because, as they said, the game was for family enjoyment and not to win or lose money.

Will and Trudy soon were seeing a lot of each other, causing more speculation between Miss Wembly and Lovey, but Trudy assured them that she wasn't going to jump into another troubled relationship. She readily admitted that they both had problems that needed to be worked out, but at the same time, as the weather warmed moving into spring, they began to take whole days and weekends together on little trips to San Jose and San Francisco.

One day in March, Trudy answered the telephone and was surprised when her former brother-in-law, Leonard, began talking with her. She recognized his voice right away. "Hello! How are you?" he said.

"Why, hello!" Trudy answered. "Gee, it's been such a long time. I intended to write and tell you where I am, but I've been so busy."

"That's what I hear!" Leonard said. "I've been busy, too. I don't work in Boise any more. I took a job in San Jose with the newspaper and I live in Palo Alto. That's just north of San Jose a few miles. I remarried, too. Listen, we'll be down in Monterey this coming weekend. Can we stop by and say hello?"

"Sure! I'll be here," Trudy said. "Do you know where I live now?"

Trudy gave Leonard her address and made sure that Will knew they were coming. She didn't want to complicate things by letting Leonard and his wife see that she had a steady boy friend right on the heels of her annulled marriage. It may have meant nothing to Leonard, but she wasn't sure. She did tell Neil about the visit however, since Leonard was Neil's uncle and she was sure that Neil would want to see him.

When Leonard and his wife arrived late the following Saturday morning he reminded Trudy that they had not seen each other since her husband's funeral over two years earlier—longer since he had seen Neil, since her son had not wanted to go to his father's funeral. Trudy and Neil enjoyed the day with a pleasant lunch,

274

Trudy's House

meeting Doris, Leonard's wife, and the inevitable chit-chat about the relatives. Sometime during the day Leonard explained that he had wondered what had happened to Trudy and made a phone call to Trudy's older sister, Jean just after she had returned from her visit to Pacific Grove.

"Your sister told me that you had found a gold mine down here," Leonard said, "and I've got to say that this house looks pretty impressive. My brother must have had good life insurance!"

Trudy laughed and said, "He didn't have any insurance. I had to sell all his tools and half of our belongings to raise some money. I bought this old place and I rent rooms here! I'm a landlady now—what do you think of that!"

"Good God! That's wonderful!" Leonard exclaimed, studying Trudy. "I thought that you might be working for someone down here. How in the world did you start that kind of work? The last time I saw you was when you were still married and living on the coast, I think you were trying to write stories or something. Didn't that pan out?"

"No," Trudy admitted. "I never sold a thing. I don't know if it was because I couldn't write, or if it was because life was so depressing for me there. Anyway, we had decided to separate right after the war started, and I went to learn how to paint airplanes. We sent Neil to Russell's place until we could decided what to do with ourselves,"

"My gosh!" Leonard exclaimed. "You've been busy! When did you decide that you could be a landlady? That last time I saw you in Delake, I had the impression that you didn't have training in anything. I mean, that sounds insulting but there you were trying to write short stories! What could be harder?"

"You know, before I came down here to look around Jean really tried to talk me out of taking the trip because she thought I was being frivolous. But, that's Jean's way. She's a stick in the mud. She stays with a job as long as they'll have her—and it seems like they always take advantage of her loyalty. She can be so old fashioned at times."

Seeing that Trudy was getting sidetracked, Leonard said, "So, how in the heck did you find this place? Did you just go driving around until you found something?"

"Well, you see, I drove down here with my friend, Faith—they lived next to us when we lived up on the hill in Portland—and we drove down as far as L.A. and started up the coast."

"What were you looking for?" Leonard asked. "Did you know that you wanted a place like this?"

"Well, no," Trudy said, clearing her throat. "Not really. You see, I had never been down to L.A. before and I wanted to see what it was like—such and awful place with those zoot-suiters! Anyway, after you gave me that wise advice at the funeral, I decided that I really should follow it. I wanted to go to see how warm and

275

sunny California was, and Faith needed a break from her life so the trip worked out for both of us. She's a wonderful driver and such a good businesswoman and she gave me a lot of good advice. We talked a lot about things I might be able to do as we drove and finally we decided that I might be able to rent rooms for a living."

"Process of elimination," Leonard said.

"Yes, I suppose so," Trudy said without understanding what he had said. "So, let's see. Oh! Then we started driving back up the coast until we got to Monterey—we had been reading about the Monterey Peninsula. We stopped and talked with this real estate lady and she showed us this place. They talked and talked to me until they convinced me that this place had potential and I went ahead and put some money down on it to buy it.

That was just about all the money I had in the world and I began to think that I had made a terrible mistake when I took the house over. I remember sitting in that dark hallway at the top of the steps and a wave of fear just washed over me. I just felt terrible! Then, I realized I had to get busy because that was the only thing I could do! I looked through the house and made some plans and got started. We've been working on it ever since and I have six rooms rented. I owe all this to your wisdom!"

"Wonderful!" Leonard said. "You know, lots of people name their beach front houses. Do you have a name for your house—how about "Trudy's House"?"

"Heavens!" Trudy said with a laugh, thinking that Leonard was joking with her. "I've never heard of such a thing! I've never even thought about it!"

After Leonard left, Trudy sat on her davenport with a cup of coffee and reminisced about his visit. She had enjoyed the visit because she had always thought Leonard was one of her husband's brothers who seemed destined to be somebody. He was also a connection to her past and although she was quite content where she was, she had a tiny impulse to make a trip someday and see Portland again and see what had changed. But she was in no hurry for that! She had only been gone two years, and if she waited five years or so the changes would be more striking. Trudy sipped her coffee and reached for a magazine to read.

After knowing Trudy for several months, Will had started to take an interest in Trudy's house by doing little maintenance jobs to help her along. He repaired leaking faucets, dripping drains, and replaced worn out or dangerous old electrical fixtures. Of course, she was grateful for his help and often made dinners for him. During one of the dinners Will mentioned that he thought the house should be painted because the shingles were beginning to show some weathering and it would be a good chance to get rid of the barn red color that Trudy hated.

"You won't be able to get it painted until summertime," Will said, "because you need some warm, dry days for the paint to dry. You still have time to save up some money."

Trudy's House

"But, I won't have enough money for that," Trudy said. "How much will it cost to get it painted? A thousand dollars, I'll bet."

"I have a cousin who needs some work right now," Will said. "He's non-union and I think I can get him to do it working time and material."

"What's that? What difference will that make?" Trudy asked.

"That's when you pay for the paint separately, then pay him for his time and that's usually by the hour," Will said. "And if he has help you pay their time, too."

"So, how's that any different?" Trudy asked.

"He's not getting any profit," Will said. "When you hire someone they usually figure in a certain percentage for profit."

"Hell-damn!" Trudy said. "Anything to get money out of me!"

"Well, that's the business world," Will said. "Everyone does it to pay for doing business."

"You know," Trudy said stiffly, "I'm just beginning to get ahead after all the work that Holden did, and the work on that car that I had done. People must think I'm made of money!"

"Here's the thing," Will said. "Tony One Eye is a good painter and he isn't going to cheat me because we're related. He'll give us a good deal and the house needs the paint. Why don't we ask him to look at it and give us a price?"

"What do you call him?" Trudy asked.

"Everyone calls him Tony One Eye to tell him from all the other Tonys around here." Will said. "He's a good guy. He lost his eye on a fishing boat years ago when a hook caught it. That's why he went into house painting, and everyone tries to hire him so he can get along. The only people he doesn't like are the union guys who try to make him pay union dues. Boy, he goes after them!"

Trudy looked at Will for a few minutes, mentally adding up her money. She didn't really have enough, but told Will to bring him by anyway. It would be nice to get the house painted, she thought.

Several days later Tony One Eye came by and Will walked him around the property while Trudy waited inside, but she watched them from her windows when she could. She could see that the two were friends and watched as they walked around, looking up at parts of the house. They laughed like they were telling each other old jokes, and she began to feel impatient with Will. Trudy had never understood why men wanted to tell each other jokes when they met to talk business. She wanted to run outside and shake some sense in their heads, but contained herself and waited for them to come back inside.

Will finally came in without Tony One Eye, saying that he had to get on to another appointment. "He's busy right now setting up painting jobs because people are expecting the war to be over soon. They all want their houses painted. He said he'd do it time and material and that he could probably spray paint it and do the trim for about $700. The thing is, he can't do it until late July or August."

277

"Well, that's six months away," Trudy said. "That will give me enough time to save some money."

"Yeah, that's what I thought," Will said.

Will had to get back to work and as Trudy watched him drive off she was thinking that Will would be a big help to her. She enjoyed his company and could see herself sharing her life with him, but she had also promised herself that she would wait before she stepped into any more serious relationships.

Several days later Will came over to help Trudy and Neil clean up a part of the yard to make the grounds neater. He brought a hand cultivator over from the ranch and with some ropes tied to it and Neil as the horse, they worked together to turn the hard soil, planning to rake out the weeds and plant a lawn in an area that was about twenty feet square. The job took all day and they seemed to be getting along well when Neil and Trudy noticed that Will was acting a little different. He was slowing down and getting clumsy, and Neil soon noticed that his breath smelled like whiskey. He told his mother and she began to watch Will suspiciously. Finally, she dropped a rake that she had been holding and walked into the house.

Trudy made herself a cup of coffee and some dry toast and retired to her davenport to think things over. She had known about drunks all her life, of course, but she had never had to deal with one on a personal basis. She had never even known anyone who got drunk and she really couldn't understand why Will had started drinking and acting strangely. Trudy had always assumed that people got drunk because they couldn't cope with something, or maybe there was something to celebrate.

She went over the events of the past few days in her mind and could find no reason for him to get drunk. It was an unexpected surprise that she'd rather not have to deal with, and seeing Will drunk completely changed her feeling for him. Before, she had seen him as an interesting, helpful man that she could depend on and she was actually considering a long-term arrangement with him. Now, as she sipped her coffee, her interest in him was fading away quickly. She was terribly disappointed and wanted nothing to do with a weak man!

When Will noticed that she was gone from the yard, he looked around awkwardly to see where she went, lost his balance and dropped down and sat on the plowed ground by his cultivator. He picked at a worn shipping tag that still hung on its handle and began humming a little tune, then lay back on the ground and looked up into the late afternoon sky, mumbling to himself.

Trudy came back a few minutes later and told Neil that she had phoned Mama Baker to see what should be done and was told that they would come and get him. In the meantime, Will fell asleep where he lay and Trudy sat down on top of a small garden rock wall and watched him. She really didn't know what to think—other than the fact that she was deeply disappointed with Will. As she sat

and watched him he began to snore and she wondered if she could put up with this drunkenness. She'd heard stories about women trying to live with drunks, but that was all she knew. As far as Trudy was concerned this new side of Will had completely destroyed the positive impressions he had created in her. As she watched him sleep in the freshly turned garden dirt Trudy decided that she had to talk with people and find out about drunks. She would avoid seeing him until she knew more because as helpful as he was, she understood that it would be easy to stop their friendship then and there, before it became a relationship.

Perhaps a half hour after Trudy sat down on the garden wall watching Will snore, Mama Baker and her husband drove up and parked their farm pickup at the curb. Trudy watched as Mama Baker struggled out of the cab. She was a large woman, and looked even larger out in the open and away from her kitchen. Mama Baker moved slowly and laboriously down the sidewalk toward Trudy's front door, and Trudy rushed to open the door for her so she could sit down and relax. She noticed that Mama Baker's husband, John, was carefully stepping through plants and flowers and was making his way on a shortcut toward his son and Neil. Neil was sitting nearby on a sack of lawn seed resting and watching the scene develop.

"Well, I guess Will has fallen off the wagon again," Mama Baker said after sitting down heavily in an occasional chair and heaving a big sigh.

"Fallen off the wagon?" Trudy repeated. "What's that all about?"

Mama Baker glanced at her and said, "Well, you know—he's drinking again in other words."

"Again?" Trudy said. "You mean he's done this before?"

"Oh God, yes," Mama Baker said. "I think he started after high school—then he really got into booze in the Army. They gave him all kinds of counseling and he's had sessions with the priests and then he dries out and he's okay for a while. Then, something triggers him and he goes through it all again. The Army got fed up with him and with his bad ear, they let him go."

"So that's what happened. Can't anything be done with him?" Trudy asked. "He seem so nice when he's sober."

"God only knows. The Army said that they think it's a sickness, but Father Perez says he thinks it's a weakness. He says it's all in his mind and his attitude about things. I think I agree with Father Perez. I think Will has a little child in him who likes to be the center of attention so he draw on people's sympathy."

"But everyone gets angry and disgusted with him," Trudy said.

"Sure!" Mama Baker said. "Then Will gets to be the poor, downtrodden man again who gets even more sympathy and attention from people."

"Maybe he just likes the flavor of whiskey, or the feeling it gives him," Trudy said. "Or, maybe he just wants to be that bad little boy again and get attention."

"Oh, God!" Mama Baker said again. "Who knows? Oh! I feel so vile! Why couldn't he be different!"

Trudy became a little alarmed and wondered if Mama Baker was going to be all right. In a few minutes, she realized that Will's mother was being dramatic, but saddened by her son's drinking.

"Then what do you do with him when he gets like this?" Trudy asked.

"Oh, God!" Mama Baker said. "I wish I knew! What usually happens is that we take him home with us and he sleeps it off. Then his father has to drive him back into town the next morning because he has left his car somewhere, and Will is always hung over in the mornings."

Mama Baker heaved a big sigh and said, "Oh! I feel so vile!"

Trudy sat back and looked at the big woman in the easy chair, thinking about what she had been saying. It seemed so simple to Trudy. All the man had to do was to not drink whisky! Whiskey would have the same effect on anyone! Trudy made a face for a moment, then made a fist and slapped it against her hip.

"For the life of me," Trudy said through clenched teeth, "I can't imagine what on earth goes through a man's mind to willingly make a mess of his life and everyone else's with it. Here I was thinking that he was such a good, helpful man, and what does he do? He proves in front of everyone that he's just a weak, good-for-nothing, over-grown kid! Well, I don't have time for that nonsense! He can count me out!"

Mama Baker burst into tears at Trudy's tirade. "Oh!" she said with a wail. "Oh! Help me up from this chair! Please! I have to go! I can't listen to more of this!"

Trudy stepped quickly across the floor, grasped Mama Baker's outstretched hand and pulled the woman up out of the chair. Trudy looked at Mama Baker and said, "I'm sorry for you. I'm not angry. I'm disappointed with Will."

"Oh, I understand," Mama Baker said. "But he's my son and it hurts me to hear those things. I'm not angry with you either."

Trudy stood aside as Mama Baker made her way to the front door and opened it. She paused in the open doorway and looked back at Trudy. "I don't know how much help we'll be but we'll work with Will and see if we can do something to keep him off alcohol. I know how you must feel, but we'd like to see you and Neil again."

Trudy felt herself softening a little and smiled. She watched as Mama Baker stepped down to the sidewalk and move toward their pickup. She could hear her talking to her husband, "Where is he? Is he in the car? Well, let's get him back to the ranch." Trudy, disappointed and still angry, watched them drive off. She liked Will and had begun thinking about him as someone who would be a good companion for her—until he got drunk and made such a fool of himself. She clenched her fists and slapped them against her hips again.

CHAPTER TWENTY

The next morning Trudy talked about Will's drunkenness with Miss Wembly and Lovey. Lovey had seen him working in the yard with Neil and had marveled at how they seemed to be working as a family. Then she looked out the window an hour later and saw Will lying on the ground. "It scared the hell out of me!" Lovey said. "I thought, 'Gee wiz! Has this guy had a heart attack?' He started moving around and then I saw that he was really plastered! How did he get wiped out so fast?"

"We think he had a bottle hidden somewhere," Trudy said. "But, tell me about that. I've never had anything to do with drunks."

"When I was a young lady, my father would have dinner parties for his business friends and we always served greasy roast goose to keep the men from getting too drunk and making fools of themselves," Miss Wembly said. "The grease in the goose prevented anyone from getting drunk—or so they said. No one in our kitchen knew how to make bubble and squeak properly. It always came out greasy, too. So whenever they served that for his friends it had the same effect. Maybe you should have those meals when that man comes by—or something else just as greasy!"

Lovey and Trudy just looked at each other for a moment. Neither had ever heard Miss Wembly talk so much about her early life. "What the hell is, 'bubble and squeak?'" Lovey asked, forgetting her manners for a moment.

"I'm not really certain," Miss Wembly said. "I think it was like a leftovers dish. I don't think I ever had to make it so I'm really not sure! They used to mash it together and fry it."

"Huh," Lovey said in acknowledgement. "Well, I can't remember what they used to do to sober up drunks when I was a kid. Everyone always said coffee, but I think they had something they'd give them to bring them around, but I can't remember what it was."

"Anyway," Miss Wembly said. "You asked about drunks and I'm afraid that all I've heard is that you should avoid them because if they have the weakness for alcohol, I don't believe that they can truly recover from it. As I said, I've heard that it's a weakness and they can cause no end of trouble."

"Trudy," Lovey interjected, "Trudy, the safest thing to do is get on with your life and don't get involved with him. I know. My sister's husband was a lush. He'd hit her if she tried to make him stop drinking. If she threw out his bottle all hell would break loose. I shouldn't say it, but he was a bastard. A real monster!"

"Good heavens!" Miss Wembly said, caught up in listening to her story. "What became of him?"

"He fell down the front steps of their brownstone building one night when he was coming home drunk, and died when he hit his head on the sidewalk," Lovey said. "It was God's way of taking care of my sister—Oh! Maybe I shouldn't talk that way, but that man deserved it. He really deserved it. He was so mean to her!

"Dump that man, Trudy! You're a nice looking woman and you can find another guy—easy!"

Trudy decided to wash her hands of Will and concentrate on taking care of her house. She soon fell back in her earlier routine of making curtains and drapes, helping Neil in the garden, and visiting friends. Thankfully, she had reached a level in renting where the rooms took care of themselves and Trudy didn't have to deal with problems with her tenants. She had never been one to listen to the radio for music and news, but she did go through the newspaper for local news and read magazines in her favorite spot near her windows in the living room.

Neil came home from school one day and announced that President Roosevelt had died and that the new president, Harry Truman was already in charge. Trudy thought that was remarkable that the national government had moved so quickly, and promptly forgot about it. Presidents and political parties bored her.

Trudy had heard about a big meeting at Yalta, and knew that somehow it was important and that she should be interested—but she couldn't bring herself to think about it. Then, there was a lot of talk about people meeting in San Francisco to try to form some kind of new world government, but again Trudy was more interested in her magazines.

On May first, Trudy was having her usual toast and coffee with Miss Wembly when the two were interrupted with car horns blaring going down the street. The two women glanced at each other and Miss Wembly said that something must have been heard on the news. After a few minutes the horn honking subsided and later that day Lovey said that Hitler had committed suicide, and quickly added that didn't mean the war was over.

"Well," Miss Wembly said, "it's quickly coming to an end in Europe, but I'm afraid that we still have to deal with the Japanese."

Trudy's House

"Do you think you'll be going back to live in France?" Trudy asked.

"Oh! Heavens no," Miss Wembly replied. I'm here now. This is my home! What about you, Lovey? Are you and your husband going back to New York?"

"Oh, yeah. Oh yeah. You bet," Lovey said with a grin. "Moe and me, we got friends and relatives all over. We want to go back and pick up where we left off. I dream about that day!"

"Well, it won't be long," Miss Wembly said. "I'd venture to say that you'll be home by the end of summer—by Thanksgiving, certainly!"

Lovey looked at Trudy and said, "Trudy, what about you? You're not going back to Oregon, are you?"

"My goodness, no!" Trudy said. "This is my house. I'll live here and rent rooms just like now. People will always want rooms at the beach."

Trudy didn't mention that she was beginning to feel a need to get out and see some of the places in the world that she had heard about. She would like to go see her relatives in Portland, and after hearing Miss Wembly's tales about France and England, and other tenants talking about their homes in various states, she could think of dozens of places she would like to see. Sometimes, listening to her tenants talk about their homes, Trudy would get so intent on listening to the descriptions and hearing the stories that she would completely forget things that she had to do each day! But, Trudy was embarrassed to tell anyone about her yearning to travel because she thought that she had to pay attention to her house and save money. Privately, she knew that she would probably have to convert her rooms into apartments, and that would require a lot of money! Somehow, travel would come later, but she needed to concentrate on her house!

A few weeks later, on May 8th, Germany surrendered and news announcers proclaimed that the war was over in Europe. Horns honked all day, and Trudy could hear church bells ringing down the street. The newspaper printed an extra edition with bold headlines and people almost forgot about the war in the Pacific for a day while they celebrated V-E Day—Victory in Europe Day!

They next day, Trudy answered the door late in the morning and found Will standing there with a potted rose bush. He handed it to her when she answered the door saying, "I've been wanting to stop by and apologize to you for making such a damned fool of myself that day, but I've found it hard to find anything to say. So, I decided to buy you a rose bush."

Contrary to her earlier conclusions, Trudy was glad to see him again. She accepted the plant and let Will in to talk with him. She had wanted to tell him exactly what she thought about his drunkenness.

"So," she began. "How have you been—and how are your parents?"

"Good—good," Will said. He paused, searching for a way to start talking. "You know, I've been going to meetings to deal with alcoholism."

"Have you—so soon?" Trudy was skeptical. "How's that?"

"It isn't easy for me," Will said. "They told me that I have to make a whole new set of friends and I have to make a lot of changes in the way I think and live. It isn't easy at all."

Trudy felt like she was being set up. "Well, now that you're sitting here, before you go on, I want to get something off my chest. I've given it all a lot of thought and I want to tell you how I feel about your drinking. When my husband died I had to start right then and fend for myself and Neil. There was no one else, and thank God I had a few friends because I discovered that I wasn't able to do a thing to earn enough money to support us."

Trudy paused and looked at Will to see if he was listening to her. He had settled back in his chair and was watching her as she spoke. "I'm telling you this so you'll understand what this house means to me, and I want you to know."

Will appeared to be listening to her so she went on. "I thought I could do things but I found out that I didn't know how to get along at all. There were times when I've thought about my life and I realize that if I had only known, I could have been more of a help to my husband. I've been so stupid about life.

"I've had this house about two years now and it means everything to me. My life started when I bought this place and I've been learning ever since. If it hadn't been for the help of a lot of really nice people I wouldn't even have this house because I didn't have any idea what to do with it, even though I was getting good advice. I don't even know where I got the nerve to buy this place. When I did, it scared me to death—and I used every red cent I could gather up to buy this place because my husband didn't have any insurance. If I had failed, or even missed a payment, I would have been out on the street with a twelve-year-old kid to support."

"Okay," Will said. "I can see that you had a rough time, but why—?"

"Because, I want you to know that there is no room in my life for a weak man that I can't depend on," Trudy snapped. "I can't do all this by myself. The war is almost over and everyone tells me that I won't be able to rent rooms anymore. I don't know if they're right, but I notice that almost everyone who rents my rooms is in the military. I can see that little efficiency apartments would rent, but I don't know how to do that! I'll be facing working this whole house all over again and I don't know if I can do that! I'll need help and I'll need someone I can rely on!

"We get along, you and I, and you know about houses. You like to go places and so do I, then you ruin everything with your silly, childish drinking! Hell-damn, Will, I want you to get out of here! Please go! Now!"

Will looked at Trudy with a glum expression, then slowly got up and walked out, closing the door behind him.

Trudy took a deep breath and wiped tears from her eyes and watched him drive away. Trudy remained sitting in the fading afternoon light for several hours, feeling drained and very tired.

Trudy's House

As the sun was going down, Neil knocked at the door and opened it. "Are you in here?" he asked. "Are we having dinner?"

Trudy answered from the darkness of her living room. "Oh! Yes. I guess I was about to go in the kitchen and start something to eat."

The doorbell rang as Trudy stood up, and she walked over to see who was there. As she opened the door she was surprised to see Will again, standing by the open screen door. He held a small paper bag out to her.

"What's this?" she asked. She opened the bag in the fading light and peered inside, then pulled out an unopened half-pint flask of whiskey and looked quizzically at Will.

"My first impulse after I left you this afternoon," Will explained, "was to go out and buy myself another bottle but I thought better of it. I think you should pour it out on the ground before we go out to dinner."

Will watched as Trudy opened the flask and poured the contents out on the ground beside the front steps. She had learned a lot about the world and the people in it since she had been renting rooms, but Trudy was still a romantic who loved a story with a happy ending, and at that moment she actually believed that Will would never touch whiskey again.

"I'll need my hat and coat," she said. Then calling back into the house Trudy said, "Neil! Can you make yourself a dinner with some leftovers? I'm going out to talk with Will."

"You bet!" came Neil's response.

END